ART FUNDAMENTALS
THEORY AND PRACTICE

ART FUNDAMENTALS
THEORY AND PRACTICE

Fifth Edition

Otto G.
Ocvirk

Robert O.
Bone

Robert E.
Stinson

Philip R.
Wigg

School of Art/Bowling Green State University

wcb

Wm. C. Brown Publishers
Dubuque, Iowa

BOOK TEAM

Karen Speerstra *Editor*
Sharon R. Nesteby *Editorial Assistant*
Edgar J. Laube/Karen Slaght *Production Editors*
Mark E. Christianson *Senior Designer*
Carol M. Schiessl *Photo Research Editor*
Mavis M. Oeth *Permissions Editor*

wcb group

Wm. C. Brown *Chairman of the Board*
Mark C. Falb *President and Chief Executive Officer*

wcb

WM. C. BROWN PUBLISHERS, COLLEGE DIVISION

Lawrence E. Cremer *President*
James L. Romig *Vice-President, Product Development*
David A. Corona *Vice-President, Production and Design*
E. F. Jogerst *Vice-President, Cost Analyst*
Bob McLaughlin *National Sales Manager*
Marcia H. Stout *Marketing Manager*
Craig S. Marty *Director of Marketing Research*
Eugenia M. Collins *Production Editorial Manager*
Marilyn A. Phelps *Manager of Design*
Mary M. Heller *Photo Research Manager*

CONTENTS

5

SHAPE 63

6

VALUE 83

7

TEXTURE 94

8

COLOR 107

9

SPACE 144

10

ART OF THE THIRD DIMENSION 172

11

FORMS OF EXPRESSION 193

FIGURES

PLATES

PREFACE

It might be assumed that constant pruning and grafting would produce a nearly perfect book. The humbling experience of book revision teaches that this is not so—and the comments of our readers are constant reminders of it. We have reconciled ourselves to the fact that we cannot be all things to all people. We have tried to acknowledge consensus criticisms in this revision, but many contradictory reviews rule each other out. They are, nonetheless, always appreciated.

The quest for more lucid writing remains one of our major tasks in revising. Here we encounter a problem: some readers have claimed that we talk down to the user, while others say that our writing level is too pedestrian. We have tried to avoid both criticisms by simply writing clearly. Our efforts in this revision have concentrated on that objective. Many sections have been rewritten or altered. In order to meet the criticism that "it seems to have been written by a committee," much of this edition has been written by one hand.

Other testimony has assured us that improvements could be made in the design. Many readers have suggested that the visuals be better juxtaposed with the related text, thus avoiding constant page turning. We have done this as best we could. Unfortunately, optimal placement is financially impossible with color illustrations. The costs of book manufacturing mandate grouping color illustrations together in the form of signatures. Optimal placement could be accomplished, but at a considerable cost passed along to the student.

Some reviewers have observed that the book has not been updated with regard to its visual selections. Usually we are so relieved to find a particularly appropriate item that we give little thought to its style or period. We take no stance, for example, on avant-garde art; our choices are made purely on the basis of suitability. With the whirlwind pace of recent art styles, avant-garde can quickly become passé. We want *good* art, but such a judgment is sometimes difficult to make without the perspective of a few years. We try to achieve some balance, although the aptness of a work's relationship to the text is always paramount in our minds.

The book should give evidence of our awareness of the changing art climates (though, as noted elsewhere, the idea of stylistic change as *progress* can be debated). There certainly are new ways of seeing things. In the nineteenth century it might have seemed that the academies had a permanent hold on the character of the art produced. When this grip was finally broken, the Impressionists, Post-Impressionists, Expressionists, and Cubists also became institutionalized. This process of enshrinement eventually extended even to the Dadaists, the group that, ironically, was dedicated to the destruction of institutions. The major concepts for many years seemed to be Cubist oriented. The influence of Cubism has now declined somewhat, allowing for an infusion of styles from many other sources. Today these styles are multiplying rapidly, resulting in a coming together of many different artistic points of view. We felt that a revision should better reflect this mix of contemporary art—not to confuse, but to make a realistic statement of the current art scene. But, in full knowledge of the transient quality of that scene, we also felt that we should not jump on any band wagons, nor should any of the finest exemplars of the traditions of western art be excluded. Knowing that the beginning art student can be easily distracted by transient fashions, we have tried to walk a middle course, still adhering to those principles we feel are necessary to the understanding and production of meaningful art.

The reader familiar with previous editions will discover that considerable portions of the book have been rewritten. We have also overhauled the exercise sections and realigned them with the text areas to produce a more logical relationship between the two.

A worthwhile book is written out of a perceived need and on the basis of how the author intends to meet that need. A book on art instruction, perhaps more than any other kind, should be equally realistic about what it *cannot* do. Beyond a certain point, the more one attempts to be systematic in this instruction, the more one misses the essential value of art. One cannot legislate feelings or emotions, and art is nothing if it lacks

these qualities. One cannot prescribe personality, and good art is stamped with the honest imprint of its author.

Art instruction, therefore, narrows down to a few simple procedures that are deceptively complex in their application. It succeeds or fails with the sensitivity of the students and their capacity for work. A person who would teach art well must learn to live with the knowledge that this student sensitivity feeds on the enthusiasm exhibited by the instructor. An atmosphere of creative excitement is always the most important step toward meaningful art instruction.

Beyond this, instruction in art must function elastically. It should be presented on as personal a basis as possible, but it should also ensure that personal experiences add up to those factors that are fundamental in art expression. In short, there should be some system to the instruction, but the system should be kept within tolerances that permit discovery. There must always be a point at which the student can take over.

This book is an effort to fulfill the need for such a cautious system of instruction. It is not a how-to book; it contains no rules, formulas, or guarantees. In art such things are not possible. The book is, however, predicated on certain principles that are presumed to be of such a fundamental nature as to encompass a wide range of expression. These principles underlie every work of art, historical and contemporary, and can hardly be said to originate with us. Our search was not for novelty but for a sound and supple method of guidance that would encourage the development of understanding and ability. One should always be aware that most of the original thinking in this field is *in* the art, not on it.

Thinking and feeling are the two prerequisites to the successful use of the exercises in this book. They are meant to be sensed and understood, not mechanically repeated. None of the problems, individually, is of any great importance, nor is the resultant work likely to be of surpassing beauty. But each exercise represents a problem that eventually appears in the total art form. Once the problem has been experienced, it is easier to recognize it as such and find its answer.

The best use of the recommended creative exercises can be made only if the text has been read before and after their execution. If the work is being done in a class, the chapters may very well serve as a basis for lecture or discussion. Text presentation has been deliberately kept at a reasonably challenging level in the belief that this approach provides stimulation for a greater range of abilities.

Organization on the basis of art elements is a method that evolved out of the instructional experiences of the authors. Any book on art must in some way break down *form* in order to illustrate and instruct. Division into the elements of art structure, *line, shape, value, texture,* and *color,* has the advantage that these elements, universal and unchanging, are unlikely to be challenged in their interpretation. The one disadvantage of this division is the one recognized as being a potential threat in any course of study—the possibility that the student may fail to make a final integration of the concepts illustrated by this breakdown. If present, the instructor is responsible for seeing that any learning developed out of the study of any *one* art element should find application in any future work.

The use of this book should be accompanied by studies of reproductions, and, even more, of original works of art. No text of this kind is able to provide ample quantity and quality of illustration. The authors chose the illustrations that they considered to be the most obvious examples of points brought up in the text. Most of the illustrations are good works of art, but certainly not of uniformly high quality in everyone's judgment. Their use here does not suggest a sweeping endorsement of their value. One of the interesting things about art is that there is rarely, if ever, an artwork that is wholly good or wholly bad. An illustration used to depict an admirable quality of one sort might very well be used to show an unfortunate lapse in some other respect. We suggest that you use the pictures with discrimination and judgment, or even as the focus of healthy debate.

Terminology is included in the book solely for the establishment of a common basis of communication among those using it. It is impossible to find universal agreement among art people on terms, their significance, or their interpretation. A glance at other art books will confirm that words, definitions, and emphases vary. Consistency seems to be the important thing here. Use of the book will be more profitable if its vocabulary is used consistently. It has been said that Georges Braque once remarked that he wanted his students to paint in his style as long as they studied with him. Only in this way did he feel that they could understand each other. Anyone who has taught art understands the wisdom and the danger in this approach. The danger is avoided if the style or method is understood as being only a temporary expedient. In a sense, this book can be considered a temporary expedient. It is *temporary* in the sense that anyone who would become an artist must go far beyond it; it is *expedient* because its composition should expedite the development of sound attitudes.

ACKNOWLEDGMENTS

The writing of acknowledgments does not become easier with practice; on the contrary, as each new edition is published we are further indebted to more people and institutions and further challenged to find new ways of expressing our gratitude.

Perhaps it is simpler and more meaningful if we fall back on conventional expressions and merely say that we are deeply grateful.

The recipients of this gratitude include the many museums and art owners whose works are illustrated here. Special acknowledgments must be made to our colleague, Debra Babylon, and her students at Bowling Green State University and the Toledo Museum of Art, School of Design; Lily H. J. Pomeroy, Livingston University, and her students; Larry L. Schuh, McNeese State University, and his students; and Carl Emmerich, Eastern State University, and his students.

The publisher's book team again overcame our intransigent slothfulness.

And, once again, our wives have been supportive and patient.

REVIEWERS

Glen B. Blakley, Dixie College
Alyce B. Coker, University of Minnesota, Duluth
Patricia B. Covington, Southern Illinois University
Kay De Marsche, Arizona State University
Robert Fox, State University of New York at Farmingdale
Gene Hatfield, University of Central Arkansas

Georg Heimdal, Ohio State University
Richard Helzer, Montana State University
James K. Johnson, Eastern Illinois University
Lynn B. Johnson, University of Wisconsin at Stevens Point
Richard Tichich, Georgia Southern College
Dennis Voss, University of Montana
Doris W. Woodson, Virginia State University

1
INTRODUCTION

The nature of art and its roles in society have been subject to many interpretations. Some people have seen art as a kind of personal therapy, others as a vehicle of political expression. These interpretations, as well as many more, all contain some truth. The practice of art has the capacity to lift the spirits by providing a focus for pent-up emotions. And art can be a vivid means of expressing political sentiment. These are but two of many roles that art has played over the centuries, in different cultures. But regardless of the time or place, one factor has been imperative: the artist has wanted to express something and has chosen the medium of art for doing so.

Unfortunately, what artists say is not always clear to all of us. This may be due to their own inability to express themselves or perhaps to their deliberate intention to be obscure. But in many cases the fault may lie, not with the artist, but with the *observer*. Many of us cannot understand the language of the artist any better than the equations of the physicist or the formulas of the biochemist. Every field has its own language that must be learned before one can become conversant in it. Art is no exception.

One might assume that the language of art would be made up of words (or their equivalents), but one cannot "read" art by memorizing the word definitions in this book. Nor can any words effectively parallel the expression of a work. Helpful as words may be, they are rather futile indications of what is being said visually. (In general, if we were forced to think of art in terms of words, we would say that it should be made up of adjectives rather than nouns; instead of telling us what things *are,* it would be telling us about their special qualities.) Just as adjectives and nouns are only two aspects of our literary grammar, so lines, shapes, values, textures, and color are the elements of the grammar of art. The artist assembles these elements in such a way that they say something—and that something does not always equate with words. Words are peculiar to literature, notes, chords, and dynamics to music, and *elements* to art.

Music makes an interesting comparison with art. The listener can be entertained, soothed, or excited by instrumental music. Art can have the same effect on us, but there is often a problem in its appreciation. The wholly abstract quality of music is easily accepted, but *art* as an abstraction (except as pure ornamentation) is more difficult to accept. The cause of the problem is that much art, now and in the past, is figurative, or *realistic* (meant to look like something). This is what many people expect, even demand. The truth is that the quality of a work of art is totally unrelated to its degree of realism. Some artists express themselves quite successfully in a realistic style, whereas others prefer to abstract the realism. Abstraction is simply a matter of alteration and reshuffling of priorities in order to convey the artist's feelings more effectively. *All* artists abstract to some degree. The complexities of nature leave no choice.

What should be remembered in looking at a work of art is that, regardless of style, the work is made up of the elements. The artist's particular arrangement of these elements constitutes form and determines the expressive power of the work. This holds true whether the images are realistic or abstract. If the artist has successfully combined the elements, the observer familiar with their language will find that something has been communicated or expressed.

During the periods of anti-aestheticism in the visual arts, the form language of the elements may be deliberately avoided as part of a program of rejection of traditional values. This has happened several times in the twentieth century with the Surrealists, the Dadaists, and the Op, Pop, and Conceptual artists. In such styles the language of art may be shelved in favor of spectacular and shocking imagery, compelling decorative effects, or deliberately abstruse statements.

Despite these sporadic revolts, the artists often unconsciously admit some of the language of art into their work, so strong is the instinctive urge for order. Artistic order is achieved by manipulation of the formal elements of the work. When the artist is successful in

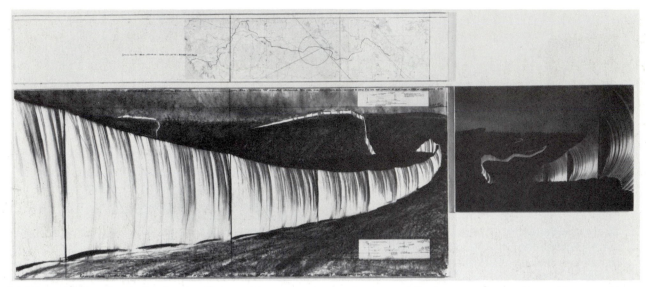

1.1 Christo (Christo Javacheff). *Running Fence.* 1976; (A) charcoal, pastel, and pencil drawing on paper, 42 × 96 in.; (B) topographical map, 15 × 96 in.; (C) color photo, 28 × 39 in. Project for Sonoma and Marin Counties, California. The variations on media, in this case lengths of supported fabric, are complemented by the formal orchestration in this contemporary artist's work. This is a demonstration of the relationship between an artist's feelings and the necessary control of artistic devices (elements of form) to create an effective artistic statement.
The San Francisco Museum of Modern Art. Gift of the Modern Art Council.

preoccupation with form, all portions of the work combine to unify the expression of the artist. When form is not a concern, mere illustration or a Babel-like concert of tongues is the result.

The emphasis here on the timeless element of form is an attempt to produce a book that can, with equal success, serve as a guide for the student in any time or place, and in most stylistic settings. Presumably, it would be useful to the medieval monk as well as to the twentieth-century artist. The works that illustrate this book have changed somewhat through different editions because art styles have changed. In the most successful of the works, the style is merely window dressing. The real determinant of quality remains the handling of form.

Form should not be misunderstood. It is not a bloodless manipulation of the art elements as in a game. True form finds its genesis in the feelings of the creator and takes shape as an effective *orchestration* of the elements in expressing those feelings. Nevertheless, some basic control of the mechanics of this orchestration is required. Thus, it is necessary for the student to indulge in exercises just as the beginning piano student must practice scales.

Change, apparently, is constant. The longer we live the more we understand this truth. It also seems true that the longer we live the more we resist this very change. As children we are endlessly fascinated by the new. As adults our view sometimes becomes dulled. We resist newness unless it adds to health and comfort. Our resistance has a damaging effect on our appreciation of art because, whether we like it or not, art also changes.

It is doubtful that this change could be called progress; it is, instead, a more appropriate voice for a changed culture.

All would agree that much of today's art is different from that of ten, or fifty, years ago (fig. 1.1). Times change and art must reflect that fact. We can no more preserve the status quo in art than we can hold back scientific progress. Yet many people want to continue seeing their art in the same window dressing. They are uncomfortable in the presence of the new.

Fortunately for those who suffer this discomfort there is relief in sight! The term *window dressing* might apply to a storefront display that changes from week to week—it is temporary and expendable. The same might be said of art styles—they come and they go. But underneath the styles there is something of greater permanence, and *that* is the language of art. By equipping ourselves to read this language we can see through the passing styles to find more profound meanings.

Our adjustment to the language of art is not easy; it requires concentrated viewing, study, and open-mindedness. The less diligent among us might be content to stand pat insofar as art matters are concerned. This may even seem the easiest path, but in the end it is the least satisfying. It is often easier to argue against things than to learn about them. Any learning (or expansion of outlook) calls for discarding old and comfortable standards, a sacrifice that in art frequently involves many of our cherished opinions. Students of art must be willing to concede the possible validity of many unfamiliar forms of individual expression. Learners must place their own tastes on trial (fig. 1.2).

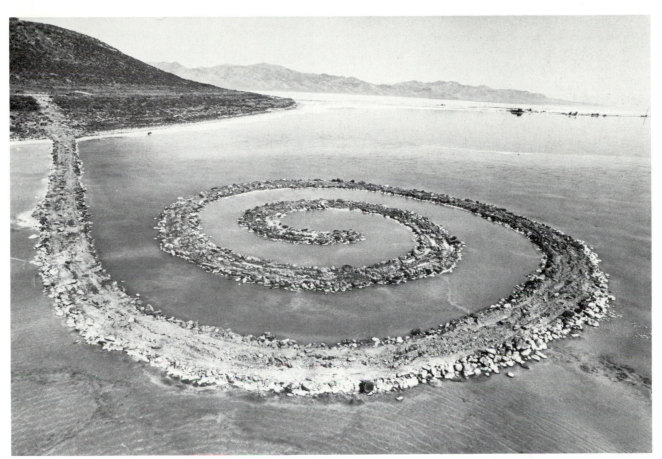

1.2 Robert Smithson. *Spiral Jetty.* **1970; rock, salt crystals, earth, algae, coil, 1500 ft. Great Salt Lake, Utah.** Students of art must be willing to concede the possible validity of many unfamiliar forms of individual expression.
John Weber Gallery, New York. Photograph by Gianfranco Gorgoni.

We cannot deny that personal taste is always influential in forming art judgments, and we would certainly be remiss in not investigating the origins of this taste. But personal preference without benefit of experience cannot legitimately pose as criticism in art or in any other field. We may argue our feelings by saying that "one man's meat is another man's poison," but in saying this we must remember that this cliché deals with exceptions to the rule. In *general,* meat is nourishing and poison is quite the opposite; although individual reaction may vary, there is still an essential difference between meat and poison for most of us. In art we may say "that's bad" or "that's good," but it is prudent to question whether we are speaking from the standpoint of purely personal reaction and, if so, whether this constitutes an acceptable evaluation. If critics are seriously pressed on this point, they are less likely to make snap judgments.

Why must an immediate reaction to a work of art be regarded with suspicion? In making a decision, we call into play all those past experiences that might have any relationship to the problem at hand. Whether we like it or not, these experiences cannot be translated into concrete, verifiable material in the field of art. Engineers, on the contrary, faced with a professional problem in building a bridge, are able to convert experience into mathematical forms that will substantiate their judgment. A problem in art judgment, compounded of feelings and understanding, is less factual and more general in nature. The solution, therefore, lies in large part with our intuition. This does not mean that a decision cannot be justified, but that it is easier to criticize than to defend. Novices in art, lacking the benefit of experience, have no alternative other than to let their feelings rule their judgments. Lacking a basis for comparison and evaluation, they are frequently led out on a limb. They form their opinions in a twinkling, instinctively. The concepts produced by their limited backgrounds quickly jell into positive or negative attitudes.

In view of the subconscious nature of the art experience, novice critics may have some difficulty accounting for their seemingly automatic reactions. They might say that a work is "pretty," but what does that say, and must it be the end of the argument? Is the prettiness

incapable of description or analysis? Are there principles by means of which this elusive quality can be argued or illustrated, or must the sensation of prettiness be confined to the individual observer? They may say that the work reminds them of something they had found pleasurable. Their experience of beauty, however, probably was not available to others, who thus lack an understanding of the basis on which the work was judged. Does this mean that the quality of a work varies according to the person viewing it, or is it possible that there are qualities that could make it meaningful to people with little in common?

These are some of the disturbing questions that can arise when we become aware that passive acceptance of inherited attitudes can thwart new experience and understanding. By taking things for granted, by failing to realize that art necessarily takes many forms, we erect a wall—a fixed concept or petrified viewpoint—that can preclude enjoyment. A solidified concept develops steadily and, frequently, unconsciously. For instance, once we are accustomed to an environment, we perform our duties with a regularity that in time becomes routine. The pattern of such activities is soon taken for granted to the extent that it may be a real discovery to find that others can have an entirely different approach to the same tasks. Our standards of morality similarly become built in. We are sometimes shocked to find that moral codes in other societies frequently contradict our own. It would take little effort, however, to establish that, in the long run, evolving economies and human relationships result in gradual but very definite moral changes in our own culture. As an example, we need only mention the contrast between mid-Victorian and contemporary attitudes (fig. 1.3).

Art expression also changes steadily according to traceable reasons, but it is often more difficult to understand because we do not live consciously with art as we do with the restraints of society. Unless art changes with the times, it loses most of its meaning, for it exists only to reflect our lives and our opinions of the world. Yet for many of us taste in art undergoes no evolution, but remains where it was when we received our first (and too often last) exposure to art as children—at the height of our formative period through the taste of our parents, the environment of the schoolroom, and the general preferences of the times. From this point on, our ideas of art are likely to undergo little revision unless an extraordinary interest in the subject motivates us toward more active observation or participation. True, we are often confronted with advertising and illustrational art, but such work is usually limited by the necessity of its commercial application.

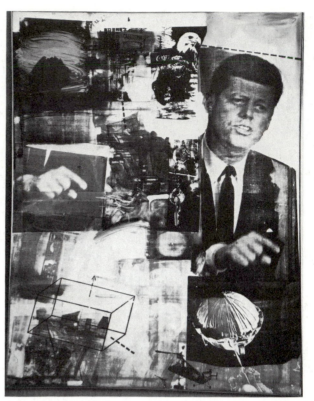

1.3 Robert Rauschenberg. *Buffalo II.* 1964; oil on canvas with silk screen, 96 × 72 in. Societal upheavals are evident in subject matter as well as art style; art exists to reflect and interpret the human condition.
Collection, Mr. and Mrs. Robert B. Mayer, Winnetka, Illinois.

In view of the foregoing, it is little wonder that people often exhibit confusion, embarrassment, or defiance when faced with a serious work of art. Genuine art is unlimited in its mode of expression; it generally sells no product but its own quality; it tells no obvious story, but inclines us toward general attitudes of thought; it exhibits its art elements simply for the excitement their relationships afford; it does not limit itself to superficial appearances, but tries to reveal that which lies deeper; it takes delight in pure adventure and invention (fig. 1.4).

If we further examine the characteristics of serious art, we discover that basically they are nonpractical in nature and obviously ask us to divorce ourselves from practical matters in order to enjoy them. In an age of automation and technical emphasis, it is difficult to imagine anything as an end in itself rather than as a means to an end. This, however, was our childhood view of things; as children, we were surprised and delighted by those things that we now think of as commonplace. We were not at all concerned with the function of the objects we encountered, but enjoyed them as things unique and marvelous in their own right. Our concepts were not fixed but constantly developing, and every

1.4 Richard Hunt. *Untitled.* 1978; print: lithograph 15 × 22¼ in. Without the benefit of obvious subject, Richard Hunt has expressed an excitement with organic shape, line, and spatial relationships. He does not limit himself to superficial appearances but tries to reveal that which lies deeper.
Collection, Otto Ocvirk.

moment of life was an adventure. True art enthusiasts must recapture some of this impractical awe if art is to be meaningful to them. They must remind themselves that one does not enjoy a sunset by counting dust particles and measuring light rays, that indeed a scientist's factual description of a sunset forfeits much of the beauty of poetic description—beauty founded on eloquence, selectivity, and exaggeration.

Whereas facts may play a part in art, there is really little excuse for judging a work of art purely on the basis of accuracy. We would probably be willing to concede that a true-false examination is a poor basis for the grading of a painting; a more effective evaluation would be a review of its effect on our private feelings. When artists work, they are moved by impressions rather than by specific things. Their reactions are general rather than precise, and to judge their products by any other standard is to miss their intentions. True critics are also affected more by impression than by fact. If they saw an area of green on a canvas, they would not immediately concern themselves with its identification as trees, grass, or water, but would be much

more interested in the feelings provoked by that particular green in its interplay with the other color areas (plate 1).

Growth of understanding and enjoyment is possible in art, as it is in other fields, *provided* that individuals have the interest and resolution to make full use of their powers of observation and introspection. It is foolish to speak of the artistic to a person who has no ambition for sensing it nor any intention of taking the time to view works of art again and again. The faculties of judgment must be enlarged and kept fresh by constant practice. Happily, the opportunities for this practice are present every day. Art infiltrates every phase of life. We must often choose wallpaper, carpeting, interior and exterior color, and all the other fixtures and furnishings that play a part in our domestic environment. Our choice is generally made on the basis of whatever feeling we have for the principles of design, and we may sometimes feel frustration because we know that our selective faculties have lain dormant, undeveloped by any of the educative processes by which our capabilities in other areas have developed.

Fundamentally, the principles upon which we design and furnish our homes are the very ones that underlie all phases of creative expression. The more closely we can keep to open recognition of these principles, the more sound will be the style created by our discrimination. The terms *fad* and *fashion* refer to temporary trends that are misapplications or misinterpretations of the underlying nature of design. On the other hand, *style* in the best sense of the word refers to a quality that is enduring because it is not icing on the cake, but the cake itself. No doubt, all of us have at times become nearsighted victims of fashions or fads whose extreme popularity while in vogue aided their infiltration into the intimacies of our lives. Yet, given the perspective of a few years, we may be appalled to find that the presumed stylishness was, in fact, a breach of good taste. The garish and synthetic character of many of the fashions of past periods, for example, is obvious to most of us now, but the delusion of the people of that time was virtually complete, much to our current amusement.

Art, being human in origin, has never been exempt from the dictates of fashion. It was nonconformity to fashion that led his contemporaries, and indeed people for many years later, to overlook Rembrandt as a significant artist. It was the fashionableness of devotion to classical art that for centuries caused people to classify art of the medieval period as Gothic or barbaric. Our own private fixation of concept is but a faint reflection of the paralysis of vision that may affect cultures and populations for generations. Of course, we cannot and should not shut our eyes to the present nor fail to be a part of it. But it is possible to develop vision that looks through the encrustations of fashion, fad, and temporary prejudice into the bone and marrow of formal structure, the ultimate gauge of soundness in art. Genuine quality may or may not exist in popular trends in art. The minor roots of art are embedded in temporary preference, but the fundamental roots are those that force downward through all eras of art and their attendant means of expression.

We could, for want of a better term, call these formal roots the *core of universality*. Attention to form epitomizes those art products that survive through generations of fluctuating taste. Form is also universal in the sense that it rises above geographical boundaries and makes the works of various cultures meaningful to each other despite the fact that they may be largely alien in other respects (fig. 1.5). We should consider ourselves fortunate that we are living in an age that through research and widespread reproduction makes the output of the peoples of the earth, past and present, accessible to us. We are in a favorable position to detect

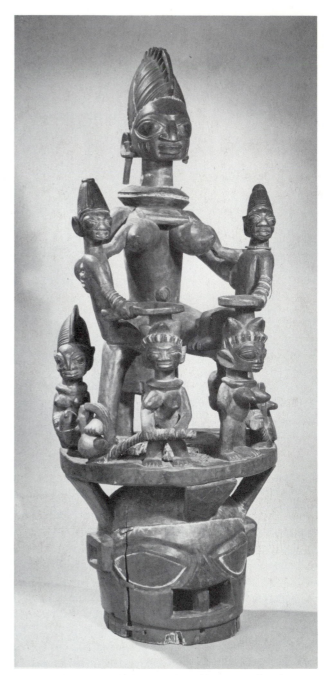

1.5 Areogun, Yoruba Tribe, Osi Village, Nigeria. EPA Mask. about 1900–1910; wood, polychrome, height 49½ in. The traditional art of Africa was particularly effective in conveying new meanings and stimulating new creative forms among European artists in the early part of the twentieth century. This demonstrates the universality of art despite other cultural differences that exist among nations.
Courtesy the Toledo Museum of Art.

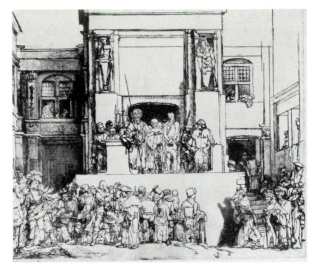

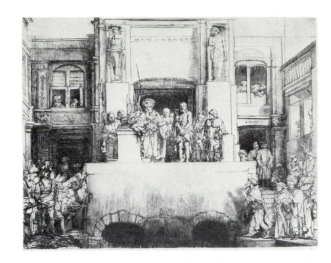

1.6 First State

1.7 Last State

1.6 and 1.7 Harmensz van Ryn Rembrandt. *Christ Presented to the People.* 1606–1609; print: etching. In the development of the plate, Rembrandt made a dramatic alteration by removing the group of people in the foreground. Such changes are to be expected in the evolution of most works of art.

Metropolitan Museum of Art, New York. Gift of Felix M. Warburg and his family, 1941.

the common qualities of those works of art that have retained their significance. Invariably, the same qualities are detectable, although they are, as would be expected in works of any depth, difficult to analyze or describe.

The development of the formal qualities of a work of art takes place in the feelings of the artist, and only through the use of our feelings are we able to perceive these qualities. Perception and intuition can be sharpened and refined by an explanation of the principles of pictorial organization, and even more by practice in their use. Ideally, this practice is sought through exercises of increasing ambition (as in this book) and through constant and critical probing of the works of art of all historical periods. Some gifted individuals possess an inherent responsiveness to form that may shorten this educative process or even render it unnecessary. But most of us can best find this new vision when our interest is tied to some systematic method of search and guidance. This is true because the fundamental properties of art are those that are most effectively concealed from the inexperienced observer. In fact, many

beginning art students are highly skeptical of the existence of some of the qualities that instructors may read into works of art. This is not surprising; the experience always lies *within* the observer, and instructors have no tangible evidence of its presence except by developing the insight of their students. In this sense, art could be compared to religion—faith must often come before understanding. If beginners are willing to accept on faith some of the basic premises of this book, they can well expect an enlarged understanding of the nature of art. This should not be interpreted as saying that such understanding will be final or that an artist will be created. Artists are those who learn to make use of their growing understanding through trial and error. As soon as they begin to feel that they know everything about art, they cease to be *artists*. Mistakes are to be expected in art as in any learning process. It is the eventual *recognition of error* that guarantees development, and recognition occurs only with a keen awareness of our thoughts and feelings (figs. 1.6 and 1.7).

2
THE NATURE OF ART

MEANING OF ART

MAJOR FORMS OF ART

NARRATION AND DESCRIPTION IN ART

ILLUSION AND REALITY IN ART

SPECIAL NATURE OF ARTISTIC EXPERIENCE

COMPONENTS OF A WORK OF ART

Subject

Form
Principles of Form Organization
Media and Technique

Content or Meaning
Abstraction
Nonobjective Art

Effect of Form on Content or Meaning
The Observer's Experience

THE VOCABULARY OF ART

abstract, abstraction A term given to forms created by the artist but usually derived from natural objects actually observed or experienced. Abstraction usually involves a simplification and/or rearrangement of the appearance of natural objects to meet needs of artistic organization or expression. Sometimes in a work of art there is so little resemblance to the original object that the shapes seem to have no relationship to anything ever experienced in the natural environment.

academic A term applied to any kind of art that stresses the use of accepted rules for technique and form organization. It represents the exact opposite of the creative approach, which results in a vital, individual style of expression.

aesthetic, aesthetics A term used in regard to the quality or sensation of pleasure, enjoyment, disturbance, or meaning people can experience in viewing works of art. Aesthetics is a study of these emotions involving the psychology, sociology, and philosophy of art. The philosophy of art analyzes the quality that we call *beauty* and its locus.

content The essential meaning, significance, or aesthetic value of an art form. Content refers to the sensory, psychological, or emotional properties that we tend to feel in a work of art as opposed to the perception of mere descriptive aspects.

craftsmanship Aptitude, skill, or manual dexterity in the use of tools and materials.

design A framework or scheme of pictorial construction on which artists base the formal organization of their total work. In a broader sense, design may be considered synonymous with the term *form*.

form The arbitrary organization or inventive arrangement of all of the visual elements according to principles that will develop an organic unity in the total work of art.

media, mediums The materials and tools used by the artist to create the visual elements perceived by the viewer of the work of art.

naturalism The approach to art in which all forms used by the artist are essentially descriptive representation of things visually experienced. True naturalism contains no interpretation introduced by the artist for expressive purposes. The complete recording of the visual effects of nature is a physical impossibility, and naturalistic style thus becomes a matter of degree.

nonobjective An approach to art in which the forms used are entirely imaginative and not derived from anything ever seen by the artist. The shapes, their organization, and their treatment by the artist are entirely personalized and consequently not associated by the observer with any previously experienced natural form.

optical perception A way of seeing in which the mind seems to have no other function than the natural one of providing the physical sensation of recognition of form. Conceptual perception, on the other hand, refers to the artist's imagination and creative vision.

realism A form of expression that retains the basic impression of visual reality but, in addition, attempts to relate and interpret the universal meanings that lie underneath the surface appearance of natural form.

representation A manner of expression by the artist in which the subject matter is presented through the visual elements so that the observer is reminded of actual forms.

style The specific artistic character and dominant form trends noted in art movements or during specific periods of history. Style may also mean artists' expressive use of media to give their works individual character.

subject This term in a descriptive style of art refers to the persons or things represented, as well as the artists' experience, that serve as inspiration. In abstract or nonobjective forms of art, subject refers merely to the basic character of all the visual signs employed by the artist. In this case the subject has little to do with anything experienced in the natural environment.

technique The manner and skill with which artists employ their tools and materials to achieve a predetermined expressive effect. The ways of using media can have an effect on the aesthetic quality of an artist's total concept.

MEANING OF ART

Art has meant many different things to different people. The term as we use it today probably derives from the Renaissance words *arti* and *arte*. *Arti* was the designation for the craft guilds of the fourteenth, fifteenth, and sixteenth centuries to which the artists were closely tied by the traditions of their calling. *Arte,* the word for craftsmanship, implied a knowledge of *materials* used by the artist, such as the chemical nature of pigments and their interaction with one another, as well as the *grounds* on which a painter applied those pigments. *Arte,* or craftsmanship, also implied skillful handling of those materials in the sense of producing

images more or less like those of nature, but certainly not in the sense of imitating the exact appearance of nature. Art in the Renaissance thus served both as a technical and an interpretive record of human experience. It has continued to fulfill this function down to the present time, although more meagerly at some times than at others. In the nineteenth century, emphasis was often placed on the technical aspects of art, but in the hands of the greatest masters it has always remained interpretive.

Visual art deals with signs to convey ideas, moods, or generalized emotional experiences. It might be called a *language of visual signs*. Unlike the language of words, however, art is not meant to be informative. Information is the province of *symbols*, as in the words of literature or the numbers of mathematics. Sometimes in the interpretation of ideas or moods the artist may employ visual symbols, but the meaning of such symbols is embodied in the forms or images that the artist creates, just as are the ideas, moods, or experiences the artist conveys.

Since art is not intended to convey facts or information, the *appreciation* of art (by which we mean understanding of art) can be enhanced when the observer attempts to grasp the *meaning* of works of art through intuition or instinct.

Although observers may realize that the language of words and that of visual signs as used in art are disparate, they might not recognize the varied problems that arise in understanding and explaining art. The limitations of the printed or spoken word in fully explaining art must be accepted as the natural inability of one medium to replace another. We have all felt the frustration that accompanies an attempt to describe a moving experience to a friend. We are soon convinced that the only description lies in the experience itself. Nonetheless, for education in a better understanding of art, the medium of words has to be used to attempt to explain the *nature* of art and the *ideas* presented by the works of art.

Unfortunately, the most moving experiences are usually those that are least expressible no matter how much we may wish to share them. The sensations of experience vary according to the senses that are stimulated, and since certain major divisions of art developed around each of these senses, we can assume that certain qualities exist that make these means separate and unique.

MAJOR FORMS OF ART

The means most frequently used to convey human feelings are prose, poetry, music, dance, film, television, theater, and the visual arts. The latter include sculpture, ceramics, architecture, drawing, photography,

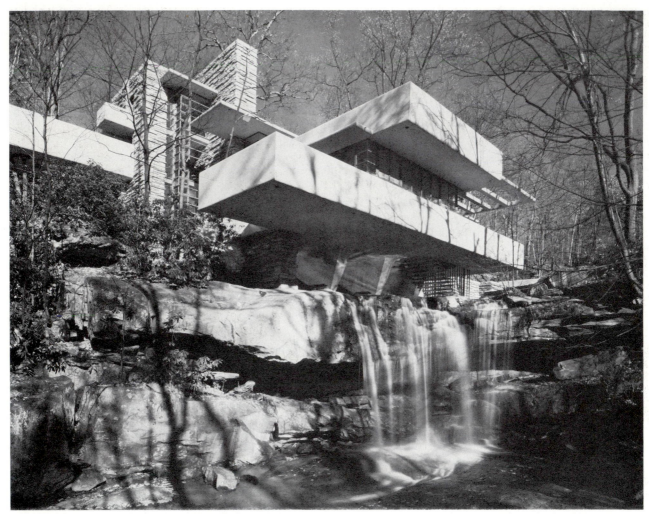

2.1 Frank Lloyd Wright, architect. Falling Water, Kaufman House. Bear Run, Pennsylvania. 1936–1939; reinforced concrete, stone, masonry, steel-framed doors and windows. enclosed area 5,800 sq. ft. To be successful every architectural design must take into consideration a diversity of factors, such as the character of the site, the taste of the owner, and the capability of the builder. Hedrich-Blessing, photographer. Chicago, Illinois.

prints, and painting. Each of these fulfills a specific need and therefore has its own province of expression. For example, we cannot very successfully paint a picture of a novel, describe a melody, or dance a poem. There have always been attempts to extend the limits of art, but they have been successful only insofar as they have respected the particular properties of the medium of translation.

The opera, the theater, film, and television are fields in which other arts are often introduced. They are rarely equally successful in all departments. Each medium has its own problems; hence, with so many demands to be met, concessions must be made. As an analogy, the building of a house requires the sacrifice of some structural strength for lighting and visibility, of living space for storage, of utility for beauty, and so forth. Each house represents a series of compromises according to the determinants of site, climate, finances available, and taste of the architect, owner, and builder. The house

that loses least in the inevitable series of compromises is, in the end, the house with the most organically successful *design*. This is equally true of the composite art divisions (fig. 2.1).

There have been periods in which one or several of the *media* or art forms have enjoyed unusual interest. Many people of the Italian Renaissance made art the measure of all things, and their lives were motivated by its enjoyment. Accomplishments in other fields were measured by their "artfulness," even to the extent that war itself became a work of art (Machiavelli). Though each of the arts found its enthusiastic audience, the epicenter of the arts lay in painting and sculpture. Here, as elsewhere, the themes depicted were usually of religious origin, the subject matter of greatest interest to the people. But interest in the subject was equalled by enthusiasm for the revolutionary concepts of *form* that derived from classical examples and that had been largely ignored during the intervening years (fig. 2.2).

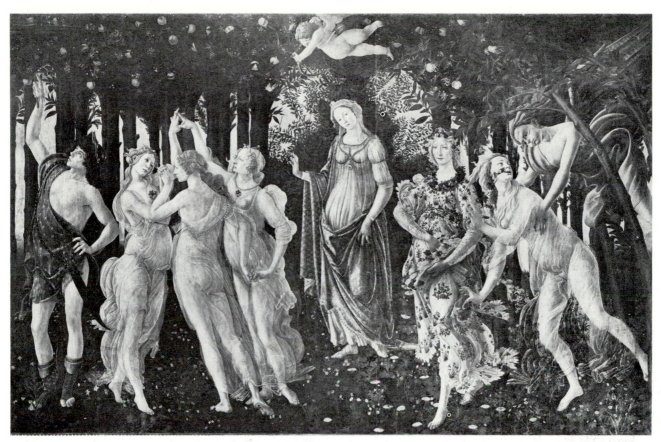

2.2 Sandro Botticelli. *Spring (Primavera).* **circa 1478; 83 × 122½ in.** This is an excellent example of an early Italian Renaissance work of art whose subject, while based on classical mythology, also implies a Christian theme. Venus, for example, is not only *classical* in concept but also symbolizes the Virgin Mary. The three-part composition, which was of Roman origin, might be said to symbolize the Christian Trinity; the classically derived dancing nymphs might be reinterpreted as representations of Christian angels. Alinari/Art Resource, New York.

The transition from medieval to Renaissance style, based on the Graeco-Roman style of antiquity, produced remarkable *form-consciousness* in the populace and introduced a period of history unique in its agreement on the value of art and its aesthetics. However, the advances that marked this revised outlook often became ends in themselves by the Baroque Period, or seventeenth century, leading to emphasis on scale and technical facility. In addition, the alliance of art with the growth of scientific method at times produced a "scientific art" that was cold and calculated, a product of conformity to standardized rules in France (figs. 2.3 and 2.4).

NARRATION AND DESCRIPTION IN ART

The layperson often assumes that a visual artwork should be recognizable, should tell a story in a visually descriptive manner. Some great works of art in the past have often told stories, but artists are under no obligation to narrate; narration is not directly a part of their medium. Even when artists have chosen to narrate, their pictorial story can be visualized in many ways due to the nature of artistically expressed form.

In the nineteenth century, when the influence of poetry and prose reached its zenith, art often became a handmaiden of literature and, aided by science, attempted factual interpretation of romantic and allegorical writing. There was marked abandonment of *form* as an expressive agent in its own right, while the favored subject matter was saturated with emotion and sentimentality. The role of art became to *narrate* and *describe,* as though one attempted to give the feeling of battle by counting the troops and weapons, or tried to express mother love by taking an inventory of nursery equipment. In short, artists had de-emphasized the essential ingredient of art and made it a second-rate translator of other media (fig. 2.5).

Art must, in its way, narrate and describe to some degree, for it has developed out of our need for a particular type of communication. However, art is at its best when its form communicates directly, with *subject* and *symbols* playing subordinate roles. The mechanics

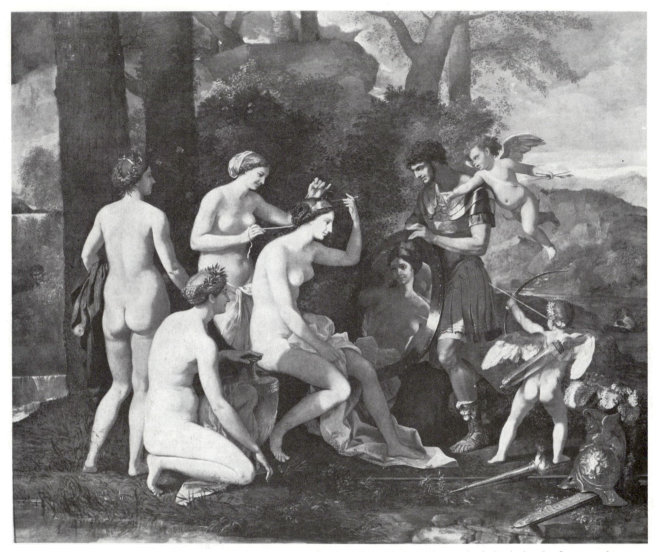

2.3 Nicolas Poussin. *Mars and Venus.* circa 1633–1634; oil on canvas, 62 × 74¾ in. The standard classical style of representing goddesses in the nude was typical of French art of the seventeenth century.
Courtesy the Toledo Museum of Art. Gift of Edward Drummond Libbey.

of art reception tend to be quite different, for the most part, from those of other media. For example, paintings and sculptures do not usually flow in time (Alexander Calder proved the exception with his mobiles beginning circa 1930; *see* p. 223), nor do they involve physical anticipation as in turning the pages of a book or listening for the next measure of music. The complete unity of a painting registers in a moment. The totality of the work can be taken in with one concentrated look, although this is hardly the recommended procedure for real appreciation. Hence, painting and sculpture, or graphic processes like drawing and printmaking, do not lend themselves wholeheartedly to the recitation of action in sequence form as does literature, which is unfolding in its presentation. Narration is more properly a *by-product* of the artist's search.

ILLUSION AND REALITY IN ART

Similarly, art is by its very nature more a matter of illusion than are the other forms of expression, music excepted. Action is never really present in paint or stone, and the human body plays very little, if any, part in the expression of action, unlike the theater or dance.[1] Although artists activate their tools in the creation of a work of art, in the work itself such activity has become static and only a reminder of past activity. Such a reminder may be stimulating in a manner somewhat like that of the present movement in the theater and the dance, but it is illusive and not real. Because of this gulf

[1]There are always exceptions to general statements: The 1960s "Happenings" sometimes involved spectators. Some artists painted people's bodies. Others dragged people through canvases daubed with paint.

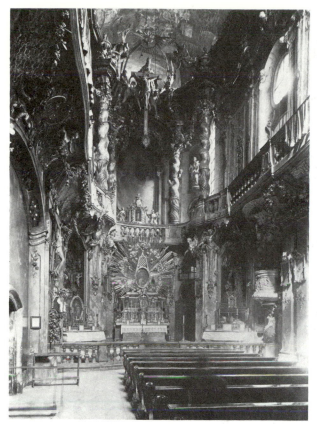

2.4 Cosmas Damian Asam and Egid Quirin Asam. St. John Nepomuk Church, Munich. 1737–1746. The interior of this church epitomizes the Baroque emphasis on scale and overwhelming ornamentation that escaped from the standards of classical form established by the Renaissance in Italy.
Courtesy Marburg-Art Reference Bureau.

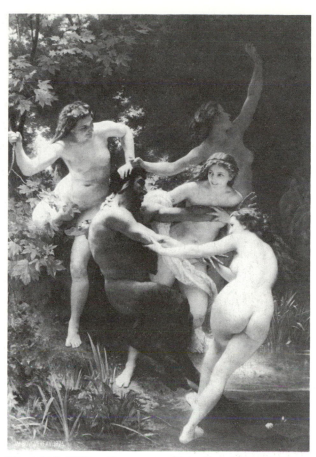

2.5 Adolphe William Bouguereau. *Nymphs and Satyrs.* 1873; oil on canvas, 102⅜ × 70⅞ in. Nineteenth-century artists often attempted to describe popular literary subjects in realistic terms rather than utilizing an expressive means deriving from *form,* or the work of art itself. In this case the theme is from classical mythology and is an excuse for a feeble eroticism. By contrast, an artist today might achieve a quality of femininity by the use of softly rendered shapes and pastel colors.
Sterling and Francine Clark Art Institute, Williamstown, Massachusetts.

between art and objective reality, there seems little reason to force art into a completely realistic or descriptive role. All media employ calculated deceits that help to create the unrealistic or imaginative atmosphere that is the unique value and appeal of the arts.

We certainly do not go to a play because we expect duplication of everyday life. Instead, we presumably hope to be transported into a situation that, through the imagination and perception of the artist, exalts and comes to grips with the fundamental forces of life. The make-believe deception in a theatrical production is purposely emphasized by our isolation from the stage— from the unnatural postures and diction of the actors, the exaggerated costumes, and the countless other stratagems. Unreality is sought in varied ways in the other arts, serving always to draw people out of themselves into a world of separate, yet meaningfully related, existence. Despite all this evidence of admittedly premeditated and justifiable guile, there are those who would miscast art in the role of a mirror reflecting the everyday world. Imagination, invention, and daring are ignored in favor of routine, rules, and rote, and unremitting slavishness to visual details, which even photography avoids through manipulation of focus and

timing. Art that places chief emphasis on accuracy of description is essentially repetitive rather than creative.

Reality as it has been used here is a convenient term for identifying the most common and superficial sensations of life. Even in this sense we could extend the description by pointing out that variations in physical and mental makeup among individuals create differences of sensation among those individuals and, thus, varying ideas of reality. Art, of course, constitutes an outlet for differences of opinion. Genuine reality for each of us is defined by our most personal experiences and interests. We each have a specialized outlook. As we progress in our studies in any field, we experience a change of mind about the truly important factors in that area. As we dig more deeply into the fields of the intellect and the subconscious, we become aware that more basic realities underlie the appearances of commonplace experience.

This reality of broader and deeper understanding marks the work of the true creator. Einstein shared the conventional patterns of life with the rest of us, but his perception revealed relationships that have helped to reshape our view of the world and our place in it. There can be little doubt as to whether the world of convention or the world of perception was for Einstein the truer reality. Beethoven was very little different from the rest of us anatomically, but inwardly he sensed revolutionary sounds that in an abstract way expressed the experiences and hopes of the human race. This to Beethoven was the true reality, not the payment of rent, the eating of meals, or the reading of the evening newspaper. Einstein and Beethoven and other people of equal significance contributed a fundamental theory of reality as discovered and transmitted through the media in which they worked. In absorbing these creative contributions, society has gradually and often unconsciously experienced a parallel change in its point of view. Creative people alter the frame of reference through which we see the world around us.

SPECIAL NATURE OF ARTISTIC EXPERIENCE

The artist's experience of reality is transmitted through a chosen medium (material) and method of execution to a particular *art form*. This *work of art* is intended to provide a unique experience with its form, or to evoke some emotion in the viewer. This kind of experience can be called unique because it differs from the objects and incidents of everyday experience, even though the artist might use such objects or incidents as *subjects*. Through various visual devices artists provide a special frame of reference to generate this unique experience, which is called the *aesthetic experience*. This term, which may sound somewhat pretentious, really just means an experience somewhat like that of the artist who created the work. Artists hope, at least, that the observer's sensations on viewing the work will be somewhat akin to their own in creating it. When looking at a piece of sculpture, for example, we should have a special attitude that is not present when we see an ordinary chair. Both forms stand on all sides surrounded by space, but the chair has a special function. The sculpture, on the other hand, is intended to arouse subtle emotional states in the observer.

This uniqueness sets works of art apart from functional or commonplace objects of everyday use, yet most people fail to understand this. When they want to know what a painting is "about," they have the same attitude toward the painting as toward any ordinary object to use. Of course, a chair may be not only of practical usefulness but also a work of art (*see* figs. 10.4 and 10.5). When this is true, new dimensions of *meaning* and *significance* are added to the usual commonplace meaning of practical use.

With the distinction of this added uniqueness in mind, observers should be able to approach works of visual art as they would poetry, as opposed to a scientific treatise, or as they would a symphony or jazz concert, as opposed to a commercial jingle on television.

Thus, we might call a painting or sculpture the objectification, record, or expression of an artist's experiences during the age and place in which the artist lives (fig. 2.6). In this way, most paintings, drawings, and sculptural images differ from the creations of industrial designers or architects. The latter must consider the practical uses the object is to serve, while the former communicate on levels of consciousness that do not include practical use. Thus, the kinds of art we will be discussing can be defined as a type of autobiography of an artist's attitude in *line, value, shape, texture, color,* and *space* that the uninitiated observer must learn to read.

The mind determines how and what we see, and mental activity is necessary before the subtle qualities or characterful nuances of painting or sculpture are discernible. Similarly, training through experience is needed to hear the handsome inflections of metric rhyme in poetry or the melodic counterpoint of music.

The province of the artist is to enlarge our comprehension of the world or universe, to widen our imaginative horizons, and to enrich our sensory enjoyment of all things. To do this, artists are obliged to create new forms by the *selection, rearrangement,* or *exaggeration (distortion)* of the forms they see or experience in the environment. This environmental influence causes artists to reflect the time and place of their endeavors.

Twentieth-century artists can be credited with reemphasizing sensory expression in the arts, a principle that was sometimes neglected during the nineteenth century when rapid scientific, industrial, and geographical expansion caused both artists and the public to think of art as a kind of science or mechanically learned skill. For example, the invention of the camera in the nineteenth century influenced many artists to work in a similarly naturalistic manner and to lose some aspects of artistic character. However, when the Post-Impressionists (*see* p. 198) came along, they began to reassert the principle of divorce from nature in favor of creating new forms that reflected inward experiences and/or the rearrangement of nature in artistic terms. They believed that the photograph recorded nature in so much detail that it dispensed with

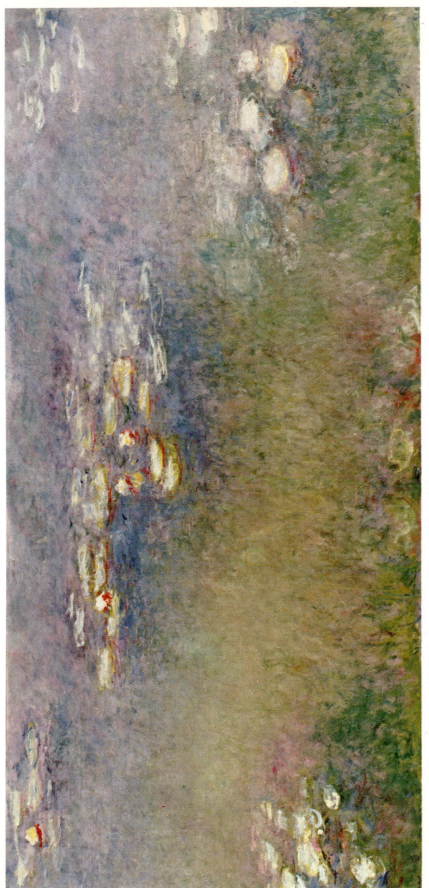

Plate 1 Claude Monet. *Water Lilies.* **1919–1926; oil on canvas, 78 × 166⅝ in.** Had he chosen to do so, Monet could have painted a more realistic image of the lilies in the water, but he was much more interested in the shimmering light and its effect on the color relationships.

The St. Louis Art Museum. Gift of the Steinberg Charitable Fund.

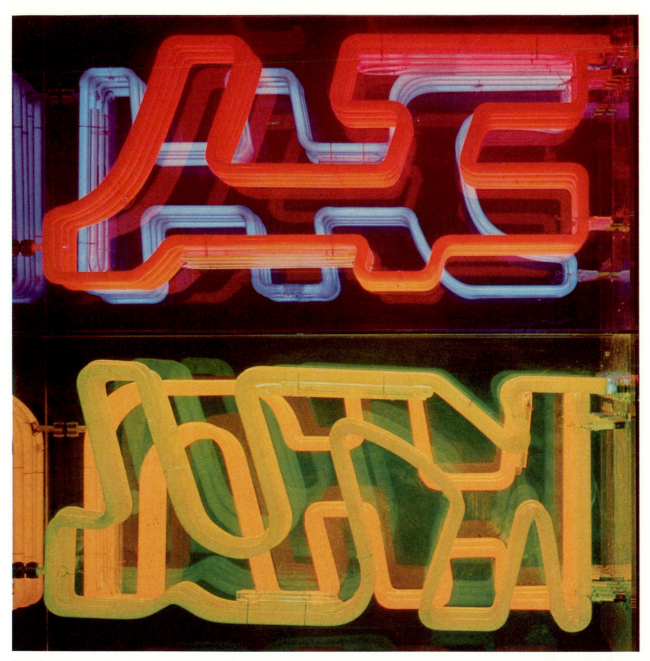

Plate 2 Chryssa. *Fragment for the Gates to Times Square.* 1966; neon and Plexiglas®, 81 × 34½ × 27½ in. As indicated in the title, neon and Plexiglas® are not normally associated with gates, although the type of lighting used in the work may be associated with Times Square. Thus the artist uses this subject as a stimulus to his creation.

Collection of Whitney Museum of American Art. Gift of Howard and Jean Lipman.

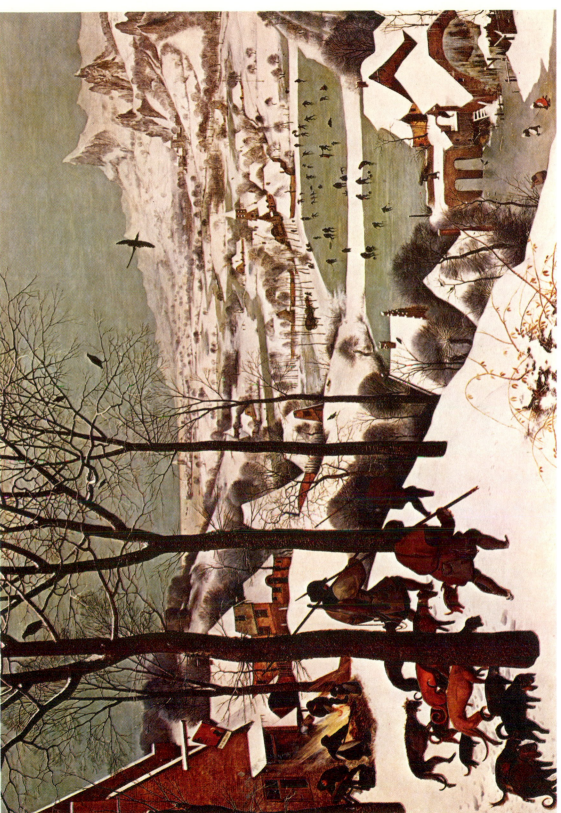

Plate 3 Pieter Brueghel. *Winter (Return of the Hunters).* **1565; oil on panel, 46 × 63¼ in.** The visual devices of line direction, spotting of light and dark areas, of rhythmic repetition of similar shape patterns, and the sense of spatial indication all contribute to the total pictorial organization called form. (Kunsthistorisches Museum, Vienna, Austria.) SCALA/Art Resource, New York.

**Plate 4 Roy Lichtenstein. *Brushstroke with Splatter.* 1966; oil on canvas, 48 × 60 in. In the abstract work there is content, but it may be the less obvious form-meaning inherent in a visual relationship such as a black line, lines set off against colored shapes, or varied contours. The Detroit Institute of Arts, Founders' Society Purchase, Friends of Modern Art Fund.

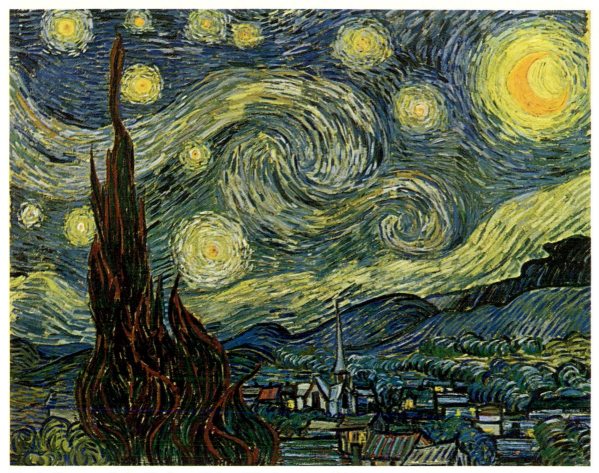

Plate 5 Vincent van Gogh. *The Starry Night.* **1889; oil on canvas, 29 × 36¼ in.** Van Gogh's impassioned response to life can be seen in his swirling shapes, intensity of colors, and heavily pigmented surfaces. Museum of Modern Art, New York. Acquired through the Lillie P. Bliss Bequest.

Plate 6 Charles Demuth. *And the Home of the Brave.* **1931; oil on composition board, 30 × 24 in.**
Sharpness, hardness, and impersonality are among the factors Demuth chose to interpret an urban situation.
Art Institute of Chicago.

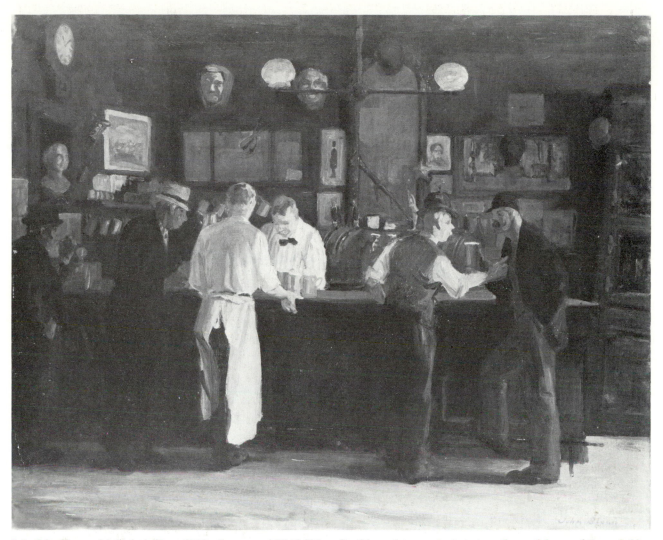

2.6 John Sloan. *McSorley's Bar.* 1912; oil on canvas, 26 × 32 in. Sensitive artists communicate to us the special aura of the period in which they lived. As an early Egyptian recorded the character of life on the Nile, so John Sloan has transmitted the life-style of the United States in the early twentieth century.
Detroit Institute of Arts. Gift of the Founders' Society.

the need for the artist to do the same. The Post-Impressionists realized that there was no such thing as a "correct procedure" for originality and that there was no basic right or wrong way to create.

However, a surprisingly large number of people apparently still believe today that art should *imitate* nature and that the best artists are, therefore, those whose works are the most faithful duplications. Some current artists play on the idea of stretching reality through scale or size. For example, Chuck Close enlarges the details of his facial features to make a point of exposing the abstract pattern of skin pores (fig. 2.7). But for the most part, the artists of this century have represented nature comparatively little. This has led some laypeople to assume that abstract artists either have not achieved the technical skills necessary to duplicate nature or that they merely were seeking notoriety by sensational images. Since art is not a science nor primarily

a technological discipline (even though it often incorporates aspects of these other fields of endeavor), the main aim of artists usually is not the surface depiction of objects.

When students understand that art does not function primarily to describe or record natural subjects, their chances of achieving their own artistic goals will be more closely realized. Then, after practicing with the formal devices, they may discover by analyzing works of art that these devices become instinctive tools of expression. Like most present-day professional artists (who are concerned with what people feel and think—their tragedies, hopes, joys, and aspirations), students may be able to conceive or imagine form in an original way.

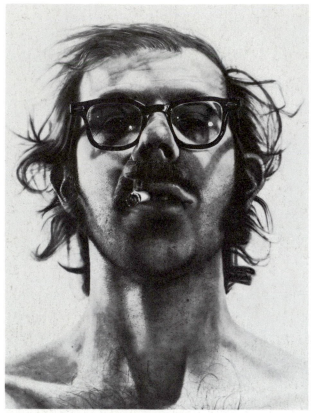

2.7 Chuck Close. *Self-Portrait.* 1968; acrylic on canvas, 107½ × 83½ in. A super-realist, such as this artist, scrupulously depicts every facet of textural detail. The immediacy of the image is enhanced by the large scale of the work.
Collection, Walker Art Center, Minneapolis.

COMPONENTS OF A WORK OF ART

To approach art from the angle of expressing *meanings* and *ideas,* the student will first need to know something of the ingredients or components that make up a work of art. These components are the *subject,* the *form,* and the *content* or *meaning* of a work.

Subject

There is nearly always a *subject* in a work of art, even when the form style is *abstract* (the subject is limited insofar as it can be based on perceivable objects from nature). The subject of abstract art lies more in the realm of ideas or of intellectual concepts that are abstruse rather than that of material objects or facts (*see* plate 24). However, even in works of art that are more obviously based on representations of perceivable objects, the subject or objects used are not of importance in themselves to the artist. An artist's subject is merely a *stimulus to creativity* (plate 2). The artist's initial response to the subject and the way thereafter in which

the artist presents the subject are of importance. During the course of giving *form* to the subject, the artist may reinterpret its character. Thus, the final form of the work of art may be far removed, in terms of what the observer sees, from the original *subject* or even from the original *response* of the artist to that subject.

The most significant problem in creating a work of art is not what one uses as a subject, therefore, but how one interprets a subject to achieve character. The "how" involves the two most important components of a work of art—*form* and *content*.

Form

By *form* we mean the totality of the work of art. Form is the organization (design) of all elements that make up the work of art. It is the use made of the *visual devices* available to the artist. The visual devices, or *elements of form* as we tend to call them, are: *lines, shapes, values (varied lights* and *darks), textures,* and *colors.* How the artist uses these elements determines the final appearance of the work of art (plate 3).

Organic Unity—Principles of Form Organization

Each of the elements of form seems to have particular physical and psychologically *intrinsic (inbuilt)* effects, which, when used in combinations with other elements, have a stronger and richer impact upon us.

The physical relationships of the elements are founded upon traditional, nearly universal, principles, generally called the *principles of organization* or of *design* or as at times in the past, *rules of composition* (that is, *balance, rhythm, domination, harmony,* etc.). Some artists use these principles more consciously or logically than others, but all artists can be said to have at least instinctive sensitivity to the value of *organization.* These principles of organization are discussed in more detail later in the text. They should be regarded as guides, not as dogmatic rules. Otherwise, the expressive quotient of *form* may be lost and the work may become anemic or spiritless. Nevertheless, throughout the history of art, people have most often agreed that the locus of beauty in art lies within the basic principles by which works of art are given order. Thus, beauty, an abstract concept, becomes tangible and universal in terms of *form organization* in art. Hence, terms like *beauty of form* or *formal beauty* are often applied to great works of art.

The real *feeling* of a work of art cannot be exposed by a breakdown of its parts. However, for the purpose of illustration and instruction we are often compelled to isolate the elements composing the form of the work. We could compare the parts of a radio with the parts or *elements of form* in a painting. If we break down

the radio and spread all the parts before us so that we are forced to examine each one separately, the form of the radio, as well as its meaning and function, is lost to us. We could then put the parts together in such a way that a completely new device is created. This contrivance would have the form of something not yet recognizable (because it is outside human experience) nor even graced by a name. It would certainly not be the *form* of a radio, despite the presence of all the *parts* needed to make a radio. The device obviously would not fit our idea of *radio form* until all the parts were once again assigned their original positions. Once reassembled, the radio would work just as a competent art form works, although the elusive property of life, in a work of art as in a human body, is impossible to define effectively. This difficulty stems from the fact that we can recognize life when all the parts are working, but we do not know what has been lost when they cease to work; life, like electricity, remains a mystery to us.

The anatomical parts of a painting that the artist manipulates are the elements of form previously listed. The artist hopes to assemble these in such a way that they will work together to create a meaningful *organic* or *living unity*. The result may be a hybrid work (similar to the device mentioned in the radio analogy) that functions only as a series of parts and that consequently has no *unity of meaning and function* (fig. 2.8). On the other hand, the artist may be successful in creating a work in which each of the parts is vital, not by itself but in the general functioning of the work as a whole. In such an ideal development, the total organization or form cannot be conceived when any one of its parts is missing. With such a work, an entity is created that, like the radio, has a separate and distinct personality, but unlike the radio, is incapable of being named or classified, except according to a broad category. A radio would not ordinarily be confused with a chair, for each has its own characteristic distribution of form in which all those things that do not serve a particular utility have been eliminated. So it is with a distinguished work of art: every part aids in the purpose of expression. The painting as an entity is inconceivable without those parts, and we can therefore say that it demonstrates perfect *unity* or total *form organization*. We could go further and say that, although there are many identical radios of a particular model, every work of art has qualities that tend to make it unlike any previously created. In the best sense of the word it is truly original.

The suggestions in this text should be used in the studio to emphasize the practice and observation of the potentialities for *form-building* and their psychological or *expressive* impact.

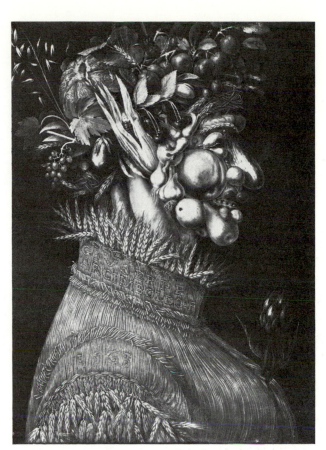

2.8 Giuseppe Archimboldi. *Summer.* **1563; 26⅛ × 19¾ in.**
This engaging work, a forerunner of Surrealism, utilizes parts related primarily by their classification as vegetable forms. (Kunsthistoviches Museum, Vienna, Austria.)
Alinari/Art Resource, New York.

Media and Technique When artists put their particular "brand" on the formal structure of a work, they are doing so with the principles of organization guiding their thoughts and instincts. While these principles are critical to the development of a work, artists have other considerations preceding or simultaneous with the guidance of the principles. Artists must select a medium suitable to their expression and, as work begins, must pick up the appropriate materials (tools) and then utilize them in an effective manner (technique).

The principles are unchanging, but this is not true of tools and technique. The nineteenth and twentieth centuries have produced many advances in scientific technology. These have spun off into many areas, including art. Artistic people have made use of new media and techniques as aids to their creative expression. One of the great visual breakthroughs was, of course, the science of photography. The camera is not as flexible as the brush, but photographic innovations have served to broaden our vision. The creative efforts of photographic artists such as Edward Steichen, Alfred Steiglitz, and Ansel Adams are as well known today as many

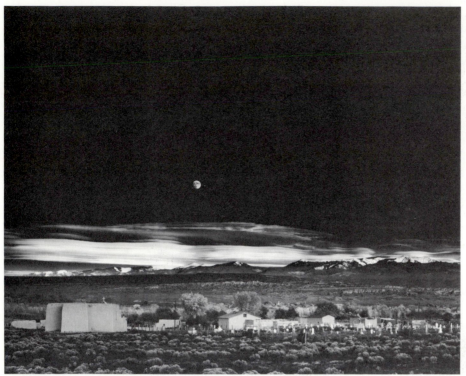

2.9 Photograph by Ansel Adams. *Moonrise.* **Hernandez, New Mexico, 1944; 15½ × 19 in.** The invention and development of photography was an important new medium to be added to the repertoire of artists in the nineteenth and early twentieth centuries. Now the accomplishments of photographers, such as Ansel Adams, rank with those of well-known painters, sculptors, and architects.

of our important painters and sculptors (fig. 2.9). From the photographic experiments of such people came creative film making, xerography, and the artistic employment of other photographically related media.

Of late there has been a deluge of new media and techniques. Some have been extensions of traditional approaches, while others are without precedent. All have been absorbed into the artist's inventory. Traditional painting media have been affected by acrylics, enamels, lacquers, liquid watercolors, roplex, and other plastics. New drawing media include new forms of chalk, pastels, crayons, and drawing pens, among many others. Sculptors now use welding, plastics, composition board, aluminum, stainless steel, and other materials and techniques (*see* figs. 10.2, 11.55, and 11.56). The unique, or *non*traditional, media include video, holography, computer-generated imagery, and performances that mix dance, drama, sound, light, even the audience. Very often the traditional and nontraditional are mixed.

Although new and exotic techniques and media have found their way into the artist's studio, they usually follow a mastery of more traditional art forms. Early preoccupation with the bizarre has been known to divert the art student from more legitimate goals. Nontraditional media usually require specialized knowledge (of a somewhat scientific nature) and specialized skill

development. The pursuit of this skill and knowledge can become an end in itself unless one has the maturity required to reconcile it with one's artistic aims. It is for this reason that this book, on art *fundamentals,* is principally concerned with helping students to establish first a foundation in the more traditional aspects of studio art.

Even the specialized skills required for the mastery of *traditional* media will take the artist beyond the content of this book. In this text one will find media suggested for use in the exercises. In using them it will soon be realized that consideration has to be given to the effect of tools on imagery, and how surfaces and/ or volumes that carry this imagery affect its total form. The natural texture of a paper surface, for instance, may dictate medium and certain tools. A pencil used on a smooth-surfaced paper will produce a different effect from rough-surfaced (or "toothed") paper (fig. 2.10). Different grades of graphite in the pencil can become a factor. In ink drawing, a felt-tip pen has a different expressive potential than a crow-quill pen. The softening effect of water in the ink or on the paper can drastically change the meaning of an image.

Choice of tools, supports (that which carries the image), and techniques must always be made in the

2.10 Thomas Hilty. *Margaret.* **1983; drawing: graphite, pastel and Conte on museum board, 33½ × 40 in.**
This drawing shows the characteristic use of mixed media by the artist. He has skillfully blended and rubbed the materials used to produce the effect of realistic, polished surfaces. The smooth texture of the museum board lends to the artist's technique a different effect than if it had been done on a coarser textured surface. Courtesy of the artist.

progress of a work. Many suggestions of this nature are made in the media exercises concluding the chapters. The suggestions are not exhaustive, however, and experimentation is certainly encouraged. If (as we hope) you go beyond this volume and, perhaps, into a career in art, you will undoubtedly want to venture into new areas of creative adventure that we have, for your sake, purposely neglected.

Content or Meaning

When we begin to analyze *why* form affects us emotionally or expressively or stimulates our intellectual activity, we are concerned with *content* or *form-meaning,* the third component of a work of art. The *quality* or *significance* of a work of art seems to reside in this component. We can define *content* as the final statement, mood, or spectator experience with the work of art. It can also be called the *significance* of the art form.

The kinds of emotions, intellectual activity, or associations we make between art objects and our subconscious or conscious experiences seem to arise out of an art form and are completely inseparable from it except for purposes of discussion. In other words, *content* is the essential *meaning* of *form*.

Abstraction In abstract art the impact inherent in visual relationships, such as the contrast of black lines set off against colored shapes of varied contours, may communicate meaning (plate 4). Sheldon Cheney says, "Abstraction is an idea stripped of its concrete accompaniments, an *essence* or *summary*."[2] However, all of us abstract from our environment the experiences that are of value to us, and these experiences are not necessarily concrete if they lie within the realm of intuition or imagination. In art, if we take away only a few of the surface effects from what is usually considered real or tangible, we are abstracting in a limited way. The artist who draws a tree as closely as possible to the optical appearance of an actual tree is still abstracting a personal "idea" of "treeness" in order to put it down in the graphic signs of art. In art terminology, however, we usually reserve the term *abstract art* for a type of form arrangement in which the *concept* of relating artistic devices (or formal elements) is more important to the artist than the perceivable objects that the artist may have seen in nature and used as the *subject matter*. The importance lies in the greater artistic possibilities the artist can *conceive* in the abstract version. These are more interesting to the artist than the appearance of the trees themselves.

Nonobjective Art Some artists use *motifs* entirely from within themselves rather than from observations of nature. They begin with form, such as areas of color or line and value, and arrive at artistic conclusions with these elements alone. Such artists have been called *nonobjective* since they never resort to the use of natural objects, believing them inconsequential in artistic expression. Artists of this persuasion feel that natural objects are unimportant as subjects because the work of art should live on its own merits (fig. 2.11).

Within these generally inclusive terms of *abstract* and *nonobjective* art, many diverse form concepts have developed over the years since 1910–11. The style in art called Abstract-Expressionism should be mentioned as an extension of abstract and nonobjective art. Artists interested in this style have often abandoned the predilection for geometric planes of some abstract and nonobjective art in favor of emotional freedom and amorphous shapes (*see* fig. 11.40 and plate 106).

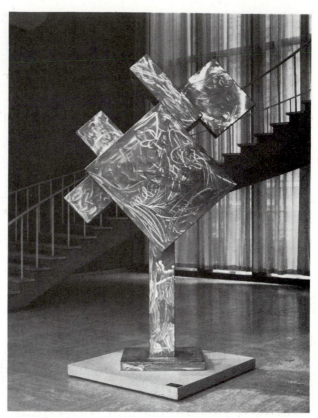

2.11 David Smith. *Cubi VII, March 8.* **1963; welded steel, 111⅜ in.** Smith was rarely concerned with likeness to natural objects. Instead, he used nonobjective forms and tried to give them a life of their own through the animation created by his sense of arrangement.
Art Institute of Chicago. Grant J. Pick Purchase Fund.

Effect of Form on Content or Meaning

The terms *abstract* and *nonobjective* perhaps tend to give the impression that nothing is perceivable in such works. But in view of the preceding explanation that concepts or ideas are manifest in such works (and are equally valid as subject matter along with natural objects), we can see that such works do have content. *Content* or *meaning* lies in the *form* and is effective insofar as the observer is familiar with *form-meaning*.

Public vision, however, has been conditioned to read form representationally, in much the same sense that a snapshot represents nature in an optical manner. Of course, as suggested earlier, photography also can be handled less in this optical or mechanical manner and more in an artistic fashion (fig. 2.12). Such images probably will not appeal too much to the object-minded person, but may attain a certain acceptance for their technological value. Object-minded individuals tend to look for similarly descriptive values in art and are happy only when *natural-appearing* objects that provide an obvious basis of recognition are produced.

[2]Sheldon Cheney *Expressionism in Art* (New York: Liveright Publishing Corp., 1934), p. 80.

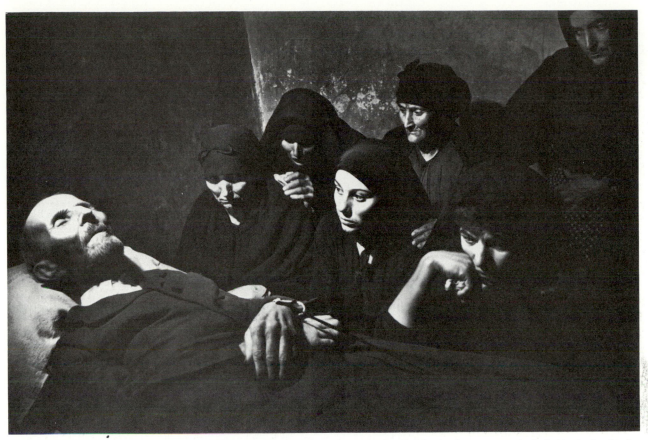

2.12 W. Eugene Smith. *Spanish Wake.* **1951; photograph.** The subject selection, lighting, and camera manipulation in the hands of a skilled photographer can evoke the character of a classic painting.
Black Star, W. Eugene Smith, © 1951.

With sufficient experience in looking at works of art, however, most individuals will eventually begin to realize that no particular emphasis on visual description of objects is needed. For them painting and sculpture may be optically understandable and yet have character above and beyond ordinary description. Almost anyone can sense the universal quality of serenity in a Cézanne landscape (*see* plate 19) or the impassioned response to objects and life expressed by van Gogh (plate 5). Van Gogh's swirling shapes, direct clash of colors, and heavily pigmented surface depict the quality of nature as a living, stimulating force in such a way as to make this painting a vital expression in its own right. The meaning of "city" in the painting by Charles Demuth (plate 6) should be apparent in his machinelike shapes and movement-tensions, all of which are a part of his *form concept.*

The Observer's Experience Previously in this chapter we mentioned that the quality or significance of a work of art lies in our interpretation of the *content.* We called this the *aesthetic* value of the work of art. Experiencing a work of art when it is enjoyable, persuasive, stimulating, disturbing, or otherwise evocative of our senses is an aesthetic or artistic sensation. The experience is meaningful and of value to us because it is *really* what we hope to feel when we look at works of art. The obvious recognition of natural objects represented in art usually is not a lasting or satisfying artistic experience. Something more than recognizability has to be added to the art form to make it *meaningful* in the deepest sense as art.

Pop artists (*see* p. 226) did this in the 1960s. They took advantage of the idea that commonplace objects could not be artistic to create original works of art that closely resembled real objects. However, the added meaningfulness of these works was partly provided by the frequency with which they were seen in mass media communications. Another addition to their meaning as art forms was the artist's translation of the original object into unusual substances—such as plaster, perhaps, to represent a soda or a piece of pie. Their emphasis and removal from the normal circumstances in which such objects were found in everyday life (artistic *emphasis* and *isolation*) made them works of art with content bordering on the satiric, ironic, or the mundane. Many became memorable images.

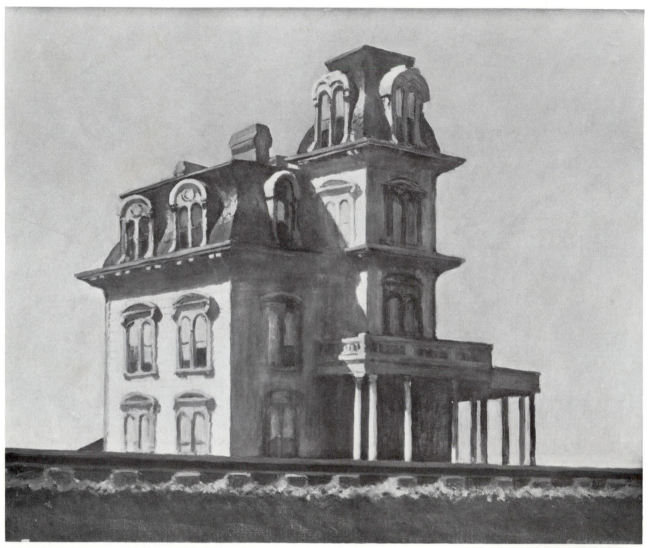

2.13 Edward Hopper. *House by the Railroad.* **1925; oil on canvas, 24 × 29 in.** The passive serenity of this painting has character beyond ordinary description.
Museum of Modern Art, New York. Given anonymously.

Thus, when works of art seem to remain a part of us after we have left them, we can call them *meaningful*. If we are inclined to see something again, like a good movie, something must have been communicated. A good work of art, even a realistic one, must be seen by the observer, as well as the artist, with aptness, power of expression, and flexibility (fig. 2.13).

When a work of art represents natural objects, many people continue to assume that it is meant to tell a visual story. But, as we discussed before, narration is really the province of literature. What the observer must learn to look for in works of art are not specifically recognizable associations with objects, stories, or events in life, but an *expression* of general experiences provided by the artist in new forms—and, thus, with uncommon *meaning* or aesthetic significance.

The *naturalist* style of the 1870s and 1880s in France, which laypeople tended to maintain as their norm of vision well into the twentieth century, was in its time a *new form* of art based on the science-centered culture resulting from the Industrial Revolution. As a new form of art with unfamiliar meaning for its time, Naturalism was largely rejected or neglected by the public in favor of the drama of *Romantic art,* to which people had been conditioned (*see* p. 195, "Romanticism").

Having now studied the main points of theory dealing with the nature of art, we can move on to examine the *form elements* and their possibilities in detail and then attempt to put into practice the suggestions offered. It should be understood that other than further theoretical discussion, as in this chapter, the studio teacher cannot really teach the *subject, form,* and *content* of works of art, but can only expose the students to *experiences* in the area of these components.

3
FORM

THE VOCABULARY OF FORM

approximate symmetry The use of similar forms on either side of a central axis. The forms may give a feeling of equal relationships, but are varied to prevent visual monotony.

asymmetrical balance A form of balance in which *unlike* ways and/or means are used to achieve a "felt" equilibrium.

balance A feeling of equilibrium in weight, attention, or attraction through various uses of the visual elements within an artwork as a means of accomplishing organic unity.

dominance The principle of visual organization that suggests that certain elements should assume more importance than others in the same composition. Some features are emphasized and others are subordinated.

23

elements of art The basic visual signs as they are combined into optical units used by the artist to communicate or express creative ideas. The combination of the basic elements of line, shape, value, texture, and color represent the visual language of the artist.

harmony The related qualities of the visual elements of a composition. Harmony is achieved by repetition of characteristics that are the same or similar.

motif A visual element or a combination of elements that is repeated often enough in a composition to make it the dominating feature of the artist's expression. A design that is repeated within a larger design. Motif is similar to theme or melody in a musical composition.

negative areas The unoccupied or empty space left after the positive shapes have been defined by the artist. However, when these areas have boundaries, they also function as design shapes in the total artistic structure.

pattern The obvious emphasis on certain visual form relationships. A repetitive configuration of elements or a combination of elements that can be distributed in a regular (allover) pattern or irregular systematic organization.

picture frame The outermost limits or boundary of the picture plane.

picture plane The actual flat surface on which the artist executes a pictorial image. In some cases the picture plane acts merely as a transparent plane of reference to establish the illusion of forms existing in a three-dimensional space.

positive shapes The enclosed areas that represent the initial selection of shapes planned by the artist. Positive shapes may suggest recognizable objects or merely be planned nonrepresentational shapes.

repetition The use of the same visual element a number of times in the same composition. Repetition may accomplish a dominance of one visual idea, a feeling of harmonious relationship, an obviously planned pattern, or a rhythmic movement.

rhythm A continuance, a flow, or a feeling of movement achieved by repetition of regulated visual units; the use of measured accents.

symmetrical balance A form of balance achieved by the use of identical units placed in mirrorlike repetition on either side of a central axis.

unity The whole or total effect of a work of art that results from the combination of all of the work's component parts, including the assigned ratio between harmony and variety.

variety The use of opposing, contrasting, changing, elaborating, or diversifying elements in a composition to add individualism and interest. The counterweight of *harmony* in a work of art.

PRELIMINARY FACTORS OF FORM ORGANIZATION

A completed work of art has three components—subject matter, form, and content or meaning. These components are common denominators that change only in emphasis. They are so interwoven that to isolate any one of them would mean total disorder. The whole work of art is always more important than any one of its components. In this chapter we study the component *form* to theorize and investigate some of the physical principles of visual order (fig. 3.1).

When we see images, we take part in *visual forming* (or ordering). In this act the eye and mind organize visual differences by integrating optical units into a unified whole. The mind instinctively tries to create order out of chaos. This order adds equilibrium to human visual experience that would otherwise be confusing and garbled.

Artists are visual formers with a plan. With their materials they arrange the elements for their form-structure: *lines, shapes, values, textures,* and *colors.* The elements they use need to be controlled, organized, and integrated. Artists manage this through the binding qualities of the principles of organization: *harmony, variety, balance, movement, proportion, dominance, economy,* and *space.* The sum total of these, assuming the success of an artist's plan and its execution, equals *unity.* Unity in this instance means *oneness,* an organization of parts that fit into the order of a whole and become vital to it.

Form is the complete state of the work. The artist produces this overall condition of the completed work by forming it from the elements of art structure, subject to the principles of organization. The artist is a "former" with a plan that is usually a mix of intuition and intellect. The plan, hopefully, will effectively communicate the artist's feeling even though it may change as the work progresses. The plan is that which can be variously termed composition or design (fig. 3.2).

Picture Plane

There are many ways to begin a work of art. It is generally accepted that artists who work with two-dimensional art begin with a flat surface.[1] To artists the flat surface is the *picture plane* on which they execute their pictorial images (fig. 3.3). A piece of paper, a canvas, a board, or a plate may be representative of the picture plane material. The flat surface also may represent an imaginary plane of reference from which an artist can

[1]The first dimension refers to height or the vertical system; the second dimension to width or the horizontal system; the third dimension to the depth system, and the fourth dimension to time.

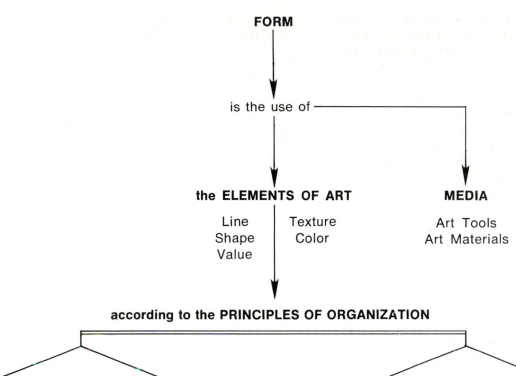

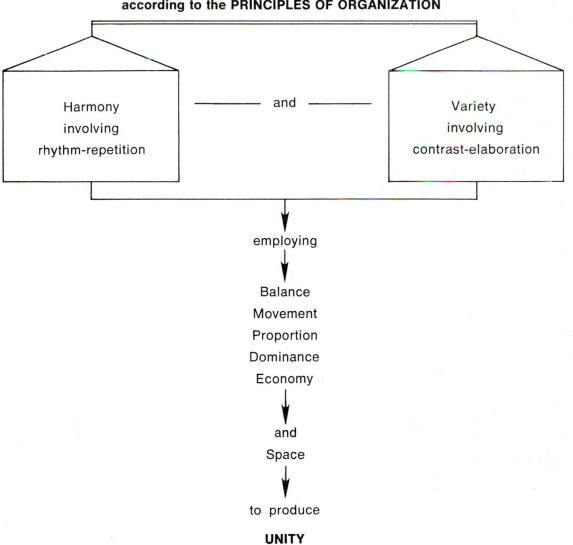

3.1 Form–Unity

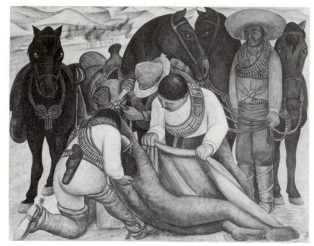

3.2 Diego Rivera. *The Liberation of the Peon.* 1931; fresco, 74 × 95 in. Here we see a politicized theme making use of appropriate and expected subject material. Without the effective use of form the statement would be far less forceful.
The Philadelphia Museum of Art. Gift of Mr. and Mrs. Herbert Cameron Morris.

3.3 Picture plane. Movement can take place on a flat surface as indicated by the vertical and horizontal arrows. The vertical lines represent an imaginary plane through which a picture is seen. The artist can also give the illusion of advancing and receding movement in space, as shown by the two large arrows.

3.4 Picture frame. The picture frame represents the outermost limits, or the boundary, of the picture plane. These limits are represented by the edges of the canvas, or paper in which the artist works, or the margin drawn within these edges.

create spatial illusions. The artist might manipulate forms or elements so that they seem flat on the picture plane, or might extend the forms/elements so they appear to exist in front of or behind the picture plane. In this way the picture plane is used as a basis for judging two- and three-dimensional space.

In three-dimensional art the artist would begin with the material (metal, clay, stone, glass, etc.) and work it as a total form against the surrounding space with no limitation except for the conceptual contour (*see* "Art of the Third Dimension," p. 173).

Picture Frame

A picture is limited by the *picture frame*—the outermost limits or the boundary of the *picture plane* (fig. 3.4). The picture frame should be clearly established at the beginning of a pictorial organization. Once its shape and proportion are defined, all of the art elements and their employment will be influenced by it. The first problem for the pictorial artist is to organize the elements of art within the picture frame on the picture plane.

The proportions and shapes of picture frames used by artists are varied. Squares, triangles, circles, and ovals have been used as frame shapes by past artists, but the most popular is the rectangular frame, which in its varying proportions offers the artist an interesting two-dimensional space variety (figs. 3.5 and 3.6, plates 7 and 8). Many artists select the outside proportions of their pictures on the basis of geometric ratios. These rules suggest dividing surface areas into odd proportions of two to three or three to five rather than into

equal relationships. The results are pleasing visual and mathematical spatial arrangements. After the picture frame has been established, the direction and movement of the *elements of art* should be in harmonious relation to this shape. Otherwise they will interrupt the movement toward *pictorial unity.*

Positive-Negative

All of the surface areas in a picture should contribute to total unity. Those areas that represent the artist's initial selection of shapes are called *positive areas*. Positive areas may suggest recognizable objects or nonrepresentational shapes (fig. 3.7). Unoccupied spaces are termed *negative areas* (fig. 3.8). The negative areas are just as important to total picture unity as are the positive areas, which seem tangible and more explicitly laid down. Negative areas might be considered that portion of the picture plane that continues to show through after the positive areas have been placed

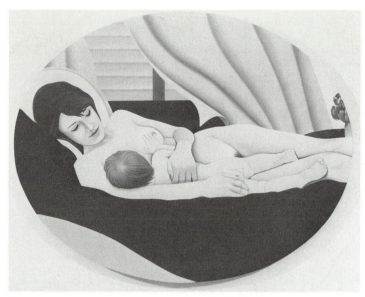

3.6 Larry Poons. *Orange Crush.* **1963; acrylic on canvas, 80 × 80 in.** Although the majority of frame shapes are rectangles, Larry Poons has elected to use a square. This gives an expanding feeling to his mini-firmament. One of the artist's challenges is to vary placement for interest, avoiding "dead," or static, areas.
Albright-Knox Art Gallery, Buffalo, New York. Gift of Seymour H. Knox, 1964.

3.5 Tom Wesselman. *Barbara and Baby.* **1979–1981; oil on canvas, 60 × 67¼ in.** Wesselman has used an unusual frame shape for a timeless subject. The organic shape helps to evoke some of the feeling of birth and motherhood.
Sidney Janis Gallery, New York.

3.7 and 3.8 Alfred Leslie. *Alfred Leslie.* **1982; oil on canvas, 84 × 60 in.** The subject in this painting represents a *positive* shape that has been enhanced by careful consideration of the *negative* areas or the surrounding space. The dark area in figure 3.7 indicates the *negative* shape and the white area the *positive* shape.
Courtesy of Alfred Leslie.

3.9 Student work. *Key.* **pen and india ink.** The white areas represent the keys, the black the spaces between them. Because of the pure whites of the positive shapes and the pure blacks of the negative shapes, the two can be confused, as might happen with an optical illusion.
Courtesy of the authors.

3.10 Ellsworth Kelly. *Red and White.* **1961; oil on canvas, 62¾ × 84¼ in.** In this nonfigurative (or nonobjective) work, some areas have been painted in, others not. It is very simple, probably deceptively so. To the eyes of the viewer the darks seem to be the negative shapes, although after some looking this may reverse itself, as in the case of the previous illustration.
The Hirshhorn Museum and Sculpture Garden, Smithsonian Institution.

3.11 Francois Morellet. *Circles and Semi-Circles.* **1952; oil on wood, 15¾ × 27½ in.** Were all of these shapes perfect circles, absolute harmony would prevail. However, some circles have been cropped (cut off by the picture plane), and there is an unexpected squiggle moving through one of the levels. These factors produce some variety, but the work is still largely harmonious because of the consistency of curved shapes.
Albright-Knox Art Gallery, Buffalo, New York. Charles W. Goodyear and Edmond Hayes Funds, 1981.

3.12 Victor Vasarely. *Orion.* **1956–1962; paper on paper mounted on wood, 82½ × 78¾ in.** Here, as in the previous work, there are motifs—little compartments and circles. But there is considerable variety in the treatment of these motifs. The circles are tilted in various directions, and they vary in size; the compartments are of different values and sometimes outlined, sometimes not.
The Hirshhorn Museum and Sculpture Garden, Smithsonian Institution.

in a framed area (figs. 3.9 and 3.10). Traditionally, foreground positions were considered positive and background spaces negative (plate 9).

The term *positive-negative* is important to students investigating art organization, since beginners usually direct their attention to positive forms and neglect the surrounding spaces. The resulting pictures are generally overcrowded, busy, and confusing.

PRINCIPLES OF ORGANIZATION

As explained earlier, the principles of organization are only guides for *seeing* for the beginning student. They are not laws with only one interpretation or application. These principles are the resources that affirm or predicate the elements into some kind of organizing action. The principles of organization may help in finding

3.13 Jean Dubuffet. *De Vidoir en Registreur.* **1978; acrylic and paper, collage on canvas, 79 × 114 in.**
This work is also compartmented (harmony) in different sizes and shapes (variety). There is some consistency
to the character of the lines (harmony), but enough variation to generate interest.
Albright-Knox Art Gallery, Buffalo, New York. George B. and Jenny R. Mathews Fund, 1979.

certain pictorial solutions for *unity*, but they are not
ends in themselves, and following them will not always
guarantee the best results. Artworks are a result of per-
sonal interpretation and should be judged as total
visual expressions. In other words, the use of the prin-
ciples is highly subjective or intuitive.

Harmony and Variety

Organization in art consists of developing a *unified*
whole out of diverse units. This is done by relating con-
trasts through certain similar means. For example, in
a picture an artist might use two opposing kinds of lines,
vertical and horizontal. Since both the horizontal and
vertical lines are already straight, this likeness of *type*
would relate them. Harmonious means seem necessary
to hold contrasts together. Unity and organization in
art are dependent upon dualism—balance between
harmony and variety. This balance does not have to be
of equal proportions; harmony might outweigh variety,
or variety might outweigh harmony (figs. 3.11, 3.12,
and 3.13, plates 10 and 11).

Harmony *Rhythm* and *repetition* act as agents for
creating order out of forces that are otherwise in op-
position. They relate picture parts. Once the forces in
opposition on a picture surface have been reconciled,
harmony results. Harmony is a necessary ingredient of
unity. Likewise, rhythm and repetition are essential to
harmony.

Repetition Repetition and rhythm are inseparable;
rhythm is the *result* of repetition. Repetition re-em-
phasizes visual units. It causes the connection of parts
and binds an artwork together. Repetition seeks atten-
tion or emphasis, and it permits pause for examination.

Repetition does not always mean exact duplication,
but it does mean similarity or near likeness. Slight vari-
ation of a simple repetition adds subtle interest to a
pattern that might otherwise be tiring (figs. 3.14, 3.15,
3.16, 3.17, and plate 12). Great variation stimulates
sustaining and absorbing interest.

3.14 The rectangles are related in this harmonious arrangement
by repeating similar shape configurations. In contrast, the
rectangles are varied in size and are set in opposing directions,
which creates tension and interest.

3.15 Eva Hesse. *Repetition Nineteen III*. 1967; nineteen tubular fiberglass units, 19–20¼ in. high × 11–12¾ in. diameter. This work, as the title implies, exploits the repetitive dimensions of identical "can forms." These are then given variety by distorting the basic shapes.
Museum of Modern Art, New York. Gift of Charles and Anita Black.

3.16 Grant Wood. *Stone City*. The repetition is in the form of the organic curvilinear shapes (varied in size). There are occasional punctuations of rectilinear (straight-line) shapes in the buildings and bridge. The flow of the organic shapes produces a rhythmic effect.
Joslyn Art Museum. Gift of Art Institute of Omaha, 1930.

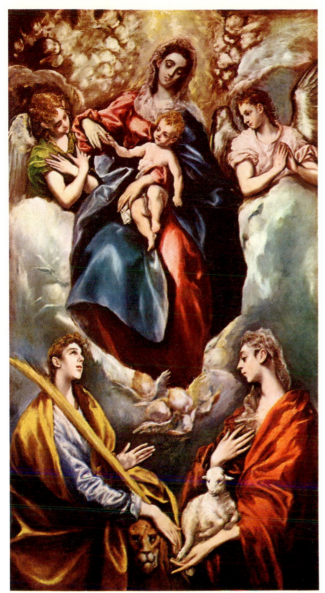

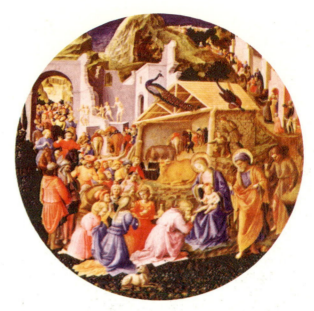

Plate 8 Fra Angelico and Fra Filippo Lippi. *The Adoration of the Magi.* 1445; wood, diameter 54 in. The artists have used figures and architecture, and the direction and movement of the elements of art in harmonious relation to a circular picture frame.
National Gallery of Art, Washington, D.C. Samuel H. Kress Collection.

Plate 7 El Greco. *The Madonna and Child with Saint Martina and Saint Ignes.* circa 1576–1580; oil on canvas, 76⅛ × 40½ in.
The rectangular frame shape, by its proportions, offers the artist a pleasing and interesting spatial arrangement. Here, El Greco has elongated his main shapes to repeat and harmonize with the vertical character of the picture frame.
National Gallery of Art, Washington, D.C. Widener Collection, 1942.

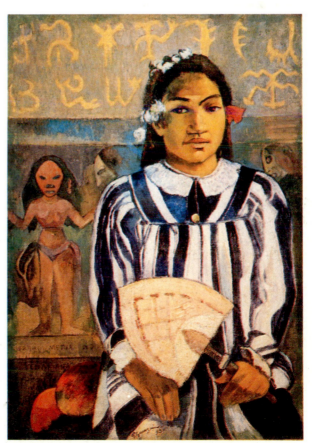

Plate 9 Paul Gauguin. *Ancestors of Tehamana.* 1893; oil on canvas, 30 × 21½ in. Those items in the foreground (generally toward the bottom of the picture plane) are, by tradition, considered *positive* areas, whereas the background (upper) unoccupied spaces are *negative* areas. This somewhat standardized view does not always apply, as can be seen by looking at the other illustrations.
Art Institute of Chicago.

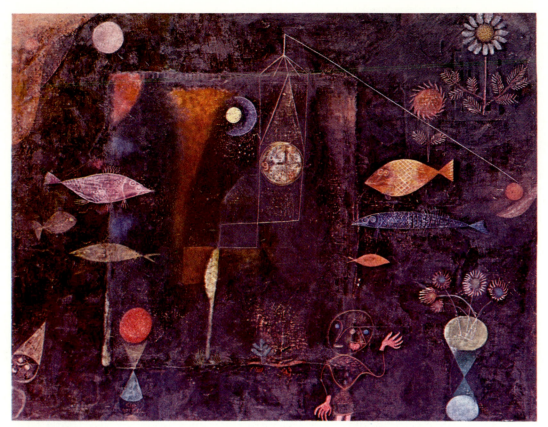

Plate 10 Paul Klee. *Fish Magic.* 1925; oil and water color varnished, 38⅝ × 30¼ in. The object shapes, through their repetition and transitional variation, create harmonious relationships. Variety in *size* and *treatment* create contrasting notes that are balanced by the repetition of color and shape character.
Philadelphia Museum of Art: The Louise and Walter Arensberg Collection.

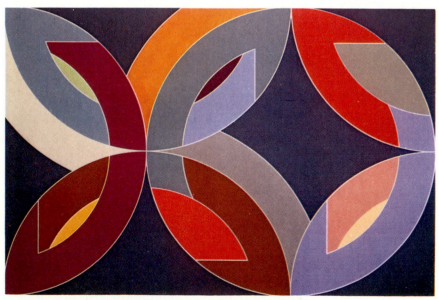

Plate 11 Frank Stella. *Lac Larange IV.* 1969; acrylic polymer on raw canvas, 108⅛ × 162 in. Stella has harmonized the painting through his insistent use of the curve; variety is provided by contrasting colors and shape sizes.
Courtesy the Toledo Museum of Art.

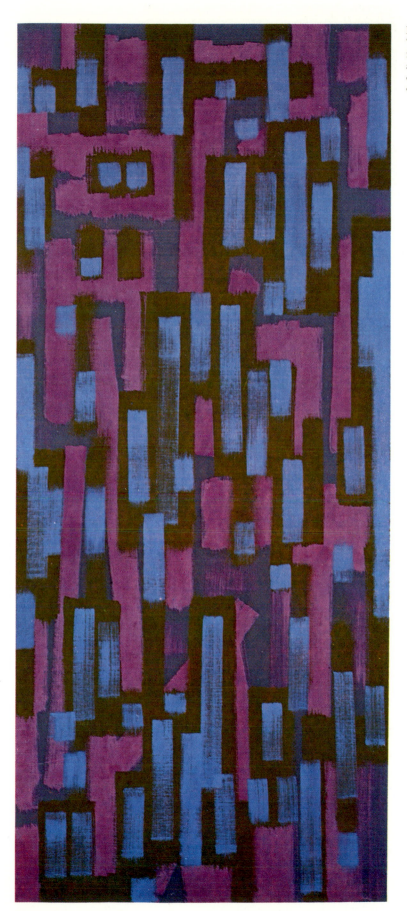

Plate 12 Ad Reinhardt. *Number 1.* 1951; oil on canvas, 79⅞ × 34 in. The visual units in Reinhardt's painting are rectangular modules. The repetition of this motif creates harmony, and the variety develops out of the subtle differences in scale and color.
Courtesy the Toledo Museum of Art.

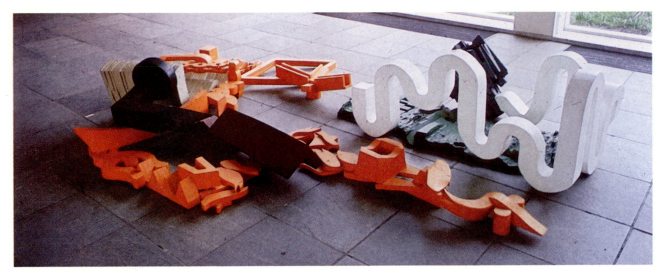

Plate 13 George Sugarman. *Inscape.* 1964; polychromed wood, 24 × 144 × 108 in. The balance between harmony and variety can be tipped to favor either principle of order depending on the artist's intention. George Sugarman is an artist who pushes his balance strongly in the direction of variety. In his three-directional work *Inscape,* Sugarman varies the shape contours and colors of his assembled pieces with a personal vigor. He arouses an initial curiosity of his viewer's attention which, after greater reflection, seems to provide enduring vitality. Robert Miller Gallery, New York. Collection of the artist.

Plate 14 Erté. *Twin Sisters.* 1982; print: serigraph, 40 × 55 in. The repetitious nature of this symmetrical work is counterbalanced and relieved by the lively details, which hold interest that might otherwise have been lost. Circle Fine Art Corporation, Chicago, Illinois.

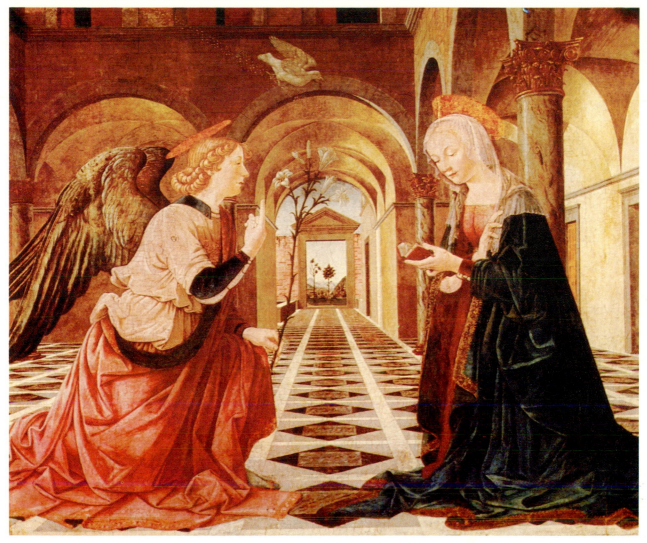

Plate 15 **No attribution.** *Master of the Gardner Annunciation, the Annunciation.* **1481; tempera on wood, 39¼ × 45 in.** Although architectural details converge on a common point and the subjects are centered around this point, the figures are not the same, nor are the structural elements. Had they been, it would have been symmetrical. As they are not, it is *approximate* symmetry.

Isabella Stewart Gardner Museum, Boston, Massachusetts.

Plate 16 Rose Window, Chartres Cathedral, Chartres, France. circa mid-13th century; stained glass. The rose windows of Gothic cathedrals are excellent examples of radial design. Originating with a central point, the glass panes flare out in all directions, producing an expanding effect.
SCALA/Art Resource, New York.

Plate 17 Richard Diebenkorn. *Man and Woman in Large Room.* **1957; oil on canvas, 71 × 62½ in.** In a symmetrical or approximately symmetrical work, the figures would most likely be centered; here, instead, they are thrust to one side. The imbalance that this would be expected to create has been modified in various ways so that the balance is restored.
Hirshhorn Museum, Smithsonian Institution.

Plate 18 Attributed to Jan van Eyck. *St. Francis Receiving the Stigmata.* **n.d.; oil on paper, 5 × 5¾ in.** As can be seen from the dimensions of this work, van Eyck has created an amazing microcosmos. Despite the miniaturization, everything is in near-perfect scale. The radical scaling-down creates a subdued, almost precious effect; there is no bombast or superficial heroism.

John G. Johnson Collection, Philadelphia.

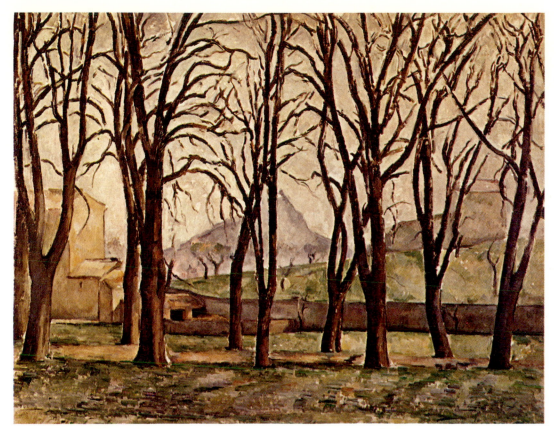

Plate 19 Paul Cézanne. *Chestnut Trees at Jas de Bouffan.* 1885–1887; oil type on linen, 29¹/₁₆ × 36⅝ in.
Dominance: Although some of the trees in this work are stronger than others, they are collectively seen as an individual unit that dominates the other parts. The dominance is achieved by size, dark value, and complex relationships. Secondary areas take their place in the dominance scale largely through reduced values and color strengths as they recede in space (atmospheric perspective).
The Minneapolis Institute of Arts. From the William Hood Dunwoody Fund.

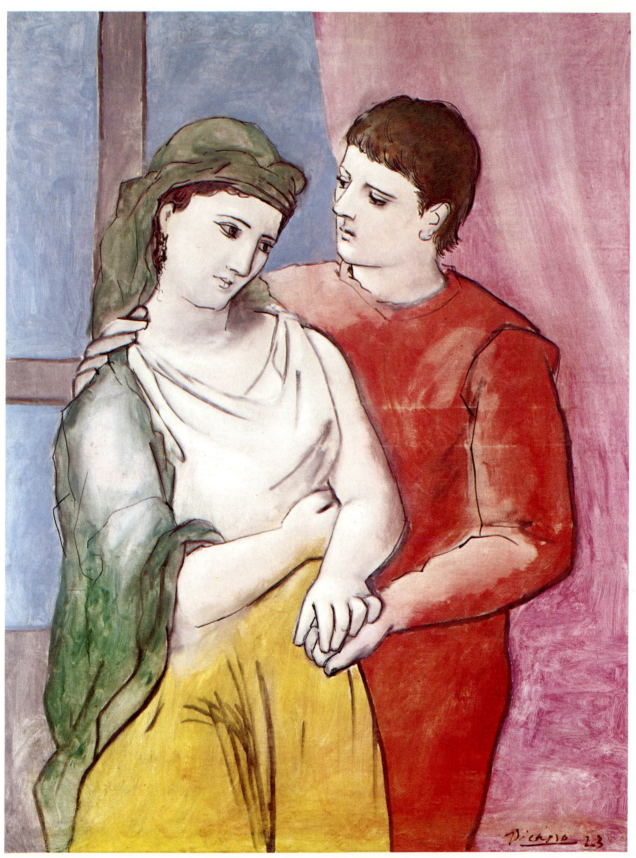

Plate 20 Pablo Picasso. *The Lovers.* 1923; canvas, 51¼ × 38¼ in. Pablo Picasso has simplified the complex qualities of the surface structures of his two figures. He has reduced the representation of his lovers to contour lines and flat color renderings. Here, Picasso has abstracted (used economical means) the two lovers to strengthen the expressive bond between them.

National Gallery of Art, Washington, D.C. Chester Dale Collection.

3.17 Copper Giloth. *Bird in Hand.* **1983; computer.** There is repetition in the pattern produced by the computer as well as in the repeating images. Nevertheless, the hands change position periodically, producing some break in this repetition.
Courtesy of the artist.

3.18 These rectangles are set in a repetitious and rhythmic order. Repetition and rhythm are agents for creating harmony and unity.

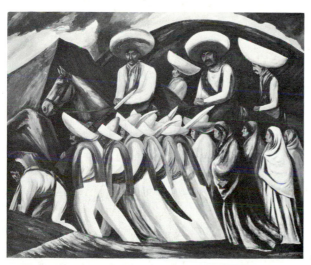

3.19 José Clemente Orozco. *Zapatistas.* **1931; oil on canvas, 45 × 55 in.** A continuous *movement* is suggested as the Zapatistas cross the picture surface from right to left. In passing, these figures form a *repetitious beat,* as their shapes, leaning in the same direction, create a *rhythmic order.*
Museum of Modern Art, New York. Given anonymously.

3.20 This drawing illustrates major shapes that are arranged in continuous, flowing, rhythmic directions for harmony. The hats, blankets, and white trousers are motifs.

Rhythm *Rhythm* is the continuance, or flow, derived from reiterating and measuring related, similar, or equal parts. Rhythm is recurrence, a measure such as meter, tempo, or beat. Walking, running, dancing, woodchopping, and hammering are human activities with recurring measures.

In art, if particular parts are recalled in a rhythmical way, a work is seen as a whole. Rhythm in this instance gives both *unity* and *balance* to a work of art (fig. 3.18).

Rhythm exists in many different ways on a picture surface. It may be *simple*, as when it repeats only one type of measure; it may be a *composite* of two or more recurring measures that exist simultaneously; or it may be a *complex variation* that recalls a particular accent in a usual way. José Clemente Orozco charges his pictures with obvious rhythmical order (figs. 3.19 and 3.20). He uses several rhythmical measures simultaneously to create geometric unity. He welds his pictures together by repeating shape directions and edges, value differences, and color modifications.

3.21 Max Ernst. *The Hat Makes the Man.* 1920; collage: pencil, ink, and watercolor, 14 × 18 in. Motif: the hats in this picture represent strong *accents, motifs,* in a system of accents and pauses. Notice the variety of style, size, and shape contour within the repetitive order.
Museum of Modern Art, New York. Purchase.

Motif In music, rhythm can be associated with a theme that is repeated with simple variation throughout a score. The *motif* of a work of art is perhaps the equivalent of the musical *theme.* Motif might be described as a composite of several rhythmical measures, or it might be looked on as a picture within a picture. A motif may be *objective* when it borrows from nature, or it may be *invented,* drawing its inspiration from configurations found in the art elements, their direction or space.

Rhythm is not a single part, but rather an order in the whole work. A motif in a picture, then, is only one accent in a *system* of accents and pauses. Once the beat of this system is felt in an artwork, visual organization is formed (fig. 3.21).

Pattern The generally repetitive nature of pattern can be used to introduce harmony into a work of art. Rhythms and repetitions with their alternating pauses participate in the creation of pattern (fig. 3.22). In certain circumstances, whether regular or irregular, pattern can also serve to direct the eye of the observer.

3.22 Student work. *Patterns: Trees.* brush, pen, and ink. Although the subject is trees, the distinctive pictorial characteristic of this work is the pattern produced by the tree relationships, a pattern that is repeated, though not identically, in all areas of the work, thus creating a unifying effect.

3.23 Peter Phillips. *Custom Painting.* 1964–1965; oil on canvas, 84 × 69 in. Variety is the hallmark of the use of the elements in this painting. Zigzags mix with spirals, and other rectilinear shapes are in conflict with curvilinear shapes. The use of varied colors also contributes to the highly dynamic effect.
Des Moines Art Center. Gift of American Republic Insurance Company, 1982.

Usually associated with graphic, or two-dimensional, art, pattern can also be produced by the arrangement of the volumes of the plastic artist. Pattern is frequently used for decoration, to please the eye, but may have other artistic functions.

Variety Variety is the counterweight of harmony. It is the another side of organization essential to unity. While an artist might bring a work together with harmony, it is with *variety* that the artist achieves individualism and interest. In this instance, interest refers to the ability to arouse curiosity and to hold a viewer's

attention. If an artist achieves complete equality of visual forces, the work usually will be balanced, but also static, lifeless, and without feeling. By adding variation to these visual forces, the artist introduces essential ingredients (such as diversion or change) for enduring attention.

Artists use variety and attention in different ways. As an example, they may find variety in opposition or *contrast* by setting opposing elements and/or their parts in proximity for an intensified effect (fig. 3.23 and plate 13). Other artists may *elaborate* upon forces that seem formal and acceptable, but lack enduring interest. They will rework areas persistently to express themselves at

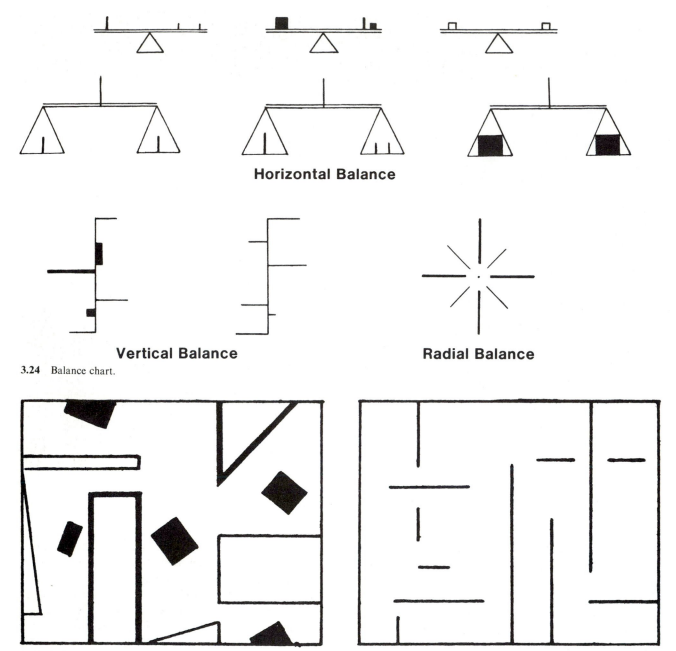

Horizontal Balance

Vertical Balance **Radial Balance**

3.24 Balance chart.

3.25 Balance in all directions—horizontal, vertical, radial, and diagonal.

greater length until an attractive solution is reached. The surfaces usually become richer with the extended changes, and the artist's concept usually develops dramatic strength and purposeful meaning.

Variations add vibration to static picture surfaces. As in music, the contrasting forces act as modulators in changing the pitch or the implied movement of an artistic pattern. If the contrast is increased, the pitch is raised; as the differences are brought in close accord, the pitch is lowered. The pitch that sets the contrast in order adds dynamic vitality to artistic organization.

Balance

Balance is so fundamental to unity that it is impossible to present the problems of organization without giving it consideration. At the simplest level, balance suggests the gravitational equilibrium of a single unit in space, or of pairs symmetrically arranged with respect to a central axis or point. Perhaps the balancing of pairs can be best illustrated by a weighing scale. A weighing scale has a beam poised on a central pivot (the fulcrum), so as to move freely, and a pan is attached to each end of the beam. When such a scale is used, balance is not achieved through an actual physical weighing process but through an observer who makes a visual judgment

3.26 Ben Shahn. *Handball.* **1939; tempera on paper over composition board, 22¾ × 31¼ in.**
Museum of Modern Art, New York. Abby Aldrich Rockefeller Fund.

that is based on past experiences and knowledge of certain principles of physics. With this type of scale the forces are balanced left and right or *horizontally* with respect to the supporting crossline. In figure 3.24 the illustrations of the horizontal balance scale show a line of one physical dimension balancing or counterbalancing a line with the same (or equal) physical characteristics. These examples also point out the balance between lines, shapes, and values that have been modified and varied. A second type of weighing scale, with which forces are balanced *vertically*, is also illustrated in figure 3.24. The third weighing device illustrated in the figure points out not only horizontal and vertical balance, but also balance of forces that are distributed around a center point. This is a *radial* weighing scale.

In picture making, balance refers to the felt optical equilibrium among all parts of the work. The artist balances forces horizontally, vertically, radially, and diagonally in all directions and positions (fig. 3.25).

Several factors, when combined with the elements, contribute to balance in a work of art. These factors or variables are *position* or placement, *size, proportion,*

quality, and *direction* of the elements. Of these factors, *position* plays the lead role. If two shapes of equal physical qualities are placed near the bottom of a picture frame, the work will appear bottom-heavy or out of balance with the large upper space. Such shapes should be positioned to contribute to the *total balance* of all the involved picture parts. Similarly, the other factors can put a pictorial arrangement in or out of balance according to their use.

In seeking balance, we should recognize that the elements of art represent "moments of force." As the eye travels over the picture surface, it pauses momentarily for significant picture parts that are contrasting in character. These contrasts represent moving and directional forces that must counterbalance one another so that *controlled tension* results. In the painting *Handball* by Ben Shahn, the moments of force are felt in tension that exists between the two figures in the foreground and the number 1 at the top of the wall (fig. 3.26). These forces together support one another. The problem of visual balance has resulted in two basic types of organization: symmetrical and asymmetrical.

3.27 Georgia O'Keeffe. *Lake George Window.* **1929; oil on
canvas, 40 × 30 in.** The window, its moldings, and its shutters
are equally distributed on either side of an imaginary vertical axis
in mirrorlike repetition. Georgia O'Keeffe has balanced this
painting symmetrically.
Museum of Modern Art, New York. Acquired through the Richard D.
Brixey Bequest.

3.28

Symmetrical (Formal) Balance The beginner will find
that *symmetry* is the simplest and most obvious type
of balance. In pure symmetry identical *optical units*
(or forces) are *equally* distributed in mirrorlike repe-
tition on either side of a vertical axis or axes (figs. 3.27
and 3.28). Because of the identical repetition, the ef-
fect of pure symmetrical balance is usually dull, tiring,
and boring. It is usually too monotonous for prolonged
audience attention. However, by its use, *unity* is easily
attained. In spite of these seemingly negative effects,
interesting variations can be achieved through the cre-
ative use of the elements of art (figs. 3.29, 3.30, and
plate 14).

Approximate Symmetry The severe monotony of pure
symmetry in pictorial arrangements is often relieved
by a method sometimes called approximate symmetry
(figs. 3.31 and 3.32). Here, the parts on either side of
the axis or axes are varied to hold audience attention,
but they are similar enough to make repetitious rela-
tionships and their vertical axis optically felt (fig. 3.33
and plate 15).

Radial Balance This is another type of arrangement
that, through repetitive association, can create true or
approximate symmetry. In radial balance, forces are
distributed around a central point. The rotation of these
forces results in a visual circulation, adding a new di-
mension to what might otherwise be a static, symmet-
rical balance. *Pure* radial balance opposes identical
forces, but interesting varieties can be achieved by
modifying the spaces, numbers, and directions of the
forces (figs. 3.34, 3.35 and 3.36). Although modified,
the principle of repetition must still be stressed so that
its unifying effect is utilized. Radial balance has been
widely used in the applied arts. Jewelers often use ra-
dial patterns for stone settings on rings, pins, neck-
laces, and brooches. Architects have featured this
principle in quatrefoils and "rose" windows (the petals
of flowers are radially arranged) (plate 16). The pot-
ter's plates and vessels of all kinds evolve on the wheel
in a radial manner and frequently give evidence of this
genesis. In two-dimensional work, the visual material
producing the radial effect can be nonobjective or fig-
urative.

3.29 Burgoyne Diller. *First Theme.* **1963–1964; oil on canvas. 72 × 72 in.** *First theme* is a simplified, formal, symmetrical composition that relies on shape size, value, and color relationships to express spatial relationships. The values and colors black, white, red, and yellow are used for maximum variety or contrast. Burgoyne Diller painted this painting in the Neo-Plastic style of Mondrian and Van Doesburg.
Albright-Knox Art Gallery, Buffalo, New York. Gift of Seymour H. Knox, 1969.

3.30 Ron Resch. *Van Leer Model.* **1980; computer.** However one turns this work, the image remains basically the same. In such imagery much interest must be worked into the elements in order to compensate for the repetitious, mirrorlike appearance.
From the artist.

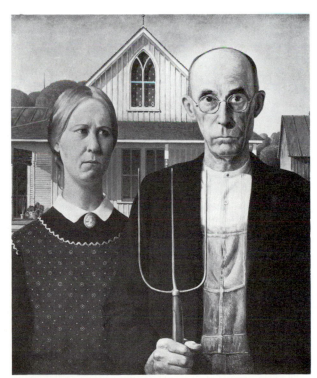

3.31 Grant Wood. *American Gothic.* **1930; oil on beaver board, 29⅞ × 24⅞ in.** The two figures in this picture create repetitious relationships so that their *vertical axis* is optically felt. This is *approximate symmetry*.
Chicago Art Institute.

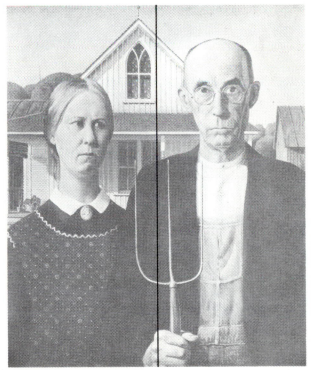

3.32

3.33 Nassos Daphnis. *11–67.* **1967; epoxy on canvas,
98 × 77 in.** The shapes and their sizes are the same *except* for
the diagonal stripes passing behind the circle. Had identical stripes
been provided moving from upper left to lower right, the work
would have been closer to symmetry. As it stands the work is
approximate symmetry.
Albright-Knox Art Gallery, Buffalo, New York. Gift of Seymour H. Knox,
1969.

3.35 Tom Defanti, Dan Sandin, and Mimi Shevitz. *Spiral PTL.*
1981; computer. The core of this work is projecting (or radiating)
outward-moving spirals that are varied by moving from solid to
broken lines.
From the artists.

3.34 Anuskiewicz. *Iridescence.* **1965; acrylic on canvas,
60 × 60 in.** In radial balance there is usually a radiation from
some (usually central) source. That is clearly the case here, but
note that there are various stresses placed on the rays as they move
away from the square; the end result is that the square seems to
emit some mystic force, as with the obelisk in the movie "2001."
Albright-Knox Art Gallery, Buffalo, New York. Gift of Seymour H. Knox.

3.36 Simon Tookoome. *I Am Always Thinking about Animals.*
1973; stonecut and stencil 3/50 (print), 24¼ × 30¾ in. Although
opposition of identical forces is usually found in radial balance,
this Canadian artist displays his imaginative native imprint within
a radial arrangement.
Art Gallery of Ontario, Toronto. Gift of the Klamer family, 1978.

Asymmetrical (Occult) Balance *Asymmetrical bal-
ance* means visual control of contrasts through felt
equilibrium between parts of a picture. For example,
felt balance might be achieved between a small area of
strong color and a large empty space. Particular parts
can be contrasting, provided that they contribute to the
allover balance of the total picture. There are no rules
for achieving asymmetrical balance; there is no center
point and no dividing axis. If, however, the artist can

**3.38 Pablo Picasso. *Family of Saltimbanques.* 1905; oil on
canvas, 83¾ × 90⅜ in.** Asymmetrical balance: an intuitive
balance is achieved through a juxtaposition of the varying shapes
and a continuing distribution of similar values and colors.
National Gallery of Art, Washington, D.C. Chester Dale Collection.

feel, judge, or estimate the opposing forces and their
tensions so that they balance each other in total con-
cept, vital, dynamic, and expressive organization on the
picture plane results. A picture balanced by contradic-
tory forces (for instance, black and white, blue and or-
ange, shape and space) compels further investigation
of these relationships and thus becomes an interesting
visual experience (figs. 3.37, 3.38, 3.39 and plate 17).

Proportion

Proportion deals with the ratio, or comparative mag-
nitudes, of parts to each other. In art the configurations
of shapes or volumes are difficult to compare with any
accuracy, and the degree of proportion becomes a mat-
ter of judgment. Very often proportional parts are con-
sidered in relation to the whole, and usually these parts
should have some consistency of ratio. This is impor-
tant in art because the artist seeks balance and logical
relationships. If sizes are greatly different, as in the case
of a very large shape alongside a much smaller one, the
work may seem lacking in acceptable proportions. The
two pears in figure 3.40 illustrate the awkwardness of
such a juxtaposition. The larger pear is much too force-
ful in its demand on our attention; the smaller one loses
all significance. In using their judgment in determining
satisfying proportions, artists rely on an educated in-
tuition—adjusting things until satisfied that they fit
their surroundings and appear comfortable with each
other.

**3.39 Ronald Kitaj. *Walter Lippmann.* 1966; oil on canvas,
72 × 84 in.** In concentration of subject matter, this painting is
weighted toward the left; but the inverted pyramidal lines produce
some degree of equilibrium, and the strongest darks are on the
right, adding weight. The balance is achieved through dissimilar
means.
Albright-Knox Art Gallery, Buffalo, New York. Gift of Seymour H. Knox,
1967.

Yet most artworks need to include a certain amount
of emphasis, or dominance. When parts have too much
equality they become overly competitive and monoto-
nous. Emphasis controls and sustains the observer's at-
tention. In the Jerome Witkin painting (fig. 3.41), the
artist has used enlargement for emphasis. The subject
as a large physical man is emphasized by the bulky torso

3.40 Diagram of pears.

3.41 Jerome Witkin. *Jeff Davis.* 1980; oil on canvas, 72 × 48 in. If there was ever a painting in which one subject dominated the work, this must be it. Most artworks do not need this degree of dominance, but Witkin evidently wanted a forceful presence—and got it.
Museum of Art, The Pennsylvania State University.

with simple, light values, surrounded by the darker forms of head, arms, jacket and pants. The result is a psychologically overpowering portrait.

The feeling of largeness we experience in looking at this artist's portrayal is the result of relative scaling. He has considered the relationships of his work to what it represents. In this case, as in most, the standard of comparison is based on what is known about size in the objective world. Also, the image seems about to burst the limits of the work's format. Thus the size of the working area can be utilized to affect the apparent reduction or enlargement of the subject. The physical size of the work can also be instrumental in affecting our understanding of its proportions if we compare it to our own size. Because of its small scale (5 × 5¾ in.), Van Eyck's ***St. Francis Receiving the Stigmata*** acquires an intimate, even reverential quality (plate 18).

Chuck Close, on the other hand, tends to overwhelm us with his enormously large human heads (*see* fig. 2.7). With the overall size (they range from five to eight feet), there is a proportional enlargement of facial details such as hairs and pores. The view of the artist in his studio (fig. 3.42) illustrates this overpowering magnification. The heads become heroic, intimidating, and, in some respects, sordid.

Dominance

Any work of art that strives for interest must exhibit differences that emphasize the degrees of importance of its various parts. These differences result from medium and need. A musical piece, for example, can use crescendo; a dramatic production can use a spotlight.

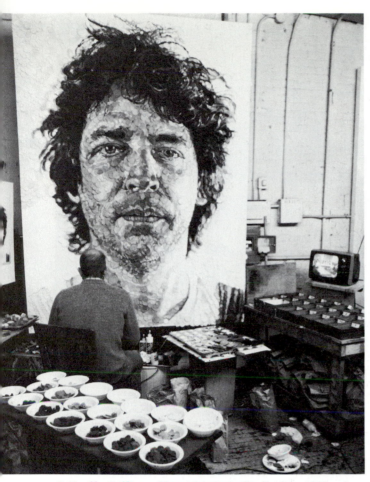

3.42 **Chuck Close.** *Photo of Artist in His Studio.* 1982; pulp paper collage on canvas, 96 × 72 in. When magnified by Close's painting, heads become geographical terrain with all of the expected (?) hillocks, gullies, and terrestrial features.
Courtesy the Pace Gallery, New York.

3.43 **Jacob Lawrence.** *Cabinet Makers.* 1946; gouache with pencil underdrawing on paper, 21¾ × 30 in. The human figures here become the focal points or "optical units" of greatest importance because of their size and activity. The dominant area is the merger of the two central figures, their centrality contributing. The other figures are lesser players, then the tables and the tools.
The Hirshhorn Museum and Sculpture Garden, Smithsonian Institution.

3.44 **James Ensor.** *Fireworks.* 1887; oil and encaustic on canvas, 40¼ × 44¼ in. Centering, color brightness, dynamic movement, and the semi-radial shape make the fireworks eruption inescapably the dominant subject.
Albright-Knox Art Gallery, Buffalo, New York. Albright and Jenny R. Mathews Fund, 1971.

The means by which differences can be achieved, in fact, are many. If we substitute the term *contrast* for *difference*, we can see that in the visual arts emphasis can be produced by contrast in scale, in character, and in any of the physical properties of the elements.

Obviously, the artist intends to use contrast to call attention to the significant parts of the work, thus making them dominant. A work that neglects *dominance* implies that everything is of equal importance; it not only fails to communicate, but also creates a confusing visual image in which the viewer is given no direction. In a sense all parts are important because the secondary ones produce the norm against which the dominant parts are contrasted.

In dealing with dominance artists have two problems. First, they must see that each part has the necessary *degree* of importance, and second, they must incorporate these parts with their varying degrees of importance into the rhythmic movement and balance of the work. In doing this, artists often find that they must use different methods to achieve dominance. One significant area might derive importance from its change in value, whereas another might rely on its busy or exciting shape (figs. 3.43, 3.44, 3.45, plate 19 and *see* plate 37).

The star system in the entertainment field; the hierarchy of political, ecclesiastical, and civic organizations; the atomic system, the solar system, and the galaxy—all, in very different ways, are witness to the basic order created by variations in dominance.

3.45 Michelangelo da Caravaggio. *Conversion of the Magdalene.* n.d.; oil on canvas, 38½ × 52¼ in. The contrast of the light value of the head and shoulders with the dark values of the background gives emphasis to the main figure of the Magdalene.
Detroit Institute of Art. Gift of the Kresge Foundation and Mr. and Mrs. Edsel Ford.

3.46 and 3.47 Titian. *Venus and Adonis.* circa 1560; oil on canvas, 42 × 53½ in. The movement in this painting was planned by Titian to carry the spectator's eye along guided visual paths. These were created (as is indicated by the accented lines in figure 3.47) by emphasizing the figure contours and the light values. The triangular shape made by the main figures serves as a pivotal motif around which secondary movements circulate.
National Gallery of Art, Washington, D.C. Widener Collection, 1942.

3.48 Gino Severini. *The Red Cross Train.* 1914; oil on canvas, 35¼ × 45¾ in. The Futurists were particularly interested in the dynamism of the modern age. Although this illustration is somewhat less violent in its movement than many of their works, it is hardly peaceful: shapes are placed in opposition and their character is highly varied.
The Solomon R. Guggenheim Museum, New York. Photo by Robert E. Mates.

Movement

A picture surface is static; its parts do not move. Any animation in a work must come from an illusion created by the artist through placement and configuration of the picture parts. The written word is read from side to side, but a visual image can be read in a variety of directions. The directions are created by the artist out of a need for a means to bind the various parts together in rhythmic, legible, and logical sequence. The *movement* should assure that all areas of the picture plane are exploited, that there are no dead spots. This goal is realized by directing shapes and lines toward each other in a not-always-obvious manner so that the spectator is unconsciously swept along major and secondary visual channels. The movement should be self-renewing, constantly drawing attention back into the format (figs. 3.46, 3.47, 3.48, and 3.49).

3.49 Käthe Kollwitz. "Losbruch" ("Outbreak") from the series *Peasants' Revolt.* 1903; print: etching, 20¼ × 23½ in. In this intaglio print the figures surge forward like a relentless tide. The thrusting movement is probably the most significant factor in the work.
Courtesy Bowling Green State University, School of Art Collection.

3.50 Tom Wesselman. *Study for First Illuminated Nude.*
1965; synthetic polymer on canvas, 46 × 43 in. Wesselman has
reduced the image to the few details he considers crucial, thus
practicing economy.
Hirshhorn Museum and Sculpture Garden, Smithsonian Institution.

Economy

Very often, as a work develops, the artist will find that
the solutions to various visual problems result in un-
necessary complexity. This problem is frequently char-
acterized by the broad and simple aspects of the work
deteriorating into fragmentation. This process seems to
be a necessary part of the developmental phase of the
work, but the result may be that solutions to problems
are outweighed by a lack of unity.

The artist can sometimes restore order by returning
to significant essentials, eliminating elaborate details,
and relating the particulars to the whole. This is a sac-
rifice not easily made or accepted because, in breaking
things down, interesting discoveries may have been
made. But, interesting or not, these effects must be sur-
rendered for greater legibility and a more direct
expression. Economy has no rules, but rather must be
an outgrowth of the artist's instincts. If something
works with respect to the whole it is kept. If disruptive,
it must be assimilated or rejected.

Economy is often associated with the term *abstrac-
tion*. Abstraction implies an active process of paring
things down to the essentials necessary to the artist's
style of expression. It strengthens both the conceptual
and organizational aspects of the artwork. In a sense,
the style dictates the *degree* of abstraction, though all
artists abstract to some extent (fig. 3.50).

Economy is easily detected in many contemporary
art styles. The early modernists Pablo Picasso and Henri
Matisse were among those most influential in the trend
toward economical abstraction (fig 3.51 and plate 20).
The "field" paintings of Rothko, Newman, and Still,
the monochromatic black canvasses of Ad Reinhardt,
and the hard-edged works of Ellsworth Kelly all clearly
feature economy (*see* fig. 3.10 and plates 12, 101, and
108). The artists of the Minimalist (which itself be-
speaks economy) style, Robert Morris, Ronald Bladen,
Donald Judd, and Tony Smith, utilize severely limited
geometric forms (*see* fig. 11.55). They have renounced
illusionism for three-dimensional objects in actual space
that excludes all excesses. The absence of elaboration
results in a very direct statement.

In economizing, one flirts with monotony. Some-
times embellishments must be preserved or added to
avoid this pitfall. But if the result is greater clarity, the
risk (and the work!) are well worth it.

Space

The problem of pictorial space is so important that an
entire chapter is devoted to it later in the text. It will
suffice here to mention that there are many spatial con-
cepts and that, whichever is chosen for a particular
work, it should be used consistently. Spatial planning
contributes immeasurably to unity in art.

SUMMARY

A unified artwork develops like symphonic orchestra-
tion in music. The musical composer generally begins
with a theme that is taken through a number of vari-
ations. Notations direct the tempo and dynamics for
the performers. The individual instruments, in follow-
ing these notations, play their parts in contributing to
the total musical effect. In addition, the thematic ma-
terial is woven through the content of the work, har-
monizing its sections. A successful musical composition
speaks eloquently, with every measure seeming to be
irreplaceable.

This describes music, but also art; everything men-
tioned has its counterpart in art. In every creative me-
dium, be it music, art, dance, poetry, prose, or theatre,
the goal is *unity*. For the creator, unity results from the
selection of appropriate devices peculiar to the medium
and the use of certain principles to relate them. In art
an understanding of the principles of form-structure
is indispensable. In the first chapters of this book, one
can begin to see the vast possibilities in the creative
art realm. Through study of the principles of form

3.51 Henri Matisse. *Lady in Blue.* **1937; oil on canvas, 36½ × 29 in.** Those familiar with the evolution of this painting know that Matisse started with a fairly conventional, and somewhat busy, image of the figure, gradually simplifying as the image took shape. There is some subdued ornamentation for interest, but it is basically an economical work.
Collection of Mrs. John Wintersteen, Philadelphia.

organization beginners develop an intellectual understanding that can, through persistent practice, become instinctive.

The art elements (line, shape, value, texture, and color) on which form is based rarely exist by themselves. They join forces in the total work. Their individual contributions can be studied separately, but in the development of a work the ways in which they relate to each other must always be considered. Because each of the elements makes an individual contribution and has an intrinsic appeal, the elements are discussed separately in the five chapters that follow. In an academic sense it is necessary to do this. But as you study an element, please keep in mind those that preceded it. At the end all the elements must be considered both individually *and* collectively. This is a big task, but necessary for that vital ingredient, unity.

FORM PROBLEMS

The problems found here and in subsequent chapters cannot pretend to exhaust the limitless potentialities of form relationships. We hope that certain significant factors of form and its component elements will be illustrated and clarified by the accompanying problems. The problems should not be considered immune to amendment or substitution. Perhaps classroom teachers can devise problems that are more effective within the context of their own instruction. Newly invented problems might also fill in the holes that admittedly exist and that cannot always be filled in a book of this magnitude.

Problem 1

Shapes can be used as a basis for a motif that, when repeated, collectively may form a larger (allover) pattern.

a. Step 1. Select a shape (rectilinear geometric, curved [biomorphic], or in combination) that is unique and imaginative. This shape will become the *motif* (module) that later (step 2) will be repeated in a pattern. This shape's boundaries should be about one inch in size. Cut the shape out of black paper and mount it on a white paper background (five by seven inch) in the direction of the pattern to be created (fig. 3.52).
Step 2. Repeat and cut out from black paper as many motif shapes (from step 1) as might be needed. Arrange them on a second white paper background (five by seven inch). Create a pattern by repeating the motif. Strong considerations should be given to the negative white shapes that are formed. The pattern may be horizontal, vertical, or diagonal (fig. 3.53).
Step 3. Repeat the same pattern (from step 2) following the same format and size. Paint a series of different flat, neutralized (greyed, from a black-and-white paint mixture) areas (five by five inch) on a good quality bond paper. These neutralized paintings (five-by-five inch pieces) should graduate from white to black. Paint at least fifteen steps for the series. Cut the motif shapes out of the neutral paintings, gradate the shapes from light at the top to dark at the bottom, and adhere the motifs to a black background rectangle five by seven inches. All three steps might be mounted or matted together (fig. 3.54).

3.52 Form Problem 1a, Step 1.

b. A motif also can be found by selecting a small portion of a previously created design. By drawing a square shape (two by two inch, three by three inch, or four by four inch) on a piece of tracing paper and passing the traced square over a larger design, a unique design can be selected and traced. Begin with a square background sheet of drawing paper (eight by eight inch, twelve by twelve inch, or sixteen by sixteen inch). Divide the background paper into sixteen squares (two by two inch, three by three inch, or four by four inch) depending on the size of motif tracing. The traced motif square can be repeated on the background paper four times from left to right to form a row of repeated motifs. Each row can be repeated four times. Number the top side of the traced square 1, the right side 2, the bottom 3, and the left side 4. Place the tracing of the first motif square (with the number 1 edge at the top) on the upper-left corner of the background (beginning of the first row). Trace the second square (with the number 2 side at the top) to the right side of the first square. Trace the third square (with the number 3 at the top) to the right of the second square. Trace the fourth square (with the number 4 side at the top) to the right of the third square. Repeat the second, third, and fourth row in the same sequence, but begin the second-row square with the number 2 side at the top, the third row with the number 3 side at the top, and the fourth row with the number 4 side at the top.

Using pencils add values, colors, and textures to the repeated sequence of squares. Overlappings can be added to unify the motifs. The numbered sides can be alternated in any order to create a patterned, allover design (fig. 3.55).

Part *a.* submitted by Debra Babylon, Instructor of Art, Bowling Green State University, Bowling Green, Ohio. Work by Timothy Guider.
Part *b.* work by Harold Fosnaught, Bowling Green State University, Bowling Green, Ohio.

3.53 Form Problem 1a, Step 2.

3.54 Form Problem 1a, Step 3.

3.55 Form Problem 1b.

Problem 2

Negative areas (ground) are just as important to a pictorial organization as are positive areas (figure) and should be given strong consideration.

a. In a rectangular frame shape (about eight by ten inches) using black paper and white paper cut out at least seven black shapes (solid or linear) and arrange them on a white background. These shapes may be either rectilinear or curved. Emphasize the black shapes as the positive shapes. The linear and/or solid shapes may be repeated and their edges lined up to create a patterned rhythm for pictorial unity. Actively involve the edges of the composition. Rubber cement can be used to adhere the shapes to the background (figs. 3.56 and 3.58).
b. Reverse the shapes of part *a*. The white shapes will become the positive and black paper will be the background (figs. 3.57 and 3.59).

Parts *a* and *b* can be mounted or matted as one total composition.

Submitted by Debra Babylon, Instructor of Art, School of Design, Toledo Museum of Art, Toledo, Ohio. Work by Timothy Rood (part 2) and Chris Cory (part b).

3.56 Form Problem 2a.

3.57 Form Problem 2b.

3.58 Form Problem 2a.

3.59 Form Problem 2b.

Problem 3

The factor of position or placement plays a very important role in achieving *balance* in a work of art. Experiment and practice arranging different kinds of balance as follows:

a. When lines or shapes are paired equally in mirrorlike repetition on either side of a vertical axis, they are *balanced symmetrically*. This type of balance is calculated, formal, and calm. Balance shapes and lines of different colors or values symmetrically in a composition (figs. 3.60 and 3.61).

b. For variation and livelier artistic interest, artists sometimes introduce balanced differences in size, position, value, color, and the like to the formal balance of a symmetrical arrangement. In a second arrangement, introduce modifications to sides of the vertical axis to achieve *approximate symmetrical* balance (fig. 3.62).

c. Since *asymmetrical balance* depends on an *occult* or *felt equilibrium* among parts of a picture, there are no rules for achieving it. Explore several means of obtaining asymmetrical balance by using shapes of varying sizes, types, colors, values, and textures. Observe principles of placement for tension or spacing and the relationship of positive elements with negative space (fig. 3.63).

Figure 3.60. Work by Tony Duda.
Figures 3.61, 3.62, 3.63, and exercises submitted by Debra Babylon, Instructor of Art, Toledo Museum School of Art, Toledo, Ohio. Works by Jana Marie Bishop.

3.61 Form Problem 3a.

3.62 Form Problem 3b.

3.60 Form Problem 3a.

3.63 Form Problem 3c.

Problem 4

Although pictorial movement can take many directions simultaneously, we will limit it in this problem to one plane of action for purposes of illustration. The movement in a developed work of art may be complex or simple, swift or slow, continuous or jerky. Some of the component movements should be dominant, while others are recessive.

Cut out a number of black square and rectangular shapes. Place these adjacent to each other on a horizontal format, adjusting them so that they flow up and down across the page. The vertical movements should create a variety of negative shapes. Try tipping some of the shapes to accelerate or decelerate the movement.

Pictorial rhythm is essentially a matter of measured accents, as in music. In this problem pictorial rhythm may take the form of repeatedly greater or smaller intervals, spacing of the dominant rectangles, or periodically tipped or straightened shapes. Try all of these methods before determining which seems most successfully rhythmic. Then glue the shapes in place.

Problem 5

The principle of dominance can impart unity of total form.

Cut some circles and rectangles of varying sizes from two different colors of paper and arrange them so that some shapes overlap others. Make one kind of shape or one color *dominate*. Remember that you are striving to create enough similarities for harmony and enough differences for contrast and elaboration. Also, try to attain a sense of equilibrium or balance throughout the entire arrangement.

Overlapping can give the illusion of the shapes moving backward and forward in space. This spatial effect should be controlled to maintain the unity of the picture plane.

Problem 6

When the picture plane is divided, the shape relationships can produce visual interest. As the work develops, an effect of pictorial space can also result. If the two-dimensional and three-dimensional aspects are made compatible, compositional unity will be achieved.

Using a compass for curved lines and a ruler for straight lines, break up a frame shape into smaller areas.

As the lines are drawn across the frame shape, linear rhythm and related shapes are created. When the lines parallel one another, they create shape harmony; when the lines oppose, they create shape contrast. Positive and negative shape relationships, as well as spatial suggestions, can be enhanced by filling in some of the areas with solid black. Thick and thin lines also will give spatial suggestions. Variation in the size of areas results in contrasting proportional relationships (figs. 3.64 and 3.65).

3.64 Form Problem 6.

3.65 Form Problem 6.

4
LINE

THE VOCABULARY OF LINE

calligraphy The use of flowing, rhythmical lines that intrigue the eye as they enrich surfaces. Calligraphy is highly personal in nature, similar to the individual qualities found in handwriting.

contour The outermost observable edge of a shape or object. Usually described by an outline and may include the edge of values, textures or colors.

cross-contour The line or lines that define a surface form between the outermost edges of shapes or objects.

decorative An effect that emphasizes the two-dimensional nature of any of the visual elements. Decorative art stresses the essential flatness of a surface.

graphic art 1. Any of the visual arts that involves the application of lines or strokes to a two-dimensional surface. 2. The two-dimensional use of the elements. 3. Two-dimensional art forms such as drawings, paintings, and prints. 4. Also may refer to the techniques of printing as used in newspapers, books, and magazines.

line The path of a moving point; that is, a mark made by a tool or instrument as it is drawn across a surface. It is usually made visible by the fact that it contrasts in value with the surface on which it is drawn.

mass In graphic art, a three-dimensional form that appears to stand out from the space surrounding it. In the plastic arts the physical bulk of a solid body of material.

51

4.1 Vincent van Gogh. *Grove of Cypresses.* **pencil and ink with reed pen, 24⅝ × 18¼ in.** By using broad-stroked lines and arranging them in a turmoil of flowing movement, van Gogh subjectively expresses agitation in a commonplace landscape. Art Institute of Chicago.

plastic art 1. The three-dimensional use of the elements. 2. On a two-dimensional surface, plasticity is always an illusion created by the use of the visual elements in special ways. 3. Three-dimensional art forms such as architecture, sculpture, and ceramics.

LINE: THE ELEMENTARY MEANS OF VISUAL COMMUNICATION

Line is a graphic device made to function symbolically in artistic and literary expression. Its expression can be employed on *objective* and *subjective* levels. Objectively, it can describe simple measurements and surface characteristics. Subjectively, it can be modified to suggest many emotional states and responses (fig. 4.1). Linear designs in the form of ideograms and alphabetical letters are used by humans as a basic means of communication. The artist uses line in a more broadly communicative manner. Line is fundamental in such expression. Since the *elements of art structure* are to be studied separately, it seems appropriate to begin with *line*.

4.2 George Romney. *Lady Hamilton as Ariadne.* **Close-up brown wash drawing; 17 × 9⅜ in.** The brushed line in this drawing is a visual shorthand for the description of the figure and a spirited summation of its movement, or "gesture." Line serves as an abstract notation in this case. Art Institute of Chicago. Gift of Tiffany and Margaret Blake.

Line, as such, does not exist in nature; it is a human invention, an *abstraction*, developed as an agent for the *simplification* of statements of visual fact and for *symbolizing* graphic ideas (fig. 4.2). Nature contains only *mass,* the measurements of which are conveniently demonstrated in art by the use of line as *contour.*

Line operates on elastic terms in the visual field, symbolizing an *edge* as on a piece of sculpture (*see* fig. 10.10), a *meeting of areas* where textural or color differences do not blend, a *contour* as it defines a drawn

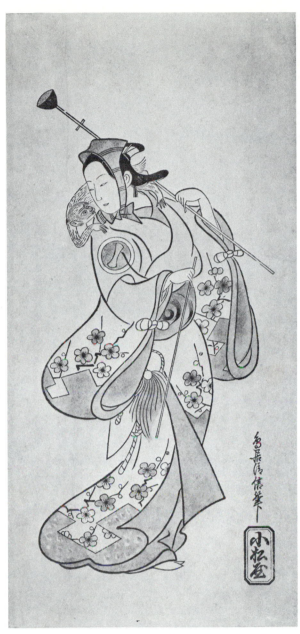

4.3 Torii Kiyonobu. *Actor as a Monkey Showman.* **n.d.; woodblock print, 13¼ × 6¼ in.** The alterations of movement in the *curved lines* of this Japanese print are visually entertaining as well as calligraphic because of their subtle rhythmic quality. Metropolitan Museum of Art, New York. Rogers Fund, 1936.

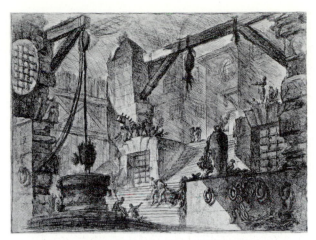

4.4 Giovanni Battista Piranesi. *Carceri, (first state).* **circa 1750; print: etching, 16¼ × 22 in.** This is a *line* etching, meaning that the image is completely composed of lines scratched on and bitten into the printing plate. The line provides contours and textures for the ropes, chains, stones, beams, and figures. National Gallery of Art, Washington, D.C. Rosenwald Collection.

PHYSICAL CHARACTERISTICS OF LINE

The physical properties of line are *measure, type, direction, location,* and *character*.

Measure

Measure refers to the length and width of line. A line may be of any length and breadth. An infinite number of combinations of long and short or thick and thin lines can, according to their use, divide or unify the *pictorial area*.

Type

Any line is by its own nature a particular *type*. If the line continues in only one direction, it is *straight;* if gradual changes of direction occur, it is *curved;* if those changes are sudden and abrupt, an *angular* line is created. In adding the dimension of *type* to that of *measure,* we find that long or short, thick or thin lines can be straight, angular, or curved. The straight line in its continuity ultimately becomes repetitious and, depending on its length, either rigid or brittle. The curved line may curve to form an arc, reverse its curve to become wavy, or continue turning within itself to produce a spiral. The alterations of movement become visually entertaining and physically stimulating if rhythmical (fig. 4.3). A curved line is inherently graceful and, to a degree, unstable. The abrupt changes of direction in an angular line create excitement and/or confusion (fig. 4.5). Our eyes frequently have difficulty adapting to an angular line's unexpected deviations of direction. Hence, the angular line is full of challenging interest.

shape. Line is *plastic* insofar as it suggests space, or *calligraphic* as it enriches a surface (plate 21 and fig. 4.3). The line may perform several of these functions at the same time. Its wide application includes the creation of *value* and *texture,* illustrating the impossibility of making a completely arbitrary and final distinction between the elements of art structure (fig. 4.4). However, it *is* possible to recognize and analyze the linear components of a work of art.

4.5 Student work. *Cock Fight.* The abrupt changes of
direction in the *angular* lines of this drawing create the excitement
and tension of the combat.
Bowling Green State University.

4.6 Mel Bochner. *Vertigo.* **1982; charcoal, Conte, crayon, and
pastel on canvas, 108 × 74 in.** Line, the dominant element, is
almost wholly diagonal. This imparts a feeling of intense activity
and stress.
Albright-Knox Art Gallery, Buffalo, New York. The Charles Clifton Fund.

Direction

A further complication of line is its *basic direction,* a
direction that can exist irrespective of the component
movements *within* the line. That is, a line can be a *zig-
zag type* but take a generally *curved direction.* Thus,
the *line type* can be contradicted or flattered by its *basic
movement.* A generally horizontal direction could in-
dicate serenity and perfect stability, whereas a diago-
nal direction would probably imply agitation and
motion (fig. 4.6). A vertical line generally suggests poise
and aspiration. Line's direction is very important be-
cause in large measure it controls the movements of
our eyes while we view a picture. Our eye movements
can effectuate continuity of relationships among the
various elements and their properties.

Location

The control exercised over the measure, type, or direc-
tion of a line can be enhanced or diminished by the *lo-
cation* of the line. According to its placement, a line
can serve to *unify* or *divide, balance* or *unbalance* a
pictorial area. A diagonal line might be soaring or

plunging, depending upon its high or low position rel-
ative to the frame. The various attributes of line can
act in concert toward one goal or can serve separate
roles of expression and design. A fully developed work,
therefore, may recognize and use all physical factors,
although it is also possible that fewer than the total
number can be successfully used. This is true largely
because of the dual role of these properties. For in-
stance, unity in a work might be achieved by repetition
of line length, while variety is being created by differ-
ence in the line's width, medium, or other properties.

Character

Along with *measure, type, direction,* and *location,* line
possesses *character,* a term largely related to the *me-
dium* with which the line is created. Different medium
conditions can be used to create greater interest. Mo-
notony could result from the consistent use of lines of
the same character unless the unity so gained was bal-
anced by the variation of other physical properties.

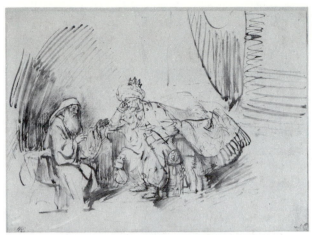

4.7 Harmensz van Ryn Rembrandt. *Nathan Admonishing David.* **n.d.; pen and brush with bistre, 7⁵/₁₆ × 9¹⁵/₁₆ in.** The crisp, biting lines of the pen are complemented by the broader and softer lines of the brush.
Collection the Metropolitan Museum of Art, New York. Bequest of Mrs. H. O. Havemeyer, 1929. The Havemeyer Collection.

4.8 Student work. *Violinist.* A number of expressive qualities can be created by the manner in which the artist varies *line character*. The idea of *violinist* is expressed in these line groupings.

Varied instruments, such as the *brush, burin, stick,* and *fingers,* contain distinctive capabilities to be exploited by the artist. The artist is the real master of the situation, and it is the artist's ability, experience, intention, and mental and physical condition that will determine the effectiveness of line character. Whether in a work of art we are to see lines of uniformity or accent, certainty or indecision, tension or relaxation, are decisions only the artist can make.

The nature of the medium is important in determining the personality or the *emotional quality* of the line. The different expressive qualities inherent in the soft brush lines of ink as opposed to the precise and firm lines of pen and ink can be easily seen (fig. 4.7).

EXPRESSIVE PROPERTIES OF LINE

The *qualities* of line can be described by general states of feeling—gay, somber, tired, energetic, brittle, alive, and the like. However, in a work of art, as in the human mind, such feelings are rarely so clearly defined. An infinite number of conditions of varying subtleties can be communicated by the artist (fig. 4.8). The spectator's recognition of these qualities is a matter of feeling, which means that the spectator must be receptive and perceptive and have a reservoir of experiences.

Through *composition* and *expression*, individual lines come to life as they play their various roles. Some lines are dominant and some subordinate, but all are of supreme importance in a work of art. Although lines may be admired separately, their real beauty lies in the *relationships* they help to establish, the *form* created. This form can be *representational* or *nonrepresentational,* but the recognition and the enjoyment of the

work on the *abstract* level is of first importance. Preoccupation with subject indentification significantly reduces the appreciation of the truly expressive art qualities.

LINE AS RELATED TO THE OTHER ART ELEMENTS

Line's other physical properties are so closely related to the other art elements that line should be studied in terms of those relationships. Line can possess *color, value,* and *texture,* and it can create *shape.* Some of these factors are essential to the very creation of line, while others are introduced as needed. These properties might be thought of separately, but nevertheless they cooperate to give line an intrinsic appeal, meaning that line can be admired for its own sake (plate 22). Artists often exploit this appeal by creating pictures in which the linear effects are dominant, the others subordinate.

Line and Shape

In creating *shape,* line serves as a continuous *edge* of a figure, object, or mass. A line that describes an area in this manner is called *contour* (fig. 4.9). Contour lines might also separate *shapes, values, textures,* and *colors.*

A series of closely placed lines create *textures* and *toned areas.* The relationships of the ends of these linear areas establish boundaries that transpose the areas into *shapes.*

4.9 Susan Rothenberg. *United States.* 1975; acrylic and tempera on canvas, 114 × 189 in. The line describing the horse in this painting is called a contour. Susan Rothenberg is a contemporary artist who is noted for her series of horses done in a manner that might be referred to as Minimalist Abstract.
Doris and Charles Saatchi, London.

4.10 Group lines produce value. The upper row of blocks can be seen to become darker left to right because the lines increase in width. In the second row of blocks, a similar effect is created because the lines on the right are positioned closer to each other.

4.12 Glenn Felch. *House with Clark Sign* (detail). India ink and colored felt pens on paper. This enlargement of a section of figure 4.11 shows the importance of line in creating interesting areas of value differences.

4.11 Glenn Felch. *House with Clark Sign.* 1972; India ink and colored felt pens on paper, 17 × 22 in. Values can be created by varying the spaces between the lines; the parallel quality of the lines also injects a degree of harmony.
Courtesy of the artist.

Line and Value

The contrast in light and dark that a line exhibits against its background is called *value*. Every line must have value to be visible. Groups of lines create areas that can differ in value. Lines can be thick, thin, or any width in between. Wide, heavy lines appear dark in value, while narrow lines appear light in value. By varying the spaces between the lines, value changes also can be controlled. Widely spaced lines appear light, and closely spaced lines appear dark (fig. 4.10). Value differences also result from mixture of media or exerted pressure. Parallel lines, cross-hatching, and the like are examples of groups of single lines that create areas that differ in value (figs. 4.11 and 4.12).

Line and Texture

When groups of lines such as those mentioned combine to produce a flat or two-dimensional effect, *pattern* results (plate 23). If, however, the result stimulates our sensation of touch by suggesting degrees of roughness or smoothness, the effect is called *texture*. Texture also resides within the character of various *media* and *tools* and gives these items their distinctive qualities (fig. 4.13). Each tool possesses the *textural properties* of its structure and use, and these in turn can be enhanced or diminished by the manner of handling. Brushes with a hard bristle, for instance, can make either sharp or rough lines, depending on *hand pressure, amount* of medium carried, and *quality* of execution. Brushes with soft hairs can produce smooth lines if loaded with thin

4.13 Student artist. *Owls.* print: woodcut. When knives and gouges are used to cut the wood, the lines and textures created are usually somewhat different from those produced by another medium.
Bowling Green State University.

4.14 Dan Christensen. *GRUS.* 1968; acrylic on canvas, 123 × 99 in. Variations in the continuous curvilinear lines within this painting help to create illusions of open space. The line variations include changes in the physical properties of lines' measure, direction, location, and character as well as the elements' value and color.
The Hirshhorn Museum and Sculpture Garden, Smithsonian Institution.

paint and thick blotted lines if loaded with heavy paint. Other tools and media can produce similar variations of line.

Line and Color

The introduction of *color* to a line adds an important expressive potential. Color can accentuate other line properties. A hard line combined with an intense color produces a forceful or even harsh effect. This effect could be considerably overcome if the same line were created in a more gentle color. Color has become identified with various emotional states. Thus, the artist might use red to symbolize passion or anger, yellow to suggest cowardice or warmth, and so forth (*see* plate 21) (*see* "Color and Emotion," chapter 8).

SPATIAL CHARACTERISTICS OF LINE

All of the physical properties of line contain *spatial characteristics* that are subject to control by the artist. Mere position within a prescribed area suggests *space*. *Value contrast* can cause lines to advance and recede (fig. 4.14). An individual line with varied *values* throughout its length may appear to writhe and twist in space. Because *warm* colors generally *advance* and

4.15 Maria Helena Vieira da Silva. *The City.* 1951; oil on canvas, 37¼ × 32¼ in. The spatial illusion, of such obvious importance in this example, is largely the product of the physical properties of the lines strengthened by value shapes.
Courtesy the Toledo Museum of Art.

cool colors generally *recede,* the spatial properties of colored lines are obvious. Every factor that produces line has something to say about line's location in space (fig. 4.15). The artist's job is to use these factors to create *spatial order* (*see* fig. 9.24).

LINE AND REPRESENTATION

Line creates *representation* on both *abstract* and *realistic* levels. In general, we have dealt primarily with abstract definitions, but it is easy to see that the application can be simultaneously observed in a material context. For example, we have discussed the *advancing-receding* qualities of value in a line. If a particular line is drawn to represent the contours of a piece of drapery, the value contrast might describe the relative spatial position of the folds of the drapery (fig. 4.16). An artist drawing a linear portrait of a person might use line properties to suggest more than a mere physical presence (fig. 4.17). The artist might also be able to convey—either satirically or sympathetically—much information about the character of the sitter. Thus, line in representation has many objective and subjective implications. All are the direct result of the artist's manipulation of the *physical properties.*

In its role of signifying ideas and conveying feelings, line moves and lives, pulsating with significant emotions. In *visual* art, line becomes a means for transcribing the *expressive language* of ideas and emotions. It

4.17 Juan Gris. *Portrait of Max Jacob.* 1919; drawing pencil, 14⅜ × 10½ in. sheet. This drawing, done entirely in line, provides information on the physical presence as well as the psychological character of the sitter.
Museum of Modern Art, New York. Gift of James Thrall Soby.

4.16 J. Seeley. *Stripe Song.* 1981; print: photo silk screen, 22 × 30 in. Seeley is an acknowledged master of the high-contrast image form. Combining the undeniable visual appeal of Op art with the implicit realism of the photographic image, his black-and-white linear abstractions are boldly decorative, highly complex, and a delightful treat for the eye.
From the photographer.

describes the edges or contours of shapes, it diagrams silhouettes, it encompasses spaces and areas—all in such a way as to convey meaning.

Line is not used *exclusively* to express deep emotion and experience in this manner. Often, it is used for planning *utilitarian* objects: an architect's line drawings of a building or an engineer's drawings of a bridge; the lines drawn on maps to represent rivers, roads, or contours; or the lines drawn on paper to represent words. Such use of line is primarily utilitarian—a convenient way of communicating ideas to another person. Whichever the emphasis—*expression* of human emotions or *communication* of factual materials—line is an important *plastic element* at the disposal of the artist.

LINE PROBLEMS

Problem 1

The artist might combine expressive calligraphy and the representational characteristics of line in the same image (fig. 4.18).

> Select a few moderately complex subjects. Draw these experimentally in a continuous contour line, defining the subject but at the same time allowing the drawing instrument to roam freely, to make sudden changes in direction, and to overlap itself. The line should dwell in some areas, moving steadily, improvising as it moves, and moving directly from one area to another. Try drawing quickly as well as slowly. The intention is to produce works that are at the same time definitive and spontaneous, expressive and disciplined. The line should have calligraphic qualities (*see calligraphy* under Vocabulary; *see also* plate 21 and fig. 4.3).

Work by Tony Duda

Problem 2

Lines vary according to their physical properties.

> a. In one or more frame shapes, create interesting line arrangements in one medium. Vary the measure, type, direction, and location of the lines.
> b. Repeat the line arrangements in several other media and compare the resulting works for differences in character.

Problem 3

Different line types can produce different expressive effects. Straight lines are rigid, diagonal lines are exciting, vertical lines are dignified, horizontal lines are

4.18 Student work. Line Problem 1.

quiet and restful. Combinations of these lines can express complex feelings.

> Create several abstract line patterns expressing the qualities (*not* things) felt in selected nouns, adjectives, and verbs. The expression should lie not in the description of objects but within the nature of the lines themselves (*see* figs. 4.5 and 4.8).

Problem 4

Lines may describe the contours of object shapes.

> Concentrating your eye on the outer edge of an object, follow the contour with a drawing instrument. When the drawing is completed, vary the lines for spatial and emotional effects.

Problem 5

Line is used for enriching areas of a work of art through value contrasts and invented textures. At times invented textures have their source in nature, but they undergo a very positive metamorphosis, an abstraction, in the hands of the artist, who changes them according to the requirements of the work.

> a. Find at least five black-and-white, good-quality copies of a single object with an interesting outside contour. Several objects in a reproduction are acceptable if you can see the entire shape of most of the objects. The objects must have a full range of *value:* highlights, light grays, dark grays, and dark

4.19 Line Problem 5.

darks. Stay away from symmetrical commonplace objects, such as bottles. Also, do not use thin objects with little or no appearance of having volume. The objects should also have varied, active outside contours.

b. Practice drawing the chosen object in light pencil line, enlarging the form, deciding about size, figure-ground relationships, and placement within a given format. It is often effective, in the final form of the problem, to have stressed the bulges of the surface, the *outside* and *cross-contours*.

c. After establishing a satisfactory linear image, divide it (lightly with pencil) into approximately one-half-inch grids. These might be horizontal/vertical, diagonal, or of your own invention. You may vary the distance between the grids or leave them the same. Studying your reproduction, proceed to fill each grid with *one invented linear texture* that matches only the *value* of the reproduction at that point. You do not match or stimulate the *actual surface texture* of the reproduction, but create a line pattern that matches only the value. We suggest that you use pen and ink directly on the drawing. The grids tend to simplify the object because there is a loss of detail. Draw new textures within each grid as you proceed. You *do* want the *volume* of the object to appear through value. You must also deal with the negative areas—any areas left totally white must be planned as part of the composition. You should end up with an image of the object that has volume and looks somewhat representational from a distance; but as you come closer, you should see that each grid of the object has a different texture. When finished, erase all visible pencil marks (fig. 4.19).

Submitted by Debra Babylon, Instructor of Art, Bowling Green State University, Bowling Green, Ohio. Work by Connie Brzoska.

Problem 6

Lines are decorative or spatial in character. When lines are of the same thickness and do not cross each other, they tend to decorate a surface without giving any significant sense of space. If lines cross, vary in thickness, and are of different colors, they can express a plastic quality; they may seem to exist in a three-dimensional or space relationship.

On a single sheet of paper draw two design patterns of lines, each pattern contained within a frame shape. The first should be a design in which the lines have a decorative effect and all seem to lie on the plane of the paper (fig. 4.20). Draw the second so that the lines seem to exist in space (fig. 4.21).

Problem 7

Line creates representation on both realistic and abstract levels. In a realistic sense, line defines the limits of subject shapes and provides information on the shapes' inner dimensions. In an abstract sense, line suggests the spatial character of the subject and assists in the expression of the subject's personality.

a. Select a moderately complex object. Draw the object carefully and lightly, concentrating on its proportions and relationships. Strengthen those contours of the object that move toward you, thereby strengthening the spatial illusion.

4.20 Line Problem 6.

4.21 Line Problem 6.

b. Try using different media to draw the same subject to determine how the new media affect the expression of the drawing.

Problem 8

Semirepetitive lines and their fluctuations often produce the illusion of an undulating surface and/or a rhythmic effect.

Start with a single line, varying its directions as it moves across the entire format. Follow this with a second line drawn below the first, and introducing a slight variation from the first in its movement. Continue this procedure down the length of the format. If a drawing pen or brush is used, varying pressures should be employed to cause variations in width as it moves across the page; or, one might draw the lines with a consistent width, returning to them to produce the variation (fig. 4.22).

Submitted by Debra Babylon, Instructor of Art, School of Design, Toledo Museum of Art, Toledo, Ohio. Student work.

4.22 Line Problem 8.

Plate 22 Steve Magada. *Trio.* **1966; oil on canvas, 29 × 36 in.**
Line is admired for its own sake. Magada has exploited this appeal
by creating a picture in which the linear effects are dominant.
Courtesy Virginia Magada.

Plate 21 Georges Mathieu. *Montjoie Saint Denis!* **1954; oil
on canvas, 147⅝ × 35½ in.** The use of red, yellow, dark blue
(primary colors), and white in these calligraphic lines serves to
produce a forceful, strong, emotional effect.
Museum of Modern Art, New York. Gift of Mr. and Mrs. Harold Kaye.

Plate 23 Pablo Picasso. *Still Life.* **1922; oil on canvas.** The artist often uses groups of lines to suggest texture. When such groups are combined to produce a flat or two-dimensional effect, pattern results.
Art Institute of Chicago. Ada Turnbull Hertle Fund.

5
SHAPE

THE VOCABULARY OF SHAPE

biomorphic shape Irregular shape that resembles the freely developed curves found in live organisms.

Cubism A term given to the artistic style that generally uses two-dimensional geometric shapes.

decorative shape Two-dimensional shape that seems to relate to the picture plane.

geometric shape A shape created by the exact mathematical laws of geometry. Geometric shapes are usually simple, such as the triangle, the rectangle, and the circle.

intuitive space A pictorial spatial illusion that is not the product of any mechanical system but that relies, instead, on the physical properties of the elements and the instincts or feel of the artist.

linear perspective A mechanical system for creating the illusion of a three-dimensional space on a two-dimensional surface.

plane A shape that is essentially two-dimensional, having height and width.

plastic shape 1. In the graphic arts, any shape suggesting the illusion of a three-dimensional shape surrounded by space. 2. In the plastic arts, any shape comprising height, width, and thickness.

rectilinear shape A shape whose boundaries usually consist entirely of straight lines.

shape An area that stands out from the space next to or around it because of a defined boundary or because of difference of value, color, or texture.

Surrealism A style of artistic expression that emphasizes fantasy and whose subjects are usually the experiences revealed by the subconscious mind.

three-dimensional shape A shape having height, width, and depth, or a plastic shape.

63

5.1 Rufino Tamayo. *Animals.* 1941; oil on canvas, 30⅛ × 40 in. Tamayo has created a semifantasy by using semiabstract shapes to picture beasts, animal-like in general appearance, but of no recognizable species. The stark shapes emphasize the savage environment. Museum of Modern Art, New York. Inter-American Fund.

two-dimensional shape An area confined to length and width and set apart by contrasts of value or color.

volume A three-dimensional shape that occupies a quantity of space. On a flat surface the artist can create only the *illusion* of a volume.

INTRODUCTION TO SHAPE

Shapes are the building blocks of art structure. Edifices of brick, stone, and mortar are intended by the architect and mason to have beauty of design, skilled craftsmanship, and structural strength. The artist shares these goals in creating a picture. Bricks and stones, however, are tangible objects, whereas pictorial shapes exist largely in terms of the illusions they create. The challenge facing the artist is that of using the infinitely varied illusions of shape to make believable the fantasy inherent in all art. In other words, an artwork is never the real thing, and the shapes producing the

image are never real animals, buildings, people—the artist's subjects, if, indeed, the artist uses subjects at all. The artist might be *stimulated* by such objects and in many cases might reproduce the objects' basic appearance fairly closely. In these cases the alterations of surface appearance necessary to communicate an idea and to achieve compositional unity, if *minor*, might be called *semifantasy* (fig. 5.1). On the other hand, the artist may deal with shapes that are not intended to represent at all, or if they are representational at the outset, they may eventually lead the artist into a situation in which copied appearances in the final work are almost totally eliminated. This could be called *pure* fantasy because the final image is entirely the product of the artist's imagination. Capable artists, whatever the degree of their fantasy, are able to convince us that the fantasy is a *possible reality*. Any successful work of art, regardless of medium, leads a sensitive observer into a persuasive world of the imagination. In the visual arts, shapes play an important part in achieving this goal.

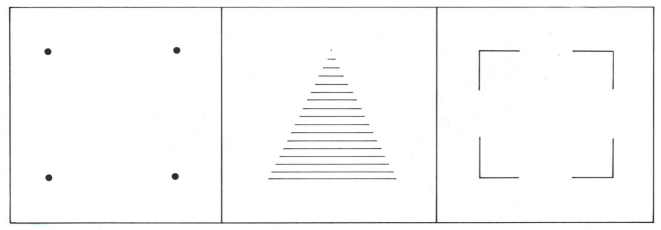

5.2 The psychological suggestion of shapes formed by dots and lines.

DEFINITION OF SHAPE

Throughout time human beings have striven to achieve order over their affairs, individual and collective. The visual arts, like all other forms of art, aspire to express human experiences. Therefore, it is not surprising that artists usually strive for order when using optical devices. When confronted with complex visual circumstances, as in nature, artists will search for the most stable, united, and simple artistic elements or forces. Psychological experiments in the '50s, consisting of placing people in tilting rooms, caused them to experience such disorientation that they rapidly became ill. Optical artists of the '60s, such as Victor Vasarely and Bridget Riley, experimented with paintings that in their psychical and physical impact were akin to such psychological experiments (*see* fig. 11.51).

When we apply human psychological responses to the visual arts, we tend to see that even the placement of simple dots or lines can be filled in by our minds to become shapes (fig. 5.2).

We might begin to define shape in art as a line enclosing an area. Such use of line is called *outline* or *contour*. Shapes can be further defined in graphic or pictorial forms of art, as any visually perceived area of value, texture, color, or line—or any combination of these elements. In such forms of art, shapes are flat, or two-dimensional images. In the three-dimensional or plastic forms of art (sculpture, architecture, environmental design), shapes are more often described as *volumetric* or *solid*. Three-dimensional artists quite often do their initial planning in terms of graphic imagery, however. This planning might be in the form of rapid sketches or more carefully drawn plans. Since so much artistic creativity and planning is done in this two-dimensional manner, artists must be conscious of the fact that the surface on which they work, the *picture plane,* is a shape. The picture plane conditions the use and characteristics of all shapes and other elements on it, as discussed at greater length in the chapter on form.

Shapes in pictorial art sometimes have exact limits, as in the case of a contour line in our first definition of shape, or they can be so vague or delicate that their edges cannot be determined with any degree of exactitude. Shapes in the plastic arts, however, are always tangible; their edges, or outer contours, are the determining factor, no matter their degree of irregularity or ambiguity.

Shapes can vary endlessly, ranging from different sizes of basic squares, rectangles, circles, and triangles to limitless combinations of angular and curving shapes of varying proportions. They can also be static and stable or active and lively. Shapes can seem to contract or expand, depending on how they are used by the artist.

Shapes are classified into different categories or families depending on whether they are imaginary (*abstract*) or visible (*objective*). The configuration of a shape gives it a character that distinguishes it from others of its kind. When the shapes used by an artist have been taken from those shaped by natural forces (stones, puddles, leaves, clouds) we term them *naturalistic, representational,* or *realistic* as well as *objective*. When they seem to have been contrived by the artist we call them *abstract, nonobjective,* or *nonrepresentational*. The distinction between objective and abstract shapes is not always easily made because the variations of both are so vast.

Natural forms generally seem to have been molded into rounded shapes. We see this in the elemental organisms encountered in biological studies (such as amoebas, viruses, and cells). Biological affinity for the curve led to the term *biomorphic* to describe the curvilinear shapes in art that suggest the possibility of life. These lifelike shape families are also often labeled *organic* or *free-forms* (plate 24).

5.3 Yves Tanguy. *Mama, Papa Is Wounded!* **1927; oil on canvas, 36¼ × 28¾ in.** Surrealists such as Yves Tanguy have given considerable symbolic significance to biomorphic shapes. Biomorphic shapes remind us of basic organic matter, or of flowing and changing shapes in dreams.
Museum of Modern Art, New York. Purchase.

With the great interest aroused by Pure-Abstract art, the increasing awareness of the microcosm through science, and the growth of Freudian psychology, the type of shape now known as *biomorphic* found great use in the hands of Surrealist artists. Their interests in the mystic origins of being and the exploration of sub-conscious revelations, as in dreams, attracted them strongly to the biomorphic shape (fig. 5.3). Other artists (Matisse and Braque are examples) abstracted organic forms in a less symbolic and primarily decorative manner (plate 25).

In contrast to the biomorphic shapes are *rectilinear* (straight-lined) shapes, called *geometric* because they are based on the standardized shapes used in that branch of mathematics. The precisionist, machinelike geometric shapes have a sense of human inventiveness about them that appealed to the Cubists, who utilized them in their pictorial dissection and reformulation of the natural world (fig. 5.4).

From these examples it can be understood that, however shapes are classified, each shape or a combination of shapes can elicit a variety of personalities derived from artistic usage and our responses to them.

5.4 Juan Gris. *Guitar and Flowers.* **1912; oil on canvas, 44⅛ × 27⅝ in.** In direct contrast to biomorphic shapes are rectilinear or straight-line shapes preferred by the Cubists. Shape families such as biomorphic and rectilinear are used by artists to unify, through repetition, their picture surface.
Museum of Modern Art, New York. Bequest of Anne Erikson Levene in memory of her husband, Dr. Phoebus Aaron Theodor Levene.

USE OF SHAPES

We have implied that shapes are used by artists for two fundamental purposes: to suggest a physical form they have seen or imagined, and to give certain visual qualities or expression to a work of art.

The physical utilization of shape in art entails some of the following:

1. to achieve order, harmony, and variety—all related to the principles of design taken up in the chapter on form;
2. to create the illusion of space, volume, and mass on the surface of the picture plane in pictorial art; and
3. to extend observer attention or interest span.

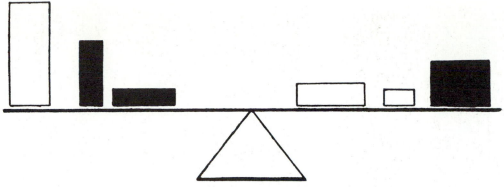

5.5 This diagram shows *amounts of force,* or weight, symbolized by shapes.

The latter usage requires further clarification. Where the arts of music, theater, and dance evolve in time, the visual arts are usually time fixed. This causes the time of an observer's psychological rapport (empathy) with most works of pictorial art to be extremely limited—in contrast to the spatial arts mentioned above—and thus, historically, a matter of much concern.

Shape and Principles of Design

If artists wish to create order or unity, increase attention span and the like, they have to conform to certain principles of order or design. In their observance of these principles, they are often forced to alter shapes from their normal appearance when working from nature. It is in this respect that shapes can be called the building blocks of art structure. Just as in the case of line, our first element of artistic form, shapes have multiple purposes in terms of visual manipulation and their psychological or emotional effect. These purposes, as suggested, vary with both the artist and the viewer.

The principles determining the ordering of shapes are common to the other elements of form. In their search for significant order and expression, artists modify the elements until:

1. the desired degree and type of balance is achieved;
2. the observer's attention is controlled, both in direction and duration;
3. the appropriate ratio of harmony and variety results; and
4. the space concept achieves consistency throughout.

These principles are important enough to merit additional investigation.

Balance As artists seek compositional balance, they work with the knowledge that shapes have different visual weights depending on how they are used. By examining the seesaw in figure 5.5, we see that the placement of shapes of different sizes at varying distances from the fulcrum can be controlled to create a sense of balance or imbalance. As there is no actual weight involved, we assume that the sensation is intuitive, or felt, as the result of the various properties composing the art elements. For example, a dark value adds weight to a shape, and substitution of a narrow line for a wider line around a shape reduces the shape's apparent weight.

The seesaw is an elementary example of a few basic elements operating along only one plane of action. Developed artworks, on the other hand, contain many diverse elements working in many directions. The factors that control the amounts of directional and tensional force generated by the various elements are: placement, size, accents or emphasis, and general shape character (including associational equivalents to be discussed under "Duration or Relative Dominance" in this chapter). The elements are manipulated by the artist until the energy of their relationships results in dynamic tension.

Control of Attention

Direction Artists can use the elements of form to generate visual forces that will control the movement of our eyes as we view their work. Pathways are devised to provide transition from one pictorial area to another. The artist will usually try to make our eye movements over these pathways rhythmic, thereby providing both pleasurable viewing and a strong unifying factor for the work. The character of rhythmic viewing depends upon the nature of the artist's expressive intentions; jerky, sinuous, swift, or slow (figs. 5.6 and 5.7).

Duration or Relative Dominance The unifying and rhythmic effects provided by eye paths are also modified by the number and length of the pauses in the eye journey. A viewing experience is relatively more monotonous if the planned pauses are of equal duration (plate 26). The artist, therefore, attempts to organize pauses so that their lengths are related to the importance of the sights to be seen on the eye journey. The

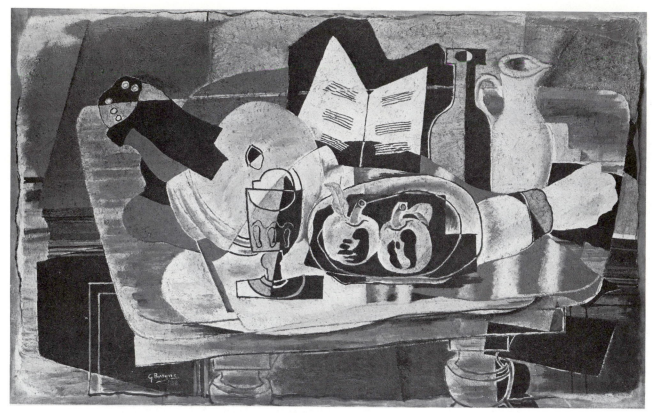

5.6 Georges Braque. *Still Life: The Table.* 1928; oil on canvas, 32 × 51½ in.
National Gallery of Art, Washington, D.C. Chester Dale Collection.

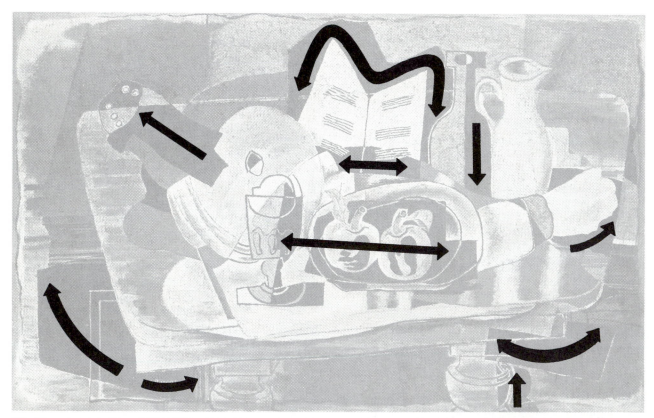

5.7 The painting in figure 5.6 by the French Cubist Georges Braque has many elements that contain direction of force. The simplified grouping of darks in figure 5.7 illustrates the controlled tension resulting from the placement, size, accent, and general character of the shapes used by the artist. The black arrows show the predetermined eye paths by which the artist created visual transition and rhythmic movement.

5.8 Paul Gauguin. *The Yellow Christ.* 1889; oil on canvas, 36¼ × 28⅞ in. Gauguin has made the figure of Christ paramount through size, location, shape, and color differences. Albright-Knox Art Gallery, Buffalo, New York. Consolidated. Purchase Funds, 1946.

5.9 Herve Huitric and Monique Nahas. *Carouline.* 1982; computer: print, 20 × 24 in. The principle of *duration* and *relative dominance* is enhanced in this print from computer-generated art by the relative centering of the principal shapes and their strong value contrast with the background. Courtesy of the artists.

duration of a pause is determined by the pictorial importance of the area. A number of factors can be used to control duration. In a work of the Crucifixion we would expect an artist to make the figure of Christ dominant (fig. 5.8). Artists can control dominance through contrast, size, value, shape, location, color, or combinations of any of these. Modification of the physical properties of any of the elements invariably affects spectator attention. Artists develop the importance scale of the work on the basis of their feelings and reconcile the various demands of the design principles and relative dominance. The degree of dominance is usually in direct proportion to the amount of visual contrast. The function of relative dominance acts in both representational and nonrepresentational work, and in the same way (fig. 5.9). The factor (size, for example) making Christ dominant would also work to make a large square dominate others of its kind. There is, however, another factor—association, or similarity—that tends to qualify the attention given shapes or other elements. The oval tree shapes in the Gauguin *Yellow Christ,* for instance, afford a contrast to Christ's Y-shape that is more dominant than size. In an abstract work of art, an oval shape may well receive more attention if by some chance it reminds us of a head.

Although artists may try to avoid such chance interpretations, they cannot always be foreseen. At other times artists can use the innate appeal of associational factors to advantage, weighing them in the balance of relative dominance and forcing them to operate for the benefit of the total organization.

Shapes and Space

Pictorial Depth: The Plane The simplest and probably most useful shape in pictorial forms of art is the *plane.* The surface on which artists work is called the *picture plane,* as you have seen. In addition to being a working surface, it is often used as a device to simplify the vast number of points, masses, or shapes in nature. Planes are used to create more economical, stable, and readily ordered units. Beyond this, planes are extremely useful in creating the illusion of pictorial depth and plastic form on the two-dimensional picture plane.

Planes vary from depiction as flat, two-dimensional shapes (*decorative shapes*) to those that seem to occupy space (*volumes*). Artists use all kinds of shapes to achieve either decorative or plastic effects of shape and space. Rectilinear shapes might look to be flat when lying on the surface of the picture plane, but even a simple overlapping of two or more can give them a sense of depth. The addition of size, color, value, and texture contrasts can effect an impression of depth even more definitively (fig. 5.10).

Curvilinear planes, those planular shapes made up of ovals, circles, or biomorphic qualities, can also create shallow effects of space, or through their curving nature suggest movements into depth. When either rectilinear or curvilinear planes are given a *foreshortened* or *perspective* appearance by tilting them into

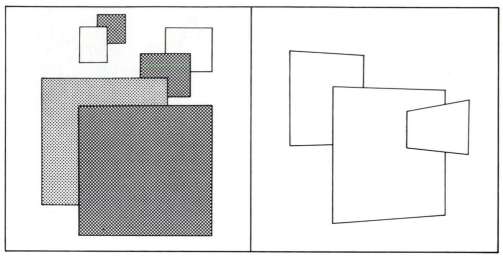

5.10 Diagrams illustrating some ways rectilinear planes suggest the illusion of space.

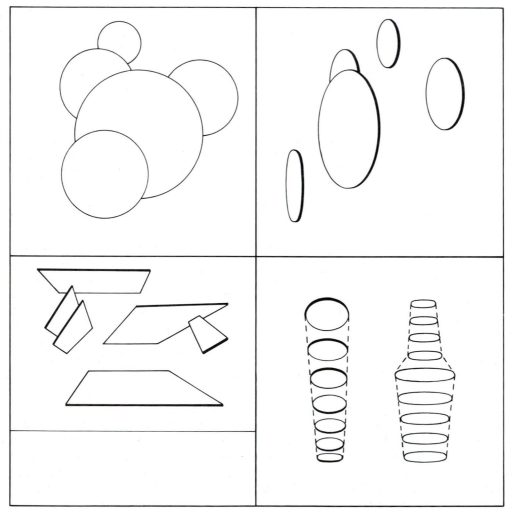

5.11 Circular planes become elliptical when drawn to give an illusion of floating in space. Rectilinear and curvilinear planes can be given any angle necessary to attain a desired spatial effect. Variations of value, size, texture, and color can enhance or diminish the spatial illusion. In line drawings of such planes, accenting the near edge of the planes will aid the illusion.

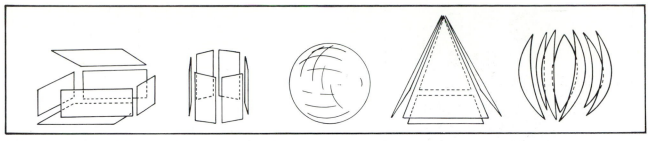

5.12 Three-dimensional shapes or volumes suggested by planes.

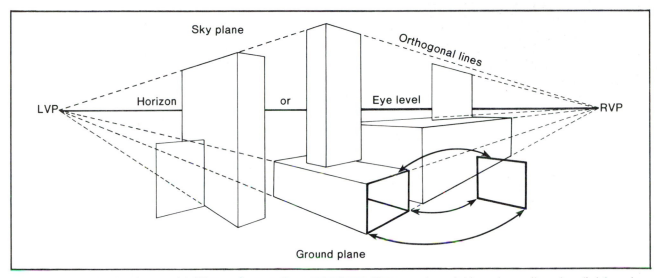

5.13 A drawing showing the essential difference between planes and volumes. Planes are shapes having only two dimensions (height and width), whereas volumes, which are made up of planes, have the effect of solidity or three dimensions (height, width, and depth). The component planes (sides) of volumes may be detached and inclined back in space at any angle as indicated by the arrows in the drawing.

The drawing is also an example of two-point perspective. Object edges are shown as solid lines; orthogonals (vanishing lines) as broken. Vanishing points (LVP & RVP) show where object edges converge at the eye level or horizon line representing infinity. The eye level divides the picture space into planes representing the ground and sky.

depth and making the near end look larger than the distant one, we have a much stronger visual statement of depth on the picture plane than the decorative use of planes will give us (see diagrams, fig. 5.11).

Every work of pictorial art contains actual or implied shapes and, with them, some degree of spatial illusion. Artists throughout history have reflected the controlling concepts of their time in their use of pictorial space. According to these concepts, spatial phenomena became decoratively flat, shallow, or illusionistically infinite (plates, 27, 28; see plates 25 and 26). The last hundred years has witnessed the transition from deep space to shallow space favored by many contemporary artists. Some artists feel that shallow space permits greater organizational control of the art elements and is more in keeping with the essential flatness of the working surface in pictorial forms of art (see plates 25, 26, and 28). However, all spatial concepts are amply in evidence today, indicating the diversity of our contemporary art scene. Space concepts are used arbitrarily and even in combination when necessary to achieve the desired results.

Planes and Volumes When two or more planes are arranged in relation to one another so as to give the appearance of the thickness that converts them into volumes, as suggested in the diagrams, there is an automatic implication of space (fig. 5.12). The planes that constitute the sides of these volumes could be detached from the parent mass and tilted back into space at any angle and to any depth (fig. 5.13). In fact, such planes do not even have to give the appearance of being closed or joined at the corners of a volume in order to afford an appearance of solidity (see fig. 5.12).

The effect of solidity created through the juxtaposition of planes makes the plane less substantial than the volume, but more flexible in the pictorial exploration of space. However, regardless of spatial suggestion, both volumes and planes are shapes whose roles in the two-dimensional arrangement of pictorial works of art must be considered.

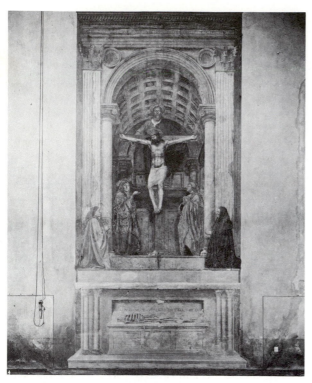

5.14 Masaccio. *Trinity with the Virgin, St. John and Donors.* **1427; fresco.** Santa Maria Novella, Florence, Italy.
Alinari/Art Resource, New York.

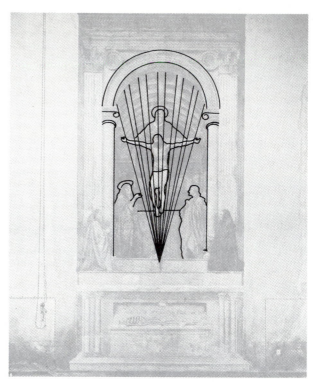

5.15 According to some art history experts, Masaccio's fresco is the first painting created in correct geometric perspective. The single vanishing point lies approximately below the feet of Christ as indicated by the overlay in this figure.

Geometric Perspective (often called Linear Perspective) *Geometric perspective* is the graphic artist's principal system of creating the illusion of three-dimensional volumes existing in space. It was the invention of three artists working together in fifteenth-century Italy, or the Early Renaissance: Masaccio, a painter; Donatello, a sculptor; and Brunelleschi, a painter turned architect (figs. 5.14 and 5.15).

Employing their knowledge of geometry (then one of the most important parts in the classical education of every student), they were able to conceive a method to create an illusion of nature more realistic than any other that had appeared in Western art for more than a thousand years. In their concept, the perspective drawing of shapes likens the picture plane to that of looking out a window into space. Either the artist or observer can be assumed to be placed in front of the window/picture plane looking out. The framing or matting of drawings and paintings descends from this idea; the frame or mat assumes the aspect of the window frame. Imaginary sight lines (*orthogonals*) are extended from the artist's or viewer's position through the edges of the planes constituting the volumes (mostly rectilinear ones) that appear in natural and human-invented forms (rows of trees, streets, buildings) receding in space. These sight lines are angled from the outer extent of the vertical axis of the artist's eyes downward

and upward toward a fixed point or points on the horizontal axis of the eyes. Since a theorem in geometry states that parallel lines vanish at infinity, the horizontal axis of the eyes corresponds to the *eye level* at which the artist is drawing the perceived view of nature, or to the *horizon* that the artist actually sees or imagines in nature. The point(s) on the horizon or eye level line drawn on the picture plane are thus termed the *vanishing points*. They are usually abbreviated to *VP* for convenience in drawings utilizing geometric perspective. The horizon on the picture plane demarcates upper and lower divisions called the *ground plane* and *sky plane* (see fig. 5.13).

Major Systems of Perspective There are three major systems of geometric perspective: *one-point, two-point* and *three-point* (fig. 5.16, plate 29; *see* figs. 5.13 and 5.14). One-point perspective is used when the artist wants the objects drawn to appear as if one face is parallel with the picture plane. In this system, the vanishing point is placed on the horizon line (eye level) a little to the right or left of center, so as not to divide the picture too evenly (monotonously). Hallways or any long views of the interior of buildings lend themselves well to one-point perspective drawings (*see* fig. 5.14). Two-point perspective is most often employed when the exteriors of buildings or of any other object, human-made

5.16 This diagram shows the use of three-point perspective. By extending the dashed orthogonals, it will be found that the vanishing points are approximately at the edges of the page.

Disadvantages of Geometric Perspective Geometric perspective has been a traditional drawing device used by artists for some centuries. During that time the system has evolved and undergone modifications in attempts to make it more flexible or more realistic in depicting natural appearances. Geometric perspective has been most popular during periods of scientific inquiry and reached its culmination in the mid-nineteenth century. Despite the seeming virtue of agreement with natural appearances, the method has certain disadvantages that in the opinion of some artists outweigh its usefulness. Briefly, the liabilities of geometric perspective are as follows:

1. It is never an honest statement of actual shape or volume as they are *known* to be.
2. The only appearances that can be legitimately portrayed are those that can be seen by the artist-observer from one position in space.
3. The necessary recession of parallel lines toward common points often leads to monotonous visual effects.
4. The extreme reduction of scale within a single object that results from the convergence of line is another type of perspective distortion (fig. 5.17).

These disadvantages are mentioned only to suggest that familiar modes of vision are not necessarily those that function best in a work of art.

Intuitive Space

Although planes and volumes are easily recognized as playing a strong part in creating illusions of space through their use in geometric perspective, they can also be used to produce intuitive space, which is independent of strict rules and formulas. Intuitive space is thus not a system, but a product resulting from the artist's instinct in manipulating certain space-producing devices. The devices that aid the artist in controlling space include overlap, transparency, interpenetration, inclined planes, disproportionate scale, and fractional representation. In addition, the artist may exploit the *inherent* spatial properties of the art elements. The physical properties of the art elements tend to thrust forward or backward the items they help to define. By marshaling these spatial forces in any combination, as needed, the artist can sense or feel the space into the pictorial image while adjusting relationships. The space derived from this method is readily sensed by everyone, although judged by the standards of the more familiar linear perspective, it may seem strange, even distorted. Nevertheless, intuitive space has been the dominant view of space during most of the history of art; it rarely implies great depth, but makes for tightly knit imagery within a relatively shallow spatial field (fig. 5.18).

or natural, appear to be at an angle to the lines of sight, or when the artist wishes them to appear at angular positions in depth on the picture plane (*see* fig. 5.13). Three-point perspective, consisting of a third point above eye level, is used when one wishes to draw the appearance of a tall form that recedes upward in space (like a skyscraper). It is also used to give a view down along a form that appears to become smaller as it recedes far below the eye level of the artist or observer. A third point is also often used when there is an angular plane within a two-point perspective drawing, such as on a gable or truss-roofed house (fig. 5.16).

Eye level or horizon VP

a b

5.17 Disadvantages of perspective diagram. The extreme reduction of scale within a single object resulting from the converging of edges (such as in walls, floors, or table tops) causes another type of distortion that reduces the design areas available to the artist. For example, this diagram indicates that a rectangular table top depicted in perspective becomes a trapezoid and leaves spatial vacuums at *a* and *b*.

5.18 Lyonel Feininger. *Street near the Palace.* **1915; oil on canvas, 39½ × 31½ in.** In this painting the artist has used intuitive (or suggested) methods of space control including overlapping planes, transparencies, and planes that interpenetrate one another and incline into space.
The Norton Simon Foundation, Los Angeles, California.

SHAPE: MEANING OR EXPRESSION

Whereas the physical effects created by artists are relatively easily defined, the qualities of expression, or character provided by shapes in a work of art, are so varied (due to individual responses) that only a few of the possibilities can be suggested. In some cases, our responses to shapes are quite commonplace; in others, our reactions are much more complex since we share our own personality traits with them: shyness, agressiveness, awkwardness, poise and so forth. These are just some indications of the kinds of characteristics or meanings we can find in shapes. Artists, naturally, make use of such shape qualities in developing their works of art.

It is hardly conceivable that an architect would use shapes to suggest natural forms in buildings. It has been done, but is very rare throughout art history. On the other hand, sculptors and pictorial artists almost always seem to want to use natural forms in their respective media. Yet the evidence indicates that they are not always interested in using shapes to represent such known objects. Artists more often tend to *present* what they *conceive* or *imagine* to be real rather than *represent* what they *perceive,* or see with objective vision, to be real. This has been particularly evident in the twentieth century, with whole movements in the arts based on this *nonrepresentational* use of shapes—from the *Abstract Movement* of the early 1900s to the *Conceptual Movement* of the '70s and '80s.

Thus, to conceive, imagine, and conceptualize have always been parts of artistic expression. It is usually a matter of degree as to how much artists use their imagination, and how much their perceptual vision; in trying to say something through their use of subject and form, artists find that their point of view cannot be made without some editing of the elements (or "grammar" of form/expression). So while the work of those artists who are more devoted to a degree of actual appearances might look to be quite natural, comparison with the original subject in nature may still show considerable disparities (figs. 5.19 and 5.20). Artists therefore go beyond literal copying and transform object shapes into their personal style or language of form (figs. 5.21, 5.22, 5.23, plates 30, 31; *see* plate 24).

5.19 Morris Broderson. *Picador with Horse.* **1967; mixed media, 33 × 26 in.**
Courtesy the Ankrum Gallery, Los Angeles. From the collection of Bernie Casey.

5.20 Conrad Marca-Relli. *The Picador.* **1956; oil on canvas.** Artists differ in their responses to subject matter. It is often a matter of degree as to how much artists use their imagination and how much their perceptual vision. Such differences of response, and concepts resulting, are apparent in the contrast between the similar subjects in these two artworks. Different attitudes toward the subject resulted in the different shape selections.
Hirshhorn Museum and Sculpture Garden, Smithsonian Institution.

5.21 Ernest Trova. *Three Men in a Circle.* **1968; oil on canvas, 68 × 68 in.** The circular elements generate subconscious and generally indefinable reactions that are in contrast to a rectilinear style.
Courtesy the Owens-Corning Collection. Owen-Corning Fiberglas Corporation, Toledo, Ohio.

5.22 Charles Burchfield. *The East Wind.* **1918; watercolor.** The shapes used by Burchfield in this painting are partly psychological and partly symbolic. These shapes suggest the qualities of an approaching spirit-ridden storm.
Albright-Knox Art Gallery, Buffalo, New York. Bequest of A. Conger Goodyear.

5.23 Jack Brusca. *Untitled.* **1969; acrylic on canvas, 30 × 30 in.** The precise, hard-edge geometric shapes are a heritage from the Cubists.
Courtesy the Owens-Corning Collection. Owens-Corning Fiberglas Corporation, Toledo, Ohio.

Just as the configuration of a shape gives it the character that distinguishes it from other shapes, so configuration also changes a shape's expressive meaning. The abstract artists of the present century seem to have been influenced by the "streamlining" of machinery, for example, to create pristine, clear-cut shape relationships. Our reactions to these, or the meaning we find in them, vary with our own psychological conditioning. Many people react adversely to simple shapes like those in Albers or Brusca paintings (*see* plate 30 and fig. 5.22). While both artists use similar shapes, there are detectable visual differences that change the shapes' meaning. Even the extremities of the shapes become important, hence our terms *soft edge* and *hard edge*. The colors as well as application of media, their texture, and darkness or lightness (value) can all affect whatever feeling or lack of it we may intuit in such works of art. Endless examples of the use of shapes, both in terms of natural and objective or nonobjective and abstract, indicate how varied expression can be; it is clearly self-evident. The student only has to glance around a class in which all members are working on a similar exercise to see the variety of personal manners in which one's colleagues work. How much more can be expected, in terms of endless expressive potential, when viewing the work of trained artists?

All these principles involved in ordering shapes will be of little value until the student is cognizant of some of the possibilities of meaning revealed though relationships made possible by the language of art. Much of this awareness, of course, comes through practice, as in learning any language.

Artists usually select their shapes to express something, but they may initially be motivated by the psychological suggestions of shape (*see* plate 24). Shapes contain certain meanings within themselves, some readily recognizable, others more complex and less

clear. Some common meanings ascribable to squares, for instance, are: perfection, stability, stolidity, symmetry, self-reliance, and monotony. Although squares may have different meanings for different people, many *common* sensations are shared when viewing this shape (*see* plate 30). Similarly, circles, ovals, rectangles, and a vast array of other shapes possess distinctive meanings; their meaningfulness depends on their complexity, their application, and the sensitivity of those who observe them (plate 32). How different is our reaction to the biomorphic shapes favored by the *Surrealists* to those of the *Hard-edge Geometric Abstractionists,* like Noland, for instance (plate 33). That we are sensitive to shape meaning is witnessed in psychologists' use of the familiar ink blot test that is designed to aid in the evaluation of emotional stability. The mere existence of these tests points out that shapes can provoke emotional responses on different levels. Thus the artist might use either abstract or representational shapes to create desired responses (plate 29). By using the knowledge that some shapes are inevitably associated with certain objects and situations, the artist can set the stage for a pictorial or sculptural drama.

SHAPE PROBLEMS

Problem 1

Shapes can be used to portray natural objects in many different ways. Shapes frequently undergo transformation or simplification (abstraction) to strengthen the pictorial design.

> Make a pencil drawing from a photograph and simplify the subject matter by leaving out some of the little details. In a second drawing flatten the object shapes and simplify their contours so that they are almost abstract in nature. You may sacrifice objective identity to unify the pictorial organization (figs. 5.24 and 5.25).

Problem 2

Every artist starts with one large shape, the picture plane. Two-dimensional shapes that lie on the surface of the picture plane are called decorative. Overlapping shapes divide the space but also create a feeling of depth. Such shapes are called planes and may create movements back and forth in space.

> Divide a rectangular picture plane with overlapping planes to create movement that goes backward into space but not so deep that unity with the picture plane is destroyed. Create variations by changing the size of the planes and placing them into different spatial relationships to the original picture plane.

5.24 Shape Problem 1.

5.25 Shape Problem 1.

5.26 Shape Problem 2.

5.27 Shape Problem 4.

5.28 Shape Problem 5.

Have enough similarity in the plane shapes so that they are considered to belong to the same shape families. You could also try overlapping transparent planes so that new shapes are created (fig. 5.26).

Problem 3

In seeking compositional balance, we must recognize that shapes represent moments of force. The moments or attractions among shapes must counterbalance one another.

Balance and counterbalance several geometric shapes within the boundaries of a picture frame. Consider these shapes as forces that should support one another in controlled tension. Add value and color to the shapes to create interest. Remember that changes of color, value, and texture can affect weight as well as size and variety of shapes.

Problem 4

Shapes with contrasting value are much more dominant in a pattern than those defined with a linear border only. Such value shapes, if large, tend to unify several smaller linear shapes.

Make an outline drawing from a section of complex subject matter, such as a piece of machinery. Using any shading medium, create several large tone shapes by combining a number of the smaller outlined forms. The lines of the smaller shapes should be light against the dark background or dark against the light background. Positive shapes may be dark against a light background, or this value relationship may be reversed in some parts of the composition. The general purpose is to simplify the basic light-and-dark pattern without losing any of the natural detail (fig. 5.27).

Problem 5

Shape families are areas with common qualities (fig. 5.28).

Create three shape families using:

a. Rectangular shapes
b. Triangular shapes
c. Biomorphic shapes

Plate 24 Matta. *Le Vertige d'Eros.* 1944; oil on canvas, 77 × 99 in. Within the limits of the human mind's ability to conceive such things, Matta has given us a vision of a completely alien milieu. Though as far as imaginable from everyday reality, this environment seems a possible reality, thanks to the facility of the artist.
The Museum of Modern Art, New York. Given anonymously.

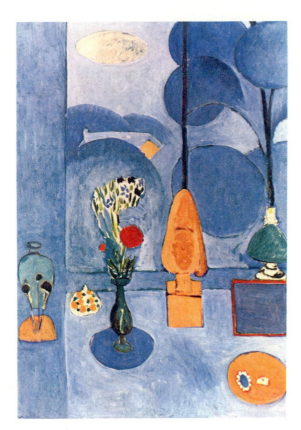

**Plate 25 Henri Matisse. *The Blue Window.* autumn, 1911; oil
on canvas, 51½ × 35⅝ in.** Matisse has abstracted organic forms
for the purpose of decorative organization.
Museum of Modern Art, New York. Abby Aldrich Rockefeller Fund.

Plate 26 Sassetta and assistant. *The Meeting of Saint Anthony and Saint Paul.* circa 1440; wood, 18¾ × 13⅝ in. In this painting by the Renaissance artist Sassetta, "station stops" of varied duration are indicated by contrasts of value. In addition, "eye paths" are provided by the edges of the natural forms that lead from figure to figure. This painting is also a shallow space concept deriving from the Middle Ages.

National Gallery of Art, Washington, D.C. Samuel H. Kress Collection.

Plate 27 Giorgione. *The Adoration of the Shepherds.* circa 1505–1510; wood, 35¾ × 43½ in. Giorgione reflects the period of the early sixteenth century when the concept of space was primarily concerned with the illusion of distance.
The National Gallery of Art, Washington, D.C. Samuel H. Kress Collection.

Plate 28 John Marin. *Phippsburg, Maine.* 1932; watercolor. Marin is an example of a present-day artist who prefers to emphasize the essential flatness of his painting surface. He does this by limiting his space.
Metropolitan Museum of Art, New York. Alfred Stieglitz Collection, 1949.

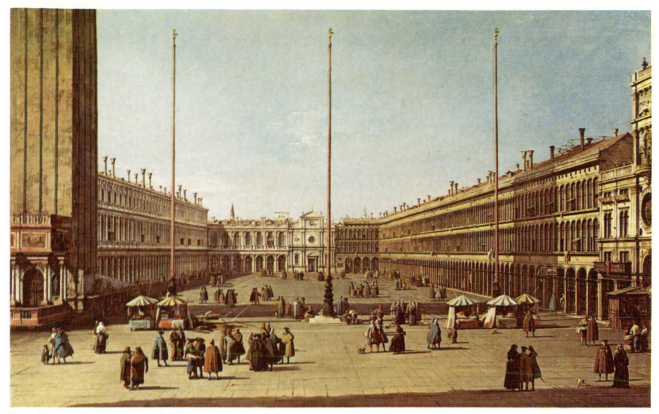

Plate 29 Antonio Canaletto. *The Piazza of St. Mark's, Venice.* circa 1735–1745; oil on canvas, 29¾ × 46¾ in. The appearance of planes and volumes in space determined by the systematic procedures of geometric perspective is well illustrated in this painting by an eighteenth-century Venetian artist.
The Detroit Institute of Arts. Purchase. Founders' Society Purchase, General Membership Fund with a donation from Edsel B. Ford.

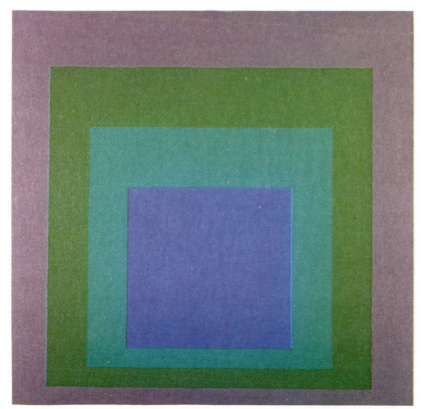

Plate 30 Joseph Albers. *Homage to the Square: Star Blue.* 1957; oil on board, 29⅞ × 29⅞ in. The shape meaning of a square lies not in likeness or association, but in the relationships developed by the artist.
Contemporary Collection of the Cleveland Museum of Art.

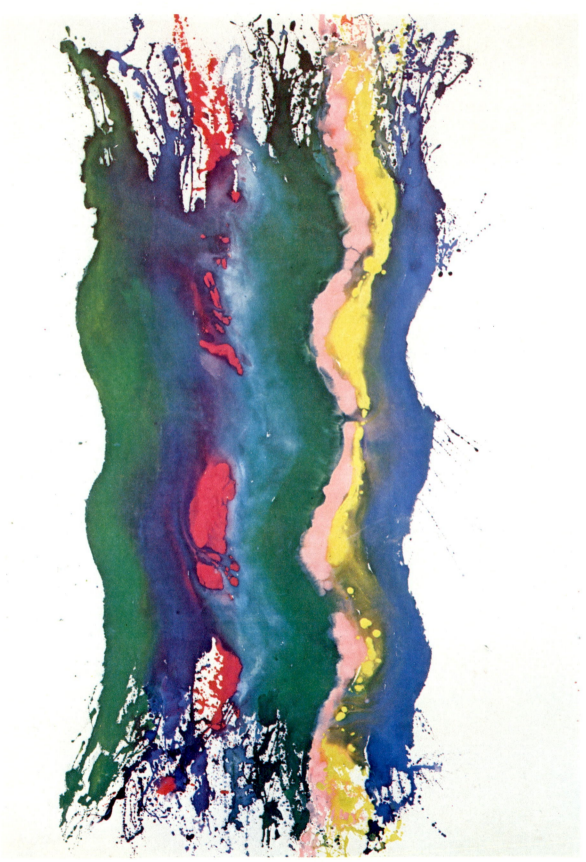

Plate 31 Pat Sutton. *Yaqui.* **1969; acrylic.** Many shapes are not meant to represent or even symbolize; instead, they are intended to provoke form-meanings of a very general (and sometimes indescribable) kind. Hirshhorn Museum and Sculpture Garden, Smithsonian Institution.

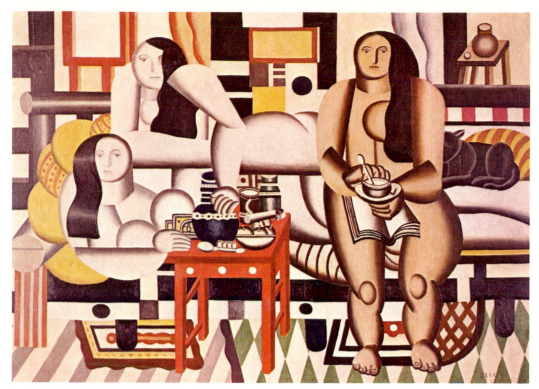

**Plate 32 Fernand Léger. *Three Women (Le Grande Dejeuner).* 1921; oil on canvas, 72¼ × 99 in. The Cubist painter Léger commonly used varied combinations of geometric shapes in very complex patterns. Here, due to his sensitive design, he not only overcomes a hard-edged shape effect, but retains a feminine meaning or expression.
Museum of Modern Art, New York. Mrs. Simon Guggenheim Fund.**

**Plate 33 Kenneth Noland. *Wild Indigo.* 1967; acrylic on canvas, 89 × 207 in. Noland's hard-edge, nonobjective painting is descended from Cubist works like Leger's. Without the benefit of any representation, the meanings we intuit in such a work are less obvious and emotional. Compared to a biomorphic work (see plate 24, Matta) with its soft edges and emotional implications, it appears we have to seek meaning in Noland by a more cerebral approach.
Albright-Knox Art Gallery, Buffalo, New York. Charles Clifton Fund, 1972.**

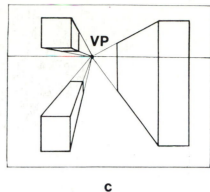

a b c

5.29 Shape Problem 7a.

Problem 6

The space concept used with shapes may be shallow, deep, or infinite. Circles, squares, and triangles are basic two-dimensional shapes; spheres, cubes, pyramids, cones, and cylinders are basic three-dimensional shapes.

a. Arrange several circles, squares, and triangles in a shallow space.

b. Transform this into deep space by substituting solid shapes, such as cubes, pyramids, etc., in a second arrangement.

Problem 7

Geometric perspective is a mechanical system for creating the illusion of three-dimensional space on a two-dimensional surface.

Shape exists primarily in terms of the illusions it creates. The artist's role is to use the illusionistic property of this element to lend credence to the fantasy inherent in art.

The creation of three-dimensional shapes (volumes or masses) automatically implies the depth of space within which these shapes must exist.

Geometric perspective of volumes is based on the artist's location in reference to the objects drawn, and is accomplished by directing parallel lines toward a common vanishing point on the eye level, or horizon, related to that location.

a. One-point perspective of parallel objects

In *one-point perspective* draw six geometric solids, whose sides in actuality would be parallel, so as to give the illusion that they project into depth from the picture plane. (Use figure 5.29 [a, b, and c] and the explanation that follows to help you.) Place two objects above eye level, three below eye level, and one resting on the ground plane but projecting above eye level (fig. 5.29c).

Always use only the *one* vanishing point (VP) for all three-dimensional volumes in the same picture. One plane—the front plane or the nearest plane of each solid—is always *parallel to the picture plane* in a one-point system (fig. 5.29c). Only one side plane, or the top plane and a side plane, or the bottom plane and a side plane (if visible) recede in depth in a one-point system.

Note that to create the illusion that the side planes recede in depth in figure 5.29c, the top and bottom edges of these planes are drawn as *diagonal* lines that come together at a vanishing point. The vertical lines representing the farthest corners from the observer's position (rear corners of the side planes) are drawn at logical but arbitrary distances from the front plane. Corners always remain vertical in both a *one-point* and *two-point* system.

To draw objects seen above and below eye level, draw rectangles or squares above and below eye level, keeping them well to the right or left of the vanishing point. Draw lines from the vanishing point to each of the corners that can be reached without passing through the shapes. Complete the object by drawing in the horizontal and vertical sides between the guidelines. You may want to draw in the hidden edges as dotted or dashed lines.

b. Two-point perspective of parallel objects

A *two-point system* seems a bit less fantastic, hence more realistic, than a one-point system since in looking at large volumes, such as buildings, *both front* and *side* planes *seem to recede* in depth. Both methods of perspective are based on a "one-eyed" principle, although the two-point system comes slightly closer to humans' actual binocular vision.

Arrange a series of three-dimensional volumes with parallel edges on your picture plane to create the illusion that they are at different distances in depth. (Use figure 5.30 [a and b] and the explanation that follows to help you.) Overlap some of the

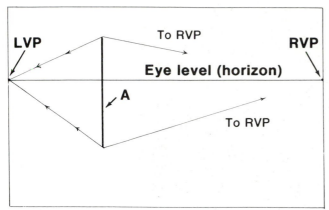

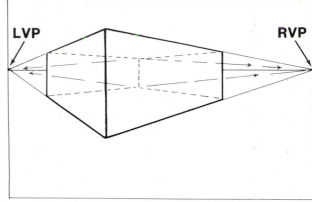

a

b

5.30 Shape Problem 7b.

volumes in space (that is, put some in front of others); make some taller than others. Try not to leave any obvious "holes" in the lower corners or center of the picture plane.

In a two-point system all volumes drawn in any one picture plane utilize only the left vanishing point (LVP) and the right vanishing point (RVP).

To reduce distortion, which results from small perspective drawings such as these, place the two vanishing points at the edge of the paper but *on* the horizon line.

To draw a two-point perspective of volumes, start with a *vertical* line representing the corner of the volume nearest you (fig. 5.30a, line A). In the two-point system *all visible planes* appear to recede in depth or diminish in size as they go into depth because all lines (except those representing the vertical corners) are drawn as diagonals meeting either at the left or right vanishing points.

The vertical lines representing the far corners of each side plane are drawn between each set of two diagonal lines going to the left and right vanishing points from the top and bottom of the front corner line. These vertical lines are drawn at logical but arbitrary distances from the front corner line.

In perspective drawings of *nonparallel objects*, a new vanishing point must be established on the horizon or eye level for *each* object drawn in one-point perspective, and two pairs, or sets, of vanishing points must be established for every object drawn in a two-point system.

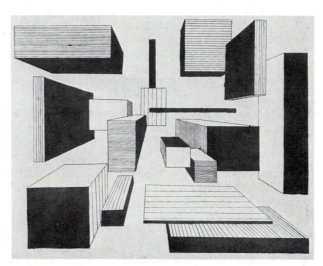

5.31 Shape Problem 8.

Problem 8

The principles of linear perspective can be used to create spatial effects with shape volumes.

Starting with simple geometric solids whose sides are parallel (cubes, rectangular solids), organize the spatial characteristics of a picture field through the perspective of these volumes. Place some solids above and below the horizon, and position some of the solids so that their base is on the ground plane and their top is above the horizon.

Try to do the same problem using more complex volumes based on cylinders, cones, and spheres (fig. 5.31).

5.32 Shape Problem 11.

Problem 9

All shapes do not have a definite border but might subtly blend into one another; likewise, some shapes might be defined by a border line only, without a change of value and color.

Using chalk, divide or break up a rectangular space with patches of color. Rub or blend some of these color shapes together so that they lose their distinct edges. Now use some lines to redefine or reaccent areas and superimpose some new linear pattern shapes.

Problem 10

Like line, shape can suggest emotional or expressive qualities.

a. Work with either free shapes, geometric shapes, or combinations of shape families to create abstract expressions for such titles as Tempest, Rowers, Strikers, Ballet Dancers, Circus Clowns, etc.

b. Try the same thing using invented words, such as Balooma, Irskt, Sleema, Rz-z-z-z-z, Sloovonious, etc.

c. Try to express your reactions to certain situations, such as loneliness, mystery, excitement, triumph, despair, conflict, etc.

Problem 11

For pictorial unity, we should use shapes that will echo or repeat the basic character of the picture frame (frame shape).

Select a real object with fairly complex and interesting outline shapes, and normal or average proportions. Draw and distort the object to fill and repeat the lines of:

a. An exaggerated or stretched-out horizontal frame shape (fig. 5.32).

b. An elongated vertical frame shape (fig. 5.33).

5.33 Shape Problem 11.

6

VALUE

THE VOCABULARY OF VALUE

cast shadow The dark area created on a surface when a form is placed so as to prevent light from falling on that surface.

chiaroscuro A technique of representation that emphasizes the blending of light and shade to create the illusion of objects in space or atmosphere.

decorative value A term given to a two-dimensional dark and light pattern. Decorative value usually refers to areas of dark or light definitely confined within boundaries, rather than the gradual blending of tones.

highlight The area of an actual object, represented in art, that receives the greatest amount of direct light.

local value The natural or characteristic value of a surface that is determined by a shape's normal color independent of any effect created by the degree of light falling on it.

shadow, shade, shading The darker value on the surface of a form that gives the illusion that that portion is turned away from the source of light.

tenebrism A style of painting that exaggerates or emphasizes the effects of chiaroscuro. Larger amounts of dark value are placed close to smaller areas of highly contrasting lights in order to concentrate attention on certain important features.

three-dimensional value pattern The illusion of objects existing in depth created by value relationships.

two-dimensional value pattern Value relationships in which the changes of light and dark seem to occur only on the surface of the picture plane.

value The relative degree of lightness or darkness.

value pattern The total effect of the relationships of light and dark within the pictorial field.

INTRODUCTION TO VALUE RELATIONSHIPS

The best definition of value for the purpose of this book is found in the dictionary, which states, essentially, that value in pictorial art is the relationship of one part or detail to another with respect to lightness or darkness. Artistic vision is concerned with both *chromatic* (reds, greens, yellows, and other hues) and *achromatic* (white, black and the limitless series of grays between white and black) experiences. Value is an integral part of both these experiences. Value is also called *tone, brightness, shade,* or even *color,* but these terms have only limited convenience and accuracy when considered in an art context.

6.1 Jacques Villon. *Portrait of a Young Woman* (detail). **1913; print: drypoint, 21⁹/₁₆ × 16¼ in.** In this print we have an example of the use of lines in general value areas to simulate the effect of volumes.
The Museum of Modern Art, New York. Gift in memory of Peter H. Deitsch.

6.2 Henry Moore. *Sheep #43.* **1972; blue black ballpoint and felt pen, 8 × 9¾ in.** The contemporary artist often uses invented textures that depend on the use of value, but not for purposes of description. Therefore, while Moore's abstract linear textures depart from the actual visual effect of wool, their source is still apparent.
Mary Moore, England.

6.3 Antonio Canaletto. *Imaginary View of Venice.* **1741; print: etching, 11¾ × 17¹/₁₆ in.** A casual glance might make one think that this is a black-and-white wash (possibly augmented by pen and ink) or a carefully rendered pencil drawing. In fact it is an intaglio print, one produced by an etched plate. Like the other media mentioned, the print gives evidence that art need not have color to be satisfying.
Toledo Museum of Art. Gift of Edward Drummond Libbey.

Anyone who studies art must consider the relationship of *value* to the other elements of art form: *line, color, texture,* and *shape.* All of these elements must exhibit some value contrast in order to remain visible.

The particular value of a line could be the result of the medium or the pressure exerted on the medium by the artist. For example, the degree of value of a pencil line would be determined by the hardness of the graphite or the force with which it is used. Value can be created by a merger of lines of the same or different qualities placed alongside or across each other to produce generalized areas of value (fig. 6.1). Shapes are also created and distinguished by the use of value. In reproducing textures, the shadows and highlights peculiar to the particular surfaces are copied. The values in abstract textures depart in some degree from the values of the objects being represented (fig. 6.2).

The intoxicating effects of a color often blind people to the fact that color's very existence is entirely dependent upon the presence of value. A standard yellow, for example, is of far greater lightness than a standard violet, although both colors may be modified to the point at which they become virtually equal. A common weakness in painting is the unfortunate disregard for the pattern created by the *value relationships* of the color; black-and-white photographs of paintings often reveal this deficiency very clearly. On the other hand, black-and-white works of art are commonplace and perfectly acceptable (fig. 6.3).

DESCRIPTIVE USES OF VALUE

One of the most useful applications of value is in its description of objects, shapes, and space. Descriptive qualities can be broadened to include psychological, emotional, and dramatic expression. Artists from time

6.4 Russell F. McKnight. *Intercepting Light.* 1984; photograph, 5½ × 5 in. A solid object receives more light from one side than another because that side is closer to the light source and thus intercepts the light and casts shadows on the other side. From the photographer.

6.5 Russell F. McKnight. *Light and Dark.* 1984; photograph, 5½ × 5 in. This photograph illustrates the even gradation of light to dark on a spherical surface and the sudden contrast of light and dark on an angular surface. From the photographer.

immemorial have been concerned with value as a problem in translating light as it plays about the earth and its inhabitants. Objects are usually perceived in terms of the characteristic patterns that occur when the object is exposed to light rays. Objects, at least according to customary occurrence, cannot receive light from all directions simultaneously. A solid object receives more light from one side than from another because that side is closer to the light source and thus intercepts the light and casts shadows on the other side (fig. 6.4).

Light patterns vary according to the *surface* of the object receiving the light. A *spherical surface* demonstrates this in an even flow from light to dark. An *angular surface* shows sudden contrasts of light and dark values. Each basic form has a basic highlight and shadow pattern. Evenly flowing tone gradation invokes a sense of a gently curved surface. An abrupt change of tone indicates a sharp or angular surface (fig. 6.5).

Cast shadows are the dark areas that occur on an object or a surface when a shape is placed between it and the light source. The nature of the shadow created depends upon the size and location of the light source, the size and shape of the interposed body, and the character of the forms on which the shadows fall. Although cast shadows give very definite clues to the circumstances of a given situation, they only occasionally give an ideal indication of the true nature of the forms. The artist normally uses, reuses, or *creates* those shadows that aid in descriptive character, enhance the effectiveness of the design pattern, and/or contribute substantially to the mood or expression (fig. 6.6).

6.6 Russell F. McKnight. 1984; photograph, 5½ × 5 in. Light can cast overlapping shadows that tend to break up and hide the true character of object forms. The unplanned shapes of shadows such as these often disorganize compositional unity. From the photographer.

Although contemporary artists generally have rejected the use of value to describe form in a traditional chiaroscuro or descriptive sense, a few artists, particularly the New Realists (who stem from Pop influence), do tend to use value in this manner. When value is used to describe volume and space, it could be called *plastic* value. Artists such as Wayne Thiebaud, Philip

6.7 Philip Pearlstein. *Female Nude in Robe, Seated on Platform Rocker.* 1973; oil on canvas, 72 × 60 in. This painting is by an artist of the contemporary New Realist trend. New Realists are using a kind of chiaroscuro derived from photography to describe volume and space or plastic form.
The San Antonio Museum Association, San Antonio Museum of Art, San Antonio, Texas.

Pearlstein, and Alex Katz, for example, are obviously influenced by the photograph and cinema. Neither of these disciplines, it should be noted, remain in the disrepute in which early twentieth-century artists held them as a part of their rejection of all descriptive reality (fig. 6.7).

EXPRESSIVE USES OF VALUE

The type of expression sought by the artist ordinarily determines the balance between light and shadow in a work of art. A preponderance of dark areas creates an atmosphere of gloom, mystery, drama, or menace, whereas a composition that is basically light will produce quite the opposite effect. Artists tend to avoid *exact duplication* of cause and effect in light and shadow because such a procedure creates a series of forms that are monotonously light or dark on the same side. The shapes of highlights and shadows are often revised to create desired degrees of unity and contrast with adjacent compositional areas. In summary, lights and shadows exist *in nature* as the by-products of strictly physical laws. Artists must adjust and take liberties with lights and shadows to create their own visual language (plate 34 and fig. 6.8).

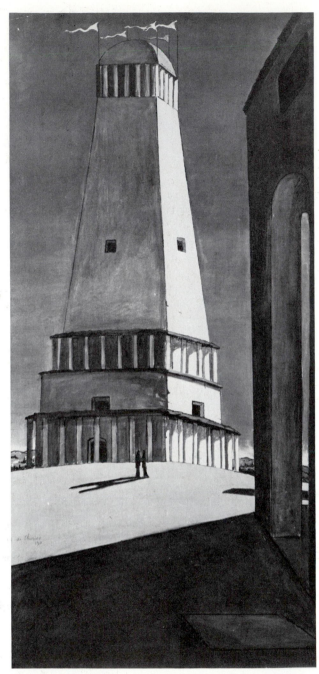

6.8 Giorgio de Chirico. *The Nostalgia of the Infinite.* (dated on painting 1911); oil on canvas, 53¼ × 25½ in. Giorgio de Chirico often used shadow effects, strong contrasts of value, and stark shapes to enhance the lonely, timeless nostalgia that is so much a part of his poetic expression.
Museum of Modern Art, New York. Purchase.

Chiaroscuro

Chiaroscuro refers to the technique of representation that makes obvious use of contrasting lights and darks. The term also alludes to the way artists handle those atmospheric effects that create the illusion that the objects are surrounded on all sides by space. Chiaroscuro

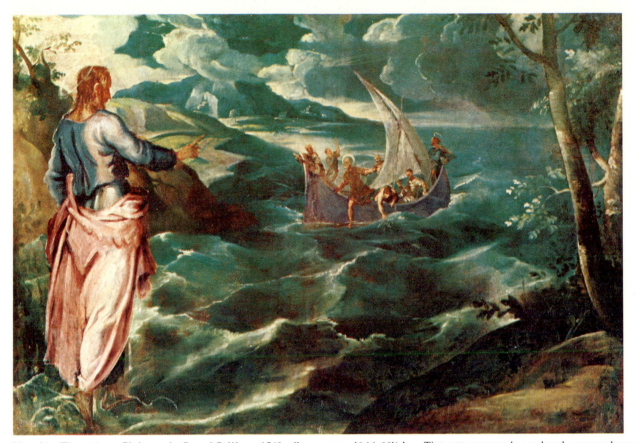

Plate 34 Tintoretto. *Christ at the Sea of Galilee.* 1560; oil on canvas, 46 × 66¼ in. Tintoretto commonly employed a preponderance of dark values interspersed with flickering lights to create an atmosphere of religious drama.
National Gallery of Art, Washington, D.C. Samuel H. Kress Collection.

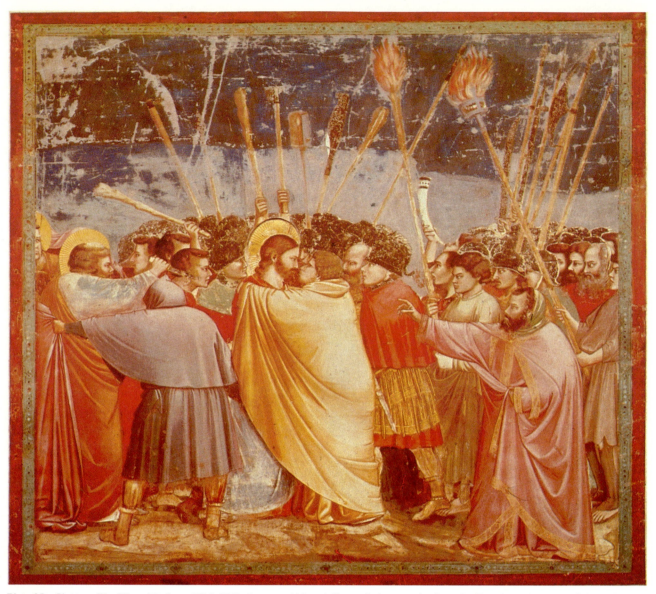

Plate 35 Giotto. *The Kiss of Judas.* 1304–1313; fresco. Although line and shape predominate in Giotto's works, some of the early attempts at modeling with chiaroscuro value can be seen.
Arena Chapel, Padua, Italy. Art Reference Bureau.

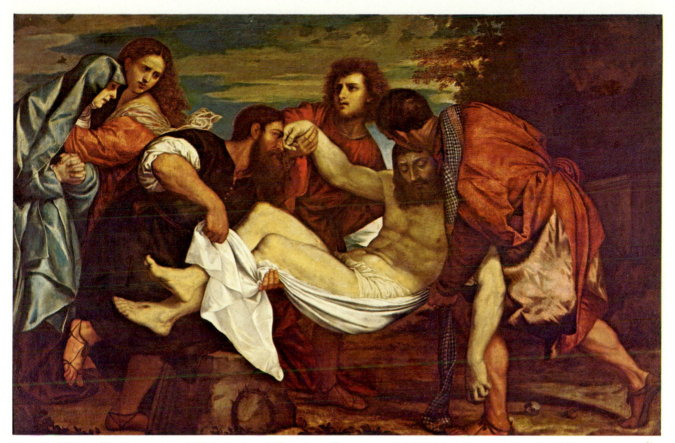

Plate 36 Titian. *The Entombment of Christ* (copy). 16th century; oil on canvas, 54 × 82½ in. The great Venetian Titian subordinated line (contrasting edges with value) and enveloped his figures in a tonal atmosphere that approaches tenebrism.
The Detroit Institute of Arts. Gift of James E. Scripps.

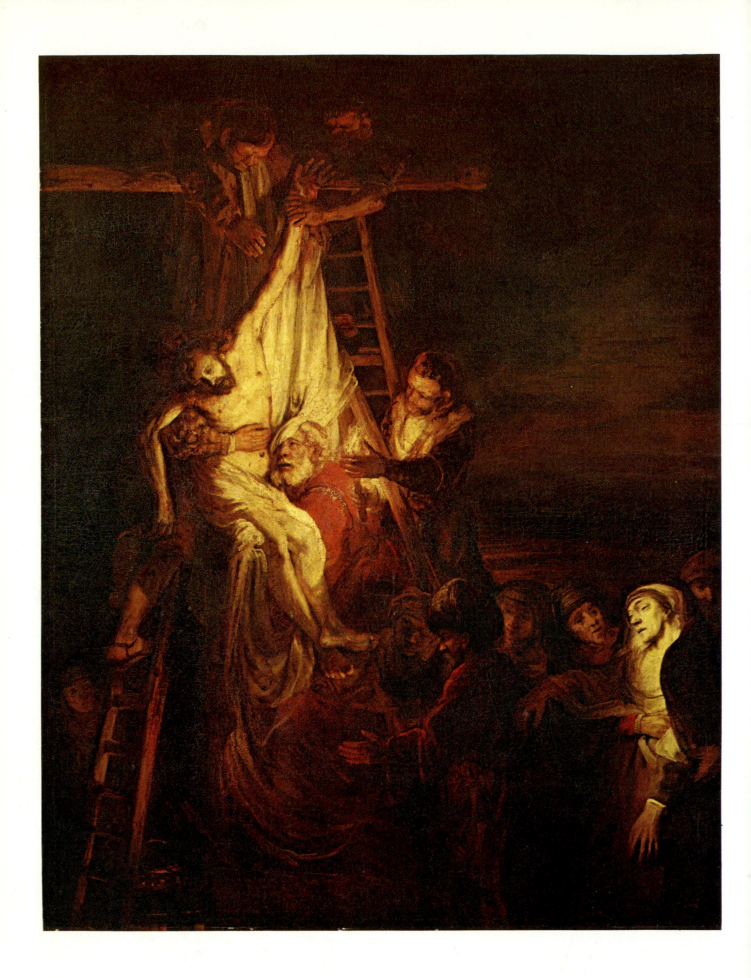

Plate 38 Edouard Manet. *The Dead Toreador.* **circa 1864; oil on canvas, 29⅞ × 60⅜ in.** Manet, a nineteenth-century naturalist, was one of the first artists to break with traditional chiaroscuro, employing, instead, flat areas of value. These flat areas meet abruptly in comparison to the blended edges used by artists previous to Manet. This was one of the basic technical advances of nineteenth-century art. National Gallery of Art, Washington, D.C. Widener Collection.

Plate 37 Harmensz van Ryn Rembrandt. *The Descent from the Cross.* **circa 1655 (altered at a later date); oil on canvas, 56¼ × 43¾ in.** Rembrandt often used inventive, implied light sources that deviated from standard light conditions to enhance the mood or emotional expression. National Gallery of Art, Washington, D.C. Widener Collection.

Plate 40 Juan Gris. *Breakfast.* **1914; pasted paper, crayon, and oil on canvas, 31⅞ × 23½ in.** Gris, an example of a later Cubist, not only simplified shape into larger, more dominant areas, but gave each shape a characteristic value producing a carefully conceived light-dark pattern. He also made use of open composition, in which the value moves from one shape into the adjoining shape, as can be seen in this example.

Plate 39 Henri Matisse. *Nuit de Noël.* **1951; stained-glass window, 11¾ × 54¾ × ⅝ in. commissioned by *Life,* executed in workshop of Paul and Adeline Bony (Paris) under artist's supervision.** Here, Matisse chose to use two-dimensional value pattern instead of traditional chiaroscuro.

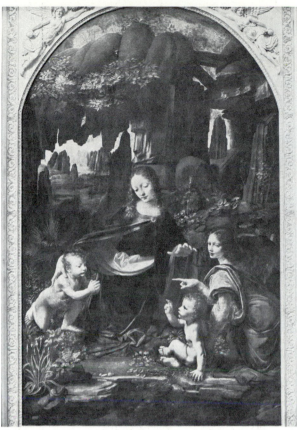

6.9 Leonardo da Vinci. *Madonna of the Rocks.* **1483;
oil/panel, 73¾ × 46½ in.** Leonardo da Vinci used chiaroscuro
with strong atmospheric effects and a much bolder contrast of
light and dark than his early Renaissance predecessors.
Courtesy Louvre, Paris. Art Reference Bureau, Inc.

6.10 Michelangelo da Caravaggio. *St. John the Baptist.* **1604;
oil on canvas, 68¼ × 52 in.** Caravaggio was essentially the
leader in establishing the dark-manner of painting in the sixteenth
and seventeenth centuries. Several of the North Italian painters
before his time, however, such as Correggio, Titian and Tintoretto,
show evidence of the tendency toward darker value composition.
The Nelson-Atkins Museum of Art, Kansas City, Missouri (Nelson Fund).

developed mainly in painting, beginning with Giotto
(1276–1335), who used darks and lights for modeling
but expressed shape and space in terms of line (plate
35). Masaccio, Fra Angelico, and Pollaiuolo, the early
Florentine masters, carried chiaroscuro a step further
by expressing structure and volume in space with an
even, graded tonality. Leonardo da Vinci employed a
much bolder series of contrasts in light and dark but
always with soft value transitions (fig. 6.9). The great
Venetian painters, such as Giorgione, Titian, and Tin-
toretto, completely subordinated line and suggested
compositional unity through an enveloping atmosphere
of dominant tonality (plate 36).

Tenebrism

Painters who used violent chiaroscuro are called *ten-
ebrists*. The first tenebrists were an international group
of painters who early in the seventeenth century were
inspired by the work of Michelangelo da Caravaggio.

Caravaggio based his chiaroscuro on Correggio's work
and instituted the so-called dark-manner of painting in
Western Europe (fig. 6.10). Rembrandt became the
technical adapter and perfector of this dark-manner,
which he got from migratory artists of Germany and
southern Holland. The dark-manner made value an in-
strument in the characteristic exaggeration of baroque
painting. The strong contrasts lent themselves well to
highly dramatic, even theatrical, work of this type.
Later, the dark-manner evolved into the pallid, muddy
monotone that pervaded much of nineteenth-century
Western painting. The tenebrists and their followers
were very much interested in peculiarities of lighting,
particularly how lighting lent itself to *mood* or *emo-
tional expression.* They deviated from *standard light
conditions* by placing the implied light sources in *un-
expected locations,* creating unusual visual and spatial
effects. In the hands of superior artists such as Rem-
brandt these effects were creative tools; in lesser hands,
they became captivating tricks or visual sleight of hand
(plate 37).

6.11 Signed: work of Khemkaran. *Prince Riding an Elephant.* Mughal, period of Akbar, 1556–1605; leaf from an album; gouache on paper. South Asian artists often disregard the use of light (illumination) in favor of decorative value compositions.
Metropolitan Museum of Art, New York. Rogers Fund, 1925.

DECORATIVE VALUE PATTERNS

Art styles that stress *decorative effects* usually ignore conventional light sources or neglect representation of light altogether. If light effects appear, they are often in composite, *a selection of appearances* based on their contribution to the *total form* of the work. This admixture is characteristic of the artworks of primitive and prehistoric tribes, children, traditional East Asians, and certain periods of Western art, notably the Middle Ages. Many contemporary artworks are completely free of illusionistic lighting. An artwork that thus divorces itself from *natural law* is obviously based on *pictorial invention, imagination,* and *formal considerations.* It is not by any means an art necessarily divorced from emotional impact (as witness, Medieval art), but the *emotion* speaks primarily through the *forms* and is consequently less extroverted.

The trend away from illumination values gained strength in the nineteenth century partly as a result of the interest in art forms of the Middle East and East Asia (fig. 6.11). It was given a Western *scientific interpretation* when Edouard Manet, a realist, observed that a multiplicity of light sources tended to *flatten object surfaces* (figs. 6.12 and 6.13, and plate 38). He found that this light condition would neutralize the *plastic*

qualities of objects, thus minimizing *gradations of value.* As a result, he laid his colors on canvas in *flat areas,* beginning with bright, light colors and generally neglecting *shadow.* Some critics have claimed this to be the basic technical advance of the nineteenth century because it paved the way for *nonrepresentational* uses of value and aided in the revival of interest in the shallow space concept (plate 39).

COMPOSITIONAL FUNCTIONS OF VALUE

The idea of carefully controlled *shallow space* finds excellent illustration in the works of the early Cubists and their followers (*see* figs. 11.17 and 11.18). In those paintings, space is given its order by the arrangement of *flat planes* abstracted from subject material. At first, the planes were shaded individually and semi-illusionistically, although there is no indication of any one light source. Later, each plane took on a *characteristic value* and in combination with others produced a carefully conceived *two-dimensional light-dark pattern* (plate 40). Eventually, the shallow spatial effect was developed in terms of *three-dimensional* pattern (or balance) through attention to the *advancing* and *receding*

6.12 and 6.13 Russell F. McKnight. *Effect of Light on Objects.* 1984; photograph, 5½ × 5 in. The photograph in figure 6.12 demonstrates how light from one source emphasizes the three-dimensional qualities of an object and gives an indication of depth. The cast shadows also give definite clues to the descriptive and plastic qualities of the various objects. The photograph in figure 6.13 shows the group of objects under illumination of several light sources. This form of lighting tends to flatten object surfaces and to produce a more decorative effect.
From the photographer.

characteristics of value. The explorations of these artists in the early twentieth century helped to focus attention on the intrinsic significance of each and every element. Value was no longer forced to serve a primary role as a tool of *superficial transcription,* although it continued to be of descriptive usefulness. Most creative artists today think of value as a vital and organic participant in *pictorial organization,* affecting *dominance,* creating *two-dimensional pattern,* establishing *mood,* and producing *spatial unity.*

Open and Closed Compositions

The emotive possibilities of value schemes are easy to see, particularly as the schemes relate to closed or open composition. In closed-value compositions, values are limited by the *edges* or *boundaries* of *shapes.* This serves to clearly identify and, at times, even isolate the shapes. In open-value compositions, values can extend beyond shape boundaries into adjoining areas. This helps to integrate the shapes and to unify the composition. The artist may employ closely related values for hazy, foglike effects, or dramatically contrasting values for sharply crystallized shapes. Thus, value can run the gamut from decoration to violent expression (figs. 6.14 and 6.15; *see also* plate 40). It is a multipurpose tool, and the success of the total work of art is in large measure based on the effectiveness with which the artist has made value serve these many functions.

6.14 Larry Rivers. *The Greatest Homosexual.* 1964; oil and collage on canvas. In this work values pass freely through and beyond the contour lines that normally serve as boundaries of color separation. This is an example of open composition.
Hirshhorn Museum and Sculpture Garden, Smithsonian Institution.

6.15 Pablo Picasso. *Reading (La Lecture).* 1926; print: lithograph, printed in black on yellow undertone, 12⅞ × 9¹³/₁₆ in. The values in this work are used in an open manner; the white value moves in and out of the figure in an arbitrary way, producing a shape not suggested by the original contours. Museum of Modern Art, New York. Gift of Abby Aldrich Rockefeller.

VALUE PROBLEMS

Problem 1

Each of the art media has the potential for creating a great range of values.

In areas of about one square inch, create a value scale consisting of nine clearly contrasting values in each of the following media: pencil, black crayon, pen and ink, ink wash (diluted with water), chalk, charcoal, and tempera paint with white and black intermixed.

Problem 2

Disturbances of a surface produce value changes of a corresponding degree: subtle disturbances result in slight value changes, while sharp changes cause greater contrasts. Objects adhered to such surfaces follow their forms, but alter their contours. The local values of such objects are interesting in their contrasts between shadows and highlights.

6.16 Value Problem 2.

Wrap a masonite panel (approximately thirty by twenty-two inches) with plain wrapping paper. Overlap and crinkle some areas of the paper to obtain a variation of the surface. String, model decals, and the like might be used to vary further the surface and produce additional values. When the construction is completed, it might be painted or drawn using oil, tempera, pencils of different grades, charcoal, or pastels. After construction, the best lighting situation should be chosen for the definition of the surface forms. The shading should generally use smoothly gradated values for curved surfaces and abrupt changes for angular breaks in the surface (fig. 6.16).

Values can be used for the interpretation of the movement of surfaces, whether smoothly flowing (gradual progressions) or sharply breaking (abrupt contrasts).

Submitted by Larry L. Schuh, Assistant Professor of Art, McNeese State University, Lake Charles, Louisiana. Work by Katrina Pitre.

6.17 Value Problem 3.

6.18 Value Problem 4.

Problem 3

Objects are readily distinguishable from each other in terms of their local values, as in a black-and-white photograph. When a light is directed at these objects, the resulting highlights and shadows tend to describe the movements of their surfaces.

Select a number of simple objects with different local values. Direct a light at the objects, and draw and erase to simulate the highlights and shadows within the context of the local values (fig. 6.17).

Problem 4

A decorative value pattern is produced when there are no value gradations in the shapes.

Create a decorative composition using abstract or semiabstract curvilinear shapes. Make large shapes at first, but then divide them into smaller areas related to the main forms. Fill in all of the shapes with varied values created from black-and-white tempera paint. Plan the values so that there are definite differences between adjoining shapes. Strive for balance between the lights and darks of the composition. Light and dark lines can be used to define the shapes (fig. 6.18).

Problem 5

The three-dimensional quality of material objects can be represented by a range of value differences. To achieve a strong degree of plasticity, solid objects should have dark shadows, strong light, and two or three medium values.

Plan an arrangement of simple objects. Make a shaded drawing of this arrangement on medium-tone gray paper, using white chalk for the light areas and black chalk, soft charcoal, or ebony pencil for the dark areas. The background may be broken into shapes harmoniously related to the main objects. Emphasize the lights by using contrasting values. Edges may be highlighted with white chalk where they adjoin dark areas. Large areas of gray paper may be left untouched for medium tones (fig. 6.19).

6.19 Value Problem 5.

6.20 Value Problem 7.

6.21 Value Problem 8.

Problem 6

Artists often prefer predominantly dark values or pre-dominantly light values in their pictures. These are sometimes called high- and low-keyed value systems. Values that range above middle gray are considered high key, and those below, low key.

Draw a simple still-life arrangement. Keep the picture small so that not too much time is required to complete the work. Using any graphic medium, create the following two value schemes for the composition:

a. Closely related light values
b. Closely related dark values

Problem 7

Massing of lines created with pen and ink, pencil, or any linear medium can be used to create variations of value.

Arrange a group of chairs, tables, tools, or similar objects as subject matter. Different views of the same object could be put together in a planned composition. Add value to the composition by massing lines in the background or negative areas. There can be a variation of values within these areas to create pictorial interest. By making the tones next to the white positive shapes darker, you can control the attention or dominance in the composition (fig. 6.20).

Problem 8

Open value is an artistic device that can be used for simplification and for tieing shapes together, producing closer relationships.

Find in a magazine an interesting illustration that contains juxtaposed images. Develop the composition for greater order. While doing this, tie the juxtaposed images together, either by extending the existing value of one into the other or by creating a new value shape that invades both of them. The contour boundaries of the images may be reduced or eliminated so that the new shape created by the merger of the two is seen as one whole shape. This may be utilized several times in the work to simplify it and relate its parts. We suggest that this exercise be done in graphite (fig. 6.21).

Submitted by Debra Babylon, Instructor of Art, School of Art, Bowling Green State University, Bowling Green, Ohio. Work by Aoi Kamamura.

Problem 9

Distribution of the proper sizes of value areas creates controlled tensions and balances, and stabilizes pictorial form. This value distribution can be accomplished by repeating similar values in different parts of a picture to create eye movement that unifies the arrangement.

Fill a pictorial space with an arrangement of shapes of varying sizes that are separated, touching, or overlapping. Open space should be allowed between some of the shapes. Create medium value in the negative areas. Fill in some of the positive shapes with black and leave others white. See if you can create paths of movement through repetition of the blacks, distributing the blacks for a balanced effect. The size variations of similar value shapes will keep the effect from becoming monotonous.

Problem 10

Just as with the other elements of art, a value pattern can have intrinsic meaning or support the emotional character of a mood. Psychologically, we often feel depressed when we see large areas of black, and we tend to associate black with tragedy and death. White usually makes us feel buoyant or even radiant.

6.22 Value Problem 10.

To explore some of the moods or meanings that can be expressed with values, create a pictorial composition incorporating some of the ideas brought to mind by the following titles: Tempest, Tragedy, Hunger, Riot, Lost, Peace, Strike, Fear, Joy, Jazz, Carnival. Do this in a representational style or use more abstract shapes (fig. 6.22).

7
TEXTURE

THE VOCABULARY OF TEXTURE

actual texture A surface that can be experienced through the sense of touch (as opposed to surfaces often imitated by the artist).

artificial texture Any actual texture created by humans.

collage An art form in which the artist creates the image, or a portion of it, by adhering real materials that possess actual textures to the picture plane surface.

genre Subject matter that concerns everyday life, domestic scenes, sentimental family relationships, etc.

illusionism The imitation of visual reality created on the flat surface of the picture plane by the use of perspective, light-and-dark shading, etc.

invented texture Patterns created by the repetition of lines or shapes on a small scale over the surface of an area. The repeated motif is an abstraction or an adaptation of nature patterns used in a more regular or planned fashion.

natural texture Textures that are created as the result of natural processes.

paint quality The use of paint to enrich a surface through textural interest. Interest is created by the ingenuity in handling paint for its intrinsic character.

papier collé A technique of visual expression in which scraps of paper having various textures are pasted to the picture surface to enrich or embellish areas.

7.1 Jan Davidsz de Heem. *Still Life with View of the Sea.* 1646; oil on canvas, 23⅜ × 36½ in. The amazingly natural appearances in Dutch and Flemish still-life paintings are largely due to the artists' careful simulation of surfaces.
Courtesy the Toledo Museum of Art, Toledo, Ohio. Gift of Edward Drummond Libbey.

simulated texture The copying, or imitation, of object surfaces.

tactile A quality that refers to the sense of touch.

texture The surface character of a material that can be experienced through touch, or the illusion of touch. Texture is produced by natural forces or through an artist's manipulation of the art elements.

trompe l'oeil A technique involving the copying of nature with such exactitude that the subject depicted can be mistaken for natural forms.

INTRODUCTION

Texture is vicariously experienced through the eyes, but is more directly and dramatically known through the sense of touch. By concentrating on your hands and fingers while holding this book, you will realize that you are experiencing texture. If the fingers are against the open side, they will feel the ridged effect of the stacked pages; if on the surface of a page, smoothness. Now look around the room in which you sit. You will find many textures. In fact *everything* has a texture, from the hard glossiness of glass through the semiroughness of a lamp shade to the soft fluffiness of a carpet. If your

room happens to contain a painting or art reproduction, textures can be seen that cannot be felt—but are made to look as if they could be felt (fig. 7.1).

RELATIONSHIP OF TEXTURE TO THE VISUAL ARTS

Texture is unique among the art elements in activating two sensory processes at the same time. In viewing a picture, we might recognize objects through the artist's depiction of characteristic shape, color, and value patterns. We might also react to the picture's surface character, which, if the artist has been successful, reminds us of the object. In such a case vivid feelings of touch may be vicariously experienced, complementing the sensations of vision (fig. 7.2).

Tactile response is the artist's concern when working in the graphic or plastic fields. Sculptors become involved with the problem of texture by the choice of material and the type and degree of finish to be used. If they wish, sculptors can re-create the textures that are characteristic of the subject being interpreted. By cutting into the surface of the material they can suggest the tactile qualities of hair, cloth, skin, and other textures that suit their purpose (fig. 7.3).

7.2 Andrew Wyeth. *The Hunter.* 1943; tempera on masonite, 33 × 33⅞ in. Skillful manipulation of the medium can effectively simulate actual textures.
Courtesy the Toledo Museum of Art. Elizabeth C. Mau Bequest, 1946.

The *graphic* arts do not exist in the round, and any exaggerated attempt to fool the eye into believing they do usually develops into an obvious display of skill that is a violation of the medium. Although their opportunities to create texture are more limited than those for sculptors, graphic artists nevertheless have a formidable array of textural effects available to them. The items in our physical environment on which these effects are based can be *natural* (such as grass, leaves, stone, and tree bark) or *artificial,* having been created by human hands (such as paper, metal, glass, concrete, and stucco) (plate 41).

THE NATURE OF TEXTURE

The sense of touch helps to inform us of our immediate surroundings. Our language, through such words as *smooth, rough, soft,* and *hard,* demonstrates that touch helps us distinguish the nature of objects. Some textures might be interpreted as being menacing and uncomfortable, others as soothing and pleasant. Texture is really *surface,* and the feel of that surface depends on how it is broken up by its structural components. Its composition determines how we *see* it as well as how we feel it. Rough surfaces intercept light rays, creating prominent highlights and shadows. Glossy surfaces reflect the light more evenly, giving us reflections and an unbroken appearance (fig. 7.4).

TYPES OF TEXTURE

We employ four basic types of texture: simulated, abstract, invented, and actual.

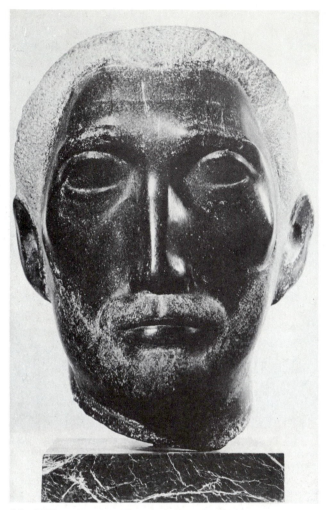

7.3 William Zorach. *Head of Christ.* 1940. stone (peridotite), 14¾ in. high. Zorach has polished portions of the surface of this bust to bring out the natural textural quality of granite. He has roughened selected surfaces, which seems suitable for simulation of subject characteristics.
Museum of Modern Art, New York. Abby Aldrich Rockefeller Fund.

Simulated Texture

The artist is capable of reproducing textures by using lights, darks, and colors to resemble existing textures (this is called simulated texture) or by producing the effect of texture not based on any particular observed surface (invented textures) (plate 42).

Texture and Pattern

Because texture is interpreted by lights and darks, there is a very fine line between texture and *pattern* similarly created. Pattern does not ordinarily pretend to have texture; according to the dictionary it is essentially a decorative design. This is an acceptable definition for the artist because pattern is, in art, ornamental and not particularly concerned with surface character (figs. 7.5 and 7.6).

7.4 Illustration A is a cross section of three materials. On the left is a hard, smooth substance, the middle is cinderblock, and on the right is weathered wood. The upper surface's texture can be clearly seen and could be felt if stroked. Illustration B shows the same cross section and its upper plane. The arrow indicates the light source. The texture is defined by the highlights and shadows created by this illumination. The material to the left, being smooth, produces no shadows (if glossy it would show reflections). The small stones in the cinderblock cast shadows among them. The undulations in the weathered wood have shadows on the left side and highlights on the right. The nature of the texture in materials is defined by light and shadow patterns.

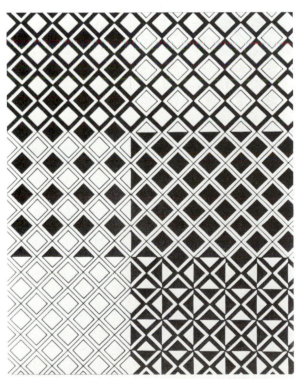

7.5 This illustration shows several types of related patterns. As with most patterns, the patterns are made up of repeated motifs, and they are basically *flat*. Space can be read into some patterns (as with these), but spatial illusions are not ordinarily the concern of patterned areas.
The Principles of Pattern by Richard M. Proctor.

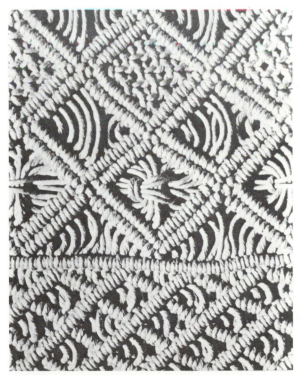

7.6 In this woven material one can also see repeated motifs creating pattern, but in this case that pattern is the product of three-dimensional textures that demonstrate the pattern through the highlights and shadows of the fibers.
The Principles of Pattern by Richard M. Proctor.

In nature and art, pattern usually suggests a repetition, as found, say, in the pattern of cornstalks in a field. Perhaps this is not an altogether accurate analogy because such a pattern would be made up of individual three-dimensional stalks of corn that, collectively, produce a real texture on the field. It can be imagined that aerial views of similar fields seen from considerable heights are seen largely as pattern; when approached from lower altitudes the textures would become more apparent. These examples suggest that texture *may* create pattern and that a pattern *may* have texture, although neither case is representative. Texture is normally identified with the three-dimensional disruption of a surface, and pattern is ordinarily two-dimensional (flat) (fig. 7.7).

7.7 a. Piece of material with light and dark pattern. b. Cross section of material (a), assuming it to be a piece of wallpaper. The dark spots are ink; the ink sits on the surface and penetrates the material. c. Cross section of material (a), assuming it to be a piece of carpet. The pattern comes from color changes *and* tufted areas (texture). Thus we have both pattern and texture in this example.

The simulated texture already cited can serve to illustrate the dual character of texture. Imagine an artist who is going to paint a picture of an old barn door. The door is so weathered and eroded that its grain stands out prominently; it would feel rough if stroked. The roughness is the product of ridges and valleys formed by its weathering. These grainy qualities are defined by lights and darks that inform our eyes of its roughness. In rendering the door, the artist arranges lights and darks so that they *look* like the surface of the door. Once the paint has dried, it appears that the artist has performed a feat of magic. The door that looks rough is, in fact, smooth, as can be determined by touching the canvas. The artist has *simulated* a texture and, at the same time, produced a wood grain pattern. In the case of a piece of sculpture it is likely that the texture would be *actual* texture (fig. 7.8).

Invented Texture

If the barn door painter were somewhat less realistic in style, he or she might be aware of the need for a texture to be associated with the old door and, without reference to any particular surface, use the imagination to produce an effect that could be interpreted as texture. This would be *invented* texture, one entirely the artist's, and probably without precedent (fig. 7.9).

Abstract Texture

Very often textures are not invented, but are abstracted from the original. This is usually a simplification emphasizing pattern, but with hints of the motivating texture (plate 43).

7.8 Russell F. McKnight. *Weathered Chair.* **1983; photograph, 5⅝ × 8⅛ in.** This texture is not natural to the wood, but rather was created by outside forces. The process induced by exposure and aging have caused the surface shellac or varnish to reticulate, producing a patterned texture.
From the artist.

7.9 Kenneth Knowlton and Leon Harmon. *Computerized Nude.* **1971; computer.** This reproduction of a photograph by a specially programmed computer has not only a range of dark and light values, but also a variety of interesting textures. It illustrates the concept that invented textures in themselves can give an ordinary subject a certain amount of aesthetic value.
Printed with permission of AT&T Bell Laboratories, Murray Hill, N.J.

7.10 Student work. tempera, 8 × 14 in. This work is an example of papier collé, meaning that paper shapes have been cut and pasted down to form a picture. The paper used was selected according to the decorative interest provided by its texture. The interest is further enhanced because the texture does not always correspond to the characteristic surface of objects depicted.

Actual Texture

Papier Collé Art history is full of simulated texture in painting and actual texture in sculpture. But *actual* texture as a part of *painting,* and as we think of it today, probably began with Picasso and Braque in the early twentieth century when these two artists started attaching actual objects to their canvasses. In 1908 Picasso pasted a piece of paper to a drawing. This was most likely the first known example of *papier collé,* or the use of paper in the form of tickets, newspapers, menus, and the like attached to artworks (figs. 7.10 and 7.11).

Collage Papier collé soon led to collage, consisting of rope, chair caning, and other *actual* textures, sometimes in combination with simulated textures (plate 44).

7.11 Georges Braque. *Still Life.* circa 1917–1918; pasted newspaper, paper, gouache, oil and charcoal on canvas, 51¼ × 29 in. This Cubist painter pioneered in the invention of the papier collé and collage forms—works of art created by fastening actual materials with textural interest to a flat working surface. These art forms may be used to simulate natural textures but are usually created for decorative purposes.
Philadelphia Museum of Art. The Louise and Walter Arensberg Collection.

We know that actual texture had already existed in the buildup of paint on the canvas. Van Gogh, for instance, used oil paint so lavishly that the paint often stands out prominently. In a sense this is actual texture, if only the by-product of the act of painting (plate 45).

The use of papier collé and collage is not always easily accepted; it leads to a certain ambiguity that can be perplexing. The central question posed by the juxtaposition of object and painting seems to be, What is real? Deriving from this are other thoughts, such as, Are the objects real, or the artistic elements, or both? and Do the painted objects have the same reality as the genuine objects? (fig. 7.12).

7.12 Mary Bauermeister. *Colour-Full.* **1968; mixed media, 19½ × 19½ × 4¼ in.** Collages feature the actual textures of real objects secured to the picture plane. These are often augmented by painted and drawn passages, sometimes producing simulated textures.
Courtesy the Owens-Corning Collection. Owens-Corning Fiberglas Corporation, Toledo, Ohio.

Whatever the answers to the previous questions, the early explorations of the Cubists (the style of Picasso and Braque at the time) stimulated other artists to explore new attitudes toward art and made artists much more conscious of surface. In the art of today we find many forms of surface embellishments, including all forms of texture. A concern for pattern eventually flowered in the works of Picasso and Braque, and this, too, has been reflected in subsequent artwork (fig. 7.13).

TEXTURE AND COMPOSITION

Relative Dominance and Movement

In terms of pictorial *composition,* texture must be considered within the context of the value changes (generally shadows and highlights) that produce it. Value contrasts, and their allusions to texture, combine to make shapes exciting and attractive (in the sense that they attract the eye). This means that texture must be used with relative dominance in mind. If an area being developed is too strong in its hold on our attention, the texture must be diminished; if the area is "dead" or uninteresting, textures can be supplied or enhanced. Texture can also inject directional thrust into an artwork. If all forces are in equilibrium, a static condition will result. If, however, the movements generated by the texture are unbalanced, the dominant push can be used to divert our eyes and thus keep our attention moving about the artwork, as can be seen in Picasso's *Dog and Cock* (plate 43).

7.13 Max Weber. *Chinese Restaurant.* **1915; oil on canvas, 40 × 48 in.** This painting shows the concern for surface enrichment that grew out of the use of actual textures. In this example of "rococo" Cubism, many areas are given a decorative patternization that in most cases does not seem to derive from anything but the artist's need for decoration.
Whitney Museum of American Art.

Psychological Factors

The artist has other textural considerations. Under certain conditions texture can generate psychological or emotional suggestions. These suggestions might be in terms of the pleasant or unpleasant attributes mentioned earlier. Textures can be associated with environments, experiences, objects, or persons that have symbolic or associative qualities. When it is said that a person is "slippery as a snake" or is a "roughneck," tactile sensations are being compared with personality traits. Textures in such a setting can be used as supplementary psychological devices. The artist might also use textures in unlikely situations to pique our curiosity, surprise us, shock us, or make us think (a Surrealist once designed a fur-lined teacup!) (plate 46).

Texture and Space

Texture can also contribute spatial sensations to art. The character of the texture of leaves helps us to know whether a tree is in the foreground or in the distance. Blurriness or reduced contrasts indicate distance, and sharpness with strong values brings us close to an object. This use of "atmospheric perspective" has long been commonplace in academic painting, but an artist who is more adventurous may use textural effects from far and near to produce controlled variations or surprising contradictions (fig. 7.14).

7.14 Albert Bierstadt. *Yosemite Valley.* oil on canvas, 27¾ × 38½ in. The foreground areas move forward because of their greater contrasts and clarity, while other areas are thrust into space by grayness and details only faintly suggested.
Columbus Museum of Art, Ohio. Bequest of Rutherford H. Platt.

TEXTURE AND ART MEDIA

Most of this discussion has dealt with painting, but there are textural problems in the making of any kind of artwork. The architect balances the smoothness of steel and glass with the roughness of stone, concrete, and brick. The ceramist works with glazes, aggregates in the clay, and the use of various impressed and incised textures in the clay. Jewelers, using their own techniques, also show concern for texture in their pins, rings, and brooches. Printmakers use transferred textures that are printed after being etched into the printing plate. Sculptors, as we have seen, manipulate the textures of clay, wood, metal, and other natural and artificial materials. From this we can see that texture is involved with all art forms, as it is in many life experiences—however unconscious of them we may be.

TEXTURE PROBLEMS

Problem 1

The textures used by the artist might be actual, simulated, invented, or abstract. Actual textures are those with a real tactile sense, or objects whose texture one can feel with the fingers. Simulated textures imitate the appearance of an actual texture so closely that they may look real. ("Trompe l'oeil" is a French term for simulated or "fool the eye" effects in art.) Invented and abstract textures use the other elements of art to create the effect of surface textural differences (with or without reference to nature).

Select a number of contrasting actual textures. They should be varied in their surface quality and values. Scraps of material of different values and roughness, such as lace, burlap, corduroy, linen (stay away from flower patterns—keep plain), ropes, yarns,

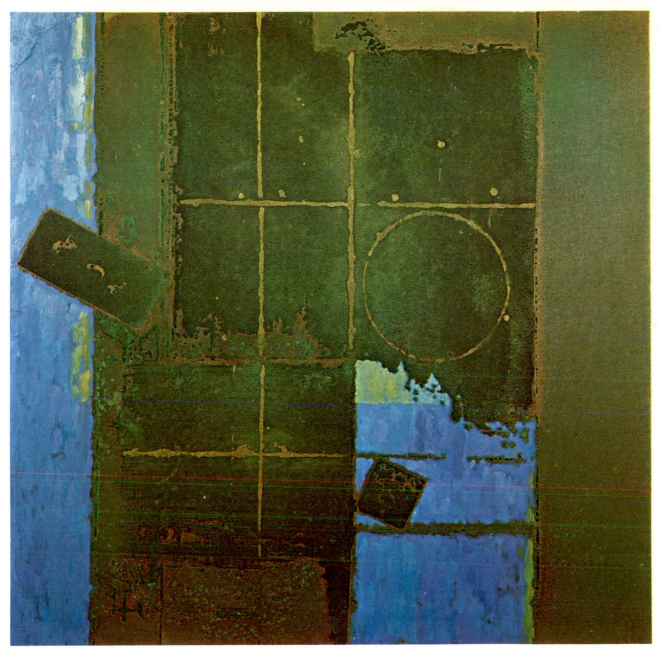

Plate 41 Gyorgy Kepes. *Moss Map.* **1971; oil and sand on canvas, 48 × 48 in.** Sand, mixed with the paint, is supported by a careful selection of color to create a total effect similar to surfaces we might see in nature.
Courtesy the Owens-Corning Collection. Owens-Corning Fiberglas Corporation, Toledo, Ohio.

Plate 42 Gary Schumer. *Simulation.* **1979; oil, 42½ × 52½ in.** As the title implies, the artist is concerned with, among other things, the simulation of textures to be found in our environment.

Courtesy the Owens-Corning Collection. Owens-Corning Fiberglas Corporation, Toledo, Ohio.

Plate 43 Pablo Picasso. *Dog and Cock.* **1929; oil on canvas, 60⅞ × 30⅛ in.** Some of the texture in this work appears to be invented (we can't be sure), but some of it is clearly abstracted, as in the dog's fur and the chicken's feathers. The texture is close enough to the original to be seen as derived from it.
Yale University Art Gallery. Gift of Stephen Carlton Clark. New Haven, Connecticut.

Plate 44 Robert Rauschenberg. *Fossil for Bob Morris.* 1965; paper, metal, plastic, rubber, and fabric on canvas, 84⅞ × 60⅝ in.
Collage features the actual textures or real objects secured to the picture plane. These are often augmented by painted and drawn passages.
Hirshhorn Museum and Sculpture Garden, Smithsonian Institution. Photo by John Tennant.

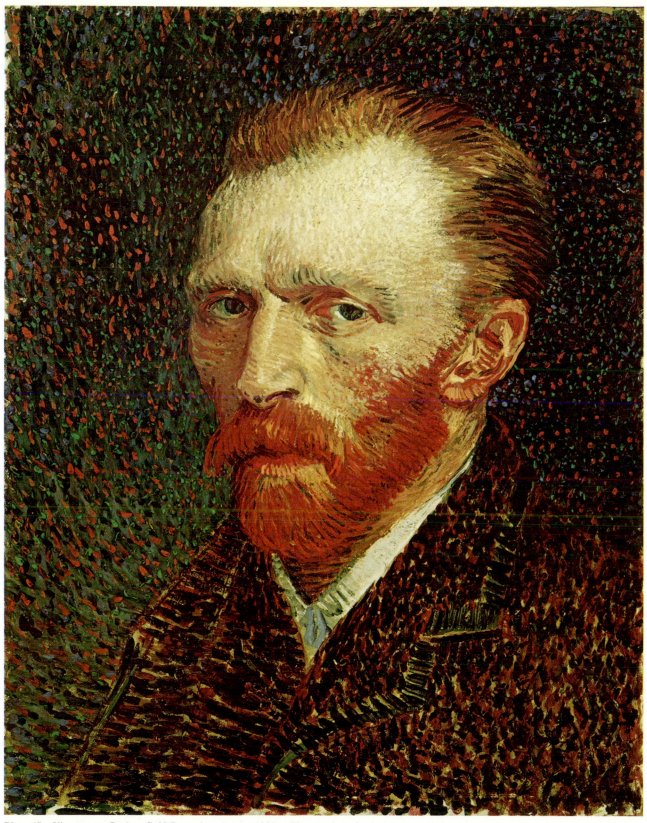

Plate 45 Vincent van Gogh. *Self-Portrait.* August 1890. The massing of paint on Van Gogh's canvases creates actual textures. The application of paint is often directly from the tube or "built up" and scraped clean with the palette knife. The ribbons of paint in his work follow or create the rhythm sensed in nature and frequently simulate natural forms.

Art Institute of Chicago.

Plate 46 Pavel Tchelitchew. *Hide-and-Seek.* **1940; oil on canvas, 78½ × 84¾ in.** The use of personal, textural style is greatly responsible for much of the emotional quality present in this painting. Here, instead of the obvious invented patterns, we find the subtle textural treatment of organic matter that evokes a feeling of biological mystery.

Museum of Modern Art, New York. Mrs. Simon Guggenheim Fund.

7.15 Texture Problem 1.

7.16 Texture Problem 1.

sandpaper, and steel wool might be used. On a surface, such as illustration board, mark off two rectangles placed side by side, each approximately five by six inches in size. Within the left-hand rectangle create an asymmetrically balanced design featuring abstract actual textures with materials like those described above. *Cover the entire surface and achieve a wide range of values* (fig. 7.15). In the right-hand box *imitate exactly* the composition and appearance of the actual textural design you have just created, using different grades of graphite (i.e., hard to soft pencils). Match the values as closely as you can. This means you must look at color and translate it into lightness and darkness. You can test accuracy by placing the drawing in a semidarkened room (colors will diminish in value). Use a clean piece of paper under your hand to keep the graphite from smearing. Use tissues and rub graphite when you need a fine value or a modeled surface. Use eraser to bring out highlights if necessary. If there is a frayed edge in the *actual texture,* you must draw a frayed edge in the *simulated one* (fig. 7.16).

Submitted by Instructor Debra Babylon, Toledo Museum of Art School, Toledo, Ohio. Work by Maryann Rossi.

Problem 2

The different media employed by the artist automatically result in varying surface effects that enhance the character of the shapes used. These changes of textural character may replace the interest created by varying shape styles. Frequently, textural variation has become a form of decoration.

Experiment with a wide variety of media to see how many different types of surface you can create. Use both the point and the side of the pencil, varying pressure strokes for diverse effects. Try mixing media, such as ink over crayon strokes, watercolor wash over crayon tones, shading with pencil strokes over color washes, pen lines drawn in wet watercolor washes, brush strokes of tempera paint in wet washes of transparent watercolor, and so forth.

Apply your effects to areas from one inch to four inches in size. Cut simple shapes, such as circles, squares, rectangles, and triangles, from these areas and assemble them in a simple, decorative shape organization. (Try using one kind of shape only, but vary the size.) These shapes may touch, overlap, or be completely separate, but the organization should be simple. In other words, depend on texture variation for interest, not on the complexity of the design relationships. Remember to leave a number of plain background areas around many of the shapes—too much texture variation can become chaotic (fig. 7.17).

7.17 Texture Problem 2.

Problem 3

Texture rubbings can quickly guide a student to the infinite varieties of actual and simulated textures.

Place a piece of white paper over a coarse-textured surface. Rub over the paper with a soft pencil or crayon. The rubbing technique will bring out a negative impression of the textured surface. Repeat the procedure on a variety of surfaces. Assemble these textures in a chart or a pictorial organization (fig. 7.18).

Problem 4

Graphic artists are often deeply interested in making their visual surfaces more varied and exciting. When they are primarily concerned with presenting their picture as a tangible object and not as an illusion of nature, they may use *actual* textures. In creating such an artistic form, artists may add unusual materials to the surface, such as papers of varying patterns, colors, and textures. When bits of paper are pasted together on a picture surface, the composition is termed a *papier collé.*

Gather several varieties of paper (for example, newspaper, construction paper, cellophane, tinfoil, printed color sheets, etc.). Cut, tear, paste, and assemble this paper on a flat surface so that it has expressive, as well as sound, structural form (fig. 7.19).

7.18 Texture Problem 3.

7.19 Texture Problem 4.

7.20 Texture Problem 5.

Problem 5

Probably one of the most difficult and underrated creative art forms from a student's viewpoint is collage. The idea of taking throwaway materials and trying to arrange them into an aesthetically pleasing composition appears hard for the beginner. In most cases success is limited because the student thinks too objectively. In approaching the collage, a student should respect compositional devices used in painting and drawing. All elements of design can be used, but emphasis is placed upon texture. Rich tactile surfaces can be readily achieved by selecting a variety of actual textures.

Collect a variety of actual textures such as cloth, sand, metal foil, wood, and colored photo textures from magazines. Make a number of interesting rubbings (with crayons or soft pencil) on ordinary drawing paper. To enhance the rubbings, one might mix up various paint colors that are thinned with water to wash over the crayon rubbings in a resist fashion. Doing so will remove the white background and make them more attractive. Don't be intimidated by the perfection of these textures—feel free to crumple, tone, wash, or invent additional textures on their surface.

Cut or tear and start arranging materials into shapes by color, value, or texture. Consider each section as a tension or force entering the composition that will culminate at a central point in your picture plane. It is necessary to intensify colors and value contrast at that point and subdue perimeter areas. Invented texture, pencil toning, and paint washes will help sensitize your composition. Remember, simple, uncluttered areas will complement rich textural areas. The success of your composition

7.21 Texture Problem 6.

will be directly affected by how you personalize the various textures used. Once the composition has been determined, glue the various parts together (fig. 7.20).

Submitted by Dr. Carl Emmerich, Professor of Art and Art Education, Eastern Illinois University, Charleston, Illinois. Work by Katherine Feeley.

Problem 6

Textures can be used to enrich and lend interest to areas that might otherwise be monotonously bare.

Create a design for a record jacket, postage stamp, or some other common item that requires imagination. Experiment with several invented textures on a separate sheet. Select one of these textures and use it to fill in portions of all of the positive or negative shapes. The texture need not be related to any of the surface characteristics of the subject, but should be chosen on the basis of its ability to decorate the chosen areas (fig. 7.21).

7.22 Texture Problem 7.

Problem 7

The interest in patterns of mosaic tile is largely due to the effects created by putting small colored pieces together. The mosaic effect can be simulated by using small pieces of colored paper.

Create abstract decorative patterns by fitting together small pieces of colored paper cut from magazine illustrations to form shapes. An interesting effect can be obtained if some of the colors used already have slight variations. To keep the design from becoming *too* confusing, do not use too small or too complex shapes and make sure that the colors chosen for different shapes are definitely contrasting in value (fig. 7.22).

Problem 8

Just as repeating similar values will serve to unify a design, developing an area of high contrast creates dominance. A value pattern can be established with textures resulting from the use of materials of varying degrees of transparency or opacity.

7.23 Texture Problem 8.

With the safelight on in a darkroom, place light-sensitive paper, emulsion side up, on an enlarger. Arrange objects on the paper. Expose to the light for five seconds. Place the print, face up, into the developer, agitating it gently to allow the developer to wash over the print. Watch closely, removing the print when the desired shades of light and dark have developed. Place immediately into the stop bath for five seconds. Remove, allowing excess to drip off, and place the print into the fixer, leaving about ten minutes. Wash in cool running water about one hour. Blot and dry (fig. 7.23).

Source: *Weevil,* published by the Alabama Art Education Association, Vol. 2, No. 2, Winter, 1982. Submitted by Lily H. J. Pomeroy, Assistant Professor of Art, Livingston University, Livingston, Alabama. Work by Kenn Ruffin.

8
COLOR

THE VOCABULARY OF COLOR

analogous colors Those colors that are closely related in hue. They are usually adjacent to each other on the color wheel.

color The character of a surface that is the result of the response of vision to the wavelength of light reflected from that surface.

color tonality An orderly planning in terms of selection and arrangement of color schemes or color combinations; involves not only hue, but also value and intensity relationships.

color triad A group of three colors spaced an equal distance apart on the color wheel. The twelve-color wheel has a primary triad, a secondary triad, and two intermediate triads.

complementary colors Two colors that are directly opposite each other on the color wheel. A primary color is complementary to a secondary color that is a mixture of the two remaining primaries.

hue Used to designate the common name of a color and to indicate its position in the spectrum or on the color wheel. Hue is determined by the specific wavelength of the color in a ray of light.

intensity The saturation or strength of a color determined by the *quality* of light reflected from it. A vivid color is of high intensity; a dull color, of low intensity.

107

local (objective) color The naturalistic color of an object as seen by the eye (green grass, blue sky, red fire, etc.).

neutralized color A color that has been grayed or reduced in intensity by mixture with any of the neutrals or with a complementary color.

neutrals Surface hues that do not reflect any single wavelength of light, but rather all of them at once. A strong reflection of all color wavelengths will produce white. When large amounts of light of all color wavelengths are reflected, light grays will result; when small amounts of light wavelengths are reflected, dark grays will result. The absence of all color wavelengths will produce black. No single color is noticed—only a sense of light or dark such as white, gray, or black.

pigments Color substances, usually powdery in nature, that are used with liquid vehicles to produce paint.

simultaneous contrast Intensified contrast that results whenever two different colors come into direct contact.

spectrum The band of individual colors that results when a beam of light is broken into its component wavelengths of hues.

split-complement A color and the two colors on either side of its complement.

subjective colors Colors chosen by the artist without regard to the natural appearance of the object portrayed. Subjective colors have nothing to do with objective reality except represent the expression of the individual artist.

value Value refers to the lightness or darkness of a color. It indicates the quantity of light reflected.

NATURE OF COLOR

Color is the element of *form* that arouses universal appreciation and the one to which we are the most sensitive. It instantly appeals to a child as well as to an adult; even infants are more attracted to brightly colored objects. The average layperson, who is frequently puzzled by what he or she calls "modern" art, usually finds its color exciting and attractive. The layperson may question the use of distortions of shape, but seldom objects to the use of *color,* provided that it is harmonious in character. In fact, a work of art frequently can be appreciated for its color style alone.

Color is one of the most expressive elements because its quality affects our emotions *directly* and *immediately.* When we view a work of art, we do not have to rationalize what we are *supposed to feel* about color but have an immediate *emotional* reaction to it. Pleasing rhythms and harmonies of color satisfy our *aesthetic* desires. We like certain combinations of color and reject others. In representational art, color identifies objects and creates the effect of illusionistic space. Color differs from the other elements in that it deals with certain scientific facts and principles that are exact and can easily be systematized. We will examine the basic facts or characteristics of *color relationships* to see how they function in giving *form* and *meaning* to the subject of an artist's work.

Source of Color

Color begins with and is derived from *light,* either natural or artificial. Where there is little light, there is little color; where the light is strong, the color is likely to be particularly intense. When the light is weak, such as at dusk or dawn, it is difficult to distinguish one color from another. Under bright, strong sunlight, such as in tropical climates, colors seem to take on additional intensity.

Every ray of light coming from the sun is composed of *waves* that vibrate at different speeds. The *sensation of color* is aroused in the human mind by the way our sense of vision responds to the different *wavelengths* of light that affect it. This can be experimentally proven by observing a beam of light that passes through a triangularly shaped piece of glass (prism) and then reflects from a sheet of white paper. The rays of light are bent, or refracted, as they pass through the glass at different angles (according to their wavelength) and are reflected from the white paper as different colors. Our sense of vision then interprets these colors as individual stripes in a narrow band we call the *spectrum.* The major colors easily distinguishable in this band are red, orange, yellow, green, blue, indigo, and violet. (The scientist uses the term *indigo* for the color the artist usually calls *blue-violet.*) These colors, however, blend gradually so that we can see several intermediate colors between them (fig. 8.1 and plate 47).

The colors of the spectrum are pure and represent the greatest *intensity* (brightness) possible. If we could collect all of these *spectrum colors* and mix them in a reverse process from the one described in the previous paragraph, we would again have white light. When such colored rays of light are recombined (or mixed), the system is called *additive* because the mixed hues are obtained by *adding* light rays instead of absorbing or subtracting them. The *pigments* or coloring matter the artist uses are not as strong in intensity nor as pure as the spectrum colors because pigments usually reflect from their surfaces more than just one dominant color, or they reflect a certain amount of white, which dilutes the intensity of the color. A mixture of all of the pigment colors will not produce white, but rather a gray, which in a sense is an impure or darkened form of white.

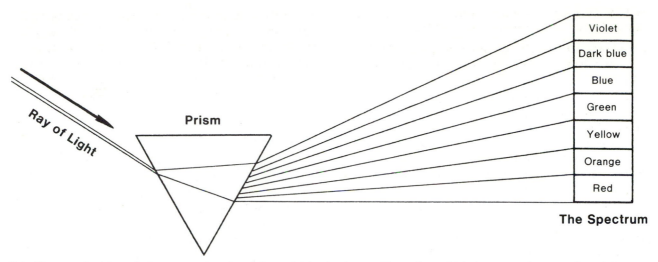

The Spectrum

8.1 The rays of red have the longest wavelength and those of violet the shortest. The angle at which the rays are bent, or refracted, is greatest at the violet end and least at the red.

Plate 47 *Prism and Spectrum.* 1944; 35 mm color photo of a beam of light shining through a prism, **4 × 5 in.** A beam of light passes through a triangularly shaped piece of glass (prism). The rays of light are bent, or refracted, as they pass through the glass at different angles (according to their wavelengths), producing a rainbow array of hues called the spectrum.
Fritz Goro Photograph, Life Magazine. © 1966 Time Inc.

Since all of the colors are present in a beam of light, how are we able to distinguish *one color* as it is reflected from a natural object? Any colored object has certain physical properties called color quality or *pigmentation* that enable it to *absorb* some of the color waves and *reflect* others. A green leaf appears green to the eye because the leaf reflects the green waves in the ray of light while absorbing all the other colors. A *pigment* has this property, and when it is applied to the surface of an object, gives it the same property.

Color in art depends on *pigments* and, therefore, can only *approximate* the intensity of the *spectrum colors* of light. From now on when we discuss *color*, we will be referring to the artist's *pigment* rather than to the sensation of *colored light*.

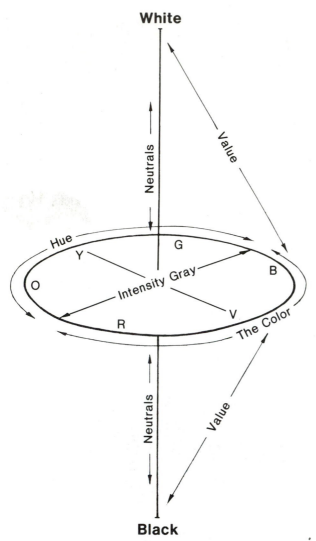

White

Neutrals

Value

Hue

Y G B

O Intensity Gray

R V

The Color

Neutrals

Value

Black

8.2 This diagram demonstrates all three physical properties of color. We can see all of the color variations as existing on a three-dimensional solid (a double cone). As the colors move around this solid, they change in hue. When these hues move upward or downward on the solid, they change in value. As all of the colors on the outside move toward the center, they become closer to the neutral values, and there is a change in intensity (*see also* plate 48).

Neutrals

All objects, of course, do not have the quality of color. Some are black, white, or gray, which do not look like any of the colors of the spectrum. No *color quality* is found in these colors; they differ merely in the *quantity of light* they reflect. Because we do not distinguish any *one* color, black, white, and gray are called *neutrals*. These neutrals actually reflect *all* of the color waves in a ray of light. One neutral, absolute black (seldom seen), reflects no light at all and consequently has no color. White can be called the total *addition* of color because it results when a surface reflects all of the color

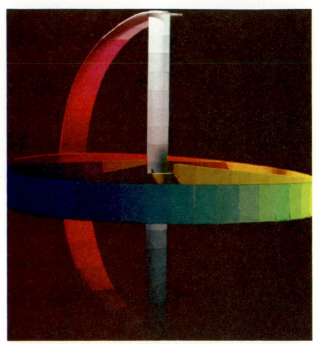

Plate 48 3–D Color Model. A three-dimensional model illustrating the three main characteristics of color (*see also* fig. 8.2).
Photograph courtesy of Ronald Coleman

waves in light to an *equal degree*. Black, then, is usually called the *absence* of color because it results when a surface absorbs all of the color rays *equally* and reflects *none* of them. If white represents 100 percent reflection of light, then any gray is an impure white because it is created by only *partial* reflection of all the color waves. If the quantity of light reflected is great, the gray is light; if the amount reflected is little, the gray is dark. The neutrals are affected by the *quantity of light* reflected, whereas color is concerned with the *quality of light* reflected.

Physical Properties of Color

As previously mentioned, the spectrum contains such colors as red, orange, yellow, blue, green, and violet. These are only a few colors, and yet we know that hundreds of *color variations* exist. Children or beginners working with color are likely to use only a few simple, pure colors. They do not seem to realize that simple colors can be varied in three specific ways. Every color actually exists in many forms, although these forms may continue to bear the simple *color name*. There are many reds, for example, that differ in character from *pure red*. Every color the artist uses must be described in terms of three physical properties: *hue, value,* and *intensity* (fig. 8.2 and plate 48).

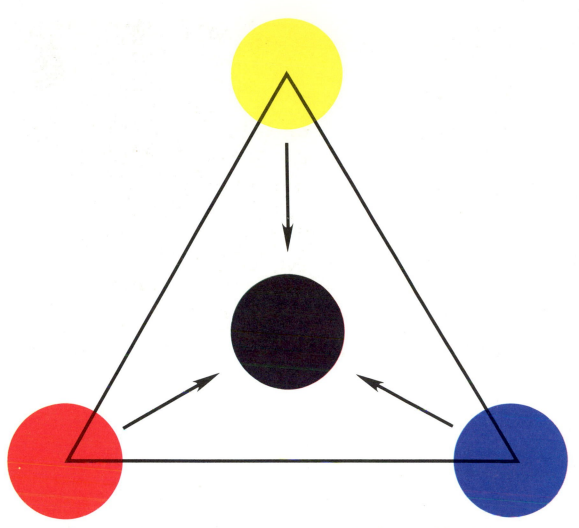

Plate 49a Primary Triad. When the colors of the primary triad are mixed together, the resulting color is gray.

Hue Hue is the property or characteristic of a color that refers to that color's *position* on the color wheel. Hue also refers to the *color name* used to differentiate the colors having different wavelengths of light. For example, yellow is a hue that differs from green (another hue) and has a different wavelength. A color's hue can be changed by mixing that color with another color; this actually changes the wavelength of the ray of light. Yellow added to green creates a yellowish green or a change in hue. Also, yellow mixed with blue creates green, and the amount of yellow used determines the kind of green that results. Yellow, yellow-green, green, and blue-green are all different hues because they have different wavelengths. However, when *pigments* of these colors are mixed, the resulting colors each contain the common hue yellow. Such variations are called *analogous hues*.

Many colors can be created by mixing two other colors. Three colors, however, cannot be created from mixtures of other colors; these are the hues red, yellow, and blue. Red, yellow, and blue are called the *primary* colors (plate 49a). When these three primaries are mixed in pairs or all together in equal or unequal amounts, they can produce all of the possible colors. A mixture of the three primaries should, theoretically, result in white; actually, this mixture produces a neutral gray, which may be considered a darkened form of white. The important point to remember is that the three primaries *neutralize* each other so that the resulting tone does not resemble *any one hue*. Mixing any two primaries produces a *secondary* color: orange results from mixing red and yellow; green results from mixing yellow and blue (plate 49b). In addition, certain *intermediate* colors are created by the mixture of a primary color with a neighboring secondary color. The

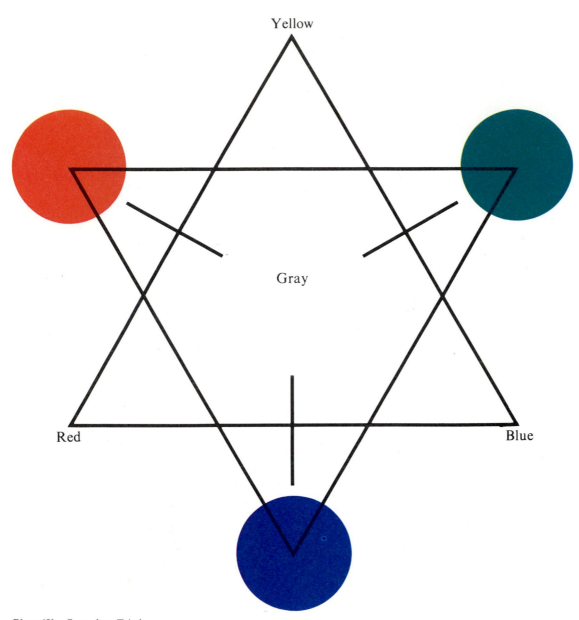

Plate 49b Secondary Triad.

number of intermediate colors actually is unlimited because a change of proportion in the amount of primary or secondary colors used will change the resultant hue. In other words, there is no one yellow-green possible by mixing green and yellow. If more yellow is used, a different yellow-green results than when more green is used (plate 49c).

To systematize color relationships, the hues are usually shown arranged around a wheel (plate 50). The three *primary* colors are equally spaced apart on this wheel with yellow usually placed at the top. The three *secondary* colors are placed between the primaries from which they are mixed. An *intermediate* color is placed between each primary and each secondary color, thus resulting in a twelve-color wheel. The *hues* of the colors change as we move around the color wheel because the wavelengths of the light rays that produce these colors change. The closer together colors appear on the color wheel, the closer their *hue relationships;* the farther apart any two hues are, the more contrasting they are in character. The hues directly opposite each other afford the greatest contrast and are known as *complementary* colors (*see* plate 53a).

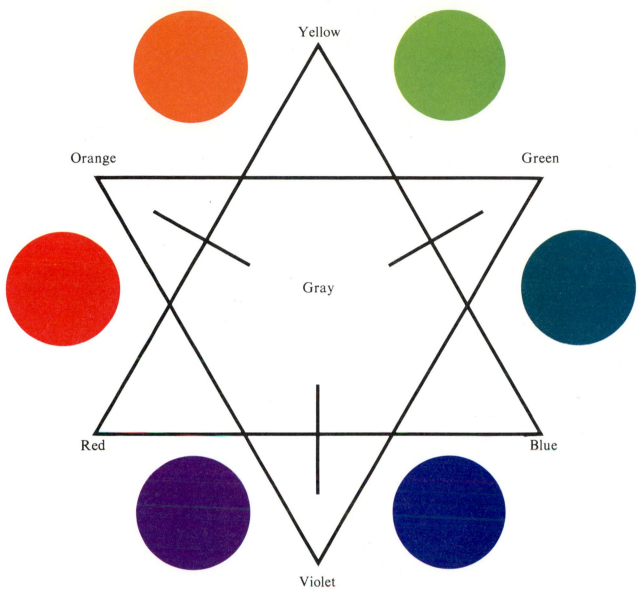

Plate 49c Intermediate Colors.

Value A wide range of color tones can be produced by modifying one *hue* with the addition of the *neutrals* black or white. This indicates that colors have characteristics other than hue. The property of color known as *value* distinguishes between the lightness and darkness of colors, or the *quantity of light* a color reflects. Many value steps can exist between the darkest and lightest appearance of any one hue. To change the tone value of a pigment, we must mix with it another pigment that is darker or lighter in character. The only dark or light pigments available that would not also change the color's hue are black and white.

All of the colors reflect a different quantity of light as well as a different *wavelength*. A large amount of light is reflected from yellow, whereas a small amount of light is reflected from violet. Each color at its maximum intensity has a *normal value* that indicates the amount of light it reflects. It can, however, be made lighter or darker than normal by the addition of white or black, as previously noted. We should know the normal value of each of the colors in order to use them most effectively. This normal value can be most easily

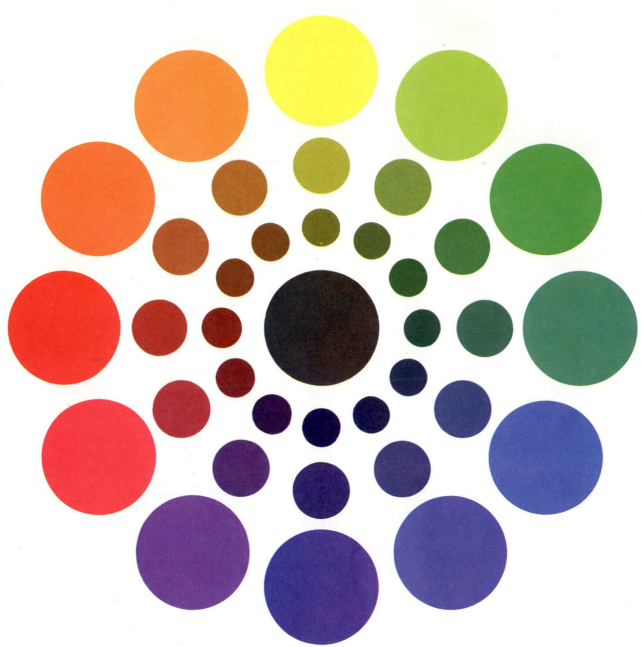

Plate 50 Color Wheel.

seen when the colors of the wheel are placed in relationship to a scale of neutral values from black to white (plate 51).

Intensity The third property of color, *intensity* (sometimes called saturation or chroma), refers to the *quality of light* in a color. We use the term *intensity* to distinguish a brighter tone of a color from a duller one of the same hue, that is, to differentiate a color that has a high degree of saturation or strength from one that is grayed or neutralized. The saturation point or

the purest color is actually found in the spectrum produced by a beam of light passing through a prism. However, the pigment used by the artist that comes closest to resembling this color is said to be at *maximum intensity*. The purity of the light waves reflected from the pigment produces the variation in the brightness or dullness of the color. For example, a pigment that reflects only the red rays of light is an intense red, but if any of the complementary green rays also are reflected, the brightness of the red color is dulled or neutralized. If the green and red rays balance each other

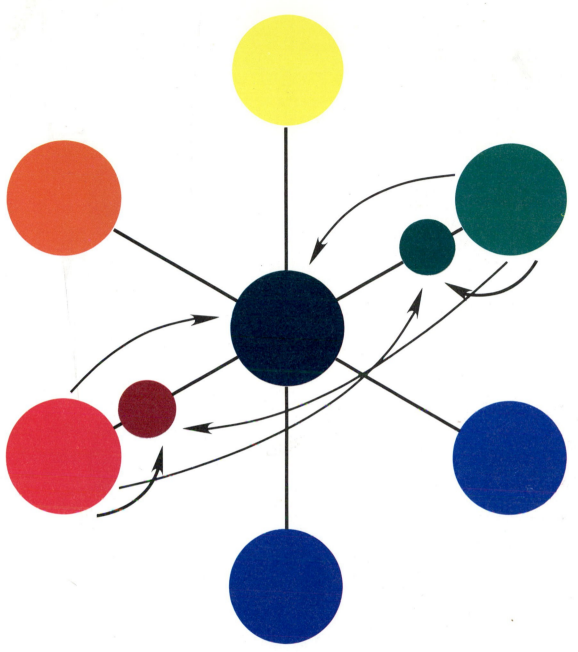

Plate 52b

in value. The color becomes less bright as more gray is added but will not become lighter or darker in tone (plate 52a). The fourth way of changing the intensity of any hue is by adding the complementary hue. The mixture of two hues that occur exactly opposite each other on the color wheel, such as red and green, blue and orange, or yellow and violet, results in a neutral gray. This is because the complementary colors represent an *equal balance* of the three primaries. The dominating hue in the mixture of two complementary colors gives its specific character to the resulting tone.

Consequently, this tone, instead of being a pure gray, is a grayed or neutralized form of the color used in the *larger amount*. When hues are neutralized by mixing complements, the resulting colors have a certain liveliness of character not present when they are neutralized with a gray pigment. This interesting character is enhanced when the complementary tones are not actually mixed, but are merely placed close together in little dots of broken color. The mixture then actually takes place in the visual sensation of the observer (plate 52b).

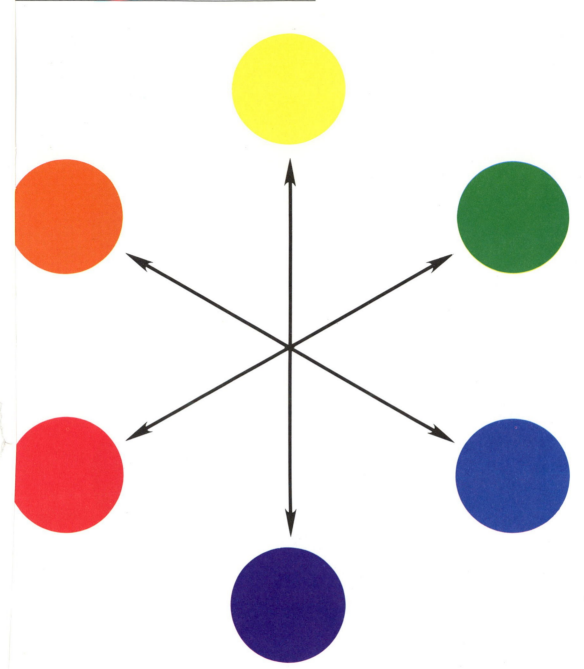

Plate 53a Complementary Colors (extreme contrast).

Color Relationships

The successful use of color depends upon an understanding of *color relationships*. A single color by itself has a certain character, but that character may be greatly changed when the color is seen with other colors. Colors might be closely related, or they might be contrasting, but the contrast can vary considerably in *degree*. The greatest contrast in hue occurs when two colors that appear directly opposite each other on the color wheel (complementaries) are used together (plate 53a). Using a split-complement system (the color and two colors on either side of its complement) results in a variation that produces less contrast (plate 53b). There is a shorter interval between colors and consequently less contrast when *three* colors that are *spaced equally* far apart on the color wheel are used together. The first group, known as the primary triad, consists

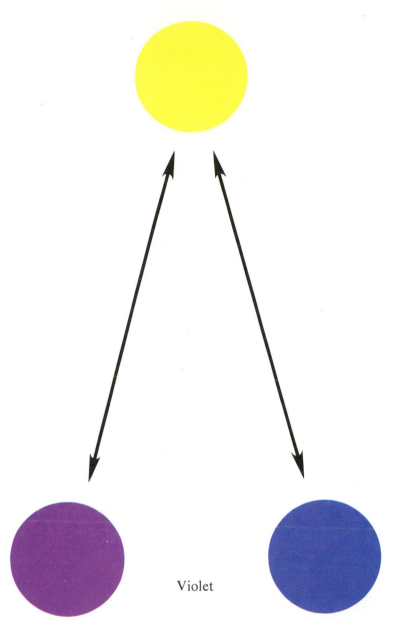

Violet

Plate 53b Split-Complementary Colors. This example shows yellow and its split complementary colors, red-violet and blue-violet, on either side of yellow's complement violet.

of red, yellow, and blue. The second group, or secondary triad, is composed of orange, green, and violet. The contrast is more striking in the *primary* triad. In the *secondary* triad, although the interval between hues is the same, the contrast is softer. This effect probably occurs because in any pair of the triad there is a *common color:* orange and green both contain yellow, orange and violet both contain red, and green and violet both contain blue. Where colors appear next to each other on the color wheel, we have the shortest interval and consequently the most harmonious relationship. This is because three or four neighboring hues always contain one common color that dominates the group (analogous colors) (plates 53b and 53c).

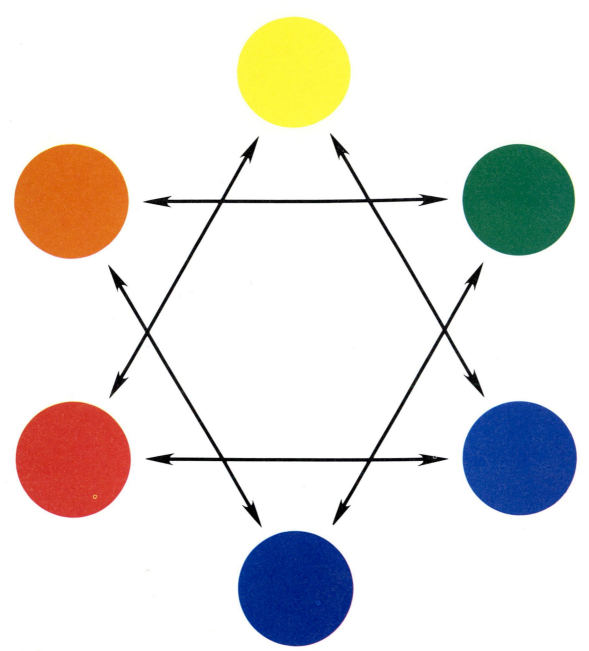

Plate 53c Triadic Color Interval (medium contrast).

Other Color Systems Humans' perennial fascination with, and consequent analysis of, color has resulted in the development of a number of color systems. One of the most successful of these systems was developed in the early 1900s by the American artist Albert Munsell. Munsell's system showed the relationships between different color tints and shades. This system was an attempt to arrive at a specific nomenclature for the many varieties of hues that result from mixing different colors with each other or with the neutrals, black, white, and gray. American industry adopted the Munsell system in 1943 as its material standard for naming different colors. The system was also adopted by the United States Bureau of Standards in Washington, D.C.

In the Munsell system the five basic hues are red, yellow, green, blue, and purple. The mixture of any two of these colors that are adjacent on the color wheel is

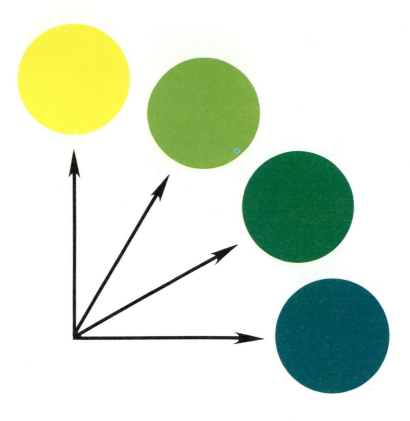

Orange

Red

Blue

Violet

Plate 53d Analogous Colors (close relationships).

called an intermediate color. For example, the mixture of red and yellow is an intermediate color called red-yellow. The other intermediate hues are green-yellow, blue-green, purple-blue, and red-purple.

To clarify color relationships Munsell devised a three-dimensional color system that classifies the different shades or variations of colors according to the qualities of hue, value, and intensity (or chroma). His system is in the form of a tree. The many different color tones are seen as transparent plastic vanes that extend from the center trunk like tree branches. The center trunk is a scale of neutral tones that begin with black at the bottom and rise through grays to white at the top. The color tone at the outer limit of each branch represents the brightest hue possible at each level of value (plate 54).

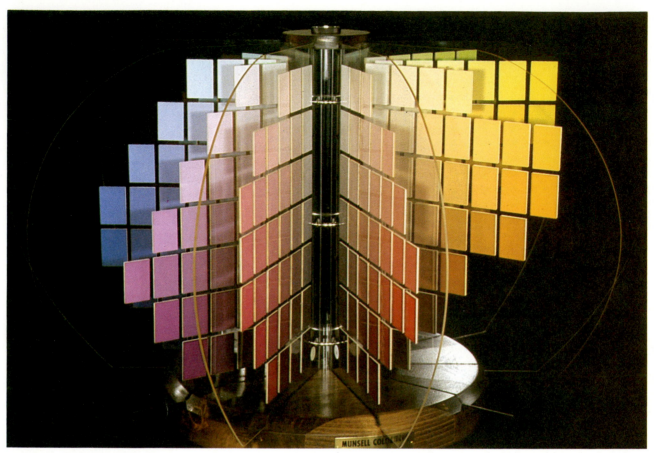

Plate 54 Munsell Color Tree. 1972. clear plastic chart, 10½ × 12 in.; base size 12 in. diameter; center pole size 12⅝ in. high; chip size ¾ × 1⅜ in. The Munsell system in three dimensions. The greatest intensity of each hue is found in the color vane farthest from the center trunk. The value of each vane changes as it moves from top to bottom of the tree. The center trunk changes only from light to dark. The colors change in hue as they move around the tree.
Courtesy Macbeth, a division of Kollmorgen Corporation, Baltimore, Maryland.

The most important part of the Munsell color system is the *color notation,* which describes a color in terms of a letter and numeral formula. The hue is indicated by the notation found on the inner circle of the color wheel (fig. 8.3). The value of the colors is indicated by the numbers on the central trunk shown in plate 54. The intensity or chroma is shown by the numbers on the vanes that radiate from the trunk. These value and intensity relationships are expressed by fractions with the upper number representing the value and the lower number indicating the intensity (chroma). For example, 5Y8/12 is the notation for a bright yellow.

It is interesting to compare the Munsell color wheel (fig. 8.3) with the one used in this book (plate 50). Munsell places blue opposite yellow-red and red opposite blue-green, while in this book we place blue opposite orange and red opposite green. In another system Wilhelm Ostwald places blue opposite yellow. Each system is designed for a particular purpose. Munsell used his circular arrangement of color in accordance with certain strict rules for standardizing many industrially used colors. Ostwald devised his system in relation to psychological harmony and order. In this book

the circular arrangement is based on a less complicated subtractive system of artist-pigmented colors. Diametrically opposing colors that the artist uses should be complementary and when mixed should produce a gray. This system of mixing color is known as the *subtractive process* because the second color, when mixed with the first color, subtracts or absorbs more light waves from a white light than the first color. The British have published a standard color wheel titled "Powder Pigments for Artists Use" that is arranged like the wheel used in this book.

Space does not permit discussion of other color systems, but a substantial number of color theorists have explored the color field. Among them are Newton, Goethe, Schopenhauer, M.E. Chevreul, Delacroix, J. C. Maxwell, Itten, and Faber Birren.

Warm and Cool Colors All of the colors usually are thought of as belonging to one of two groups: *warm colors* or *cool colors.* Red, orange, and yellow usually are associated with the sun or fire and are considered warm. Any colors containing blue, such as green, violet, or blue-green, are associated with air, sky, and

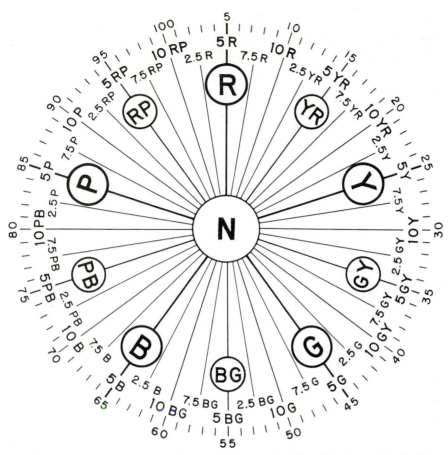

8.3 Munsell Color Wheel. This diagram shows the relationships of the hues on the wheel in terms of a specific type of notation as explained in the text.
Courtesy Macbeth, a division of Kollmorgen Corporation, Baltimore, Maryland.

water and are called cool colors. This quality of warmth or coolness in a color may be affected or even changed by the hues *around* or *near* it. The artist may mix a color on a palette and then find that the color appears entirely different when in juxtaposition on the canvas with other colors.

Simultaneous Contrast The effect of one tone upon another is sometimes called the *Rule of Simultaneous Contrast.* According to this rule, whenever two different color tones come into direct contact, the contrast intensifies the *difference* between them. The effect is most noted, of course, when the colors are directly contrasting in hue, but it occurs even if the colors have some degree of relationship. For example, a yellow-green surrounded by green appears to be yellow, whereas if it is surrounded by yellow, it is more noticeably green. The contrast can be in the characteristics of *intensity* or *value* as well as in *hue*. A grayed blue looks brighter if placed against a gray background; it looks grayer or more neutralized against a

bright blue background. The most obvious or strongest effect occurs when directly opposite or *complementary hues* are juxtaposed: blue is brightest when seen next to orange, and green is brightest when seen next to red. When a warm tone is seen in simultaneous contrast to a cool tone, the warm tone is warmer and the cool tone cooler. A color always tends to bring out its complement in a neighboring color. When a neutralized gray made up of two complementary colors is placed next to a strong positive color, it tends to take on a hue that is opposite to the positive color. When a person wears a certain color in clothing, the complementary color in the person's complexion is emphasized.

All of these changes in color feeling should make us realize that no one color should be used for its character alone, but should be considered in relation to the other colors present. For this reason it is better to develop a color composition *all at once* rather than try to finish one area completely before going on to another. Only after understanding the basic facts of color and the effects of color relationships can we explore color's function as an *element of form* in composition.

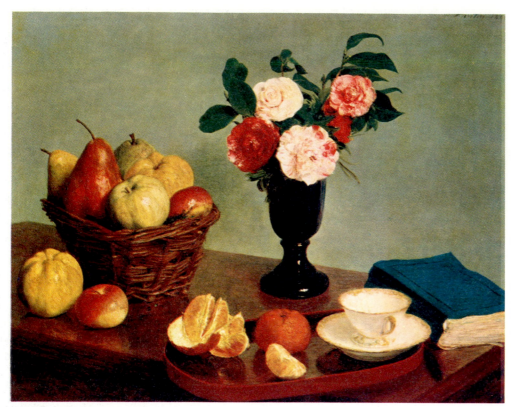

Plate 55 Henri Fantin-Latour. *Still Life.* Dated 1866; oil on canvas, 24⅜ × 29½ in. This still life is painted in local color, or color that tends to simulate the natural hues of the objects in nature.
National Gallery of Art, Washington D.C. Chester Dale Collection.

USES OF COLOR

Being familiar with the sources of color and its principal properties is of little value unless we can understand how these facts are used by the artist. Color serves several different purposes in artistic composition. These purposes, however, are not always separate and distinct, but rather frequently overlap and interrelate. Color can be used in the following ways:

1. To give spatial quality to the pictorial field
 a. Color can supplement, or even substitute for, value differences to give plastic quality.
 b. Color can create interest through the counterbalance of backward and forward movement in pictorial space.
2. To create mood and symbolize ideas
3. To serve as a vehicle for the expression of personal emotions and feelings
4. To attract and direct attention as a means of giving organization to a composition
5. To accomplish aesthetic appeal by a system of well-ordered color relationships
6. To identify objects by describing the *superficial facts* of their *appearance*

The last of these functions was considered of greatest importance when painting was seen as a purely *illustrational* art. For a long period in the history of Western art, color was looked upon as something that came from the object being represented. Color in painting that is used to indicate the natural appearance of an object is known as *local color* (plate 55). A more expressive quality is likely to be achieved when the artist is willing to disassociate the color surfaces in the painting from the *object* to which the color supposedly belongs. An entirely *subjective* color treatment can be substituted for local color. The colors used and their relationships become the *invention of the artist* for purposes other than mere representation (plate 56). This style of treatment might even deny color as an *objective reality;* that is, we might have purple cows, green faces, or red trees. Most of the functions of color are mostly subjective in character; they are of particular importance in contemporary art and should be examined separately.

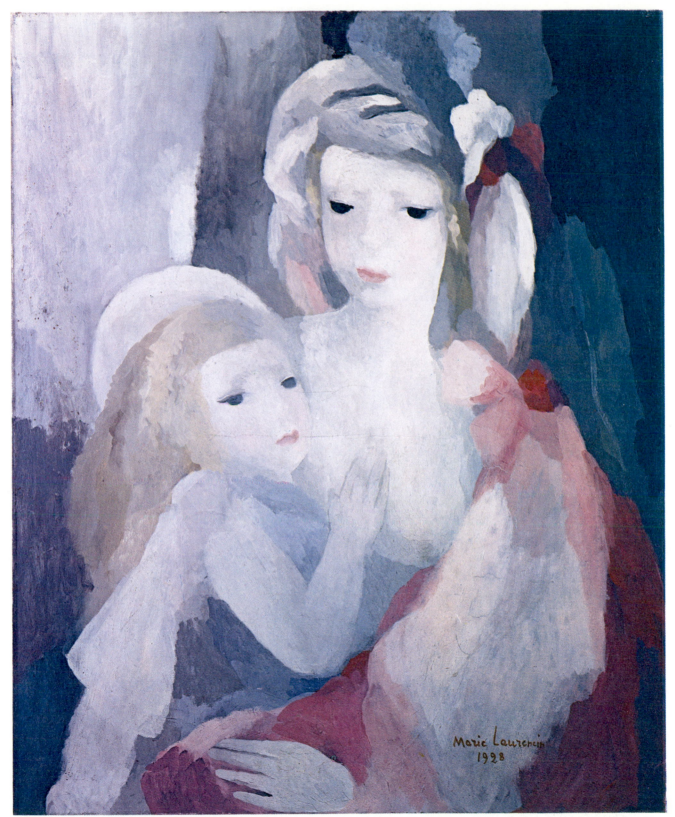

Plate 56 Marie Laurencin. *Mother and Child.* 1928; oil on canvas, 32 × 25½ in. This French artist used color to construct a personal (or subjective) interpretation that sets the charming mood of the painting.
The Detroit Institute of Arts, City of Detroit Purchase.

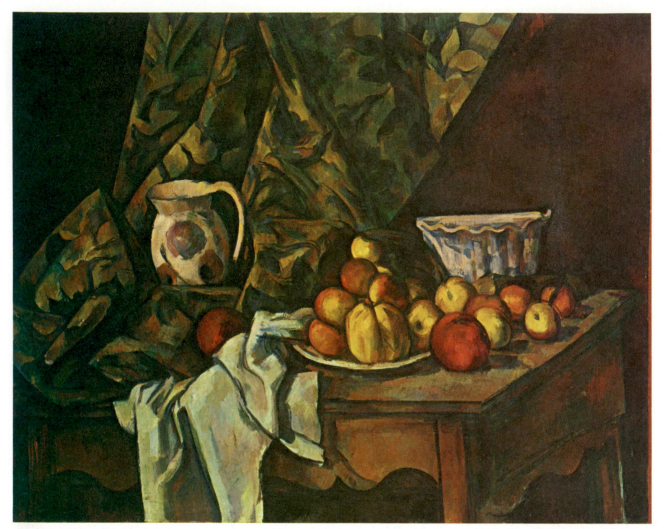

Plate 57 Paul Cézanne. *Still Life with Apples and Peaches.* 1905; oil on canvas, 32 × 39⅝ in. Cézanne uses changes of color as a means of modeling form. Cool colors indicate recession rather than a mere darkening of the characteristic tones. National Gallery of Art, Washington, D.C. Gift of Eugene and Agnes Meyer.

Plastic Quality of Color

As used by the present-day artist, color that does not describe the surface of an object might be used to give the essential reality of the object's plastic character. This ability of color to *build a form* comes from the advancing and receding characteristics of certain colors. When placed upon a surface, colors actually seem to have a *spatial* dimension. For example, a spot of red on a flat surface seems to take a position *in front* of that surface; a spot of blue, similarly placed, seems to *sink back* into the surface. In general, warm colors seem to advance, and cool colors seem to recede. The character of such effects, however, can be altered by differences in the value and/or intensity of the color. These spatial characteristics of color were first noted by the

French artist Paul Cézanne in the latter part of the nineteenth century. He admired the sparkling brilliancy of the *Impressionist artists* of the period but thought that their work had lost the *solidity* of earlier painting. Consequently, he began to experiment with expressing the bulk and weight of forms by modeling with *color tones.* Previous to Cézanne's experiments, the traditional academic artist had modeled form by a change of values in monotone (one color). The artist then tinted these tones with a thin, dry *local color* characteristic of the object being painted. Cézanne discovered that a *change of color* on a form could serve the purpose of a *change of value* and not lose the intensity of expression. He felt that the juicy richness of positive colors served to express the actual structure of

a solid object. Later, contemporary artists realized that Cézanne's advancing and receding colors could also create those backward and forward movements in space that give liveliness and interest to the picture surface (plate 57). Many abstract artists have used the relationships of balance and movement in space to give *content* (meaning) to a painting, although no actual objects are represented. Color has been used as just another means along with line, value, and texture to accomplish this purpose.

Color and Emotion

A second function of color involves its ability to create mood, to symbolize ideas, and to express personal emotions. Color itself, as found upon the canvas, can express a mood or feeling, although it is not *descriptive* of the objects represented. Light, bright colors make us feel happy and gay, while cool, dark, or somber colors are generally depressing. The different hues of the spectrum have different emotional impacts. Psychologists have found that red is happy and exciting, whereas blue is dignified, sad, or serene. Also, different *values* and *intensities* of the hues in a color tonality may have an effect on its *feeling tone*. A decided value range (strongly contrasting light or dark hues) gives a color scheme vitality and directness; closely related values and low intensities suggest subtlety, calmness, and repose (plates 58 and 59). We cannot escape the emotional effect of color because it appeals directly to our senses.

Artists may also take advantage of the power of color to *symbolize* ideas, thus making their work stronger in content or meaning. Such ideas or abstract qualities as *virtue, loyalty, honesty, evil,* and *cowardice* are symbolized by the colors that have come to be traditionally associated with them. In many cases we do not know the origin of these associations but are nevertheless affected by them. For example, blue is associated with loyalty and honesty (true *blue*), red with danger, yellow with cowardice (*yellow* streak), black with death, green with life or hope, white with purity or innocence, and purple with royalty or wealth. Some colors may have many different associations. For example, red may mean fire, danger, bravery, sin, passion, or violent death. The colors in a painting may enhance the impact of the subject matter by suggesting or recalling the meanings associated with them (plate 60).

In addition to expressing meanings by association, color might express an artist's *personal emotions*. Most truly creative artists evolve a personal style of color tone that comes primarily not from the subject but from their feelings about the subject. Albert Pinkham Ryder expressed what he felt about the sea in a very original style of color. John Marin's color is essentially suggestive in character with little expression of form or solidity (*see* plate 28). It is frequently delicate and light in tone in keeping with the medium (watercolor) with which he works. The color in the paintings of Vincent van Gogh is usually vivid, hot, intense, and applied in snakelike ribbons of pigment. His use of texture and color accounts for the intensely personal style of his work (plate 61). The French artist Renoir used a luminous, shimmering color in his painting of human flesh so that his nudes have a glow that is not actually present in the human figure. The emotional approach to color appealed particularly to the expressionistic painter, who used it to create an entirely *subjective treatment* having nothing to do with *objective reality.*

Aesthetic Appeal of Color Tonality

The final function of color involves its ability to evoke in the observer sensations of pleasure because of its well-ordered system of color tonality (plate 62). This appeal refers to the sense of satisfaction we derive from seeing a well-designed rug or drapery material whose color combination is harmonious. The same appeal can be found in a purely nonobjective painting. There are no exact rules for arriving at pleasing effects in color relationships, but there are some *guiding principles.* We can develop the ability to create pleasing color by studying and analyzing color schemes that appeal to us. This study should be followed by experiment and practice in *color organization.* The problem is, *first,* the *selection* of hues to be used together in a composition and, *second,* their *arrangement* in the pictorial field in the proper amounts for color balance. No color is important in itself, but is always seen on the picture surface in a dynamic interaction with the other colors present. Combinations and arrangements of color are for the purpose of expressing content or meaning; consequently, any arrangement ought to have a definite *feeling tone.* In talking about pleasing color, we must realize that there can be brutal color combinations as well as refined ones. These brutal combinations are satisfying in the sense that they accomplish the artist's purpose of exciting us rather than having a quieting effect. Some of the German expressionist painters have proven that these brutal, clashing color schemes can have definite aesthetic value when they are done in a purposeful manner (plate 63).

Plate 58 Claude Monet. *Rouen Cathedral, West Facade Sunlight.* 1894; oil on canvas, 39½ × 26 in.
National Gallery of Art, Washington, D.C. Chester Dale Collection.

Plate 59 Claude Monet. *La Cathedrale de Rouen le Portail et la Tour d' Albane, Le Matin.* **1894; oil on
canvas, 42 × 29 in.** Monet, with the interest in light characteristic of the Impressionists, often painted the
same subjects at different times of the day. As a result, the hues, values, and intensities are markedly affected,
as can be seen in plates 58 and 59. Structure is dissolved in the artist's preoccupation with color, light, and
atmosphere.
Galerie Beyeler, Basel.

Plate 60 Morris Broderson. *Lizzie Borden and the Ghost of Her Beloved Mother.* 1968; pastel and pencil, 40 × 26 in. The personal style of this artist seems fraught with imminent mystery. This is partly due to his use of predominantly blue color hues.

Courtesy the Ankrum Gallery, Los Angeles, California. Collection of Mr. and Mrs. Walter Nathan.

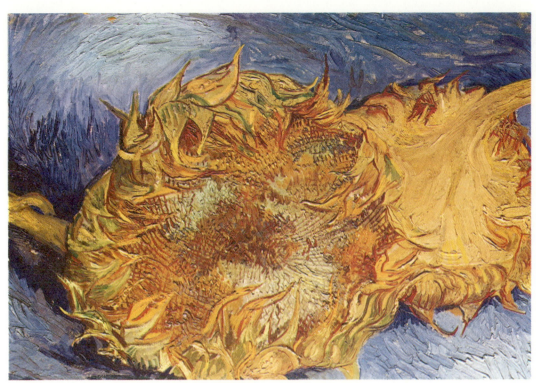

Plate 61 Vincent van Gogh. *Sunflowers*. 1887; oil on canvas. During the late 1880s, van Gogh developed a mature style featuring dominantly hot and lively hues painted with a verve that indicates his personal discovery and passion for the sunny climate of Mediterranean France.
Metropolitan Museum of Art, New York. Rogers Fund, 1949.

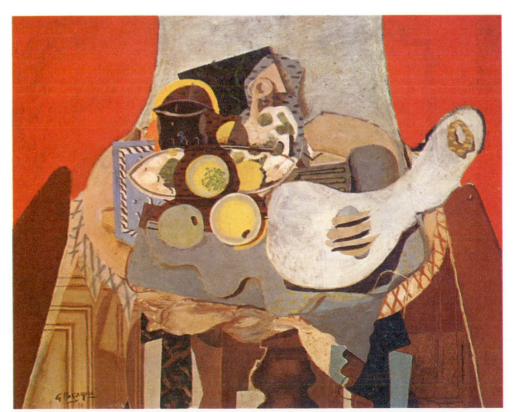

Plate 62 Georges Braque. *Fruits and Guitar*. 1938; oil on canvas, 31⅞ × 39½ in. The Cubist painter Braque commonly achieves aesthetically pleasing arrangements of color and value areas. His inventive hues are probably the choicest of early twentieth-century painting, and his selectivity of placement is equally significant.
Art Institute of Chicago.

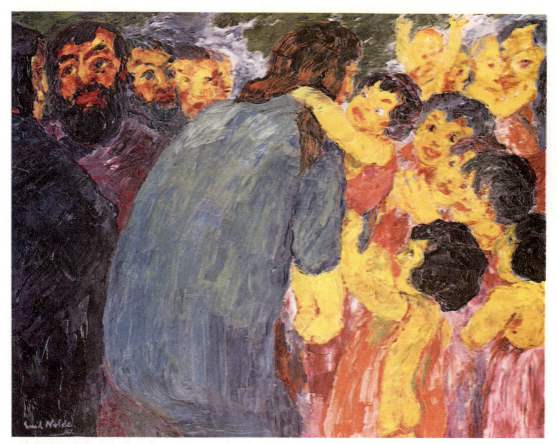

Plate 63 Emil Nolde. *Christ among the Children.* 1910; oil on canvas, 34⅛ × 41⅞ in. The
Expressionists usually employed bold, clashing hues to emphasize their emotional identification with a subject.
Intensity of feeling is created by the use of complementary and near-complementary hues.
Museum of Modern Art, New York. Gift of Dr. W. R. Valentiner.

Color Balance

In all good color combinations there are some relationships and some contrasts. Where colors are related in *hue,* they can exhibit some contrast in *value* and/or *intensity.* The basic problem is the same one present in all aspects of form organization: *variety in unity.* There must be relationships between the color tones, but these relationships must be made alive and interesting through variety. A simple device for creating unity and balance is the *repetition* of similar color tones in different parts of the composition. An important aspect of color balance is based upon our perception of complementary hues. If we look fixedly at a spot of intense red for a few moments and then shift our eyes to a white area, we see an afterimage of the same spot in green-blue, its complement. The phenomenon can be noted when any pair of complementary colors is used. This psychological fact is the basis for our use in many color schemes of a note of *complementary color* to balance the *dominating hue* used (plate 64).

The pleasing quality of a color pattern depends frequently on the amounts or proportions of color used. In general, equal amounts of different colors are not as interesting as a color arrangement in which one color or one kind of color *predominates* (plate 65). We are often confused by color schemes in which all of the tones demand equal importance because we cannot find a *dominant area* on which to fix our attention. The dominance of any one color in a pattern can be due to its hue, its value, or its intensity; dominance can also be affected by the character of the surrounding hues (plate 66). A small, dark spot of color, through its lower value, can dominate a large light area. A spot of intense color, though small, can balance a larger amount of a grayer, more neutralized color. Also, a small amount of warm color usually dominates a larger amount of cool color, although both may be of the same intensity. Complementary colors, which of course vie for our attention through simultaneous contrast, can be made more attractive if one of them is softened or neutralized.

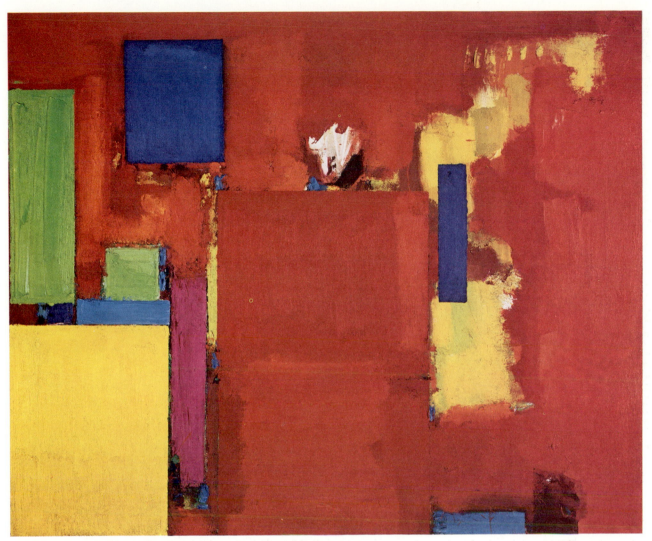

Plate 64 Hans Hofmann. *The Golden Wall.* 1961; oil on canvas. The large areas of red in this painting serve to unify its color tonality. A smaller area of green is used to give balance to the total color pattern. Complementary colors balance and enhance each other.
Art Institute of Chicago. Collection of Mr. and Mrs. Frank G. Logan.

Plate 65 Fernand Léger. *Propellers.* 1918; oil on canvas, 31⅞ × 25¾ in. Although a variety of strong colors appear in this painting, the careful repetition of a key hue (yellow) creates harmony and color balance.
Museum of Modern Art, New York. Katherine S. Dreier Bequest.

Plate 66 Maurice Utrillo. *Rue à Sannois.* circa 1911; oil on canvas, 21½ × 29¼ in. Blue is used as a dominant hue in the painting by Utrillo. He achieves a dynamic balance by his use of smaller areas of complements and neutral white.
Collection, Virginia Museum, Mr. and Mrs. Paul Mellon.

Color Combinations Any attempt to base the aesthetic appeal of color pattern on certain fixed theoretical color harmonies is not satisfactory. For one thing, the effect will depend as much on how we *distribute* our tones as on the *relationships* of the tones themselves. Most combinations, however, can be reduced to *two basic types* of color organization. In the first one, the *unity of the hues* is dominant; in the second, hue combinations that depend on *strong contrast* and *variety* of color for their interest are used. In the unified color scheme enough variety of color must be introduced to keep the effect from becoming too monotonous; in the contrasting color scheme the basic problem is to unify the contrasts without destroying the general strength and intensity of expression. In the first type of color pattern the hue intervals are closely related as in analogous colors; in the second type the hue intervals are further apart, the greatest possible interval being that between two complementary colors.

Unified Color Patterns

Unity is often made dominant in a color scheme by the use of *one hue only*. Naturally, variety can only be achieved in a combination of this kind by using contrasting values or intensities (plate 67). This scheme can be varied by the introduction of a small amount of a subordinate contrasting hue or even a contrasting neutral such as white or black (plate 68). Another way of relating colors where unity is desired is to *key* a number of colors toward one hue (plate 67). This one hue will be a harmonizing factor if a little of it is mixed with every color used in the combination. The same effect can be created by glazing over a varicolored pattern with a single tone of color, which becomes the *key color*. A third type of unified pattern is found when all warm or all cool colors are used in combination (plate 68). Again, however, a small amount of a complementary or a contrasting neutral can be used for variety in the color pattern (plate 69). As a rule, where warm and cool colors are balanced against each other in a composition, it is better to allow one temperature to dominate.

Plate 67 Auguste Renoir. *Two Little Circus Girls.* 1879; oil on canvas, 51½ × 38½ in. Here, unity is achieved by the French artist
Renoir through a dominantly warm color scheme keyed toward yellow to invoke a sense of childhood grace and charm. Although very slight
traces of cool color are found in the painting, variety is basically achieved through modulations of value.
Art Institute of Chicago.

Plate 68 Chang Dae Chien. *Mountain after Rain.* **oil.** This contemporary Chinese artist obviously
follows some of the artistic traditions of his homeland. This painting is largely analogous in hue (blues and
greens), faintly punctuated by other colors.
Courtesy Ankrum Gallery, Los Angeles, California.

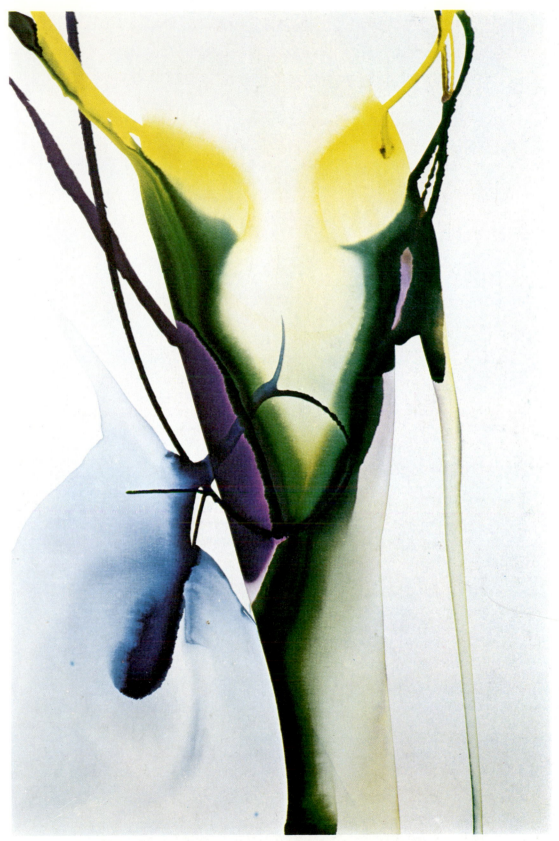

Plate 69 Paul Jenkins. *Phenomena Shield and Green.* 1969; acrylic on canvas, 40 × 26 in. Analogous (related) colors can serve to produce harmony, while touches of a complementary color contribute variety.
Courtesy the Owens-Corning Collection, Owens-Corning Fiberglas Corporation, Toledo, Ohio.

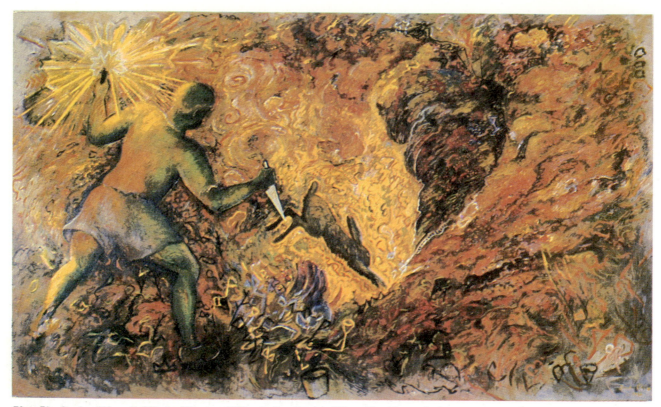

Plate 70 Sandro Chia. *Rabbit for Dinner*. 1981. Italian Sandro Chia, a Neo-Expressionist, uses contrasting hues to charge his emotional picture. The hues are neutralized with black so that unity is achieved without the loss of liveliness. The Museum Stedelijk, Netherlands.

Contrasting Color Patterns

Color schemes based upon a strong *contrast of hue* or *intensity* have great possibilities for expressive effect (plate 70). These contrasts can sometimes be controlled by the amount of contrasting color used. Where the basic unity of a color pattern has been established, strong contrasts of color can be used in *small accents;* their size, then, prevents them from disturbing the basic unity of the color theme. Another commonly used method of controlling contrasts is to separate all or a part of the tones by a *neutral* line or area. Absolute black or white lines are the most effective neutrals for this purpose because they are so positive in character themselves. They not only tie together the contrasting hues, but also serve to enhance their color character because of value contrast. The use of the neutral black leading between the brilliant colors of stained glass windows is an example of this unifying character. Such modern painters as Georges Rouault and Max Beckmann found a black line effective in separating their highly contrasting colors (plate 71; *see* plate 99). A similar unifying effect can be brought about by using a large area of neutral gray or a neutralized color as a *background* for clashing contrasts of color.

Finally, we should remember that combinations of color frequently defy the exactness of any rules and are still satisfying to the eye. Artists use color, as they do the other elements of art structure, to give a highly personalized meaning to the *subject matter* of their work.

COLOR PROBLEMS

Problem 1

Every color the artist uses must be described in terms of three physical properties: *hue, value,* and *intensity.*

a. Hue change
 Using tempera paint, mix the twelve colors indicated in figure 8.4 and mount them in the spaces provided.

b. Intensity change
 Use any pair of complementary colors to create the horizontal/intensity scale illustrated at the top of figure 8.5. At either end the colors should be at spectrum intensity. Gradually mix a little of the complement with each color until a neutral gray is produced, which is placed in the middle rectangle.

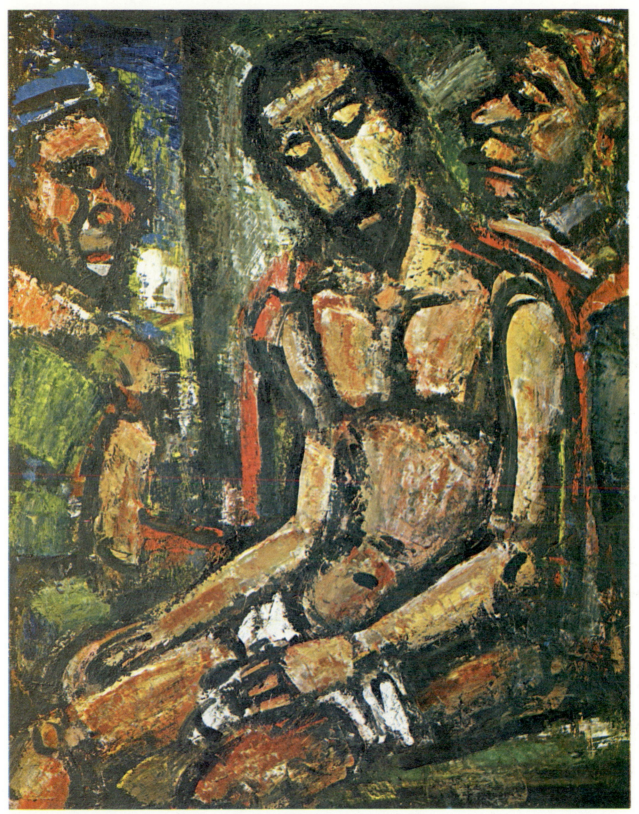

Plate 71 Georges Rouault. *Christ Mocked by Soldiers.* 1932; oil on canvas, 36¼ × 28½ in. Again we have an Expressionist contrast of clashing complements. The pattern and harmony of the painting in this case are stabilized without loss of expression through the heavy neutralizing lines of black suggested to Rouault by medieval stained glass.
Museum of Modern Art, New York. Given anonymously.

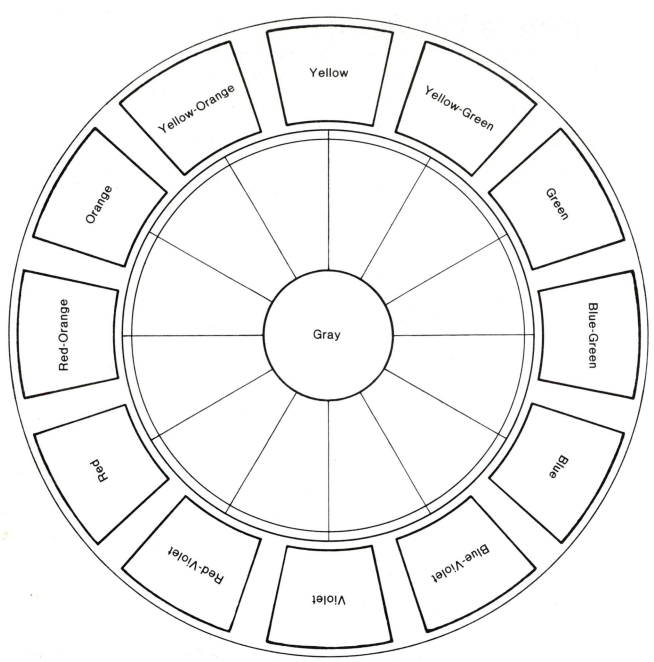

8.4 Color Problem 1a.

c. Value change

In the left vertical column of figure 8.5 create a value scale from white to black by mixing tempera paint. In the right column place any hue from the color wheel, matching it to its nearest corresponding value in the left column. Mix white with this color to match the lighter values, and black to match the darker values.

Problem 2

The use of certain standard color combinations should be explored by the student. The use of such schemes without sensitivity to the quality and relative amounts of color used, however, will not produce a satisfying result.

Lay out a page of drawing paper with five four-by-five-inch rectangles. Within these rectangles repeat a simplified geometric design and paint each one with a different type of color combination. Work some neutrals (black, white, or gray) into each color combination. Use the following standard color schemes:

a. Monochromatic
b. Analogous
c. Complementary

Intensity Change

Spectrum intensity				Gray				Spectrum intensity

Value Change

White	
High light	
Light	
Low light	
Medium	
High dark	
Dark	
Low dark	
Black	

8.5 Color Problem 1b and 1c.

d. Split-complementary (the use of a color and a color next to its direct complement)

e. Triad (secondary or intermediate)

Problem 3

Every color exists in many forms or modifications, although these forms continue to bear the simple hue name. Modification of a color by mixing it with neutrals or even a little of its complement does not change its basic hue. Many modifications can be created from a basic color scheme.

a. Use a simple abstract pattern created by placing a small shape and a medium-sized shape on a larger background area (about 2½ by 3½ inches). Choose any three contrasting colors widely separated on the color wheel and paint each part of the design, including the background, with these colors in their maximum intensity. This represents the basic color scheme.

b. Modify each of the same colors used in part *a* by adding varying amounts of black, white, or gray, or a little of the complementary color. Each color modification should be painted on swatches larger than

the original shape design. Cut the parts of the design from these modifications to make a color variation of the original color scheme.

c. Continue making variations of the original color scheme in the same manner as part *b* until you have ten or twelve.

d. Mount the original color scheme and variations in a pleasing arrangement. Label the original basic color pattern.

Problem 4

The rule of simultaneous contrast states that any color can vary in appearance, depending on the color placed next to it.

a. Research and bring to class several different, interesting styles of numbers. Choose one number in one style and form a repeated pattern composition by first drawing a grid of three horizontal rows, or of five vertical rows, into which you will fit your number motifs. Single or double (or more) motifs are acceptable.

b. Use *one constant* color of low intensity near middle-gray on the value scale. Repeat this color fifteen or twenty times in the shapes of your composition without any touching another. Any shape (positive or negative) counts as a single shape in the design. Fill in the remaining shapes with new colors that contrast with the low-intensity constant in terms of *higher intensity, complementary mixtures,* and *related* or *analogous hues*. Also vary the *values of the hues* (have a range of light, medium, and dark colors). Do not duplicate these colors. Use as many new, contrasting colors as you can. The goal is to change the appearance of the constant color by the new colors you put next to it (i.e., the *rule of simultaneous contrast* will be at work) (plate 72.)

Submitted by Instructor Debra Babylon, Bowling Green State University, Bowling Green, Ohio. Work by Connie Brozska.

Problem 5

Nature's variety of colors can be better understood if a natural object such as, a shell, leaf, rock, or tree bark is utilized as a source of color study.

Select a natural object. Mix tempera paint to match the colors of the object. Cut several three-inch lengths of string. Dip or paint the string so that the painted string matches the colors of the object. When dry, arrange the string so that the colors are in order and in the same proportion as those on the object, from top to bottom. Cut an opening in matt board 2 × 3 inches. Glue the painted string on a piece of matt board slightly larger than the opening. Attach it to the back of the board so that it can be seen through the opening. The natural object (in this case a shell) is then mounted to the front of the matt board. For total design effect, the size of the opening and the placement of the mounted object can be varied (plate 73).

Submitted by Lily H. J. Pomeroy, Assistant Professor of Art, Livingston University, Livingston, Alabama. Source: Mr. Joe Pacheco, Kansas State University. Work by Mike Davis.

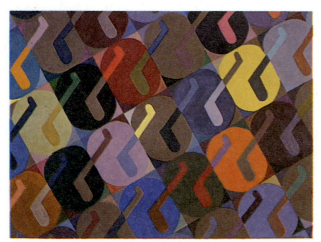

Plate 72 Connie Brozska. *Color Problem 4.* 1984; acrylic paint on illustration board, 15 × 20 in.
Bowling Green State University, Debra Babylon.

Plate 73 Mike Davis. *Color Problem 5.* 1984; string painted with tempera; mounted with shell on mat board.
Livingston University, Mr. Joe Pacheco.

Problem 6

A natural subject may be interpreted by the artist in many different styles of color tonality, either unified or contrasting in hue character. Ignoring the local color character of the object enables the artist to express a personal feeling or emotional quality.

Set up an arrangement of three or four simple still-life objects. Using any medium or combination of media, interpret the subject in several of the following color organizations:

a. Strongly contrasting hues and values
b. Closely related hues and values
c. Dominant cool colors with warm accents
d. Dominant warm colors with black or white accents
e. A dark-toned color scheme with contrasting hues
f. A light-toned color scheme with contrasting hues
g. Contrasting colors used with black or white lines

Lines and textures in neutral tones can be used as decorating embellishments on, in, or around the color shapes. Areas of shadow might be ignored or considered color shapes. Remember that the expressive quality of the color pattern is more important than the naturalistic appearance of the subject matter.

Problem 7

Plastic use of color implies spatial relationships created by certain types of color organization. Colors that are warm in hue character and have high intensity seem to advance, whereas those that are cool and have low intensity seem to recede. Also, colors that are complementary to their background seem to occupy a space in front of it.

Plan an arrangement of simple planes overlapping in space. Vary the size and position of the planes to create interest. Cut these shapes from a variety of colored papers and paste them on a background of neutral or neutralized color. Choose the colors so that they will help to establish the spatial recession of forms.

Problem 8

 Colors make a direct appeal to the emotions. Generally speaking, such emotional states as anger, melancholy, jealousy, and the like have come to be associated with specific colors. Sensitive color employment in combination with appropriate use of the other elements of form may express greatly varied emotional feelings.

Select a black-and-white reproduction of a painting (or even a photograph) that seems to have a specific mood. Reproduce this work in any medium using a color scheme expressive of that mood. Pay no attention to the naturalistic qualities of color, but make sure that all other factors (particularly the light-and-dark pattern) are true to the work being reproduced.

Problem 9

The Impressionistic painters of the nineteenth century developed a technical painting method to simulate the illusion of light, color, and atmosphere. Because they knew that light was composed of varying wavelengths of color, they painted surfaces with dabs of different colors placed side by side in an attempt to catch the vibrating quality of light rays. They realized that the eye would mix or fuse these colors into the variations or color mixtures they desired.

Set up a group of simple still-life objects and draw the group in simple outline form. Using tempera paint, express the quality of color in the objects by painting dots or short dabs of color on the picture surface. Instead of mixing colors on a palette, merely place them on the paper so that they will mix when the eye perceives them from a distance. For example, dots of pure green could be used with dots of blue or yellow to create modifications of hue and value. In some areas, dabs of complementary color might be used to modify the local colors seen. Dabs of cool color could be used in shadow areas to create spatial recession. The dots of color may mix with or overlap each other. It will probably be necessary to create definite value differences between forms in order that they will stand out from each other. Do not feel bound by rules in this problem. Instead, experiment with different tonal effects.

9
SPACE

THE VOCABULARY OF SPACE

atmospheric (aerial) perspective The illusion of deep space produced in graphic works by lightening values, softening contours, reducing value contrasts, and neutralizing colors in objects as they recede.

decorative space A concept in which the visual elements have interval relationships in terms of a two-dimensional plane.

four-dimensional space A highly imaginative treatment of forms that gives a sense of intervals of time or motion.

fractional representation A device used by various cultures (notably the Egyptians) in which several spatial aspects of the same subject are combined in the same image.

infinite space A pictorial concept in which the illusion of space has the quality of endlessness found in the natural environment. The picture frame has the quality of a window through which one can see the endless recession of forms into space.

interpenetration The movement of planes, objects, or shapes through each other, locking them together within a specific area of space.

intuitive space The illusion of space resulting from the exercise of the artist's instincts in manipulating certain space-producing devices, including overlapping, transparency, interpenetration, inclined planes, disproportionate scale, fractional representation, and the inherent spatial properties of the art elements.

orthographic drawing A two-dimensional graphic representation of an object showing a plan, a vertical elevation, and/or a section.

plastic space A concept in which the visual elements on the surface of the picture plane are made to give the illusion of having relationships in depth as well as in length and breadth.

shallow space Sometimes called *limited depth* because the artist controls the use of the visual elements so that no point or form is so remote that it does not take its place in the pattern of the picture surface.

space Can be characterized as boundless or unlimited extension in all directions; void of matter. Artists use the term to describe the interval or measurable distance between preestablished points.

three-dimensional space A sensation of space that seems to have thickness and depth as well as length and breadth.

transparency A situation in which a distant plane or shape can be seen through a nearer one.

two-dimensional space Measurable distances on a surface that show length and breadth but lack any illusion of thickness or depth.

INTRODUCTION

Although *space* is not considered an *element* of two-dimensional art, its presence is nevertheless felt in every work of art, presenting fundamental problems that the artist must face. Space is here conceived as a *product* rather than as a *tool*. It is created by the tools or art elements discussed in the preceding chapters. The importance of space lies in its function, and a basic knowledge of its implications and use is essential for every artist. Space, as defined in this chapter, is limited to the graphic fields, that is, two-dimensional surface arts such as drawing, painting, printmaking, and the like. The space that exists as an illusion in the *graphic* fields is actually present in the *plastic* areas of sculpture, ceramics, jewelry, architecture, and so forth. Their three-dimensional space concepts are discussed in chapter 10.

SPATIAL PERCEPTION

All spatial implications are mentally conditioned by the environment and experience of the viewer. Vision is experienced through the *eyes* but interpreted with the *mind*. Perception involves the whole pattern of nerve and brain response as well as the visual stimulus. We use two eyes to perceive objects in nature and continually shift our focus of attention. In so doing, two different types of vision are used: *stereoscopic* and *kinesthetic*. Having two eyes set slightly apart from each other, we see two different views of the object world at the same time. The term *stereoscopic* is applied to our ability to overlap these two slightly different views into one image. This visual process creates an illusion of three-dimensional depth, making it possible to judge distances.

With kinesthetic vision we experience space in the movements of the eye from one part of a work of art to another. Space is experienced while viewing a two-dimensional surface because we unconsciously attempt to organize its separate parts so that they can be seen as a whole. In addition, we explore object surfaces with eye movements in order to make mental recognition of them. Objects close to the eye require more ocular movement than those more distant, and this factor adds spatial illusion to our kinesthetic vision.

9.1 Stuart Davis. *Standard Brand.* **1961; oil on canvas, 60 × 46 in.** Davis worked with planes generally parallel to the picture surface. Certain devices such as overlapping and transparency are employed but never in such a way as to seriously contradict the concept of flatness.
Courtesy of the Detroit Institute of Arts. Founder's Society Purchase, General Membership Fund.

TYPES OF SPACE

Two basic types of space are available to the artist: decorative space and plastic space. Both are fundamental to spatial conception.

Decorative Spatial Concept

The actual surface to which graphic artists are physically limited in their art is two-dimensional, and suggestions of space as they occur on this surface are almost entirely a matter of premeditated illusion. The usual *picture plane* (paper, canvas, board, etc.) has height and width (*see* chapter 2 *form* definition) but no depth that could be of any significance to the artist. This depthless surface could be called *decorative space* or a space that exists *across* the plane rather than in it. When artists add any element of art to this blank surface plane, they begin to cut, divide, and rearrange the decorative space into smaller units. When this happens, the illusion of depth can appear either *accidentally* or *intentionally*. The depth (or three-dimensional space) and the divisions across the surface (or two-dimensional space) are of vital concern to the artist, for they must both be organized into a coherent whole.

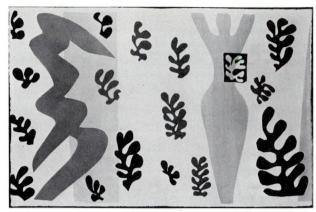

9.2 Henri Matisse. *The Knife Thrower* from *Jazz.* **1947; color stencil, 15⅞ × 25½ in.** No depth was intended in this decorative and ornamental abstraction. The flatness of the shapes is exaggerated by avoiding modeling, but vitality is maintained by variations of contour, value, and color. A silhouetted effect is the dominant feature.
Philadelphia Museum of Art. Purchased: McIlhenny Fund.

Decorative space invariably exists in the sense that distances between images or elements can be measured *across* the picture plane. It exists in theory only in the sense that the image is completely confined to the picture plane. Thus, in terms of depth, decorative space becomes a matter of degree. Decorative space ceases when it is obvious that the artist intends to divorce the *image* from the *plane* on which it physically rests. The human mind probably could not accept the idea of a perfectly flat surface in an artwork. Because of memory overlays of objective experiences, the slightest manipulation of line, value, or color generates *an illusion of depth-space* (figs. 9.1 and 9.2).

Plastic Spatial Concept

The term *plastic* is applied to all images that assume the qualities of the third dimension. Artists base much of their work on their experiences in the objective world, and it is a natural conclusion that they should explore the resources of pictorial space.

Deep and/or Infinite Space

An artwork that emphasizes *deep space* denies the picture plane except as a starting point from which the space begins. The observer of such a work seems to be moving continuously in the far distances of the picture field. This spatial feeling is similar to looking through an open window over a landscape that seems to roll on and on into infinity. The infinite quality of *illusionistic space* is created by the recognition of spatial indications that are produced by certain relationships of art form. Size, position, overlapping images, sharp and diminishing details, converging parallels, and perspective are the traditional methods of indicating deep spatial penetration (*see* fig. 7.14).

9.3 Box of space (side). The box represents the imaginary "box of space" behind each picture. Overall, the diagram simulates a simple landscape, A being the picture plane, B the ground plane (slightly rolling) and C large hills or mountains. Check the accompanying diagram to verify this effect.

Note that in this diagram the building is presented as projecting from the picture plane. Artists can create the effect of protrusion. Sometimes it is called a *violation* of the picture plane, at other times "trompe-l'oeil" (fool the eye). The planes represented here could have been equipped with wheels because the artist can move them back and forth by manipulating the elements.

9.4 Box of space (front). This is roughly what we would see if the box of space were viewed from the front. It gives us some simulation of atmospheric perspective because the foreground plane has been made darker. The sky has been left vacant; if given a value it would shrink the space somewhat.

Infinite spatial concepts, sometimes called atmospheric perspective, dominated Western art from the beginning of the Renaissance (about 1350) to the middle of the nineteenth century. During this period, generations of artists, such as Uccello, Botticelli, Ruisdael, Brueghel, Rembrandt, Poussin, and Corot, to name only a few, developed and perfected the deep space illusion because of its obvious accord with *visual reality* (plate 74). Present-day art is largely dominated by the *shallow space concept*, but many contemporary artists work with strongly recessed fields. Any space concept is valid if it demonstrates consistent control of the elements in relation to the spatial field chosen.

Shallow Space

Artists often take an intermediate spatial position, keeping some of the qualities of deep space but relating them to the picture plane. Awareness of the presence of the picture surface usually limits the space of a composition. Varying degrees of *limited space* are possible, ranging from the near-decorative to the near-infinite. Limited or *shallow space* could be compared to the restricted spatial feeling of a box or stage (figs. 9.3 and 9.4). Egyptian, Oriental, Byzantine, and medieval artists used comparatively shallow space in their works.

The works of the early Renaissance were often based on shallow sculpture reliefs (plate 75). In the neoclassic paintings of Jacques Louis David, a nineteenth-century artist, most of the figure action was limited to a single plane in the foreground. David interwove his figures decoratively on a stagelike plane that was limited by a backdrop of flat architecture (fig. 9.5 and *see* fig. 11.1).

Many modern artists have elected to use shallow space on the theory that it allows more positive control and is more in keeping with the flatness of the working surface. Gauguin, Matisse, Modigliani, and Beckmann are typical advocates of the limited spatial concepts (fig. 9.6).

TRADITIONAL TYPES OF SPACE INDICATION

Artistic methods of spatial representation are so interwoven and interdependent that an attempt to isolate and examine all of them would be impractical and inconclusive. The illustration of all spatial means would be an interminable task and leave the reader with the feeling that art is entirely formulaic.

Our comprehension of space that comes to us through objective experiences is enlarged, interpreted, and given meaning by the use of our *intuitive faculties*. Spatial order develops when the artist *senses* the right

9.5 Shallow space. As a variation on the concept of shallow space, artists occasionally define the planes that make up the outer limits of a hollow boxlike space behind the picture plane. The diagram shows this concept, although in actual pictorial practice, a return to the picture plane would be made through objects occupying the space defined. The back plane acts significantly as a curtain that prevents penetration into deep space (*see also* fig. 11.1 and plate 84).

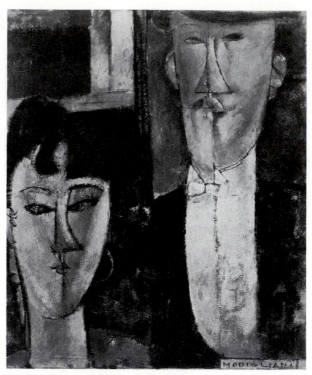

9.6 Amedeo Modigliani. *Bride and Groom.* 1915–1916; oil on canvas, 21¾ × 18¼ in. Modigliani dealt with simplified monumental forms given plasticity by subtle linear and value treatment and enriched by sensitive paint application. The space behind the figures is usually limited to broad, severe shapes that restrict the vision of the viewer to a narrow corridor of space. Museum of Modern Art, New York. Gift of Frederic Clay Bartlett.

balance and the best placement and then selects vital forces to create completeness and unity. Obviously, then, this process is not a purely intellectual one but a matter of instinct or subconscious response (fig. 9.7).

Since the *subjective* element plays a part in the control of space, we can readily see that emphasis on formula here, as elsewhere, can quench the creative spirit. Art is a product of human creativity and is always dependent on individual interpretations and responses. Space, like other qualities in art, might be both spontaneous or premeditated, but always is the product of the artist's will. If an artist has the impassioned will to make things so, they will usually be so, *despite inconsistency and defiance of established principles.* Therefore, the methods of spatial indication discussed in the following pages are those that have been used frequently and that guarantee one effect of space, though not necessarily one that is always exactly the same. These traditional methods are presented merely as a means of giving the student a basic conception of the more significant spatial forces.

Size

We usually interpret largeness of scale as meaning nearness. A smaller scale conversely suggests spatial distance. If two people were to stand at distances of five and fifteen feet from us, the nearer figure would appear larger than the other. The difference of scale between the two figures would not ordinarily be understood as showing a large and a small person (although this could conceivably play a part in our perception), but people of approximately the same size placed at varying distances from us (fig. 9.8). Therefore, if we are to use depth-scale as our guide, a figure, regardless of all other factors, must assume a scale to correspond to its distance from us. This concept of space has not always been so in art. In many broad periods and styles of art and in the works of children, large scale is assigned according to importance, power, and strength, regardless of spatial location (fig. 9.9 and plate 76).

Position

For many artists and observers there is an automatic inference that the *horizon line*, providing a point of reference, is always at *eye level*. The position of objects is judged in relation to the horizon line. The bottom of the picture plane is seen as the closest visual point, and the degree of rise of the visual units up to the horizon line indicates subsequently receding spatial positions

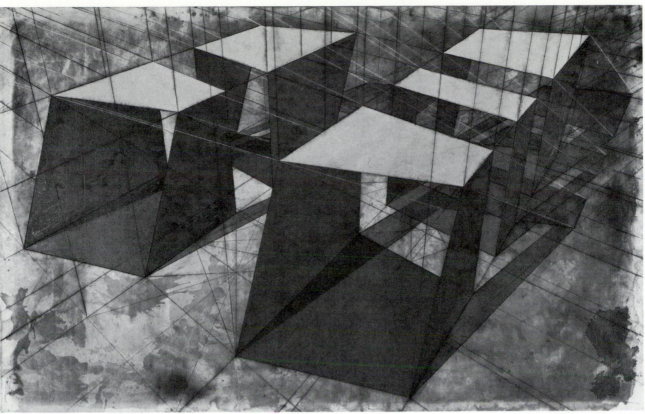

9.7 Ron Davis. *Parallelepiped Vents #545.* 1977; acrylic on canvas, 114 × 180 in. The strict order of linear perspective is not observed here, but space is achieved by other means under the control of the artist's instincts.
Courtesy of the Los Angeles County Museum of Art. Museum Purchase, Art Museum Council Fund.

9.8 Figures in space. These shadow figures grow smaller as they recede into space. The illusion of space is enhanced by the horizon line by which spatial depths are often judged. As the figures are divided roughly in half, we can estimate (assuming six-foot figures) that the viewer's position is about three feet high.

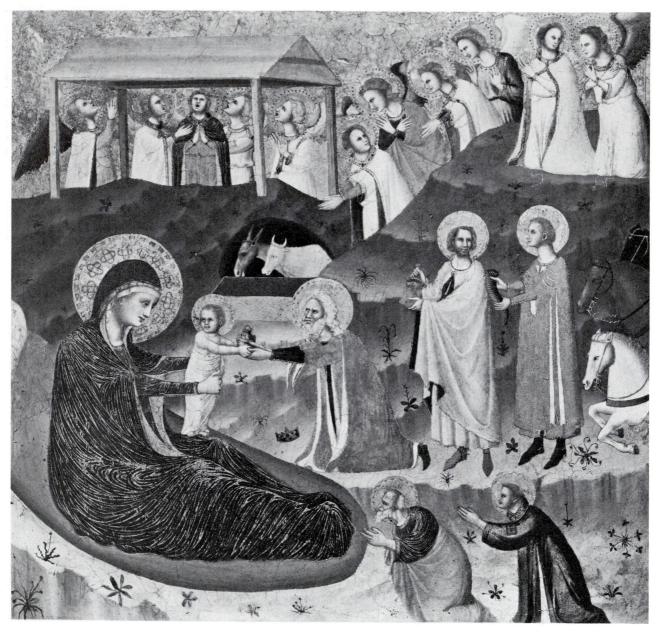

Figure 9.9 Master of the Blessed Clare. *The Adoration of the Magi.* circa 1340; tempera/gesso on panel, 31½ × 31¼ in. (including frame). The importance of the Madonna accounts for the unexpectedly large scale of her figure. This disproportionate size produces a strange conflict with the semirealistic space with which the size of the angels is more in harmony. The adjustment of size to equal importance is known as hieratic scaling.
Lowe Art Museum. University of Miami. Coral Gables, Florida. Kress Collection.

(fig. 9.10). Evidence suggests that this manner of seeing is instinctive (having grown out of continued exposure to the objective world), for its influence persists even in viewing greatly abstracted and nonobjective work (plate 77). The alternative, of course, is to see the picture plane as entirely devoid of spatial illusion and the distances of the visual elements as actually measurable across the flat surface. It is difficult to see this way even when we discipline ourselves to do so, for it calls on us to divorce ourselves entirely from ingrained environmental factors.

Overlapping

Another way of suggesting space is by *overlapping* planes or volumes. If one object covers part of the visible surface of another, the first object is assumed to be nearer. Overlapping is a powerful indication of space, for once the device is used, it takes precedence over other spatial signs. For instance, if one ball is placed in front of a larger ball, it appears closer than the larger ball, despite its smaller size (fig. 9.11).

9.10 Placement of squares. A line across the picture plane reminds us of the horizon that divides ground plane from sky. Consequently, the lower shape seems close, the intermediate shape more distant, and the upper square is in a rather ambiguous position in space because it touches nothing and seems to float in the sky.

9.12 Rectilinear upright planes with overlapping and transparency. The small shape on the left seems distant from its partner partly because of its smaller size and partly because of its position up the picture plane. The smaller shape in the lower group is closer because of its overlapping, but its smaller size makes it retreat and seem to push against the other shape; the space is shallow. In the upper group the top shape is considerably distanced from the one that overlaps it while the other small shape, though overlapped, is drawn fairly close to the large shape by its transparency.

9.11 Overlapping.

Transparency

The overlapped portion of an object is usually obscured from our view. If, however, that portion is continued and made visible through the overlapping plane or object, the effect of *transparency* is created. Transparency tends to produce a closer spatial relationship and is clearly evident in the upper triangle in the painting by Jack Brusca (*see* fig. 5.23). It is most noticeable in the works of the Cubists and other artists who are interested in shallow space (fig. 9.12 and *see* fig. 11.18).

Interpenetration

Interpenetration occurs when planes or objects pass through each other, emerging on the other side. It provides a very clear statement of the spatial positioning of the planes and objects involved, and can be used to create the illusion of either shallow or deep space (fig. 9.13).

Fractional Representation

Fractional representation can best be illustrated by pointing out the treatment of the human body by Egyptian artists. Here we can find, *in one figure*, the profile of the head, a frontal eye, the front of the torso, and the side view of the hips and legs. This is a combining of the most representative aspects of the different parts of the body (figs. 9.14 and 9.15). Fractional representation is a spatial device revived in the nineteenth century by Cézanne, who used its principles in his still-life paintings (*see* "Plastic Image" in this chapter), and employed by many twentieth-century artists, most conspicuously Picasso. The effect is flattening in Egyptian work, but plastic in the paintings by Cézanne since it is used to move us "around" the subjects.

9.13 Interpenetrating planes. The passage of one plane or volume through another automatically indicates a spatial situation.

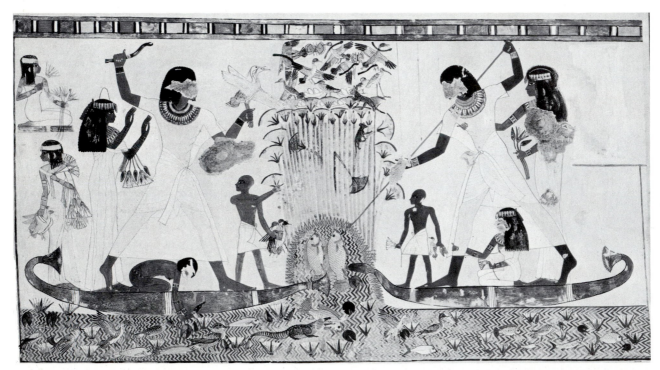

9.14 Egyptian reproduction. *Fishing and Fowling.* wall painting, XVIII Dynasty, circa 1415 B.C. Thebes; tomb of Menena, scribe of the fields of the lord of two lands; (copy in tempera). This work illustrates the Egyptian concept of pictorial plasticity as a combination of various representative views of the figure combined in one image (fractional representation) kept compatible with the flatness of the picture plane. The arbitrary positioning of the figures and their disproportionate scale add to this effect.
Metropolitan Museum of Art, New York.

9.15 Fractional representation. This drawing illustrates the Egyptian technique of fractional representation of the human figure. The head is in profile, but the eye full-face. The upper body is frontal, gradually turning until the lower body, from the hips down, is seen from the side. This combines characteristic views of the body; in order to see these views one would have to move around the body.

Sharp and Diminishing Detail

Because of the construction of the human eye, we are not able to see *with equal clarity* near and distant planes at the same time. A glance out the window confirms the fact that close objects appear sharp and clear in detail, whereas those at great distances seem blurred and lacking in definition. Artists have long been cognizant of this phenomenon and have used it widely in illusionistic work. In recent times artists found that they could use this method and other traditional methods of space indication in works that are otherwise quite abstract. Thus, in abstract and nonobjective conceptions,

9.16 Converging parallels.

sharp lines, clearly defined shapes and values, complex textures, and intense colors are associated with foreground or near positions. Hazy lines, indistinct shapes, grayed values, simple textures, and neutralized colors are identified with background locations. These characteristics are often included in the definition of atmospheric perspective (plate 78).

Converging Parallels

The general principle of spatial indication of converging parallels can be illustrated through the use of a rectangular plane such as a sheet of paper or a tabletop (fig. 9.16). By actual measurement, a rectangle possesses one set of short parallel edges and one set of long parallel edges. If the plane is arranged so that one of the short edges (*A*) is viewed head-on, its corresponding parallel edge (*B*) will appear to be much shorter. Since these edges appear to be of different lengths, the other two edges (*C* and *D*) that connect them must seem to converge as they move back into space. Either set of lines, when separated from the other set, would continue to indicate space quite forcefully. The principle of converging parallels is found in many works of art that do not abide by the *rules of perspective*. It is closely related to perspective, but it is not necessarily restrictive in a creative sense (plate 79).

9.17 One-point perspective. In this simple diagram linear perspective controls the image. This is done in one-point perspective, the vanishing point being the point of convergence at the right. This point determines the reduction in size of the telephone poles and road. By carrying this method one step further, the distances between the poles diminish as they recede in space.

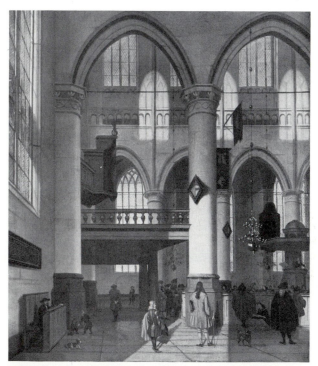

9.18 Hendrik van Streek. *Interior of the Old Church in Amsterdam.* **1690s; oil on canvas, 21⅞ × 18¾ in.** The artist's position is the reference point from which all edges are defined in this work utilizing linear perspective.

Courtesy the Toledo Museum of Art, Toledo, Ohio. Gift of Edward Drummond Libbey, 1958.

Geometric Perspective

Geometric perspective is a system used for converting sizes and distances of known objects into a unified spatial order. Its use involves the application of some of the other spatial indications, such as size, position, and converging parallels. Since the Renaissance linear perspective has been the principal device for spatial representation in the art of the Western world.

The general understanding of perspective did not originate with the Renaissance, but the wave of scientific inquiry that swept many countries during that period brought this spatial system to a point of high refinement. Renaissance artists focused their attention on one view, a selected portion of nature, seen from one position at a particular moment in time. The use of *vanishing points, eye levels* and *horizon lines,* and *guide lines* gave this view mathematical exactitude (fig. 9.17). To a certain extent, artists became prisoners of the system they had helped to produce. Because it is a system of inflexible rules, perspective places emphasis on *accuracy of representation,* an emphasis that does not favor *creative expression.* If, however, artists see perspective as an aid rather than an end in itself, as something to be used *when* and *if* the need arises in the

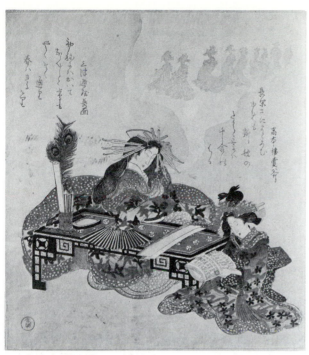

9.19 Kubo Shunman. *Courtesans Dreaming.* The reversal of normal perspective in the table is a deliberate device used by this Japanese artist to limit the depth of space in the painting. Metropolitan Museum of Art, New York. Bequest of Mrs. H. O. Havemeyer, 1929. The H. O Havemeyer Collection.

creation of a picture, it can be very useful to them. Many fine works of art that ignore perspective or show "faults" in the use of the system have been created. In such cases the type of spatial order created by perspective simply is not compatible with the aims of the artist. Perspective, then, should be learned by artists simply so that it is available to them (fig. 9.18, plate 80, and *see* plate 29).

The traditional East Asian artist could be cited as a dramatic countertype to the Renaissance artist of the West. Ancient canons prescribed convergence of parallel lines as they *approach* the spectator, creating a *reverse perspective*. This type of presentation closes the space in depth so that the picture becomes a stage and the spectator an actor-participant in an active spatial panorama rarely losing its identification with the picture plane (figs. 9.19 and 9.20). Similar space concepts have been employed in the West during various historical periods. Ideas on pictorial space usually agree with the prevailing mental climate of the society that produces the art. In this sense, space is a form of human expression.

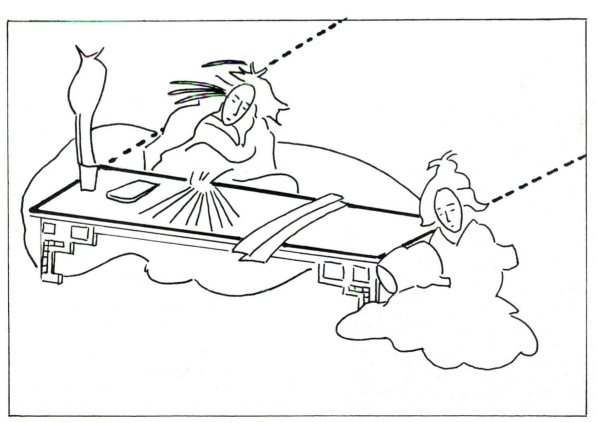

9.20 A simple analysis of *Courtesans Dreaming* shows that if the lines defining the ends of the table are extended (dotted lines) into space they will never meet, as they would in the linear perspective of the western artist. The closer end of the table is no larger than the other, as would be expected. These are characteristics typical of the open perspective of East Asian art.

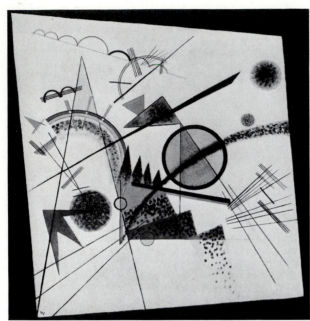

9.21 Vasily Kandinsky. *In the Black Square.* 1923; oil, 38⅜ × 36⅝ in. Kandinsky has varied the physical properties of the abstract elements so that they take different positions in space. Solomon R. Guggenheim Museum, New York.

9.22 Lines of various physical properties. Vertical, horizontal and some diagonal lines often occupy a fixed position in space. Wavy, spiral, serpentine and zigzag lines move back and forth in space. Alterations in line thickness modify spatial position.

SPATIAL PROPERTIES OF THE ELEMENTS OF ART STRUCTURE

The spatial effects that arise from the use of the elements of art structure must be recognized and controlled. Each of the elements possesses some inherent spatial qualities, but the interrelationship among elements yields the greatest spatial feeling. Many types of spatial experiences can be achieved by manipulating the elements, that is, by varying their position, number, direction, value, texture, and color. The resultant spatial variations are endless (fig. 9.21).

Line and Space

Line, by its physical structure, implies continued direction of movement. Thus, line helps to indicate spatial presence. Since, by definition, a line must be greater in length than in breadth (or else there would be difficulty in distinguishing a line from a dot or shape), it tends to emphasize one direction. The extension of this dominant direction in a single line creates continuity, moving the eye of the observer from one unit or general area to another. Line can be a transition that unifies the front, middle, and background areas.

The physical properties of line contain other spatial ingredients. Long and short, thick and thin, and straight, angular, and curved lines take on different spatial positions and movements in contrast with each other. The indications of three-dimensional space mentioned earlier in this chapter are actively combined with the physical properties of line. A long and thick line, for instance, appears larger in size (a spatial indication) and hence closer to the viewer than a short and thin line. Overlapping lines establish differing spatial positions, especially when they are set in opposite directions (that is, vertical against horizontal). A diagonal line seems to move from the picture plane into deep space, whereas a vertical or horizontal line generally seems to remain comparatively static (fig. 9.22). In addition, the plastic qualities of such overlapping lines can be increased by modulating their values. The plastic illusion invariably suggests change of position in space. A single line similarly can be modulated in value and dimension to add to its plastic qualities (figs. 9.23 and 9.24).

The spatial indication of line convergence that occurs, subject to rule, in mechanical perspective is always in evidence wherever a complex of lines occurs. The types of spatial suggestions arising out of this general principle are of such infinite variety that particular effects are usually the product of the artist's *intuitive* explorations. Wavy, spiral, serpentine, and zigzag line types adapt to all kinds of space through their unexpected deviation of direction and accent. They seem to move back and forth from one spatial plane to another. Unattached single lines seem to define their own space and may have plastic qualities within themselves. Lines also serve to clarify the spatial dimensions of solid shapes.

9.25 Planes in space. In this example the outlines of the two-dimensional shapes (or planes) are varied in thickness and placement, while two edges converge toward the back to give the effect of three-dimensional space. The overlapping of planes enhances the effect of hollowing out behind the picture plane.

Shape and Space

In terms of space, *shape* may refer to planes, solids, or volumes, all of which occupy space and are therefore entitled to consideration in this chapter. A plane, which to the artist is physically two-dimensional, may create the illusion of three-dimensional space (fig. 9.25). The space appears two-dimensional when the plane seems to lie on the picture surface (fig. 9.26). The space appears three-dimensional when its edges seem to converge at a point toward either the front or the back of the picture plane.

Solids, volumes, and masses automatically suggest three dimensions. Such shapes express the space in which they must exist and actually become a part of it. Planes, solids, and volumes can be made to take a distant position by diminishing their size in comparison to others in the frontal picture areas and by neutralizing their value, color, intensity, and detail. This treatment relates back to the indications of space outlined earlier in this chapter (figs. 9.27 and 9.28).

Value and Space

The plastic effect of value can be used to control pictorial space. When a light source is assumed to be in front of a work, the objects in the foreground appear light. The middle and background objects become progressively darker as they move away from the picture plane (*see* plate 78). When the light source is located at the back of the work, the order of values is reversed. The order of value change is consistent in gradation from light to dark or dark to light (fig. 9.29).

9.23 Robert Shuler. *Leucoryx.* 1950; print: engraving, 12 × 14¾ in. Variation of line width suggests movement in space. When the line serves for mass, the spatial movement modifies the line's plastic qualities, causing it to take on new dimensions. Courtesy of the artist.

9.24 Vivien Abrams. *Changing Dynamics.* 1984; oil on masonite, 21¾ × 21½ × 2¼ in. The overlapping and convergence, as well as the physical properties of the lines in this work, have been orchestrated to create a strong illusion of space. Luise Ross Gallery, New York.

9.26 Flat planes. Since the shape outlines consist of horizontals and verticals repeating the essential two-dimensional nature of the picture plane (as determined by the horizontals and verticals of the border), this diagram is an example of two-dimensional space-shape relationships.

9.27 Planes and solids in space. The relationship of planes in this diagram describes an effect of solids or volumes that in turn seem to occupy space. The size, overlapping, and placement of these volumes further increase the effect of solidity. The horizontal shaded lines are used to indicate an imaginary position for the picture plane to cause a projection of the near-volume into the observer's space, or in front of the picture plane.

9.28 Al Held. *B/WX* 1968; acrylic on canvas, 114 × 114 in. Although the physical properties of the lines in this work are consistent throughout, the *arrangement* of the lines causes the enclosed shapes to be seen in different spatial positions as in an optical illusion. There is some similarity to Op art.
Albright-Knox Art Gallery, Buffalo, New York. Gift of Seymour H. Knox.

In the natural world, foreground objects are seen with clarity and great contrast, while distant objects are ill-defined and gray. Therefore, neutral grays, when juxtaposed with blacks or whites, generally take a distant position.

Cast shadows are sometimes helpful in describing plastic space, but may be spatially confusing and even injurious to the design if they are not handled judiciously (*see* figs. 6.6 and 11.27).

Value-modeling can be *abstract* in the sense that it need not follow the *objective natural order* of light and dark. Many artists have totally ignored this natural order, using instead the inherent spatial position resulting from the *contrast* of dark and light (fig. 9.30).

Texture and Space

Because of the surface enrichment that texture produces, it is frequently a temptation to think of this element purely in terms of *decorative* usefulness. Actually, texture functions *plastically* by describing the depth position of surfaces. Generally speaking, sharp, clear, and bold textures seem to advance, while fuzzy, dull, and minuscule textures recede. When modified through varied use of value, color, and line, texture significantly contributes to the total pictorial unity.

Plate 74 Jacob van Ruisdael. *Wheatfields.* **circa 1670; oil on canvas, 51¼ × 39⅜ in.** Early Dutch landscape painting, which aimed at the maximum illusion of visual reality, emphasized the infinite space concept. Diminishing sizes of objects and hazy effects of atmospheric perspective give the viewer a sense of seeing into far distances. Metropolitan Museum of Art, New York. Bequest of Benjamin Altman, 1913.

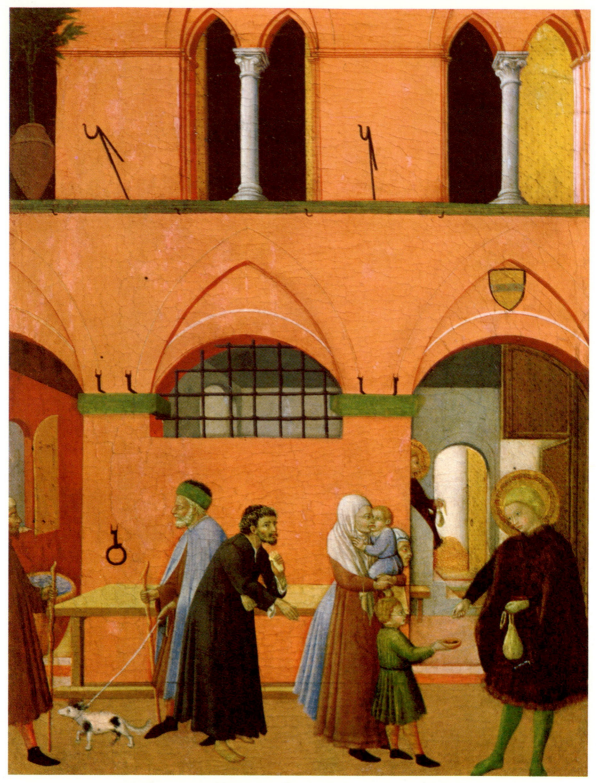

**Plate 75 Sassetta and assistants. *St. Anthony Distributing His Wealth to the Poor.* 1440; paint on wood,
18⅝ × 13⅝ in.** A shallow stagelike space is achieved in this early Renaissance painting. The work is
composed in terms of two flat planes represented by the figures in front and the architectural structure in back.
National Gallery of Art, Washington, D.C. Samuel H. Kress Collection.

Plate 76 Georges Seurat. *Sunday Afternoon on the Island of La Grande Jatte.* 1884–1886; oil on canvas, 81 × 120⅜ in. The obvious progression of sizes in the figures of Seurat's painting are a strong indication of spatial recession. At the same time, these figures are carefully placed to give balance to the pattern of space and shape relationships. Another characteristic of this picture is its use of small dabs or dots of color, inherited from the impressionist technique, to express the illusion of light, color, and atmosphere. Art Institute of Chicago.

Plate 77 **Winslow Homer.** *Breezing Up.* **1875–1876; oil on canvas, 24⅛ × 38⅛ in.** The horizon line in this painting describes a separation of space into a ground plane below and a sky plane above. The smaller size and higher position of the distant boat helps to achieve the spatial effect.
Courtesy the National Gallery of Art, Washington, D.C. Gift of W. L. and May T. Mellon Foundation.

Plate 78 Meindert Hobbema. *The Watermill with the Great Red Roof.* circa 1663–1665; oil on canvas, 32 × 43⅛ in. Concerned with the lyric qualities of landscape painting, Hobbema commonly used back-lighting. This created a unified gradation of dark moving toward a light, though consistently atmospheric, background.
Art Institute of Chicago.

Plate 79 Richard Balabuck. *Home Again.* 1982; computer print: photo silk screen, 20 × 24 in. The principle of converging parallels is closely related to the rule of perspective, but is not restrictive in a creative sense.
From the artist. Produced with the assistance of the Computer Graphics Research Group, Ohio State University.

Plate 80 Pieter de Hooch. *A Dutch Courtyard.* 1668; oil on canvas, 26¾ × 23 in. This Dutch painting of the seventeenth century is an indication of the impact that the fixed perspective system of the Renaissance, two hundred years previously, had upon the way artists "saw" space.
National Gallery of Art, Washington, D.C. Andrew Mellon Collection.

**Plate 81 Gino Severini. *Dynamic Hieroglyphic of the Bal
Tabarin.* 1912; oil on canvas with sequins, 63⅝ × 61½ in.** The
works of the Futurists were devoted to motion for its own sake.
They included not only the shapes of figures and objects and their
pathways of movement, but also their backgrounds. These features
were combined in a pattern of kinetic energy.
Museum of Modern Art, New York. Acquired through the Lillie P. Bliss
Bequest.

9.29 Harmansz van Ryn Rembrandt. *The Blinding of Samson.* 1636; oil, 80 × 106 in. In this painting the values range from dark (foreground) to light (background), reversing the usual sequence. This makes for a very dramatic effect.
Städelsches Kunstinstituts, Frankfurt.

9.30 Tony King. *Map: Spirit of '76.* The format with its papier collé surface is perfectly flat, but use of light and dark values creates a strongly three-dimensional illusion. Courtesy the Owens-Corning Collection. Owens-Corning Fiberglas Corporation, Toledo, Ohio.

9.31 Pablo Picasso. *Seated Woman.* 1927; oil on canvas, 51½ × 38½ in. Because of their obviously decorative quality, abstract textures emphasize the flatness of the picture plane. Background and foreground forms become closely integrated so that little sense of spatial recession is felt by the observer.

Texture is one of the visual signs used to produce the decorative surface so valued in contemporary art. The physical character of texture is related to allover patterned design and, as such, operates effectively on decorative surfaces. When patterned surfaces are repeated and distributed over the entire pictorial area, the *flatness* of the picture plane becomes of vital importance. The works of Pablo Picasso frequently illustrate the contemporary use of texture surfaces to preserve the concept of the *flat picture plane* (fig. 9.31).

Color and Space

One of the outstanding contributions of modern artists has been their reevaluation of the plastic potentialities of color. Color is now integrated directly into the form of the picture because it is used in a positive and direct manner to model the various spatial planes of surface areas (*see* chapter 8, "Color"). Since the time of Cézanne, there is a new awareness of the advancing characteristics of color in art. Prior to this time, deep space was considered as *beginning with* the picture plane and *receding from it*. Today many artists, chiefly through the use of color, deal with the spaces *on* or *in front of* the picture plane. Hans Hofmann, the contemporary abstractionist, often used intense colors to advance shapes *beyond the picture plane* (*see* plate 64).

Analogous colors, because they are so closely related, create spatial movement, and contrasting colors provide varied accents or focal points of interest. Both are used to exploit the limitless dimensions of space.

9.32 Rene Magritte. *La Lunette D'Approche.* **1963; oil on canvas, 69 × 45½ in.** On close inspection it seems that this work is *not* consistent in its use of space; but it is deliberately *in*consistent spatially. As a Surrealist, Magritte often created ambiguous and unexpected effects to titillate our senses.
Menil Collection, Houston, Texas.

RECENT CONCEPTS OF SPACE

Every great period in the history of art has espoused a particular type of space conception. These spatial preferences reflect basic conditions within the civilization that produced them. Certain fundamental space attitudes seem to recur in varied forms throughout recorded history. During the period of their influence, these attitudes become a norm of vision for people, gradually conditioning people to see things in much the same way. When an epic social change ushers in a new space attitude, it is resisted at first by the public but finally becomes the standard filter through which people see things. These changes were fairly cyclical and even predictable through the Renaissance. The acceleration of change prompted by the cataclysmic revelations of modern science has today produced new concepts that are without precedent. Today, artists are groping for ways of understanding and interpreting these ever-widening horizons, and as they do, their explorations are met by characteristic recalcitrance from the public (fig. 9.32).

Search for a New Spatial Dimension

Artists of the Renaissance, conditioned by the outlook of the period, set as their goal the optical, scientific mastery of nature. They sought to accomplish this by reducing nature, part by part, to a *static geometric system.* By restricting their attention to one point of view, artists were able to develop perspective and represent some of the illusionary distortions of actual shapes as seen by the human eye.

Modern artists, equipped with the findings from new scientific and industrial materials and technology, have extended the search into nature initiated by the Renaissance. They have probed into nature's inner and outer structure with the microscope, camera, and telescope. With the automobile and the airplane, they have had the opportunity to see more of the world than any of their predecessors. The radically changed environment of the artist has brought about a new awareness of space. It has become increasingly evident that the essence of space cannot be described from the one point of view characteristic of the Renaissance, and a continuing search has been instituted for a new graphic vocabulary to describe visual discoveries. Since one outstanding feature of the modern world is motion, new artistic representation must move, at least illusionistically. Motion has become *a part of space,* and this space can be grasped only if a certain *period of time* is allotted to cover it. Hence, a new dimension is added to spatial conception—the fourth dimension, which combines the elements of space, time, and motion and presents an important graphic challenge. This challenge is the discovery of a practical method for representing things in motion from every viewpoint on a flat surface. In searching for solutions to this problem, artists have turned to their own experiences as well as to the work of others.

Plastic Image

Paul Cézanne, the nineteenth-century Post-Impressionist, was an early pioneer in the attempt to express the new dimension. His aim was to render objects in a manner more true to nature. This nature, it should be pointed out, was not the Renaissance world of optical appearances; instead, it was a world of forms in space, conceived in terms of a plastic image (fig. 9.33). In painting a still life, Cézanne would select *the most characteristic viewpoint* of all his objects; he would then change the eye levels, split the individual object planes, and combine all of these views in the same painting, creating a composite view of this group. Cézanne would often shift his viewpoint of a single object from the right side to the left side and from the top to the bottom,

9.33 Paul Cézanne. *Still Life with Ginger Jar, Sugar Bowl, and Oranges.* 1902–1906; oil on canvas, 23⅞ × 28⅞ in. Cézanne was concerned with the plastic reality of forms as well as with their organization into a unified design. Although the plate, jar, and pot are present in the same picture, they are depicted as seen from different viewpoints. For example, Cézanne felt that the plate would seem to have greater reality if drawn as seen from a higher angle; the jar placed behind this object, however, seems to be observed from a lower viewpoint. Museum of Modern Art, New York. Acquired through the Lillie P. Bliss Collection.

always creating the illusion of *looking around the object*. If we wished to see these multiple views, we would be forced to move around the object or revolve it in front of us. This act would involve *motion, space*, and *time*.

The *Cubists* adopted many of Cézanne's pictorial devices. They usually showed an object from as many views as suited the discrimination of the artist. Objects were rendered in a type of *orthographic drawing* in which the basic intention was division into essential views that could be drawn in *two dimensions*. The basic view, the top view, is called a *plan*. When the plan was used as a basis, the *elevations* (or profiles) were taken from the front and back and the *sections* from the right and left sides. The juxtaposition of these views in a painting illustrated the movement of the objects in space. Such a painting was a composite that showed much more of the object than would normally be visible. The technique seems a distortion to the lay spectator conditioned to a static view, although within the limits of artistic selection everything is present that we would ordinarily expect to see (figs. 9.34 and 9.35).

In the works of the Cubists we find the suggestion that a picture can have a life of its own, and that the creation of space is not essentially a matter of portrayal or rendering. The Cubist works step by step to illustrate that the greater the departure from *object resemblance*, the clearer the *spatial order*. One of the offshoots of this discovery was the synthetically designed picture—a picture that divorces itself from the model (fig. 9.36).

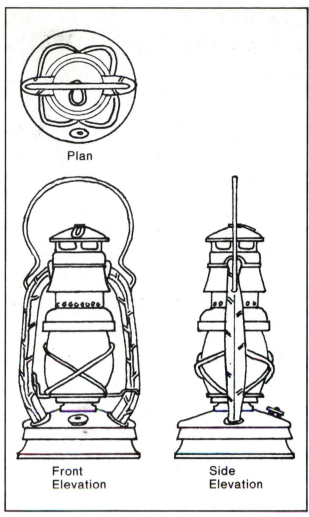

Plan

Front
Elevation

Side
Elevation

9.34 Tom Haverfield. *Kerosene Lamp.* **circa 1960; pen and ink, 9 × 12 in.** In this work objects are rendered in a type of orthographic drawing in which the basic intention is division into essential views that can be drawn in two dimensions.
Courtesy of the artist.

9.35 Tom Haverfield. *Kerosene Lamp II.* **circa 1960; pencil on paper, 14 × 18 in.** The juxtaposition of orthographic views in a drawing illustrates the movement of objects in space. Such a drawing is a composite that shows much more of an object than would normally be visible.
Courtesy of the artist.

Pictorial Representations of Movement in Time

From time immemorial, artists have grappled with the problem of representing movement on the stationary picture surface. In the works of prehistoric and primitive humans, the efforts were not organized, but were isolated attempts to show a limited phase of observed movement.

In an early attempt to add movement to otherwise static figures, Greek sculptors organized the lines in the draperies of their figures to accent *a continuous direction.* By means of this device, the eye of the observer is directed along a constant edge or line.

The artists of the Medieval and Renaissance periods illustrated the life and passion of Christ by repeating a series of still pictures. The representation of the different phases of Christ's life (either in sequence form or combined in a single work) created a visual synopsis of his movement, the space he covered, and the time he

took to cover it. These pictures were antecedents of modern comic and motion-picture techniques that actually fill the gaps between the still views in the final product (fig. 9.37).

Another representational device used for the suggestion of movement is the superimposition of many stationary views of the figure or its parts in a single picture. This device catalogs the sequence of position of a moving body, indicating the visible changes of movement.

Twentieth-century artists have attempted to fuse the different positions of the figure by filling out the pathway of its movement. Figures are not seen in fixed positions but as *moving paths of action.* The subject in Marcel Duchamp's **Nude Descending a Staircase** is not the human body, but the type and degree of energy the human body emits as it passes through space. This painting signified important progress in the pictorialization of motion because the plastic forces are *functionally integrated with the composition* (fig. 9.38).

**9.36 Juan Gris. *The Chessboard.* 1917; oil on wood,
28¾ × 39⅜ in.** Spatial movements formed in abstractly designed
paintings give variety and interest to the pattern relationships.
Natural spatial indications are ignored in favor of a more
subjective interpretation of the objects represented.
Museum of Modern Art, New York. Purchase.

**9.37 Unknown. *David and Goliath.* Paris, circa 1250;
152 × 117 in. (dimensions of manuscript).** The element of time is
present here, but in a conventional episodic manner. The order of
events proceeds in a style similar to that of a comic strip.
Pierpont Morgan Library.

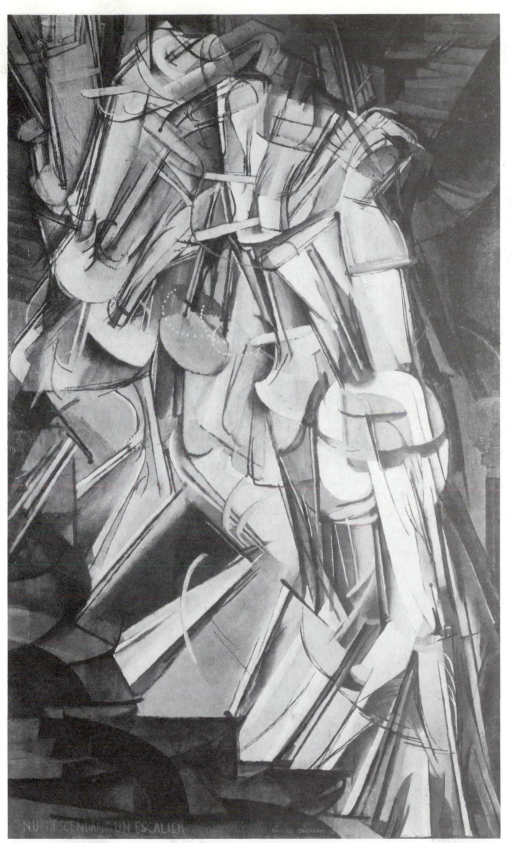

9.38 Marcel Duchamp. *Nude Descending a Staircase, No. 2.* **1912; oil on canvas, 58 × 35 in.** The subject in Duchamp's painting is not the human body, but the type and degree of energy the human body emits as it passes through space.
Philadelphia Museum of Art. The Louise and Walter Arensberg Collection.

9.39 Giacomo Balla. *Leash in Motion.* 1912; oil on canvas, 35⅜ × 43¼ in. In an effort to solve the problem of suggesting motion as it is involved in time and space, Balla invented the idea of repeated contours. This soon became a device commonly imitated in newspaper comic strips, thus losing aesthetic uniqueness.
Albright-Knox Art Gallery, Buffalo, New York. Bequest of
A. Conger Goodyear.

The Futurists (*see* "Futurism," chapter 11) were devoted to motion for its own sake. They included not only the shapes of figures and objects and their pathways of movement, but also their backgrounds. These features were combined in a pattern of kinetic energy. Although this was not entirely new as a form of expression, it provided a new type of artistic adventure—simultaneity of figure, object, and environment (fig. 9.39 and plate 81).

The exploration of space in terms of the four-dimensional space-time continuum is in its infancy. As research reveals more of the mysteries of the natural world, art will continue to absorb and apply them according to their effect on human relationships. It is not unreasonable to assume that even more revolutionary concepts will emerge in time, producing great changes in art style. The important thing to remember is that distortions and unfamiliar forms of art expression do

not occur in a vacuum—they usually represent earnest efforts to apprehend and interpret our world in terms of the latest frontiers of understanding.

SPACE PROBLEMS

Problem 1

In conjunction with linear perspective, artists of the past frequently used diminishing contrasts of hue, value, intensity of color, and texture to achieve deep penetration of space on a two-dimensional surface. This is known as the infinite concept of space or atmospheric perspective.

Create a pictorial composition on the theme "objects in space." Conceive of the picture plane as the

near side of a volume of deep space. Use the indications of space suggested in the preceding paragraph, and soften the edges of objects as they are set back in depth. The human figure might be used to help suggest the scale of objects in space. Foreground, middle ground, and deep space can be indicated by the size of similar objects.

Problem 2

Certain artists of the past, particularly the Egyptians, conceived of space in their art as a two-dimensional arrangement. Objects to be shown were placed vertically, above one another, or side by side. This is essentially a decorative space concept.

Using graphite throughout, create several base lines or *registers* that subdivide the drawing area. Select a few (very few) subjects and draw these, sometimes repeatedly, within the registers. This repetition will provide a degree of unity for the composition. Introduce a new invented texture into each of the basic shapes in which the subjects are found. Use a wide range of values in the shapes and in the textures. The ultimate objective is the effect of the barest minimum of space (fig. 9.40).

Submitted by Debra Babylon, Instructor of Art, School of Design, Toledo Museum of Art, Toledo, Ohio. Artist: Cynthia White.

Problem 3

Many artists today prefer a shallow space concept in which some qualities of the design are provided by decorative elements of space, while some suggestion of three-dimensional depth is retained.

a. Without radically altering the two-dimensional surface of the picture plane, create a semiabstract form using some of the spatial tools in problem 1: that is, gradation in size; placement in picture plane; overlapping; transparency; open or closed composition; closely related hues, values, and brightness. The effect created should be of a measurable depth, as if the furthest penetration into the space back of the picture plane were limited rather than infinite in depth (fig. 9.41).

b. Create a boxlike space back of the picture plane with the side planes, top plane, and ground plane, as well as the back plane, clearly defined by color, value, texture, or other means (*see* fig. 9.4). Movement in depth should be resolved by returning the eye travel to the foreground through various devices. Use planes and thin solids to give form and pattern to the enclosed space.

9.40 Space Problem 2.

9.41 Space Problem 3.

9.42 Space Problem 4.

Problem 4

There are various ways of organizing objects in space.

Utilizing either abstract solids or realistic objects, organize the resultant volumes into a diagonal or circular series of movements penetrating into semi-deep space (fig. 9.42).

Problem 5

Spatial order occurs when the artist senses the right balance and best placement of the vital forces affecting spatial illusions.

Using the traditional methods of spatial indication, such as shape-size, position, overlapping, sharp and diminishing detail, converging parallels, reverse perspective, color, value, and texture, create a non-objective picture based on the theme of intuitive space (fig. 9.43).

Problem 6

Many contemporary artists consider transparency an important way of defining space.

Using linear perspective or parallel convergence of lines, create the effect of looking through transparent planes set at different angles to one another within a volume of space. Define several different distances in depth by having some planes that are opaque or semitransparent. Mix color, texture, and value as the transparent planes meet.

9.43 Room Interior, Space Problem 5.

Problem 7

Ambiguous space is a type of space that is not immediately understood; it usually requires more prolonged viewing for interpretation. It is used to challenge the viewer's thinking and to attract and hold the viewer's attention. Ambiguous space usually involves a combination of unlikely space concepts. This can be done nonobjectively, as in Op Art, where several images present themselves simultaneously, or in figurative art, where conflicting ideas of size are mixed.

Gather subject matter from various sources that represent different spatial positions and eye levels. Blend these images in a composition so that there is "consistent inconsistency" of space, with the usual space relationships being altered or even reversed. We recommend that this be done with colored pencils on colored drawing paper (fig. 9.44).

Submitted by Debra Babylon, Instructor of Art, School of Design, Toledo Museum of Art, Toledo, Ohio. Artist: Andy Liauw.

9.44 Space Problem 7.

Problem 8

While normal perspective is conventional and expected, exaggerated perspective, or foreshortening, can be used to introduce new meanings and a greater sense of drama.

Arrange a group of objects, one of which has greater length and projection toward the observer. Magnify the length of this object so that it seems to reach the limit of, or beyond, the format. The other objects would occupy their normal spatial positions. We suggest that this be done in graphite (fig. 9.45).

Submitted by Debra Babylon, Instructor of Art, School of Art, Bowling Green State University, Bowling Green, Ohio. Artist: Connie Brzoska.

Problem 9

One way of achieving the effect of deep space is by using the principles of atmospheric perspective. According to this system, the nearest objects have the greatest clarity and contrast, whereas those in the background are less well defined and somewhat grayed (depending on the depth of the space).

Using black and white Conté crayon on gray paper, draw a grouping of objects that are set some distance apart. Draw the objects in such a way that the

9.45 Space Problem 8.

9.46 Space Problem 9.

9.47 Space Problem 10.

nearer the object the sharper the edges and the greater the contrast between the whites and blacks. Reverse this procedure with the objects receding in space. As they move back the edges should be increasingly blurred and the distinctions between the lights and darks less obvious (fig. 9.46).

Submitted by Debra Babylon, Instructor of Art, School of Art, Bowling Green State University, Bowling Green, Ohio. Artist: Jennifer Rolfe.

Problem 10

Surface textures and patterns are often used by the contemporary artist to control spatial suggestions. Such decorative relationships permit a freer interpretation of object shapes and encourage variations that can contribute to organic unity of the pictorial elements. The result is a shallow or decorative space concept.

Create a composition of forms derived from still-life, sculptural, or architectural forms. Omit indication of naturalistic light and shade, substituting decorative textures or patterns, such as lines, spots, and stripes. Break up background areas into arbitrary shapes that seem related to objects, and use decorative texture in some of these spaces as well. Solid tones of varying values and/or color may be used to keep the overall design from becoming too busy and over elaborate (fig. 9.47).

Problem 11

Cézanne and the Cubists often combined several viewpoints of a plastic image in one painting. The juxtaposition of multiple views in a single painting implies movement of the observer around the objects.

Select a single object to be used as a model for this problem. On three pieces of tracing paper draw the top or plan view, the elevation view, and a section view of the same object to the same scale. Place these drawings one over another and in a single work combine the most characteristic parts of each view. Add value differences for contrast, variety, and enhancement of spatial position (fig. 9.48; *see also* figs. 9.34 and 9.35).

9.48 Space Problem 11.

9.49 Space Problem 12.

Problem 12

An early representational device for suggesting movement, as used by twentieth-century artists, was superimposition of stationary views of a figure or its parts in a single picture.

a. Select a moving figure or object as a model. Draw a series of pictures representing this figure or object as it rotates, tilts, or falls in space. Each of the drawings should indicate a slight change of movement in space or position. Superimpose and place the drawings together in such a way as to suggest a continuous movement in space. This problem is not intended to create a complete pictorial organization, but is an experiment in representing movement on a flat surface (fig. 9.49).

b. Select parts of the sequence of motion created in part *a*. Combine these within the limits of a frame shape to create an organized pattern. Add value differences for contrast, variety, and enhancement of spatial position.

NOTE: Geometric perspective is a mechanical technique of optical illusionism that produces a standardized spatial effect based on the single viewpoint of the observer/artist. Many art teachers believe, and with some justification, that the inherent dangers in perspective outweigh its value. Others feel that it is an established form of vision and, as such, deserves some consideration, even though there may be disagreement on the desirable scope of instruction. We believe there is some legitimacy to both of these viewpoints. The intricacies of perspective are too great to be covered in depth here. The extent of study in this phase of art is left to the judgment of the individual instructor. If this book is not being used under the supervision of an instructor, the reader is advised to seek further information on perspective in the many books and manuals that deal with the subject.

10

THE ART OF THE THIRD DIMENSION

THE VOCABULARY OF THE THIRD DIMENSION

addition A sculptural term meaning to build up, to assemble, or to put on.

atectonic The opposite of tectonic; a quality of three-dimensional complexity involving fairly frequent and often considerable extension into space, producing a feeling of openness.

Bauhaus Originally a German school of architecture that flourished between World War I and World War II. The Bauhaus attracted many of the leading experimental artists of both the two- and three-dimensional fields.

casting A sculptural technique in which liquid materials are shaped by pouring into a mold.

form The total organization of a work of art.

glyptic 1. A term referring to the quality of an art material like stone, wood, or metal, that can be carved or engraved. 2. An art form that retains the tactile, color, and tensile quality of the material from which it was created. 3. The quality of hardness, solidity, or resistance found in carved or engraved materials.

manipulation To shape by skilled use of the hands; sometimes used to mean modeling (*see* definition of *modeling*).

mobile A three-dimensional, moving sculpture.

modeling A sculptural term meaning to shape a pliable material.

patina A film, usually greenish in color, that results from oxidation of bronze or other metallic material; colored pigments, usually earthy, applied to a sculptural surface.

sculpture The art of shaping expressive three-dimensional forms. "Man's expression to man through three-dimensional form" (Jules Struppeck, *The Creation of Sculpture,* 1952).

silhouette The area existing between or bounded by the contours, or edges, of an object; the total shape.

substitution A sculptural term meaning the replacement of one material or medium by another; casting (*see* definition of *casting*).

subtraction A sculptural term meaning to carve or cut away materials.

tectonic Pertaining to the quality of simple massiveness; lacking any significant extension.

void The penetration of an object to its other side, thus allowing for the passage of space through it; an enclosed negative shape.

BASIC THREE-DIMENSIONAL CONCEPTS

In the preceding chapters, examination of art fundamentals was limited mostly to the graphic arts. These art forms (drawing, painting, photography, printmaking, etc.) have two dimensions (height and width), exist on a flat surface, and any sensation of space they generate is the product of illusion created by the artist. This chapter deals with the unique properties of three-dimensional artwork and the creative concepts evolving from these properties.

In three-dimensional art, we have the additional dimension of *depth*. Depth results in a greater sense of reality and, as a consequence, increases physical impact. This is true because graphic work is limited to one format plan, always bounded by a geometric shape called the picture plane. The format in three-dimensional work, on the other hand, is the outer contour of any number of views and contains spatial planes.

10.1 Piece of alabaster (mass). This piece of alabaster stone represents a three-dimensional mass of raw unsculptured material.

Practicing artists and art authorities designate the three-dimensional qualities of objects in space with such terms as *form, shape, mass,* and *volume.* The term *form* here can be misleading because it has a number of different meanings that can be confused with the meaning defined in the early chapters of this book. In a broad structural sense, form is the sum total of all the means used through media and technique to organize the three-dimensional elements. In this respect, a church is a total form and its doors are contributing shapes; similarly, a human figure is the total form, while the head, arms, and legs are contributing shapes. In a more limited sense, form may refer to a contour, a shape, or an object. *Shape,* when used in a three-dimensional sense, may refer to a positive or open negative area. In comparison, *mass* invariably refers to a solid physical object of relatively large weight or bulk (fig. 10.1). Mass may also refer to a coherent body of matter, like clay or metal, that is not yet shaped—a lump of raw material that could be modeled or cast. Stone carvers, accustomed to working with glyptic materials, tend to think of heavy, weighty mass; modelers, who manipulate clay or wax, favor the use of a pliable mass. *Volume* is the amount of space the mass, or bulk, occupies, or the three-dimensional area of space that is totally or partially enclosed by planes, linear edges, or wires (fig. 10.2). Many authorities conceive of masses as positive solids and volumes as negative open spaces. For example, a potter who throws a bowl on a turntable adjusts the dimensions of the interior volume (negative interior space) by expanding or compressing the clay planes (positive mass), whereas the sculptor who assembles metal wires may enclose negative volumes with the linear relationships.

10.2 John Goforth. *Untitled.* **1971; cast aluminum, 15¾ in. high with base.** The volume incorporates the space, both corporeal and incorporeal, occupied by the work.
Courtesy of the artist.

In the larger view, most things in our environment have three-dimensional qualities, although in many cases these qualities are so minuscule that we tend to disregard them. This variety of three-dimensional objects can be divided into natural and human-made forms. Although natural forms might serve to stimulate the thought processes, they are not in themselves creative forms. Artists find it necessary to invent forms to satisfy their need for self-expression. In the distant past, most three-dimensional objects were created for utilitarian purposes and included human implements, such as prehistoric stone axes and knives, and also clothing, shelter, and objects for decoration and worship. Nearly all of these human-made forms contained varied qualities of artistic expression. Such expression, when achieved through three-dimensional media, is considered a part of the sculptural impulse.

Sculpture

The term *sculpture* has had varied meanings throughout history. The word derives from the Latin verb *sculpere*, which refers to the process of carving, cutting, or engraving. The ancient Greeks' definition of sculpture also included the modeling of pliable materials, such as clay or wax, to produce figures in relief or in-the-round. The Greeks developed an ideal standard for the sculptured human form, which was considered the perfect physical organization—harmonious, balanced, and totally related in all parts. The concept of artistic organization was part of the definition of sculpture.

Modern sculpture has taken on new qualities in response to the changing conditions of an industrialized age. Science and machinery have made sculptors more conscious of materials and technology, and more aware of the underlying abstract structure in their art.

Sculpture is no longer limited to carving and modeling. It now also refers to any means of giving intended form to all three-dimensional materials. These means include welding, bolting, riveting, gluing, sewing, machine hammering, and stamping. In turn, the three-dimensional artist has responded with an expanded range of sculptural forms, which include planular, solid, and linear constructions made of such materials as steel, plastic, wood, and fabric (fig. 10.3; *see* plate 88). The resulting sculptures are stronger (even with the use of lighter materials), are more open, and have extended spatial relationships. Three-dimensional forms like wire constructions and mobiles have changed the very definition of sculpture that, previous to the nineteenth century, would have included only solid, heavy, and sturdy glyptic forms. An innovative sculptor like Michelangelo di Buonarroti, with his Renaissance time frame, thought only in terms of massive materials and heavy figures.

The diversity of newfound materials and techniques has led to greater individual expression and artistic freedom. Sculptors create objects to please themselves and experiment with new theories. They have found new audiences and new markets.

Other Three-Dimensional Areas

The bulk of this book has addressed itself to works of pure or fine art that are designed to have no practical function. Sensitivity to the sculptural (and/or artistic) impulse, however, is not confined to the fine arts; it permeates all three-dimensional structures. The same abstract quality of expressive beauty that is the foundation for a piece of sculpture can underlie such functional forms as automobiles, television receivers, telephones, industrial equipment, product designs, displays, furniture, and architecture. Artist-designers of these three-dimensional products organize elements, shapes, textures, colors, and space according to the same principles of harmony, proportion, balance, and variety. Although form principles can be applied to such useful objects, the need for utility often restricts the creative latitude of the artist.

Plate 82 Harold Hasselschwert. Pendant Necklace. 1972; Cast silvergilt with transparent enamel, cultured pearls, and a 55-carat rutilated kunzite, 4½ in. height of pendant. Articles of jewelry, although decorative in intent, often are sculptural in concept.
Courtesy of the artist.

Plate 83 Dominic Labino. Conflagration. 1972; free hand-blown glass with hot design on opaque white glass, cased in colorless glass, 8 in. high, 5½ in. diameter. The forming of glass requires an understanding of three-dimensional principles, as well as knowledge of the chemistry and techniques of the medium.
Courtesy of the artist.

Plate 84 Charles Lakofsky. *Stoneware.* The aesthetic form of ceramic ware is an important consideration of the potter.
Courtesy of the artist.

Plate 85 Kathleen Hagan. *Crocheted Series #5.* **1979.** Contemporary textile design frequently goes beyond its largely two-dimensional traditions.
Courtesy of the artist.

Plate 86 Telephone. This example of product design
incorporates a streamlined aspect that enhances the three-
dimensional beauty of the curved and planular shape relationships.
Printed with permission of AT&T Bell Laboratories, Murray Hill, New
Jersey.

Plate 87 Isamu Noguchi. *The Opening.* 1970; French rose and Italian white marble. The sculpture is
enriched by the artist's choice of materials of contrasting colors and variegated graining.
Courtesy of the artist.

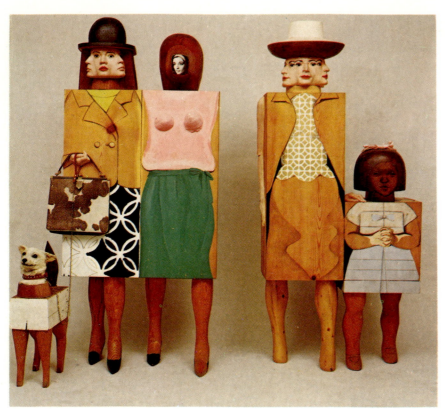

Plate 88 Marisol. *Women and Dog.* 1964; wood, plaster, synthetic polymer and miscellaneous items, 72 × 82 × 16 in.
An example of Pop art that reveals the willingness of some contemporary artists to use bright color to heighten three-dimensional characteristics of form at the same time that it enriches surfaces. The form further suggests sources in previous twentieth-century styles, while the use of combine-assemblage tends to fuse the medias of sculpture and painting into one.
Courtesy Collection of the Whitney Museum of American Art. Gift of the Friends of the Whitney Museum of American Art.

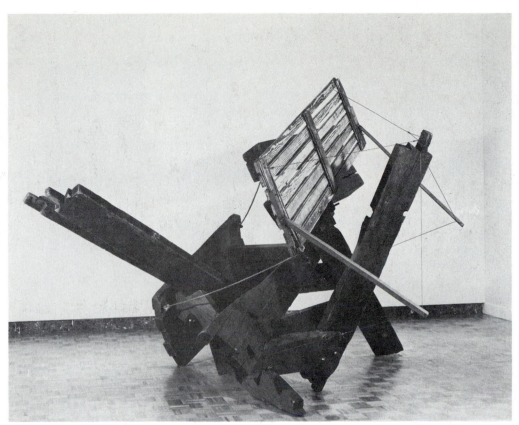

10.3 Mark di Suvero. *Tom.* 1960–1961; wood, metal, rope, cable, and wire construction, 9 × 10 × 12 ft.
Recent sculpture exploits every conceivable material that suits the intentions of the artist.
Courtesy of the Detroit Institute of Art. Founders Society Purchase, Friends of Modern Art Fund, Mr. and Mrs. Walter Buhl
Ford II Fund and contributions from Samuel J. Wagstaff, Jr.

The famous architect Louis Sullivan made the oft-repeated remark that "form follows function." This concept has influenced several decades of design, changing the appearance of tools, telephones, silverware, chairs, and a vast array of other familiar and less familiar items. Sometimes this concept is misapplied. The idea of streamlining is practical when applied to moving objects such as trains and cars, but it has no logical application when used on spoons and lamps. Although streamlining is helpful in a larger sense in eliminating irrelevancies from design, even the idea of simplification can be overdone. The *Bauhaus* notion of the house as a "machine for living" helped architects rethink architectural principles, but it also produced many cold and austere structures against which there was inevitable reaction.

Contemporary designers are very aware of the functional needs of the objects they plan. Consequently, they design their forms to express and aid their function. However, these designers are also conscious of the need for these objects to be aesthetically pleasing. All of this points up the necessity for the creator of functional objects to be well grounded as a practicing artist in applying the principles of fundamental order within the strictures of utilitarian need. Frank Lloyd Wright, the celebrated American architect, combined architecture, engineering, and art in shaping his materials and their environment. The unity of his ideas is expressed in the chair he designed for the Roy Evans House (fig. 10.4). The sophisticated design that Frank Lloyd Wright projected into an ordinary object with formal balance like the chair can be seen in his highly selective repetitions, proportional relationships, and detail refinement.

The balance that exists between design, function, and expressive content within an object varies in emphasis with each creator. For instance, when designing his rocking lounge chair, Michael Coffey placed strong emphasis on expressive form without totally sacrificing the function of reclining comfort (fig. 10.5). At first glance, we are taken by the visual format of the dominant outer contour of the chair and with its open shape. This unique chair resembles many freely expressed contemporary sculptures. Expressive form follows function in a new and creative way.

We will now briefly describe some of the general areas of three-dimensional design in which works usually serve some useful purpose.

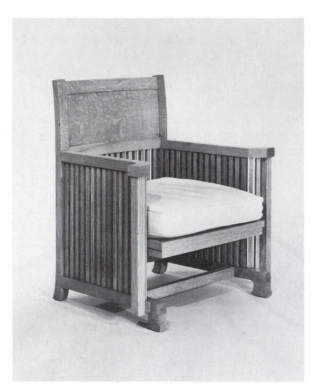

10.4 Frank Lloyd Wright. Armchair. furniture, woodwork-oak. American, Ray Evans House, Beverly Hills, Illinois. To Wright, form and function were inseparable. The chair, which functions for sitting, should be considered along with the whole architectural environment. This armchair, an integral part of an enclosure of interior space to be lived in, was designed by Wright in the original scheme of the Ray Evans House.
Art Institute of Chicago. Gift of Mr. and Mrs. F. M. Fahrenwald.

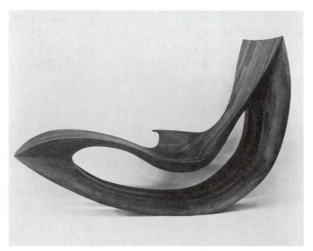

10.5 Michael Coffey. *Aphrodite.* 1978; a rocking lounge chair, laminated mozambique, 90 in. wide, 54 in. high, 28 in. deep.
A useful article can be affected by the style of contemporary sculpture.
Courtesy of the artist. Photo by Rich Baldinger. Schenectady, New York.

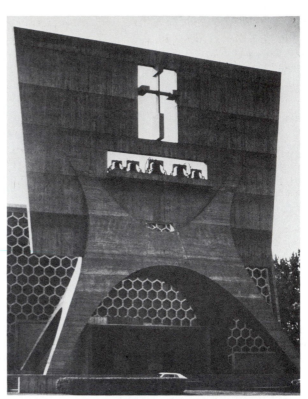

10.6 Marcel Breuer, architect. Bell Tower, St. John's Abbey and University, Collegeville, Minnesota. circa 1967; reinforced concrete. This structure, based on the traditional campanile of Romanesque cathedrals, is typical of the contemporary approach to three-dimensional design in architecture.
St. John's Abbey and University, Collegeville, Minnesota.

Architecture Recent technological innovations and new building materials have given the architect much more artistic flexibility. Thanks to reinforced concrete and cantilevering, buildings need not be as massive as they were in the Romanesque period. Since the advent of electric lighting, they do not need the great window spaces of the Gothic cathedral. Because of air conditioning, buildings can be completely enclosed or sheathed in glass. Cantilevering permits extensions out into space. Sophisticated and free-form shapes are possible with the use of precast concrete. All of these structural improvements have allowed architects to think and plan more freely. In many ways architects are today "building sculptors," and their designs require a thorough grounding in artistic principles as well as an understanding of engineering concepts (fig. 10.6).

Metalwork Most of the changes in the area of *metalworking* have been in concept, rather than technique. Although traditional techniques are still in use, modern equipment has made procedures simpler and more convenient. To a large degree, fashion determines the character of metalwork, but it is safe to say that contemporary work is larger and more sculpturally oriented than most work of the past. There is a constant

cross-fertilization among the art areas, and metalwork is not immune to these influences. The metalworker benefits from the study of the art principles of both two- and three-dimensional art (plate 82).

Glass Design *Glassworking* is similar to metalworking in that modern equipment has simplified traditional techniques. The *designing* of glass objects, however, is very much an art form of present times. Many free-form and figurative pieces have the look of contemporary sculpture. Colors are used to augment the designs in a decorative, as well as an expressive, sense. Thus, the principles of art structure are integrated with the craft of the medium (plate 83).

Pottery In recent years the basic shape of the ceramic object has become more sculptural as ceramic work has, in many cases, become less functional. The ceramist must be equally aware of three-dimensional considerations and of the fundamentals of graphic art, since designs are often incised, drawn, or painted on the surface of the piece (plate 84).

Fiberwork *Fiberwork*, traditionally considered to produce flat objects such as rugs and tapestries, has undergone a considerable revolution in recent works. It has become increasingly three dimensional, particularly as its function is diminished. Woven objects now include a vast array of materials incorporated into designs of considerable scale and bulk. Traditional, as well as contemporary, concepts of fiberwork require an understanding of two-dimensional and three-dimensional principles (plate 85).

Product Design A relative newcomer on the art scene, *product design* usually is concerned with commercial applications. The designer produces works that are based on function but also geared to consumer appeal. To be contemporary in appearance and thus attractive to consumers, products must exploit all of the design principles of the age. The designs of the common objects in our daily environment are the products of the designer's training in these principles (plate 86).

COMPONENTS OF THREE-DIMENSIONAL ART

Subject, form, and *content*, the components of graphic art, function in much the same manner with regard to the plastic arts. The emphasis on each of the components, however, varies within the three-dimensional arts of architecture, ceramics, metalwork, and sculpture. Subject, for example, is taken from those objects and concepts having affinity for the third dimension and/or having functional uses. The human figure may be suitable as a subject for the sculptor, the ceramist,

or the jeweler, but not for the architect. The human figure is *served* by the architect, but not depicted by the architect. *Subjects* suitable for an architect are those types of forms that serve the *functional* aspects of human activity.

Formal organization is more complex in three-dimensional art than it is in the graphic arts. Actual materials developed in actual space through physical manipulation exist in a tactile, as well as in a visual, sense. The resultant complexities expand the *content* or meaning of the form and add greater aesthetic dimension.

Materials and Techniques

In the three-dimensional arts, materials and techniques play more important roles than in the graphic arts. Artists of three-dimensional works soon find that they must conform to the physical laws governing the materials they use. The nature of the materials limits the structure to be created and the technique to be used. For example, clay modelers must understand and adapt the characteristics of clay to their concept. Also, sculptors would not use a saw to cut clay but would manipulate the material with their hands, a block, or a knife. An understanding of materials and the techniques for using those materials is necessary for three-dimensional control. Materials and techniques are not ends in themselves but are necessary ingredients in the development of the artist.

There are four primary technical methods for creating three-dimensional forms: *subtraction, manipulation, addition,* and *substitution.* These are general methods used with a variety of materials. Although they can be used and discussed separately, many three-dimensional works are produced by combinations of the four methods.

Subtraction Artists cut away materials capable of being carved (glyptic materials), such as stone, wood, cement, plaster, clay, and some plastics. They may use chisels, hammers, torches, saws, grinders, and polishers to reduce their materials. It often has been said that when carvers take away material, they free form and a sculpture emerges. The freeing of form by the subtraction method, although not simplistic, does produce unique qualities that are characteristic of the artist's material (fig. 10.7).

Manipulation Widely known as *modeling,* manipulation is based on the type of materials used. Clay, wax, and plaster are common media that are pliable or that can be made pliable during their working periods. Manipulation is a direct method for creating form. Artists

10.7 Subtracting stone. In the subtractive process, the raw material is removed until the artist's conception of the form is revealed. Stone can be shaped manually or with an air hammer, as above.
Photograph courtesy of Ronald Coleman.

10.8 Welding. In the additive process, pieces of material are attached to each other and the form gradually built up. Welded pieces, such as the one illustrated, are often, though not always, more "open" than other sculptural techniques.
Photograph courtesy of Ronald Coleman.

can use their hands to model a material like clay into some form that, when completed, will be a finished product. For expanded control, special tools, such as wedging boards, wires, pounding blocks, spatulas, and modeling tools (wood and metal), are used to work manipulative materials (see fig. 10.31).

Manipulative materials respond directly to human touch, leaving the artist's imprint, or they are mechanically *shaped* to imitate other materials. Although many artists favor the honest autographic qualities of pliable materials, others—especially those in business and manufacturing—favor the economic qualities of quick results and fast change. Techniques and materials are important only as they contribute to the quality of the final form.

Because of the lack of permanence of the most common manipulative materials in their workable states, they usually undergo further technical change. For instance, clay might be fired in a kiln, or it may be cast in a more permanent material like bronze (*see* plate 84 and fig. 11.38).

Addition Methods of addition cover the greatest extension of technology and, in terms of sculpture (nonfunctional), have brought about the newest innovations. When using additive methods, artists add materials that may be pliable and/or fluid, such as plaster or cement. They may assemble materials like metal, wood, and plastic with a welding torch, bolts, screws, nails, rivets, glue, rope, or even thread.

Since three-dimensional materials and techniques are held in high esteem today, the additive methods with their great range, freedom, and diversity offer many challenging three-dimensional form solutions (fig. 10.8).

10.9 Substitution process. In the substitution process, molten metal is being poured into a sand mold, which was made from a model.
Photograph courtesy of Ronald Coleman.

Substitution Casting and substitution are the same. One material, called the *model*, is exchanged for a duplicate form in another material, called the *cast*, by means of a *mold*. The purposes of substitution are, first, to duplicate the model, and, second, to change the material of the model. For example, clay or wax can be exchanged for metal. A variety of processes (such as sand casting and lost-wax casting) and molds (such as flexible molds, waste molds, and piece molds) are used in substitution. Substitution is the least creative or inventive of the technical methods since it is imitative (fig. 10.9).

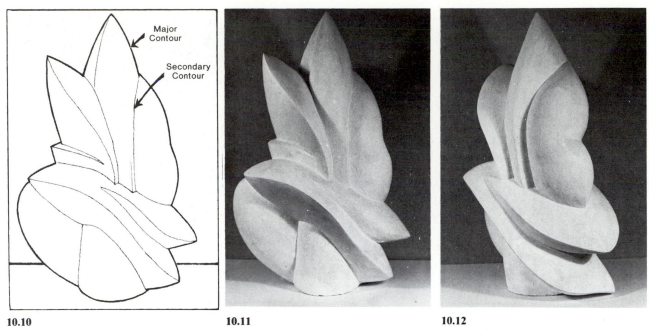

10.10 **10.11** **10.12**

10.10, 10.11, and 10.12 Major and secondary contours. In figure 10.10 the major contour surrounds the silhouette, or the total visible area of the work. Secondary contours enclose internal masses. In figures 10.11 and 10.12 (student work, plaster) each change in position reveals new aspects of a three-dimensional work, or sculpture in the round.

Besides acquiring a knowledge of three-dimensional materials and their respective techniques, artists also must be aware of the elements of form.

The Elements of Three-Dimensional Form

Three-dimensional form is composed of the visual elements *shape, value, space, texture, line, color,* and *time.* The order of listing is different from that for two-dimensional art and is based on significance and usage.

Shape The artist working in three dimensions instinctively begins with shape. Shape, a familiar element in the graphic arts, takes on expanded meaning in the plastic arts. It implies the totality of the mass lying between its *contours,* including the *planes* creating the projections and depressions. We can speak of the overall space-displacing shape of a piece of sculpture or architecture, of the flat or curved shape that moves in space, or of a negative shape that is partially or totally enclosed. These shapes are generally measurable areas that are limited by and/or contrasted with other shapes, values, textures, and colors. The three-dimensional artist should define clearly the actual edges of shape borders. Ill-defined edges often lead to viewer disinterest or confusion because they lack the authority to direct attention. The shape edges guide the eyes through, around, and over the three-dimensional surface in controlled movement.

In three-dimensional art the visible shape depends on the viewer's position. A slight change of position results in a change in shape. The outer limits are seen as *contours.* These contours are not essentially linear, however, as they are in graphic art. A major contour is viewed as the outer limit of the total three-dimensional work as seen from one position (figs. 10.10, 10.11, and 10.12). Secondary contours are perceived as shapes moving across, back and forth, and between the major contours. Some three-dimensional works are constructed so that the secondary contours are negligible (fig. 10.13).

A shape can be a *negative space*—a three-dimensional open area surrounded by solid material. The open shape of this penetrated material is called a *void.* Alexander Archipenko, Henry Moore, and Barbara Hepworth are prominent twentieth-century sculptural innovators who have pioneered in the use of the *void* (fig. 10.14). The void has provided varied opportunities for these artists: it has exposed interior surfaces, opened a direct route to the other side of the sculpture, reduced excessive weight, and created new spatial relationships for otherwise unexciting surfaces. Void shapes should be considered integral parts of the total form. In linear sculpture, enclosed void shapes become so important that they often dominate the width, thickness, and weight of the materials that define them (fig. 10.15).

10.13 Student work. *Untitled.* wood-birch laminated, about 20 in. high. In this example, tectonic because of its massive simplicity, secondary forms have less significance than they might in a more complex structure.

10.14 Alexander Archipenko. *Woman Doing Her Hair.* circa 1958; bronze casting from plaster based on original terra cotta of 1916. This is a significant example of sculptural form where the shapes create negative space, or a *void.* Archipenko was one of the pioneers of this concept, which helped establish a short time later the fourth-dimensional use of time—motion in space.
Courtesy the Kunst Museum, Dusseldorf, Germany, and the Art Reference Bureau, Inc.

Value As the artist physically manipulates three-dimensional shapes, contrasting values appear through the lights and shadows produced by the forms. *Value* is the quantity of light actually reflected by the object surfaces. As in the other visual arts, three-dimensional values range from white to black. Surfaces that are high and facing a source of illumination are light, while surfaces that are low, penetrated to any degree, or facing away from the light source appear dark. Any angular change of two juxtaposed surfaces, however slight, results in a change of value contrasts. The sharper the angular change, the greater the contrast (fig. 10.16).

When any part of a three-dimensional work blocks the passage of light, shadows result. Three-dimensional objects are solid, and any variation in arrangement creates partially or totally shadowed areas (*see* fig. 10.13). The shadows change when the position of the work or of its source of illumination changes. If a work has a substantial shape variation and/or penetration, the shadow patterns are more likely to define the work, regardless of the position of the light source. Sculptors who create *mobiles* demonstrate interest in

the changing of light and shadow. The intensity of light markedly changes the shadow effect.

Value changes can also be affected by the addition of a pigmented medium to the surface of a three-dimensional work. Light pigments generally strengthen the shadows, while dark pigments weaken them. The more lightly pigmented media work best on pieces that depend on secondary contours; darker pigmentations are most successful in emphasizing the major contour. Thin linear structures that depend more on background contrast for visibility most often appear in strong dark or light silhouetted value (fig. 10.17).

Space *Space* might be characterized as a boundless or unlimited extension in all directions, void of matter. When artists use space, they tend to limit its vastness. They may mark off extensions in one, two, or three dimensions, or measurable distances between preestablished elements. Three-dimensional artists use their objects to displace space and to control spatial intervals

10.15 Richard Lippold. *Variation within a Sphere, No. 10, the Sun.* **22-carat gold-filled wire, height 11 ft., width 22 ft., depth 5½ ft.** Development of welding and soldering techniques for use in sculpture made the shaping and joining of thin linear metals possible, as in this work by Lippold.
Metropolitan Museum of Art. Fletcher Fund, 1956.

10.16 Student work. *Untitled.* A piece of sculpture "paints" itself with values. The greater the projections and the sharper the edges, the greater and more abrupt the contrasts.
Photograph courtesy of Ronald Coleman.

10.17 Student work. *Untitled.* balsa wood, about 20 in. length. The value of the background is an important factor in the visibility of some types of work.

10.18 Rectangular and ovoidal shapes.

and locations. The rectangular and ovoidal shapes in figure 10.18 are examples of space-controlling objects. The weight of these solids is felt and established by the dimensions of the planes, which whether flat or rounded seem to define spatial dimensions. The two shapes seen together create spatial interval. Although the two solids illustrated are three-dimensional, their spatial indications are minimal. Any designed three-dimensional object whose dimensional features are restricted is not taking full advantage of its major asset. Viewers who are accustomed to the basic flatness of *graphic* works tend to see masses as a series of two-dimensional views rather than as total space-displacing units.

Artists can change spatial effects by manipulating their three-dimensional materials. As they cut material away, space moves inward; as they add material, space moves outward.

In figure 10.19 the four bricks have been arranged in a very restrictive manner, at least with regard to spatial dimension. Collectively, they form a large, minimal rectangular solid. The individual bricks are distinguished only by the cracklike linear edges seen in the frontal and side planes. These linear edges are reminiscent of graphic techniques in which object surfaces are embellished without regard to the third dimension.

The four bricks illustrated in figure 10.20 are separated by indentations similar to the mortar joints used by masons. These gaps, although relatively shallow, nevertheless produce distinctively clearer and darker edges than those shown in figure 10.18. Line engravers use a similar technique in handling metal plates (*see* fig. 10.24). Although the darker edges indicate greater three-dimensional complexity than the previous illustration, the plastic quality still has decided limitations. The channeled edges in an engraved plate can actually be felt. Many shallow relief sculptures function within the kinds of limits imposed by the act of engraving (*see* fig. 10.25). Since depth is an integral ingredient of the plastic arts, artists should make maximum use of this dimension within the limits of their concept.

The bricks in figure 10.21 show increasing utilization of space. The bricks are positioned so that the planes moving in depth are contrasted with the frontal and side planes, moving toward and away from the viewer. The light that strikes the grouping now produces stronger shadows and more interesting value patterns. This arrangement is characteristic of the achievements of high relief sculpture. The play of deep shadows against the light on projecting parts of a high relief sculpture increases the expressive or emotional meaning of the sculpture (*see* fig. 10.26).

10.19

10.20

10.21

10.22

10.23

10.24 Engraving. The engraver uses this instrument, the burin, to cut furrows in the metal that will hold ink to produce a line. The engraved plate is a very shallow sculptural relief that is used to produce linear illusion in the print.

Although still in a compact and closed arrangement, the rotation of the bricks in figure 10.22 brings new directions and spatial relationships into play. The work is becoming more truly sculptural as contrasts of movement, light, and shadow increase. In a way, this inward and outward play of bricks is similar to what the sculptor creates in a *free-standing* form. Such works are no longer concerned with simple front, side, and back views, but with multiple axes and multiple views. Although all the brick illustrations are actually *free standing*, or *in-the-round*, in the first two examples the surface characteristics are closer to the condition of relief, as was previously indicated. Some authorities use the terms *free standing* and *sculpture in-the-round* interchangeably to mean any three-dimensional work of art not attached to a wall surface (*see* fig. 11.6).

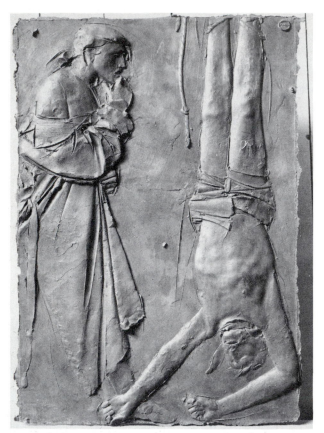

10.25 Giacomo Manzu. *Death by Violence.* 1963; bronze cast from clay model. This is a study for one of a series of panels for the doors of St. Peter's. The confining spatial limitations of relief sculpture are evident. To create a greater feeling of mass, Manzu used sharply incised modeling that, in technique as well as effect, is similar to the engraved lines of the printmaker's plate. The crisp incising creates sharp value contrasts that accent movement as well as depth.
Courtesy Giacomelli, Venice. Art Reference Bureau, Inc.

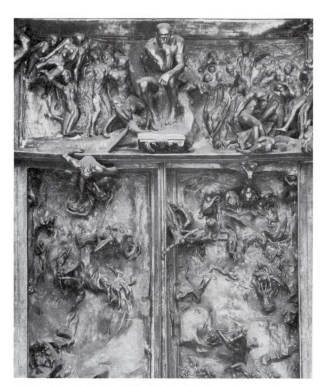

10.26 Auguste Rodin. *The Gates of Hell* (detail). bronze. In this high relief the forms nearly break loose from the underlying surface.
Rodin Museum, Philadelphia, Pa.: Gift of Jules E. Mastbaum.

The greater variety of brick positions in figure 10.23, particularly the introduction of the diagonal in the tipped brick, creates far greater exploitation of space than other groupings. The *void*, or open space, gives even greater emphasis to the three-dimensional quality of the arrangement by producing a direct link between the space on each side.

Although the fundamentals of three-dimensional form are the principal concern of this chapter, this emphasis does not imply that the *plastic* arts are better than the *graphic* arts. Such an evaluation is not determined by dimensions or media. All artists select the means and form by which they will reach their creative goal, and their work is judged within the terms of these choices.

Texture Texture enriches a surface, complements the medium, and enhances expression or content. Textured surfaces range from the hard glossiness of glass or polished marble to the roughness of fingerprinted clay (and bronze when cast) or weathered wood (*see* fig. 7.3).

Certain surfaces are indigenous to media, and traditionally, these intrinsic textures have been respected. However, artists sometimes surprise us with a different kind of treatment. The artist usually employs texture as a distillate of the distinctive qualities of the subject. The sleek suppleness of a seal, for example, seems to call for a polished surface, but the character of a rugged, forceful person suggests a rough-hewn treatment (fig. 10.27). The actual, simulated, and invented textures of graphic artists are also available to plastic artists and are developed from the textures inherent in plastic artists' materials.

Line Line is a phenomenon not actually existing in nature nor in the third dimension. It is primarily a graphic device used to indicate the meeting of planes or the outer edges of shapes. Its definition might be broadened, however, to mean also the axis of a three-dimensional shape whose length is greater than its width. Within this context, line relates to the thin shapes of contemporary linear sculpture using wires and rods. Development of welding and soldering techniques made possible the shaping and joining of thin linear metals in sculpture. Such artists as Richard Lippold and José de Rivera have expanded the techniques of linear sculpture (*see* fig. 10.15 and fig. 10.28).

The incising of line in clay or in any other soft medium is similar to the graphic technique of drawing. In three-dimensional art, incised lines are commonly used to accent surfaces for interest and movement. Giacomo Manzu, an Italian artist, employs such lines to add sparkle to relief sculpture (*see* fig. 10.25).

Color Color is also indigenous to sculptural materials. Sometimes it is pleasant, as in the variegated veining of wood or stone (plate 87), but it can also be bland and lacking in character, as it is in the flat chalkiness of plaster. Pigment is often added when the material needs enrichment or when the surface requires color to bring out the form more effectively. The elements of value and color are so interwoven in sculpture that artists often use the terms interchangeably. Thus, an artist may refer to value contrasts as "color," actually thinking of both simultaneously. Many applications of color are an attempt to capture something of the richness and form-flattering qualities of the patina often found on bronzes oxidized by exposure to the atmosphere. This approach stresses subdued color subordinated to structure of the piece. However, during some periods (for example, early Greek art) application of bright color was commonplace. Some revival of this technique is evident in contemporary works. In every case the basic criterion for its use is compatibility with the form of the work (plate 88).

10.27 Paul Nesse. *Portrait of Ron Russel.* **1974; painted plaster, life size.** The surface character is selected by artists to express their conception of the subject's character and/or physical characteristics.
Courtesy of the artist.

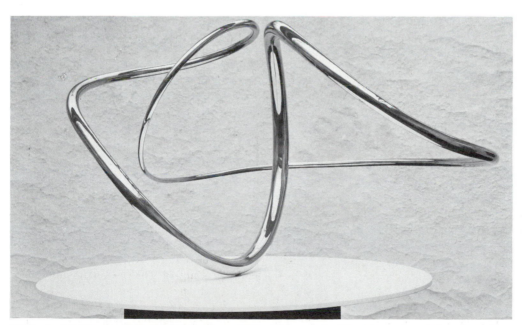

10.28 José de Rivera. *Brussels Construction.* **1958; stainless steel.** The concept of attracting observers to a continuous series of rewarding visual experiences as they move about a static three-dimensional work of art led in the present century to the principle of having the work of art become kinetic or mobile, as with this sculpture set on a slowly turning motorized plinth.
Art Institute of Chicago. Gift from Mr. and Mrs. R. Howard Goldsmith.

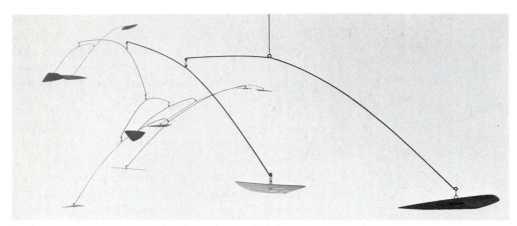

10.29 Alexander Calder. *Mobile: Horizontal Black with Red Sieve.* 1957; steel, approximately 9 ft. long, 5½ ft. high. This noted artist introduced physically moving sculptures called mobiles. Movement requires time for observation of the movement, thus introducing a new dimension to art in addition to height, width, and space. The result is a constantly changing, almost infinite series of views of the parts of the mobile. Courtesy the Toledo Museum of Art.

Time Time is an element unique to the three-dimensional arts. It is involved in graphic arts only insofar as contemplation and reflection on meaning are concerned. The physical act of viewing the work as a totality requires only a moment. However, in a plastic work the added dimension means that the work must turn or that we must move around it if it is to be seen completely. It is important to the artist that the time required for the work's inspection be a continuum of rewarding visual variation. Each sequence or interval of the viewing experience must display interesting relationships and lure the observer ever further around the work, extending the *time* spent on it.

In the case of sculpture called *kinetic*, the sculpture itself, not the observer, moves. Such works require time for their movements. Mobiles, examples of this kind of sculpture, present a constantly changing, almost infinite series of views (fig. 10.29; *see also* figs. 10.17 and 11.39).

Principles of Three-Dimensional Order

The basic components of graphic art—*subject, form,* and *content*—also relate to the three-dimensional fields. Subject matter, the starting point, may be realistic or naturalistic, abstract to lesser degrees of likeness, or exist only as theme or concept. The underlying *content* or meaning derives from the artist's handling of form, as it does in graphic work. *Form* and its principles of order, which are the controlling factors in each work, have the same central importance. Although the principles are the same as those observed in two-dimensional work, the three-dimensional object with its unique spatial properties calls for a somewhat different application of those principles.

Plastic artists have the added responsibility of making their work function successfully from a variety of views. Observing the principles of order, then, becomes a much more complicated matter; the artist's satisfaction with one aspect of the work is not enough to make it a wholly effective piece. As a result, the three-dimensional work represents a continuous series of adjustments designed to give it a spatial wholeness or *unity.* The problems faced in arriving at this solution are related to the basic nature of the work as conceived by the artist. The work may be *tectonic* (massive and simple with few and limited projections) or it may be *atectonic* (to a large degree, open space with frequent, extensive, and often quite thin projections) (fig. 10.30; *see also* fig. 10.13). All works of architecture, jewelry, sculpture, ceramics, and fibers fall into or somewhere between these two classifications.

Obviously, when we consider the matter of artistic equilibrium (involving degrees of symmetry and asymmetry), the difficulties increase if the subject is of *atectonic* complexity, particularly when the balance must be felt from any viewpoint. *Balance* is partly the result of *proportion,* a significant three-dimensional factor. Proportion creates the silhouette, the basic shape, of the three-dimensional work; it determines the posture or major thrust of the work (*see* fig. 10.15). *Rhythm* is introduced with the adjustment of secondary masses to the major core masses that have established the basic proportion (*see* fig. 10.17). The secondary masses are varied in attitude and placement to develop movement around the core and to relate the internal and external

10.30 Sally (Hobbib) Rumman. *Reaching Figure.* 1974; welded steel, about 16 in. high. A work that features open space, usually as the result of thin, outreaching form, is called *atectonic.*

10.31 Three-Dimensional Problem 1.

space to the core. Semienclosed negative shapes resulting from incorporation of external space are significant factors in the *balance* and total silhouette (*see* fig. 10.30). Three-dimensional artists seek *economy* because they, like their fellow workers in other areas, are interested in coming directly to the point by eliminating irrelevancies (*see* fig. 10.13). *Relative dominance*, the principle of assigning each area its proper degree of emphasis, is of course a vital concern of every artist (*see* fig. 10.16).

When properly combined, the dual concepts of *variety* and *harmony* produce unity in all forms of art, but there are differences of application in each field. In the three-dimensional field the similarities and differences of the *plastic* forms involved are important. In other words, the physical properties of size, character, location, and attitude, familiar to the graphic artist, should be considered, but in terms of translation into the third dimension.

THREE-DIMENSIONAL PROBLEMS

Problem 1

Manipulation is achieved by using flexible materials, such as clay, plaster, or wax. Clay is a particularly good material for students in the early stages of studying three-dimensional form concepts. Since clay is flexible and pliable, students can apply and take away, and push and pull the material in a direct manner.

Model a simple human or animal form with clay. At first, consider the large or major contour of the clay mass as it might be seen from a multiple series of views. Use your hands or a wooden forming block to compress and/or wedge the clay into this large form. Then add secondary contours and smaller shapes to create expanded spatial dimensions. Special tools may be used for cutting, blocking, modeling, or sharpening the clay (fig. 10.31).

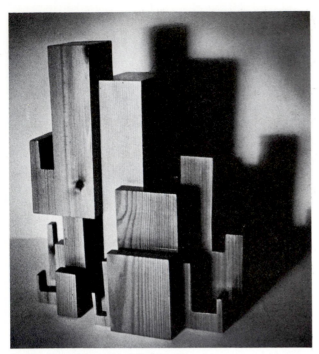

10.32 Three-Dimensional Problem 2a.

Problem 2

Sculptors organize the space around and within a main mass by cutting into it or by adding to it.

a. Cut five or six blocks of varying sizes and proportions from soft white pine. Cut smaller blocks from within the larger blocks so that the larger blocks now contain negative shapes. Assemble any number of the blocks by gluing them together. Work for variety in inward-outward movement (fig. 10.32).

b. Repeat part *a* using two or three colors and thicknesses of Plexiglas®. Shape the Plexiglas® by sawing, sanding, and/or buffing. Special carbide-tipped or fine metal blades work best with Plexiglas®. Wet-dry papers or cloth abrasives, when combined with special buffing cloth wheels and rouge, will finish the cut edges. The Plexiglas® can be joined with special solvent or Plexiglas® screws (fig. 10.33).

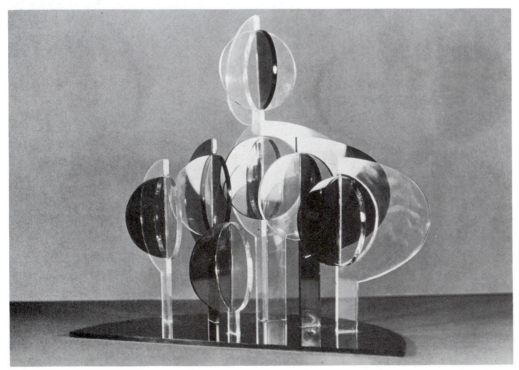

10.33 Three-Dimensional Problem 2b.

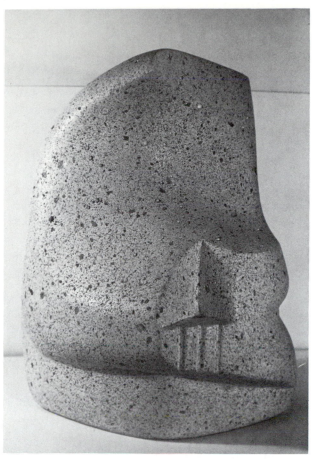

10.34 Three-Dimensional Problem 3a.

10.35 Three-Dimensional Problem 3b.

Problem 3

Commonly available materials, such as perlite, zono-lite, and vermiculite mixed with cement and Styro-foam®, can be used to explore subtractive and carving techniques for the creation of three-dimensional forms.

a. Combine one-third portland cement (white or gray) with one-third vermiculite or zonolite and one-third perlite. Add water and mix until the mixture has the consistency of heavy cream. Pour the mix-ture into a heavy corrugated box. (Be sure the box is not too thin.) Allow four to six hours for setting so that when the box is removed, the cement will not crumble. At this stage the cement should be capable of being cut with a knife. Using a knife, carve away the cement until a desired form is reached. The sur-faces can be refined and integrated by using a rasp (fig. 10.34).

b. Styrofoam® is ideally suited for basic subtractive carving. This material is light, stiff, and easily shaped with wood saws, keyhole saws, serrated knives (grapefruit or tomato), and hot wire cutters. Tex-tures can be produced by using a variety of solvents, such as turpentine and acetone. (Be sure of ade-quate ventilation.) The Styrofoam® carving might be used as a maquette (model) for a larger three-dimensional piece that is covered with paint (coat-ings can be latex or acrylic), plaster, or plastic (poly-ester, epoxy, and fiberglass). Styrofoam® should be covered with a separator such as latex before ap-plying the plastics (fig. 10.35).

Problem 4

A work is considered harmonious when its different parts contain similarities.

Start with one four-by-four-inch wood block about seven to ten inches in length. This should be a simple rectangular form or one that is partly curved. Cut this block into three to five shapes with a band saw. Experiment with arranging these shapes together into varied relationships. Further alteration of the shapes might be made. When satisfied with the total effect, glue the shapes together (fig. 10.36).

10.36 Three-Dimensional Problem 4.

10.37 Three-Dimensional Problem 5a.

10.38 Three-Dimensional Problem 5b.

Problem 5

Paper and cardboard, generally thought of as being two dimensional, can be used to create sculpture in-the-round. The degree of complexity is limited only by the artist's imagination.

a. Select several pieces of paper of varying dimensions. Alter these shapes by bending, curling, scoring, slitting, and perforating. Join the sheets so that they produce structures that have interesting spatial relationships (fig. 10.37).

b. Using cardboard (mat board or illustration board work well), make three simple forms, such as cubes or pyramids, that have flat planes. Experiment with various arrangements of these three shapes to create one sculptural volume. Holes may be cut into the planes to create voids. Interpenetration of these planes can be used if carefully planned (fig. 10.38).

10.39 Three-Dimensional Problem 6a.

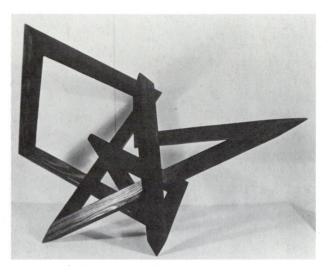

10.41 Three-Dimensional Problem 7.

Problem 7

Volumes add measurable spatial interest to a three-dimensional form and can be varied in character and structure.

Cut strips of ¾-inch wood. Fasten the strips together with dowels, nails, and/or glue to create irregular spaces of different sizes. The strips can be next to, on top of, or within each other to produce unified structures. Consideration of size and space will result in greater interest (fig. 10.41).

Problem 8

Three-dimensional linear sculpture usually employs open spaces. These spaces are defined by metal wires, metal rods, or wood strips. They are often suspended and may be mobile in the sense that they actually move in space.

a. Select strips of balsa wood of varying lengths and thicknesses and glue them together to create a structure to be suspended in space. Begin with larger forms and then introduce smaller forms. Consider filling in the open spaces with colored paper, tissue paper, or cellophane (fig. 10.42).
b. Repeat part *a*, suspending independent but related shapes within the total form. These shapes, because they are independent, are capable of individual movement, as in a mobile (fig. 10.43).

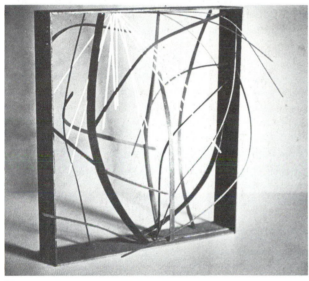

10.40 Three-Dimensional Problem 6b.

Problem 6

Paper and cardboard also can be used to produce relief sculpture.

a. Cut a number of flat pieces of paper or cardboard and mount them on a background so that projections are created (fig. 10.39).
b. Try using strips of cardboard or heavy paper within a boxlike frame for spatial effects (fig. 10.40).

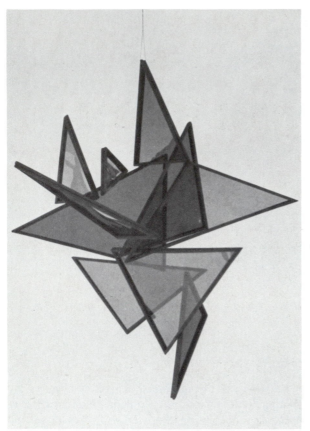

10.42 Three-Dimensional Problem 8a.

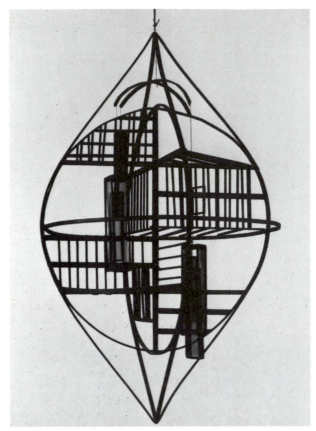

10.43 Three-Dimensional Problem 8b.

Problem 9

The advent of welded metal and the use of wire have expanded linear three-dimensional form in sculpture.

Select a subject to be used as a model or work directly and let the linear material suggest the subject and/or the form for a single sculpture. Form and bend manually malleable wire about twelve feet in length and ⅛ inch in diameter. Work the wire as a graphic artist would a continuous line in a drawing, stopping only to change direction or to join an intersection of wire. Generally, it is best to begin with larger shapes and progress to smaller shapes and details. Remember that the directional qualities of line and wire can suggest movement. Work for interest from a variety of views (fig. 10.44).

10.44 Three-Dimensional Problem 9.

11
FORMS OF EXPRESSION

INTRODUCTION

DEFINITION OF EXPRESSION

NINETEENTH-CENTURY FORMS OF EXPRESSION

Neoclassicism

Romanticism

Realism and Naturalism

Impressionism

Post-Impressionism

Nineteenth-Century Sculpture

EARLY TWENTIETH-CENTURY FORMS OF EXPRESSION

Expressionism

French Expressionism: Fauves

German Expressionism: Die Brucke, Die Blaue Reiter, and Die Neu Sachlichkeit

Expressionism in the United States and Mexico

Post-Impressionist and Expressionist Sculpture

Abstract Art

Cubism

Futurism

Pure Abstraction

Nonobjective Art

Abstract Art in the United States

Abstract Sculpture

Fantastic Art

Dadaism

Individual Fantasists

Surrealism

Surrealist Sculpture

ART FORMS OF THE 1940s AND 1950s

Abstract Surrealism

Abstract Expressionism

Abstract Surrealist and Abstract Expressionist Sculpture

ART FORMS OF THE 1960s AND 1970s

Post-Painterly Abstraction: Hard-Edge Painters, Color Field Painters, and Minimalists

Neo-Dada, Combine or Assemblage, Pop, Happenings, and Op Art

Kinetic Sculpture

New Realism

Primary Structurist, Minimalist, and Constructionist Sculpture

Environmentalism: Earthworks

Process and Conceptual Art

ART FORMS OF THE 1980s

Neo-Expressionism

INTRODUCTION

This chapter is concerned with the third component or part of each work of art: *content, meaning,* or *expression*. Obviously, when time permits, probing the historical traditions of the past increases students' understanding of art forms and what the artist is trying to express through them. However, the coverage of this chapter has been restricted for several reasons.

First, we were trying to limit the length so that a wide range of people interested in art—but not wishing to become artists—could use it, while also making it useful to those persons taking their first steps towards artistic training.

Second, the text was restricted to a simplified account of the successive movements or schools and primary aims of nineteenth- and twentieth-century art because it was felt that the fundamental roots referred to in the introductory chapter are well illustrated in these "Modern art" centuries.

Finally, this text is more in the nature of a guide to learning about art by student participation in creative activities than as a survey or history of art for purely appreciative purposes.

If there are people who find they need to go further toward lecture, analysis, and discussion of past art tradition than the text allows, there are many excellent general and specific sources on which they can draw.

DEFINITION OF EXPRESSION

The fixing of an image, whether it be oil pigment on canvas or pencil on drawing paper, is only one aspect of the act of artistic creation. The character or personality of this formal image is determined as much by the artist's mental and emotional response to a subject as by the artist's choice of media and manipulation of tools.

Expression in art is primarily concerned with the intangible quotient of creativity previously mentioned in chapter 2, "The Nature of Art." It is this unique creative urge and its formal crystallization that art critics consider when making the distinction between ordinary artists and those who are truly marked with genius.

Artists express feelings about life growing out of their continuing experiences with people, places, events, objects, and ideas. These experiences, interwoven with associations, sentiments, and memory, are molded or reworked in the mind through artists' understanding of artistic values. Finally, this feeling image is given *form* and *meaning* through artists' mastery of their chosen medium. Expression becomes the stylistic *form* in which artists couch sensuous-visual meaning; it is an attempt to say something about a *subject* in terms of an artist's own time. Expression is thus directly related to the basic components of a work of art.

There are two broad classifications of *expression* as stylistic form: *individual* and *group*. Group expressions are those of a society as a whole. They are created and achieve sophistication with the birth and growth of a culture. An example of group expression is the development in ancient Greek civilization of *idealism,* wherein the artist saw humanity transfigured by its destiny. Within such group expressions, social changes affect *style* so that discernible variations of attitude toward *subject, form,* and *meaning* take place. These variations can be traced from the lively *conceptualism* of early Greece (seventh century B.C. to early fifth century B.C.) through the refined *perceptualism* of the Classic Age (late fifth century to fourth century B.C.) to the Hellenistic Age (fourth through the third centuries B.C.), when there was a gradual loss of artistic values in favor of purely associational, imitative, and academic qualities.

Individual expressiveness in the handling of subject, form, and content seems more appropriate to our own time than to the group expression of the past. This is probably due to present-day extolment of self-assertion and individualism. Although general groupings or categories of artists with similar intentions can be made in the art of the nineteenth and twentieth centuries, hosts of variations within these basic directions are discernible. The contemporary accent on individuality has resulted in a greater diversity of artistic expression since the mid-nineteenth century than in art previous to that time.

A summarization of the movements in the art of today will help us realize that the traditions of the past did not suffer wholesale rejection. Actually, these traditions have merely been reevaluated in the light of modern tastes. The changing concepts of physical beauty down through the ages illustrate that each period has its own standards of taste: women in paintings by Rubens look rather bulky in comparison with our modern concept of fashion-figure slimness. In a like manner, certain artists of the past who were once rejected are now preferred to many others. Occasionally, even a whole artistic tradition, once considered of great significance, may be relegated to a lower level of consideration. No tradition of the past, whatever its direction, should be completely rejected because it is possible to find something of beauty or quality in each of them. It is essentially a matter of orienting ourselves to see those qualities in a manner similar to the way their creator saw them. It is this conceptual manner of seeing that explains why once-rejected traditions are now wholly acceptable and even preferred to those that were at one time considered to be of greater significance.

NINETEENTH-CENTURY FORMS OF EXPRESSION

Most forms of expression in nineteenth-century art contributed in some degree to the character of art in the present century. On the one hand, twentieth-century Western art can be considered a reaction to all art since the latter half of the eighteenth century. On the other, it is possible to see that present-day art also developed out of past traditions.

Until the middle of the last century, artists were still directly inspired by the appearance of the world around them. With the invention of the camera, however, science disposed of any difficulties remaining in the imitation of natural appearance. Also by that time, artists had so completely solved the problem of representing reality that they were compelled to search for new directions of expression. Some turned toward introspection in their search for new forms; others looked toward the reevaluation of concepts of artistic form that prevailed prior to the Renaissance. These included the ideals of ancient Greek art, forms of expression used by primitive humans, and styles characteristic of the Medieval Period. The opportunity to examine photographs of hitherto unknown art manners (East Asian art and that of Native Americans) provided a background for evolution in new directions.

Economic influences, many of which still affect the art of today, also played a part in this search for new principles of expression. From about the High Renaissance during the 1600s in Italy until the 1850s, artists came to depend more and more for their economic welfare on the patronage of a wealthy clientele. Rather than assert their own inventiveness and individuality, artists gradually adopted the less aesthetic viewpoints of their patrons—the wealthy aristocrats and burghers. Many artists were content to supply works of art that were designed to satisfy and flatter the vanity of their patrons. A few great artists naturally evaded such bonds of artistic degradation and drew their inspiration from the society around them as well as from universal meanings.

Neoclassicism

Artists sought freedom from the economic bondage inflicted by the patronage of wealthy clients. Reaction to the earlier patronized form of art resulted in the formation of formal institutions such as the French Academy. The art of the Academy was characterized by rules for achieving correct works of art that contained messages of a high moral order. Artists involved in the Neoclassic movement at the beginning of the nineteenth century did not reject patronage so much as they rejected the class of people who had patronized the artist of the eighteenth century. Such prominent artists as Jacques Louis David and Jean A. D. Ingres largely replaced the patronage from the effete French aristocracy with that from the Napoleonic state and the upper middle class (fig. 11.1).

Romanticism

The first group of artists to reject any kind of servitude to a patron, or even to a class of patrons, were the Romantics. They can be considered the first revolutionaries of modern times because of their concern with the work of art itself rather than with its significance for a patron or even for an observer. True revolutionaries realize that they do not have to seek an audience; if they have something worthwhile to say, people will eventually be convinced of their viewpoint. This has become

11.1 Jacques Louis David. *Oath of the Horatii.* **1786; oil on canvas, 51¼ × 65⅝ in.** A cold, formal
ordering of shapes with emphasis on the sharpness of drawing characterized the neoclassic form of expression.
Both style and subject matter seemed to be derived from ancient Greek and Roman sculpture.
Courtesy the Toledo Museum of Art. Gift of Edward Drummond Libbey.

one of the fundamental principles underlying the creative art of our time. As a result of this revolt, artists have based their expression upon their own inspiration and their study of past traditions; they are again tuned to the world of all human experience. However, in this world artists have found many contradictions, and, as a result, we find many contradictions in present-day art.

The most important artists of the Romantic group were: Eugène Delacroix in France, Francisco Goya in Spain, Joseph M. W. Turner in England, and Albert Pinkham Ryder in the United States. The paintings of these men show the characteristics of the movement (fig. 11.2 and plates 89 and 90).

Realism and Naturalism

Where the art of the Romantics had been a reaction to the pseudoclassic, academic formulas of Neoclassicism, the Realist movement was a reaction against the exotic escapism and literary tendencies of Romanticism. Wishing to avoid the pretentious attitudes of the previous group and stimulated by the prestige of science, the Realists wanted to show the world as they

thought it appeared to the average layperson. They wanted to avoid mere surface appearances but also to give a sense of immediacy they found missing in the idealistic expression of Romantic and Neoclassic artists (fig. 11.3; *see* plate 77). A related group, now known as Naturalists, wanted to go beyond the results achieved by the Realists. Their attempts to make a visual copy of nature, exact in all its minute details, were probably influenced by the results obtained with the newly invented camera (plate 91; *see* plates 38 and 55).

Impressionism

In the nineteenth-century Impressionist movement there was a strong shift toward the contemporary view in art: the *form* of the work of art (materials and methods) was emphasized rather than significant *subjects* from nature. Where previous movements had developed the trend toward freedom of choice in subject, the Impressionists contributed a new technical approach to painting that stressed the artist's interest in the appearance of the work in terms of form as much as in the appearance of nature. Impressionism represented the transition between tradition and revolution. The

11.2 Francisco Goya. *El Famoso Americano Mariano Ceballos.* circa 1815; print: etching, 12¼ × 15¾ in. The romanticism of Goya is here displayed in both his choice of subject matter and characteristic dramatic use of light and dark values. Philadelphia Museum of Art. Purchased: The McIlhenny Fund.

Impressionists still wished to show nature in its most characteristic way but were mildly revolutionary in using technical aids to represent special conditions of light and atmosphere.

The Impressionists' interest in the illusion of light and atmosphere required intensive study of the scientific light theory of color and the effect of light on the color of objects. The Impressionists discovered the principle of juxtaposing complementary colors in large areas for greater brilliance; they interpreted shadows as composed of colors complementary to the hue of the object casting those shadows. To achieve the vibratory character of light, they revived the old principle of *tache* painting, a technique in which the pigment is put on the canvas in thick spots that catch actual light and reflect it from the surface. The tachist method of painting seems to have been invented by the Venetians of the sixteenth century and can be seen in the work of

Titian (*see* plate 36). Later application of the technique is found in the paintings of Hals, Goya, and Constable. The Impressionists employed the style in a new way by using complementary hues in the dabs of pigment. When seen from a distance, the dabs tend to form fused tones from the separate hues.

Local color was all important to the Impressionists because their whole intent was to capture the transitory effects of sunlight and shadow or of any kind of weather condition. Landscape became the favorite subject of the Impressionist painter because of the variability of local color under changing weather conditions.

Traditional methods of artistic interpretation underwent a second alteration when the Impressionists discovered the fascinating possibilities of unexpected angles of composition. The new photographic views of

11.3 Honoré Daumier. *Advice to a Young Artist.* **Probably after 1860; oil on canvas, 16⅛ × 12⅞ in.** Influenced by a climate of scientific positivism, the artists of the Realist movement strived toward a recording of the world as it appeared to the eye, but interpreted with overtones of timeless quality. This painting by Daumier suggests not so much the particular appearance of costume and setting but rather the universal quality in the subject—the idea that the working people of all ages have similar qualities.
National Gallery of Art, Washington, D.C. Gift of Duncan Phillips.

the natural scene were often different from the conventional arrangements used by artists for many years. Japanese block-prints imported into France for the first time also encouraged new views. These prints often placed a dramatic decorative emphasis on high-angle views, or views looking down on landscape subjects and people. They were also frequently cropped down for shipment to Europe, resulting in curious truncated compositions that seemed unique to Western artists.

Artists representative of Impressionism in France about 1870 were Claude Monet, Camille Pissarro, Auguste Renoir, and sometimes Edgar Degas (plates 92 and 93; *see also* plates 58, 59, and 67). There were deficiencies in Impressionist theory that caused some artists in the group to separate and pursue their own direction. One of the principal deficiencies was the loss of structural form resulting from the acceptance of surface illusion alone. A second was related to the effect that outdoor lighting has on the way an artist sees color. In strong sunlight it was difficult to avoid making greens too raw, and there was a tendency to overload the canvas with yellows.

Post-Impressionism

Late in the nineteenth century, painters who had once been inspired by Impressionist theories began to abandon many of the principles of the movement. The most important artists in this reaction were Paul Cézanne, Paul Gauguin, and Vincent van Gogh. From these three pioneers stem the major expressions or directions of twentieth-century art.

This group of artists was later classified under the term Post-Impressionism, an ambiguous title at best. This vague title does not satisfactorily indicate the far-reaching objectives of the artists in the movement. These artists sought (1) a return to the structural organization of pictorial form, (2) an emphasis on decorative organization for the sake of unity as well as for the enchanting patterns that might result, and (3) a more or less conscious exaggeration of natural appearances for emotionally suggestive effects (commonly called *distortion*) (*see* fig. 9.33). Cézanne can be said to represent primarily the first of these aims, Gauguin, the second, and van Gogh, the third; each, however, incorporated some aspect of the other's objectives in his form of expression. It is these similarities that cause them to be grouped in the same movement, although, unlike the Impressionists, they worked independently toward their goals.

Cézanne was the dominant artist in the Post-Impressionist movement. In a manner contrary to the haphazard organization and ephemeral forms of the Impressionists, he saw a work of art in terms of the interrelationships of all of its parts. He retained the individual color spots of the former group, but in his painting, these became building blocks in the total physical structure of the work (*see* plate 57). Although he might be called an *analyst* of reality rather than a *recorder* of reality (like the Impressionists and Naturalists), he went beyond mere analysis. Reality for him was not the object in nature from which he drew his inspiration, but rather represented all of the artistic conclusions arrived at in the completed work. He conceived of reality as the totality of expression derived from the appearance of nature as it became transformed in the mind and under the artist's hand. Therefore, although Cézanne found his beginning point in nature (as was traditional), he became the first artist of modern times to consider the appearance of his *pictorial form* more important than the *forms of nature* (*see* plate 19).

In this search for his own kind of reality, he looked beneath the surface matter of the world for the universal or changeless form. He once wrote to a friend that he found all nature reducible to simple geometric

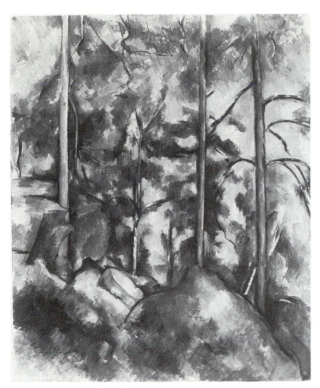

11.4 Paul Cézanne. *Pines and Rocks.* circa 1896–1899; oil on canvas, 32 × 25¾ in. Cézanne looked for the essence of natural forms rather than for mere surface description. In this painting the artist has simplified the tree and rock shapes to produce a solid compositional unity.

Museum of Modern Art, New York. Lillie P. Bliss Bequest.

shapes such as cones, spheres, and cubes. The essentialness of these forms seemed more permanent to Cézanne than the transient face of nature (fig. 11.4). Due to the intellectual processes involved in his realizations of form, he is considered a classicist in spirit. Nevertheless, he became the forerunner of modern Cubism as well as of other intellectualized abstract forms of the twentieth century.

In contrast to the architectural character of Cézanne's forms, the works of Paul Gauguin show the invention of a vivid, symbolic world of decorative patterns (plate 94; *see* plate 9 and fig. 5.8). The patterns owe their particular character to the type of form expression found in medieval frescoes, mosaics, and enamels. Although Gauguin's themes were inspired by the primitive peoples of the South Seas, the works always demonstrate a sense of the sophistication typical of most Western art. An underlying suavity tempers Gauguin's work and gives it a quality reminiscent of the old masters' paintings, in spite of its barbarity of color and freedom of pattern. The decorative style of the French Fauves in the early twentieth century stems primarily from the work of Paul Gauguin.

The work of Vincent van Gogh, the third pioneer Post-Impressionist, represents the beginning of the new, highly charged, *subjective expression* that we find in many forms of contemporary painting. The character of twentieth-century Expressionism owes a great deal to the impetuous brush strokes and the dramatic distortions of color and object forms first found in the work of van Gogh (plate 95; *see* plates 5, 45, and 61).

Nineteenth-Century Sculpture

At this point we turn to nineteenth-century sculpture to trace the factors leading to the changing values in the twentieth century. (Since this is a text of fundamentals, we restrict the discussion primarily to sculptors who manifested an outstanding influence on the course of sculpture.)

First, we should point out variances between the points of view and procedures of painters and sculptors. The major difference between painting and sculpture lies in the elements of material and regard for space.

Painters work with flexible materials in an additive manner. In their concern for space they must not only invent their own illusion but also the kinds of three-dimensional shapes that seem to occupy that space.

Sculptors, on the other hand, work with tangible materials, creating actual masses and volumes in actual space. Obviously, the thinking of sculptors is dominated most by the weight and mass of the materials they employ. Yet, paradoxically, the thinking of nineteenth-century sculptors was primarily painterly, or additive. Clay modeling dominated the procedures and thinking. Modeling is primarily an additive, rather than a subtractive, process. Thus, nineteenth-century sculptors' losing sight of traditional sculptural values was due to the strong dominance of modeling during that time.

Another factor leading to revolutionary changes in sculpture during the early twentieth century involved the inhibitions imposed by the vested authority of various European academies. More so than in painting, commissions to sculptors were awarded on the basis of fidelity to nature and to observance of the classical principle of using the human figure to personify abstract ideals or symbolic meanings. Is it any wonder that the best sculptural talent was submerged by such strictures on originality of expression, or that sculptors more than painters in the nineteenth century lost sight of the older fundamentals of their craft?

There was a void in innovative sculpture during the nineteenth century until Auguste Rodin. True, there were people who could handle the tools of sculpture with virtuoso dexterity, and there is a great deal that is admirable in their handling of resistant materials like

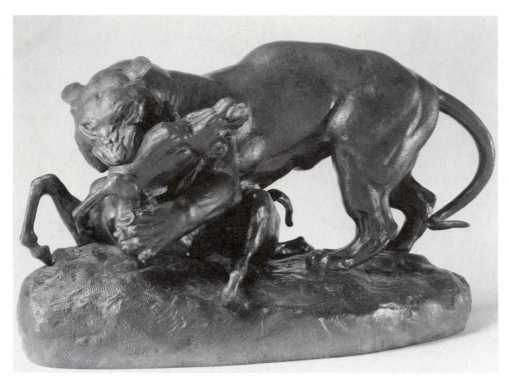

11.5 Antoine Louis Barye. *Tiger Devouring an Antelope.* 1851; bronze, 13 × 22½ × 11⅝ in. Barye's use of emotionalized romantic form is similar in dynamism to the intense coloristic qualities of Romantic painters such as Delacroix and Turner.
Philadelphia Museum of Art. The W. P. Wilstach Collection.

marble or malleable materials such as the clay from which bronze castings were made. Unfortunately, the thinking behind their work was not definably different from ideas that had been in existence for about three hundred years, or since the early Renaissance. Antonio Canova, the outstanding early nineteenth-century classical sculptor, and Jacques Louis David, his counterpart as a painter, merely reestablished the classical ideal of the allegorical figure representation. If we compare Canova with any of the great originators of the past, such as Donatello or Michelangelo, however, he pales into insignificance. His figures seem artistically lifeless. Their expression depended on attention to surface detail and on mannered gestures demonstrating a somewhat borrowed attitude in representing beauty of the human form, rather than a new way of using sculptural materials to express human life. The Romantic sculptor Antoine Louis Barye seems more original in his grasp of the essentially dynamic, monumental, and ferocious character of animal life, his favorite subject (fig. 11.5). But the idea behind Barye's use of animals in combat or feeding on their prey followed the essentially Romantic principle of evoking human emotional parallels—an artistic principle that had been in existence at least since the seventeenth century. Then they had been expounded by the great Dutch philosopher Baruch Spinoza. Old values and thinking were merely being reiterated. New forms expressive of humanity in nineteenth-century life were not being invented.

Of all nineteenth-century sculptors only Auguste Rodin was a dominant figure. Rodin looked to the future as well as to the past. He was, in the historical sense, the link between traditional forms of representation and modeling and the twentieth-century sculptors' exploitation of form, materials, and expression for their own inherent values.

Although he was never a direct follower of the Impressionist movement, Rodin worked in a manner that was often like that of Impressionistic painters. But Rodin went far beyond Impressionism. His search for new ways to express emotional states directly through form was to be one of the crucial directions that evolved in the early part of the twentieth century. Rodin's attitude parallels the endeavors of expressionistic Post-Impressionist painters such as Vincent van Gogh and Toulouse-Lautrec.

Rodin's impressionistic effects come from dependence on the way light falls upon his forms to suggest the musculature and bone structure of his figures. He expanded this impression of form to express the inner condition of humanity as it was understood toward the end of the century (an often-used theme of Symbolist painters, followers of Paul Gauguin).

In his late work Rodin also tended to see sculptural form in terms of fragmentary objects, probably the result of criticism of his early work as being too literal.

Rodin's *Age of Bronze* (1876) (fig. 11.6) was so implicitly naturalistic that salon critics insinuated that he had cast it from a living model. Tremendously upset by this criticism, Rodin moved away from ostensibly literal effects toward the expression of psychological or emotional states. During this change he rediscovered the principle of suspended or fleeting movement, due partly to its exploration by some contemporary painters (Degas, Toulouse-Lautrec) and partly to his own study of the great seventeenth-century sculptor Giovanni Lorenzo Bernini. Rodin greatly admired Michelangelo also and tried to restore sculptural values that he discovered in Michelangelo's work and that he felt had been lost since that sculptor's time. These values include feeling for the ponderousness and texture of stone and the contrast between highly polished surfaces and unfinished roughness.

In his renewal of such old values, Rodin was led to an interest in the interplay between volume and mass and between hollows and protuberances. Clay and wax remained his favorite materials in which to sketch or create new forms, and he carried the great malleability of these materials into finished bronze castings so well that the observer can feel the tactile sensations of thrust and pressure used in the process of forming. Thus, Rodin no longer used primarily a modeling approach to produce naturalistic figures as his nineteenth-century predecessors had aimed to do.

Certainly, Rodin was a paradox during his lifetime since he was first denounced for being too natural and, then, in his late work, criticized again for creating unnatural distortions. He ran the gamut between sweetly bland sculptures in marble and plaster to others that suggested mauled, distorted, amputated bodies—fragments of human form in plaster and bronze. From Michelangelo he learned the trick of letting a figure or head emerge from a roughly finished block of stone (fig. 11.7). These figures and parts of figures tend to suggest human striving against fateful forces. Expressionistic sculpture was initiated by the strange psychological effect of such works because some early twentieth-century sculptors used fragments and figural distortions mainly for emotional effect.

Like Michelangelo, Rodin also enlarged limbs, or he gave them a painful twist, as did Bernini. He also gave figures unnatural torsion and dimension to emphasize potential power and the effect of inner torment. Thus, the tense, turbulent, distorted side of Rodin's work predicted the future and paved the way for the sculptors of the twentieth century to escape the academic inhibitions that had ruled so much art in the nineteenth century. Rodin's career also reconfirms the fact that it is always the individual genius who leads the way to new ideas and forms. Most artists, substantive though they may be, tend to profit from only one or two of the directions foreseen by the genius.

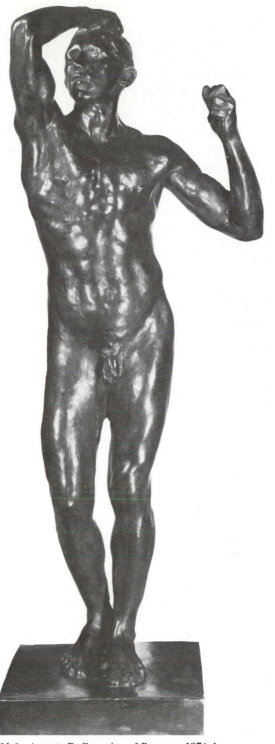

11.6 Auguste Rodin. *Age of Bronze.* **1876; bronze, 25½ × 9⁵⁄₁₆ × 7½ in.** Rodin was excited by the possibility of expressing human psychological states. In early works, such as the example illustrated, he used a quasi-impressionistic effect of natural light to suggest the quality of human anatomy as the outward form of mental processes.
Detroit Institute of Arts. Life Interest Gift of Robert H. Tannahill.

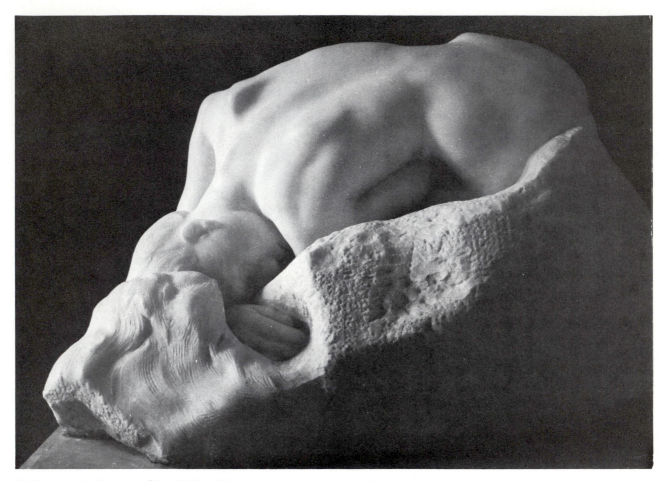

11.7 Auguste Rodin. *Danaïde.* **1885; marble.** An example of the sculptor's later work that reflects Michelangelo's influence in its partially revealed form emerging from the roughly finished stone. The psychological effect of such a work helped to bring about twentieth-century Expressionist art.
Giraudon/Art Resource, N.Y.

EARLY TWENTIETH-CENTURY FORMS OF EXPRESSION

Expressionism

French and German Expressionism, perhaps the most significant phase in the evolution of newer art forms, began as the first decade of the twentieth century was almost over. The young artists of this movement were the first to declare on a large scale their complete freedom to work in a manner consonant with their feelings about a subject. In a sense, these artists are merely more liberal Romantics. However, it was possible to be more liberal only after those intervening years of change that had introduced new ways of seeing and feeling.

The twentieth century saw the growth of a new awareness or consciousness that was related to the many changes taking place, or about to take place, in the whole order of existence. Cézanne, Gauguin, and van Gogh had opened the door through which hosts of young artists were now eager to move, anxious to explore this new world of previously unknown artistic sensations, diversions, and mysteries. The shape of this new artistic world was signaled by an explosion of color and an exciting style of drawing that ran the gamut from the graceful curves of Matisse to the bold slashings of Kokoschka.

French Expressionism: Fauves The members of the earliest Expressionist group were called the *Fauves*. This title was attached to them because of the wild appearance of their paintings in comparison to the academic formalism that was accepted and expected by the general public of the period. The term, literally translated, means "wild beasts." Whereas the public had been only dimly aware of Cézanne and van Gogh as revolutionaries, they could not ignore this host of young painters who threw Paris into a turmoil with group exhibitions, pamphleteering, and other forms of personal publicity. In fact, the Fauves seemed to be trying to live up to their name. However, within a period of only seven years they had lost their original vigor and were considered rather calm compared to the newer movements that were evolving. Fauvism is a form of expression that tries to arrive at the emotional essence of a subject rather than to show its external appearance. Its characteristic style is decorative, colorful,

spontaneous, and intuitional. When an artist's emotional excitement about the subject is communicated to the spectator, the artist's work of art can be called successful.

The color, brilliance, and persuading sophistication found in the work of Henri Matisse, nominal leader of the group, was largely influenced by Persian and Middle Eastern art (*see* fig. 9.2, and plates 25 and 39). The group as a whole felt similar influences, often searching for patterns in the areas of the museums dedicated to older and more remote group expressions. The Fauves received inspiration from the work of the Byzantines, the Coptic Christians, the Greek artists of the archaic age, as well as the primitive tribal arts of Africa, Oceania, and the Native Americans. The use of African masks and sculpture can be detected in the mask-like, impersonal quality of the human faces found in Matisse's paintings. Back of this impersonal effect there also seems to lie a sense of mystery or threat engendered by the enigmatic quality of an alien style of expression (plate 96).

Despite the rather strong, vibrant color generally preferred by the Expressionists, Matisse, Utrillo, Vlaminck, and Modigliani often built charming, decorative structures that continued the long tradition of classical restraint found in French and Italian art (plate 97; *see* fig. 9.6, and plate 66). Georges Rouault, on the other hand, is an exception in French Expressionism, his work being more dramatic like that of the German artists. His paintings express a violent reaction to the hypocrisy and materialism of his time through a favorite use of thick, crumbling reds and blacks. His images of Christ are symbols of man's inhumanity to man. His portrayal of judges reveals the crime and corruption that can reach even into those areas where justice should prevail (plate 98; *see* plate 71). Rouault's artistic comments on the French leaders of the day were anything but complimentary.

German Expressionism: Die Brucke, Die Blaue Reiter, and Die Neu Sachlichkeit The artists of Germany felt that they, as prophets of new, unknown artistic values, must destroy the conventions that bound the art of their time. The foundation of painting in Europe for the next fifty years was provided by the goals of three groups of German artists: *Die Brucke* (The Bridge), *Die Blaue Reiter* (The Blue Knights), and *Die Neu Sachlichkeit* (The New Objectivity). The Expressionism of these artists, drawn from an environment that seemed complacent toward social and political injustices, was ultimately an art of protest, but it also was an attempt by German Expressionists to assert their basic urge for expression as directly as possible. The combination of this driving, creative urge and the desire to protest became the foundation for a number of varied movements in German art. The resulting art forms took on

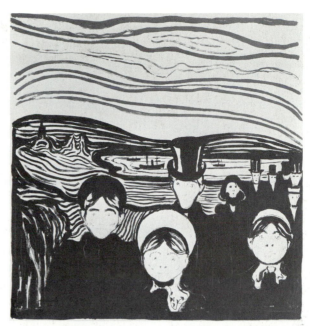

11.8 Edvard Munch. *Anxiety.* **1896; print: color lithograph. 16⅜ × 15⅜ in.** Some of the unhappy experiences in the life of this artist are presented with the characteristic exaggeration of emotional content. Childish terrors and medieval superstitions are interwoven into a form expressive of frightful conditions seen at the time.
Museum of Modern Art, New York. Abby Aldrich Rockefeller Fund.

a quality of vehemence, drama, gruesomeness, and fanaticism never completely achieved by the *raison* (reason) of French art.

The young German artists of this style identified with the religious mysticism of the Middle Ages as well as with the tribal arts of primitive peoples. Many followed the manner of children with a naive but direct expression of emotional identification with environment. For example, the art of Emil Nolde is similar in feeling to the mystic art of the Middle Ages, while Edvard Munch based many of his creations on medieval and primitive folk art traditions (fig. 11.8; *see* plate 63). Franz Marc used the emotional reality of prehistoric art as a basis for his inspiration. Protests against Prussian *jingoism* became the subject matter of the paintings of George Grosz and Otto Dix (fig. 11.9).

Max Beckmann, although not a part of any organized group of Expressionists, followed a path somewhat kindred in spirit to the work of Otto Dix. Following World War I, Dix worked in a style that satirized the swampy, degraded underworld of political society. Beckmann cultivated a similar style of frank, satirical veracity but modified the emotional intensity of his expression with the calm, geometric arrangement he had learned from Cubism. This latter quality gives a certainty of execution to his manner of painting that is quite reminiscent of the work of the old masters (plate 99).

11.9 George Grosz. *Fit for Active Service.* 1918; pen, brush, and india ink. 20 × 14⅜ in. In this work, characteristic German emotionalism is forced to new limits of satire as a result of the artist's personal experiences during World War I. Expressionism, which shows moral indignation at its peak, now becomes an instrument of social protest. Niceties of color are ignored in favor of harsh, biting black lines.
Collection, the Museum of Modern Art, New York. A. Conger Goodyear Fund.

11.10 Jack Levine. *Election Night.* 1954; oil on canvas, 63⅛ × 72½ in. Influenced by the social and political problems of the post-World War II period, the artist arrived at a distinctive manner that combines a complicated and glowing technique with an expressionist pungency of feeling.
Museum of Modern Art, New York. Gift of Joseph H. Hirshhorn.

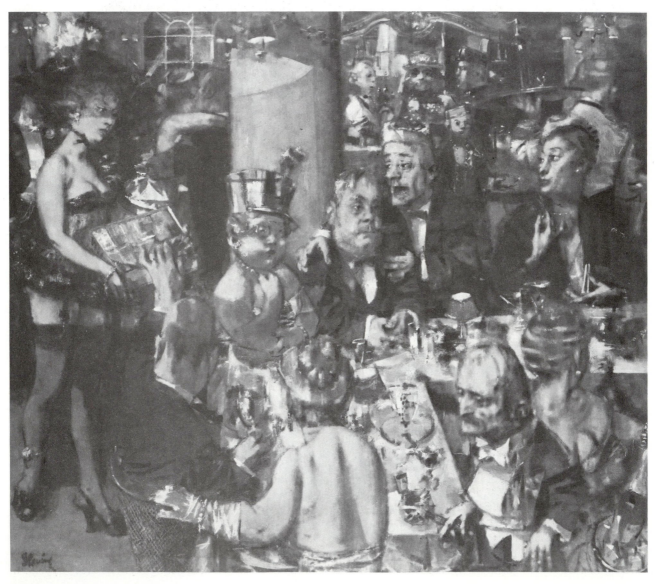

11.11 José Clemente Orozco. *Barricade.* 1931; oil on canvas, 55 × 45 in. Slashing diagonals of line combine with agitated hues and values to express the feeling of this artist concerning the furor of the Mexican revolution in the early twentieth century.
Museum of Modern Art, New York. Given anonymously.

Expressionism in the United States and Mexico The expressionistic style had adherents in the Americas as well as in the European countries. The Great Depression of the 1930s influenced such artists as Max Weber and Ben Shahn to make mournful and satiric comment on American society of the period (*see* fig. 3.26). Philip Evergood and Jack Levine are more recent artists making similar commentary on the political and social confusion of the cold war years (fig. 11.10).

Mexico during the 1920s and 1930s underwent an artistic renaissance that many artists found fruitful ground for an Expressionistic style—a style based on identification with problems inherent in the growth of freedom for the Indian and mestizo classes. José Orozco, whose art evolved during this period, became the greatest exponent of Expressionism in the Western Hemisphere. Inspired by the rapidly changing social order in Mexico, he produced work that had a quality of expression similar to that of Rouault in Europe. There is something of the same black tragedy in the work of both artists, although at the same time, their styles are different in form and meaning (fig. 11.11; *see* fig. 3.19).

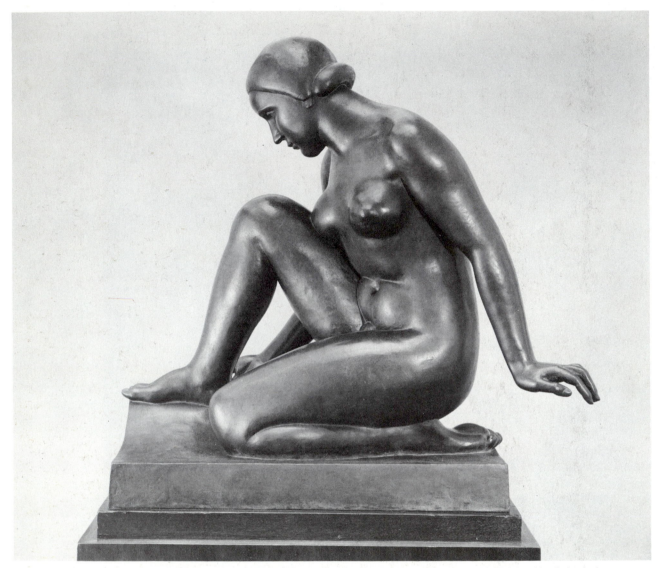

11.12 Aristide Maillol. *Monument to Debussy.* 1931; bronze base, 15⅜ × 29½ in.; height 35 in. Maillol combined classical concepts with a sense of contemporary monumental form.
Courtesy the Toledo Museum of Art. Gift of Edward Drummond Libbey.

Post-Impressionist and Expressionist Sculpture

New concepts in painting remained in advance of those in sculpture until about the 1950s, but a continuous interchange of ideas guaranteed that, even though sculptors did not follow the movements in painting, similar lines of development were parallel in the two groups.

By 1900, revolutionary changes can be detected as sculptors began to express their reaction to contemporary thought and experience rather than to ancient myth or legend. Sculpture then took three general directions: (1) the human figure was retained but simplified to express only the essential structure and material; (2) forms were abstracted from nature, or new forms of a highly formal or structured character were invented; and (3) experimentation with new materials produced new shapes and new techniques.

There was no Post-Impressionist movement as such in sculpture, but the works of some artists, such as Aristide Maillol, Gaston Lachaise, and Wilhelm Lehmbruck, suggest a new interest in the totality of form and an accent on the intrinsic beauty of materials that is similar to the new synthesis of form from nature in Post-Impressionist painting.

Maillol pioneered simplification of figural form to recover the sense of sculptural monumentality that reasserts the essential blockiness of stone and the agelessness of bronze and lead. He began the trend away from academic representation of the human figure by using slightly exaggerated proportion, and also achieved a classical sense of serenity and repose suggestive of the work of Cézanne and Seurat (fig. 11.12).

Gaston Lachaise, a Franco-American sculptor, created weighty, voluminous female figures that evoked the sensuous through exaggerated proportions that were

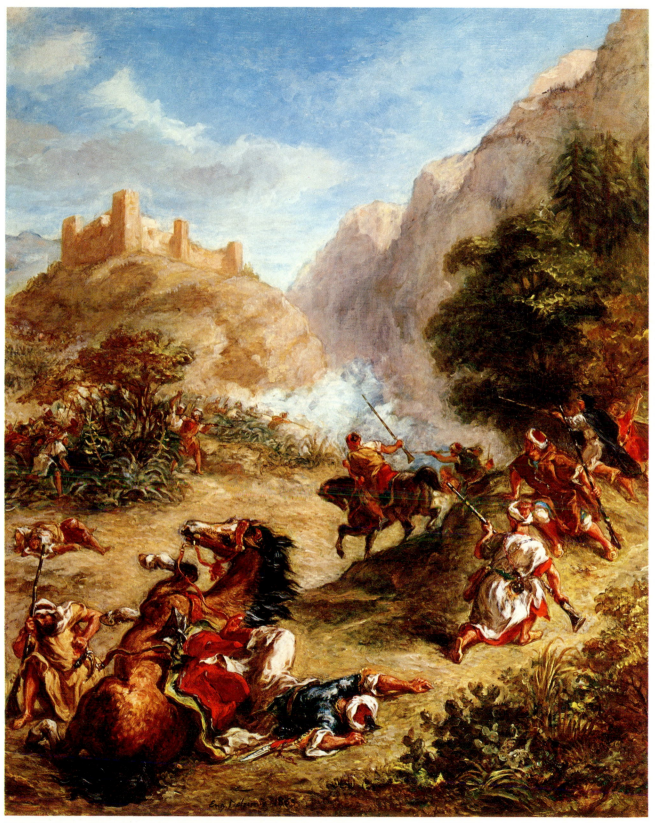

**Plate 89 Eugene Delacroix. *Arabs Skirmishing in the Mountains.* 1859; oil on canvas, 36⅜ × 29⅜ in. A subject matter offering violent action in exotic foreign settings was often found in paintings of the Romantic movement. Although relaxed in style, interpretation was generally bold in technique with an emphasis on the selection of bright colors.

National Gallery of Art, Washington, D.C. Chester Dale Fund.

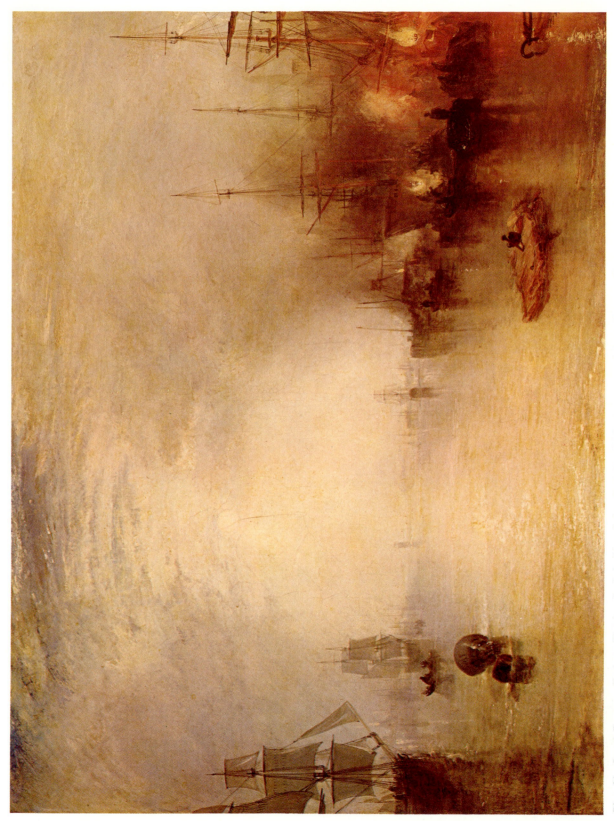

Plate 90 Joseph Turner. *Keelmen Heaving Coals by Moonlight.* Probably 1835; oil on canvas, 36¼ × 48¼ in. The historical origin of theme and seminarrative presentation of subject are qualities found in many works of the Romantic movement. In his manner of using color to produce atmospheric effects, Turner anticipated the techniques of the later Impressionists. Like these artists, he placed less emphasis on formal organization.
National Gallery of Art, Washington, D.C. Widener Collection, 1942.

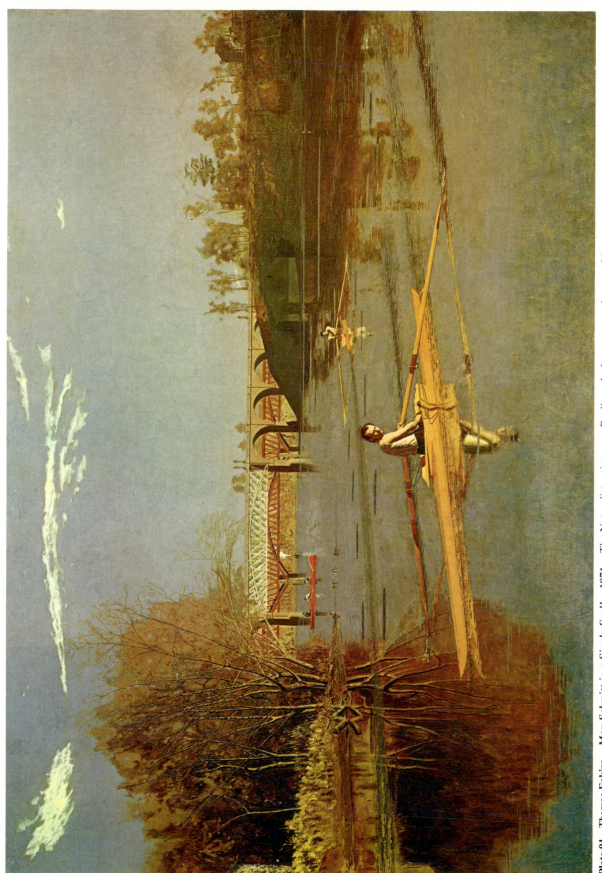

Plate 91 **Thomas Eakins.** *Max Schmitt in a Single Scull.* **1871.** The Naturalist artists were Realists who became more interested in particularizing people and events by a carefully descriptive style of expression. The oarsmen are here minutely described by the artist in terms of specific people taking part in a particular activity and in a particular setting.

Metropolitan Museum of Art, New York. Purchase 1934. Alfred N. Punnett Fund and Gift of George D. Pratt.

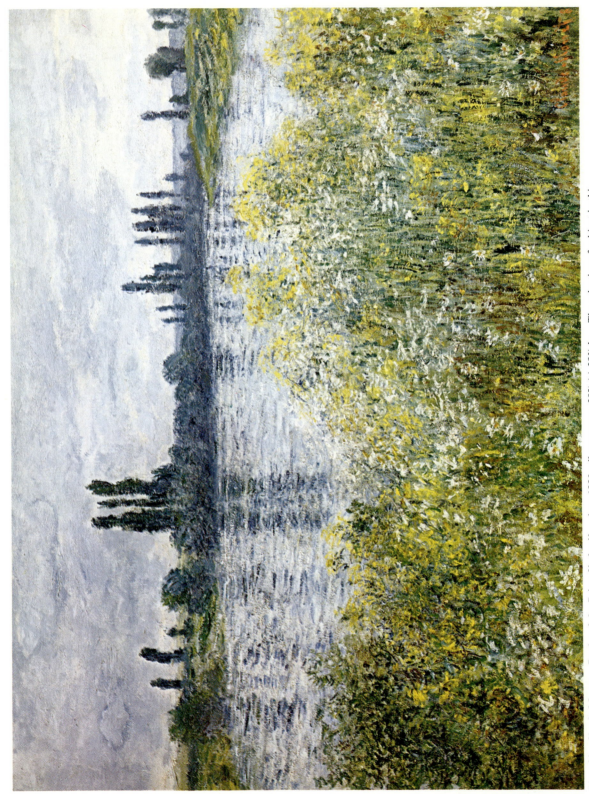

**Plate 92 Claude Monet. *Banks of the Seine, Vetheuil.* circa 1880; oil on canvas, 28⅞ × 39⅝ in. The selection of subject in this painting is typical of the Impressionist movement. The bright scene and the shimmering water offered opportunity for the expression of light and atmosphere through a scientific approach to the use of colors.
National Gallery of Art, Washington, D.C. Chester Dale Collection, 1962.

Plate 93 Edgar Degas. *Four Dancers.* **circa 1899; oil on canvas, 59½ × 71 in.** Two aspects of the Impressionist artist's recording of natural form can be found in this painting of four dancers. First, the work demonstrates the customary interest in the effects of light. Second, the painting also shows a high-angle viewpoint of composition derived from Japanese prints or from the accidental effects characteristic of photography.
National Gallery of Art, Washington, D.C. Chester Dale Collection.

Plate 94 Paul Gauguin. *The Moon and the Earth.* **1893; oil on burlap, 45 × 24½ in.** Color and form are here freely interpreted to suggest the naive qualities of an uncivilized people. The relationships of these elements are expressed in terms of an overall decorative structure that adds to the general effect of tranquility.
Museum of Modern Art, New York. Lillie P. Bliss Collection.

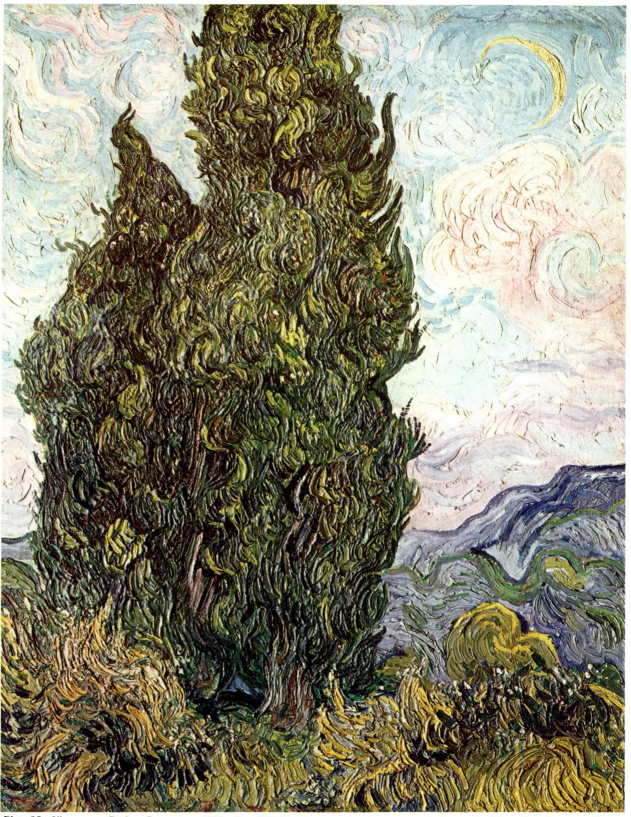

Plate 95 Vincent van Gogh. *Cypresses.* 1889; oils. This highly personal style exaggerates the organic forces of nature and makes them dramatically expressive. The heavy, swirling applications of paint enhance the movements extracted from the natural form.
Metropolitan Museum of Art, New York. Rogers Fund, 1949.

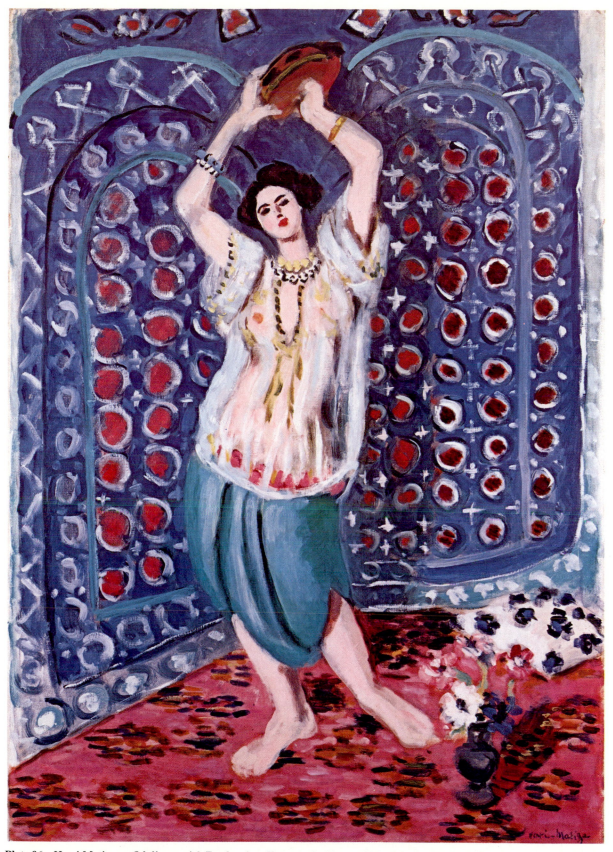

Plate 96 Henri Matisse. *Odalisque with Tambourine: Harmony in Blue.* **1926; oil on canvas, 36 × 25½ in.** The Fauve Expressionists, led by Matisse, tried to arrive at the emotional essence of a subject rather than its external appearance. Matisse also reveals the characteristic decorative, colorful, spontaneous, and intuitional qualities of this French Expressionist style.
Courtesy of the Norton Simon Foundation, Pasadena, California.

Plate 97 Amedeo Modigliani. *Gypsy Woman with Baby.* 1919; oil on canvas, 45⅝ × 28¾ in. The artist's painting stresses sensitive shape arrangement and subtle modeling of form within a shallow space concept. His interpretation of the figure is a personal mannerism suggesting the influence of Gothic and black African sculpture.
National Gallery of Art, Washington, D.C. Chester Dale Collection.

**Plate 98 Georges Rouault. *The Three Judges.* 1913; gouache and oil on cardboard, 29⅞ × 41⅝ in. Rouault's intensity of feeling is expressed by the use of somber reds framed in black and nocturnal blue. Rouault's work lacks the ingratiating character usually found in the other French artists of the movement.

Museum of Modern Art, New York. Sam A. Lewisohn Bequest.

Plate 99 Max Beckmann. *Departure.* 1932–1935; oil on canvas, triptych, center panel 84¾ × 45⅝ in., both side panels 84¾ × 39¼ in. Here, style is emotionally intensified through strong contrasts of value and the impasto with which the artist has applied his pigment. However, this intensity of expression is partially modified by the cool, orderly arrangement derived from Cubism. Museum of Modern Art, New York. Given anonymously.

Plate 100 Giacomo Balla. *Speeding Automobile.* **1912; oil on wood, 21⅞ × 27⅛ in.** This artist's handling of the image of a speeding machine is characteristic of the Futurist idiom. Incorporated into the dynamic form is a sense of the hysterical approach to violence and the psychological impact of tensions in modern times.

Museum of Modern Art, New York. Purchase.

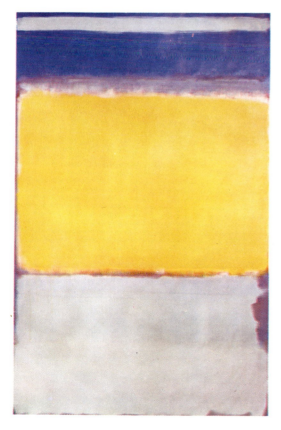

Plate 101 Mark Rothko. *No. 10.* **1950; oil on canvas, 90⅜ × 57⅛ in.** Using apparent simple masses of color on a large scale, the artist is able to evoke emotional sensations in the observer. Rothko was one of the American artists who worked in the pure abstract idiom.

Museum of Modern Art, New York. Gift of Philip C. Johnson.

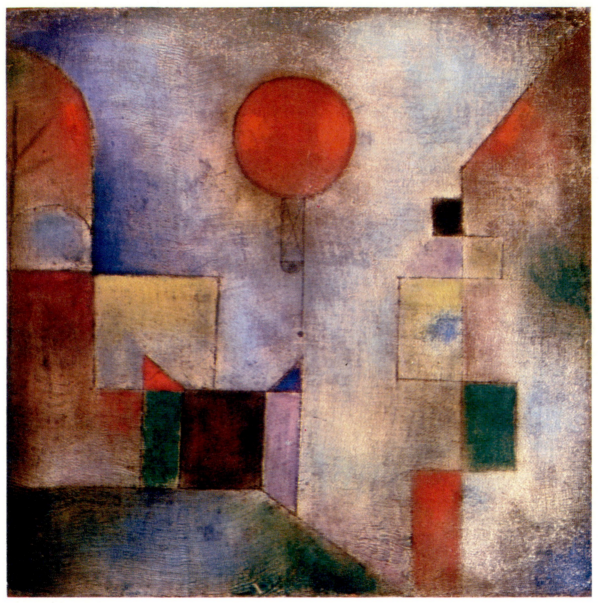

Plate 102 Paul Klee. *Red Balloon.* 1922; oil on chalk-printed linen gauze, mounted on board, 12½ × 12¼ in. Many artists developed fusions of twentieth-century concepts that defy classification insofar as any one category of expression is concerned. This reproduction illustrates a refined synthesis of relaxed Cubism forms and the naive charm of children's art.
Solomon R. Guggenheim Museum, New York.

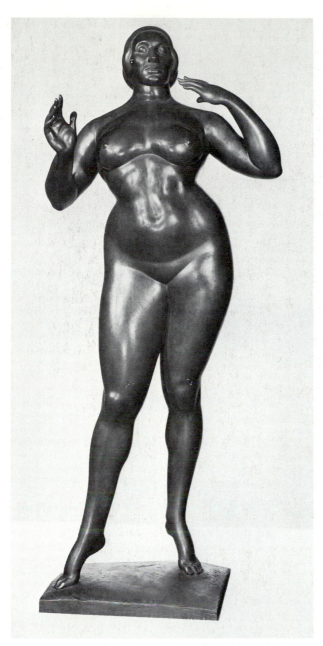

11.13 Gaston Lachaise. *Standing Woman.* **1927; bronze.**
Ponderous figures were given a feeling of lightly balanced poise.
Art Institute of Chicago.

rhythmically balanced. At times his sense of poise gave figures a feeling of aerial suspension seemingly at odds with the amplitude of his forms but reconciled by his exquisite sense of balance and the finish he gave to metal (fig. 11.13).

Lachaise and Lehmbruck both worked in a manner similar to the more emotional aspects of Post-Impressionism, comparable in some ways to the painters Gauguin or van Gogh. Lehmbruck evolved a style of elongated figures that were suavely charming or nostalgic and melancholy. Like Lachaise, he distributed the masses of his figural forms rhythmically, but used a strong vertical axis, unlike Lachaise's variable axis.

Where Lachaise used rounded masses, Lehmbruck created relatively spare forms that were almost stripped of fleshy connotation (fig. 11.14).

Just as there was not a clearly defined Post-Impressionist movement in sculpture, neither was there a clearly perceivable expressionist sculptural school. Several sculptors worked in a manner related to the ideal the *Blaue Reiters* in Germany had expressed as "stripping away surface reality to arrive at underlying truths." Generally speaking, however, those sculptors who can be called Expressionist were less disposed than the painters toward violent distortion of form to reveal the psyche. Lachaise and Lehmbruck are sometimes also called Expressionist because of their *moderate* distortion of human form.

Jacob Epstein, the Anglo-American sculptor, developed an expressionist, as well as an abstract, manner during his lifetime. His expressionist works, usually cast in bronze, were based on an exaggerated clay-pellet technique. These works seem distantly related in emotional impact and technique to the style of Rodin. When Epstein carved in stone, his approach was more often formal and semiabstract, rather than emotional (fig. 11.15).

There are more recent sculptors whose work is reminiscent of this mildly expressionistic idiom of early twentieth-century sculpture. Among these are the American graphic artist and sculptor Leonard Baskin. Baskin seems concerned with the tragic tension between humans and environment as expressed through figures of people and birds, and more recently through studies of figures and heads of cultural heroes and heroines. It is as if in the great of the past, Baskin finds hope for solution of present-day problems.

The Italian artist Marino Marini also works in a manner of slight distortion in his best-known works—equestrian figures produced in the late 1940s and early 1950s. The slightly abstract shapes of horse and rider may be related to Kandinsky's rider series of 1909–10 and seem to imply Marini's concern with the impersonality of modern life (fig. 11.16). Marini's sculpture has become increasingly abstract.

Abstract Art

Cubism About 1906 in Paris a new attitude toward nature was observed in the work of certain artists. Before Cézanne, European artists tended to see nature in terms of material surfaces. Cézanne began the trend toward the search for reality (the universal unvariables) beneath these material surfaces. He observed and emphasized the basic structure of nature. This new way of seeing developed gradually over a period of twenty-five years, paralleling the changing concepts of reality

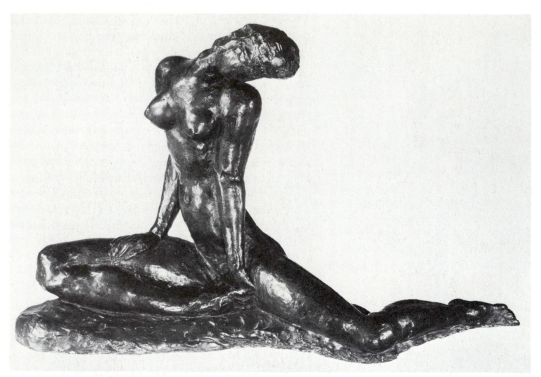

11.14 Wilhelm Lehmbruck. *Seated Girl.* 1913–1914; bronze, cast patina, 11 × 17⅝ × 5½ in. This work exemplifies the mildly expressionistic sculpture that dominated the early twentieth-century pioneering phase of contemporary sculpture.
Detroit Institute of Arts. Bequest of Robert H. Tannahill.

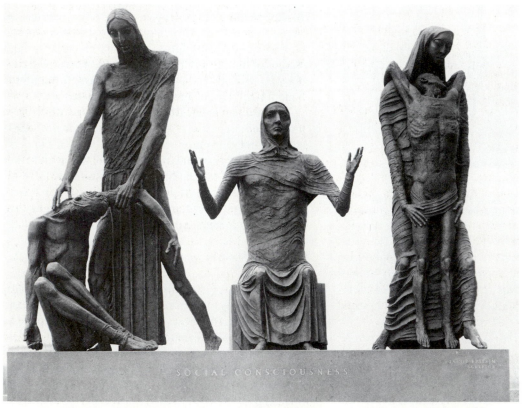

11.15 Jacob Epstein. *Social Consciousness.* circa 1954–1955; bronze. Multiple figures can be used to express human as well as formal relationships.
Philadelphia Museum of Art: On Deposit from the Commissioners of Fairmount Park.

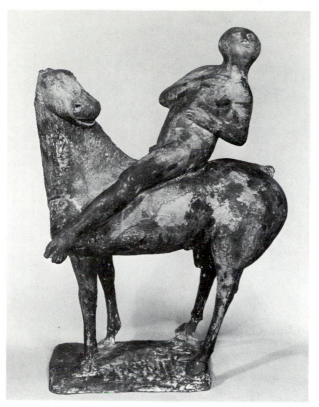

11.16 Marino Marini. *Horse and Rider.* 1947; bronze, 40 × 12 in. The tradition of equestrian sculpture is joined to twentieth-century abstraction and formal tension. Art Institute of Chicago.

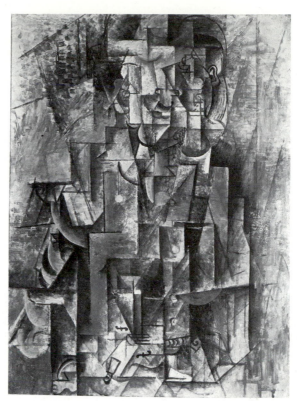

11.17 Pablo Picasso. *Man with Violin.* 1911; oil on canvas, 39¼ × 28⅞ in The shapes in Picasso's facet-Cubist style are component planes coaxed forth from subject forms and freely rearranged to suit the artist's design concept. Some facets are retained in their original position, and certain elements of the figure are fleetingly recognizable. Philadelphia Museum of Art. The Louise and Walter Arensberg Collection.

in science. Cézanne stated that the artist should seek the universal forms of nature in the cube, the cone, and the sphere. Artistic exploration founded directly on this concept developed gradually in the work of the Fauves and finally resulted in a style labeled Cubism.

One of the most active young artists of the Fauve movement in Paris from 1903 to 1906 was the Spaniard Pablo Picasso (*see* figs. 3.38 and 6.15). Possibly because of his admiration for the work of Cézanne or because of a desire to challenge Matisse's leadership of the Fauves, Picasso began to look for new possibilities of form expression in his painting. He based his exploration on analysis of volume and space structure. Like Cézanne, Picasso became dissatisfied with the emphasis on the external characteristics of objects and sought a method of expressing their internal structure. He eventually developed paintings that displayed many facets of the same object at the same time on the same canvas. Many of Picasso's ideas can be traced back not only to Cézanne but also to characteristic styles of primitive art forms—archaic Greek sculpture as well as traditional African sculpture (fig. 11.17; *see* plate 43).

The most noticeable aspect of Cubist form as evolved by Picasso, his colleagues, and their followers was geometric crystallization of shapes. By this means, artists tried to arrive at a more permanent type of order than that found in natural form. At the same time, the traditional illusionistic rendering of space was reordered into what the artists felt was a more stable form of spatial relationship, independent of the vagaries of light and the distortions of shape caused by the use of linear perspective.

In his concern with arriving at a new statement of the structure of matter seen from an aesthetic point of view, Picasso often stripped away many aids to expression, for example, richness of color. However, in this process of reduction he formulated a new artistic language that put an end to the respect for surface appearance observable in all art since the time of the Renaissance. Paintings were now made with the primary intention of emphasizing the artistic devices *for their own sake* rather than of merely adapting these devices to the *imitation of nature;* traditionally accepted object forms began to give way to pure or maximum form. With the new emphasis on the intrinsic quality of the artistic elements (line, shape, value, texture, and color), a new set of terms had to be invented to explain what the artist was trying to do—especially for those who were not prepared to accept complete purity of form. The term *abstraction,* which had had only

a general meaning up to the 1900s, was now applied to this form of expression, which was considered no longer associational with observed objects. Cubism, which is a semiabstract art form, can now be seen as the forerunner for all the later forms of *abstraction* in art. In semiabstract art we generally can still recognize certain objects from nature; the transformation of such forms in the process of abstraction is meant to express the artist's convictions about life and matter. Transformation of forms is a matter of degree and varies from the semiabstract styles of Cubism and Futurism to the pure abstraction of Wassily Kandinsky and Piet Mondrian.

Cubism as the beginning of Abstract art was of major importance. It was introduced to the world not only in the works of Picasso, but also in those of Georges Braque, a French artist who collaborated with him. The two artists occupied the same studio for a number of years. Braque added a uniquely expressive quality to the usual Cubist approach with the use of foreign, textured materials that he attached to the canvas surface—a technique called *papier collé* or just *collage* (fig. 11.18; *see* fig. 7.11). On the whole, Braque remained true to the typical French art tradition of quietness of expression in spite of his use of new forms; this contrasted with the more forceful, explosive quality of Picasso's work. In all of Braque's work produced during the peak years of Cubist expression (1911–1914) is a sense of charm engendered by his restrained manipulation of color and value patterns. These patterns were developed in terms of the finite volume of space, one of the chief Cubist idioms (*see* plate 62 and fig. 5.6).

Two other Cubists of note were Fernand Léger, another French artist, and Juan Gris, a countryman of Picasso. These two preferred the more austere expression of Picasso but not the violence of the other side of that artist's personality. Léger and Gris developed individual form qualities within the Cubist pattern that set them apart as important creators in their own right. Because of the impact of industry on society, Léger accepted the machine as a styling motif for Cubist form (fig. 11.19; *see* plates 32 and 65). Instead of abstracting away from nature, Gris dealt with volumes or decorative patterns that suggested recognizable objects. He would then develop these shapes in the direction of object recognition without resorting to mere imitation of superficial appearance (*see* figs. 5.4 and 9.36, and plate 40).

Futurism Futurism, like Cubism, remained a submovement within the overall abstract category. Futurism was actually a form of Cubism remodeled by certain Italian artists who had been to Paris during the excitement caused by the new artistic ventures of Picasso

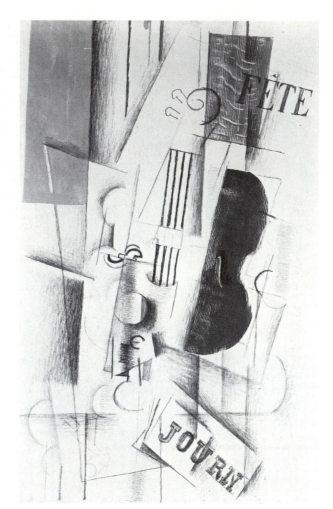

11.18 Georges Braque. *Musical Forms.* 1913; mixed: paper, oil paint, 36¼ × 23½ in. Braque varies the usual Cubist handling of form with the inventive inclusion of textured foreign materials. Such textures added a new beauty of surface manipulation to the repertoire of contemporary art.
Philadelphia Museum of Art. The Louise and Walter Arensberg Collection.

and Braque. Among the more important artists in this movement were Umberto Boccioni, Giacomo Balla, and Gino Severini (plate 100; *see* fig. 9.39 and plate 81). These artists studied in France, and on their return to Italy, they were much intrigued by the rapid advances that had been made in domestic industry. Together with the poet Marino Marinetti, they formed a union of ideas. Their expression was formulated on the basis of the modern machine, the speed and violence of contemporary life, and the psychological effects of this ferment on human mentality and activity. Boccioni, Severini, and their followers attempted to show the beauty of modern machines through sheaves of lines and planes, which created an effect of dynamic movement and tension within the canvas. The translation of rapid motion into artistic terms was a constant preoccupation. The Futurists also attempted to interpret

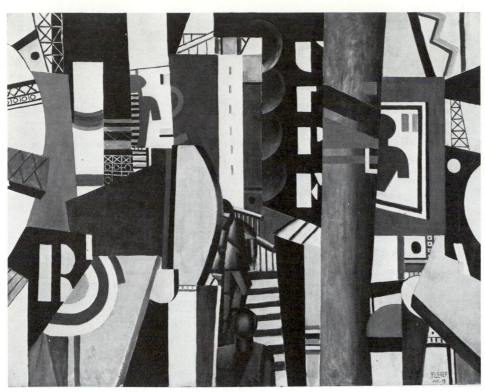

11.19 Fernand Léger. *The City.* 1919; oil on canvas, 90¾ × 117¼ in. The rigidity and simple geometric character of industrial structures were subjects ideally suited to the Cubist style. The paintings of Léger follow this principle and become true products of a "machine-age aesthetic."
Philadelphia Museum of Art. The A. E. Gallatin Collection.

contemporary incidents of violence, such as riots, strikes, and war, that presumably would affect future events.

The fervor of this group was not matched by its artistic contributions. The artists merely energized the somewhat static geometry of Cubism and brought back richer coloring. Perhaps the group's attention to the new subject of the machine was the most important contribution, for other artists and the public became more aware of the nature of their time. Following the traditional mission of art, the art of the Futurists expressed the age in which it was created.

Pure Abstraction During the period from 1910 to 1918, the chief motivation of artists throughout Europe was complete elimination of nature from art. Deriving inspiration primarily from the experiments of Picasso, artists explored pure abstraction in two main directions. Some, like the Russian Vasily Kandinsky, preferred an emotional, sensuous expressionism, which later influenced American abstract painting. Other artists, such as Mondrian, were more interested in the cold precision of geometric arrangement. Kandinsky's best-known work featured powerful rhythms and loose

biomorphic shapes that had a feeling of great spontaneity (fig. 11.20; *see* fig. 9.21). Although it was rarely evident, Kandinsky's paintings usually originated from specific conditions or circumstances. The artist always attempted to interpret his response in terms of pure visual language without reference to outward appearance. Kandinsky's loose, direct manner is essentially that of a romantic. His appeal is directed at pure emotion, and to assess his works the observer must have had similar experiences to those motivating the artist. Later, while working at the German Bauhaus (an architectural school that stressed the unity of all art in terms of design), Kandinsky's work began to be influenced by the Geometric Abstraction practiced by some of the school's artists.

The most representative exponent of Geometric Abstraction was Piet Mondrian of Holland. Like Kandinsky, Mondrian dealt with the pure elements of form, but unlike Kandinsky, purged them of the emotional extremes of Romanticism. Mondrian's art is the unemotional rationalization of line, shape, value, and color pushed to maximum optical purity (fig. 11.21). In such work, meaning or *content* is inherent in the precise relationships established. This direction seemed sterile and shallow to artists and critics alike when it first appeared. That it was, instead, momentous and rich in

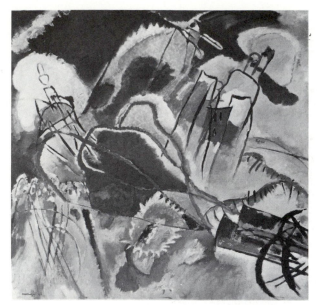

11.20 Vasily Kandinsky. *Improvisation No. 30 (Warlike Theme).* **1913; oil on canvas, 43¼ × 43¾ in.** About 1910 the Russian Vasily Kandinsky began to paint freely moving biomorphic shapes in rich combinations of hues. The characteristic early style that the artist evolved can be seen in this illustration. Such an abstract form of expression was an attempt to show the artist's feelings about object surfaces rather than to describe their outward appearance.
Art Institute of Chicago. Arthur Jerome Eddy Memorial Collection.

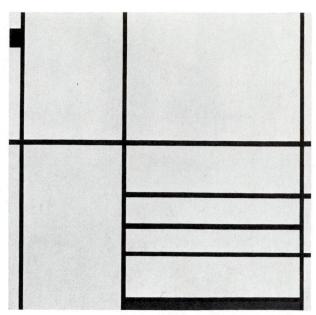

11.21 Piet Mondrian. *Composition in White, Black, and Red.* **1926; oil on canvas, 40¼ × 41 in.** Mondrian created a "pure" art purged of all but the elements of art structure. His simple, bold style, which evolved from study of the subtle relationships of these elements, has been readily assimilated into many forms of contemporary expression. Its influence on present-day commercial and industrial design is obvious.
Museum of Modern Art, New York. Gift of the Advisory Committee.

possibilities is proven by its tremendous impact on thousands of artists. The dissidents taking verbal slaps at Geometric Abstraction were soon in the minority.

Nonobjective Art Heretofore, the abstract art discussed originated from nature; the next development was so-called Nonobjective painting, which presumed to divorce itself from nature altogether and to originate entirely (insofar as this can be determined) within the mind of the artist. The differences between Pure Abstraction and Nonobjective works of art are not readily apparent; perhaps an attempt to differentiate is of theoretical interest only. Both concepts opened up a new realm of aesthetic endeavor, and exploration in this area continues to the present time. The term *nonobjective* does *not* mean that the artist has no objective. The artist definitely communicates, but without resorting to *objective* reporting. Ideas about the use of the elements of form, unencumbered by literal objects, became the subject for nonobjective artists. Obviously, they were stimulated or inspired by qualities attainable through manipulation of pure form. A certain amount of pure abstract and nonobjective work is more imitative than original. It is easy to produce synthetic abstract art that is an end in itself. However, it is as a creative process that abstraction is more properly employed, and this calls for the maximum power of the artist.

A great part of what we see in our world today derived its personality from the continuing influence of the abstract concept. Modern designers readily assimilated the theories of form underlying this concept. Buildings, furniture, textiles, advertising, machines, and costuming are only a few of the areas that bear witness to the tremendous impact of abstract art. Stylistically, the gap has constantly narrowed between fine art and art of a commercial or industrial nature. This may be in part due to abstract art developing out of an environment in which the practical function of the machine had become an unconscious, as well as a conscious, part of life. In a sense the abstract artist created a machine-age aesthetic.

Abstract Art in the United States Abstract art was slow in coming to America, but shortly after World War II the movement quickly gathered momentum. The influence of European expatriate artists was an important factor. Actually, during the period between the two world wars many American artists were affected by the structural order of Cubism. Arthur Dove (who actually began pure abstraction in 1912), John Marin, Lyonel Feininger, Georgia O'Keeffe, Stuart Davis, and Marsden Hartley were among the early pioneers of abstraction in the United States (fig. 11.22; *see also* figs. 3.27, 5.18, and 9.1, and plate 28). In a peculiarly American way, however, they seem to have refrained from surrendering completely to pure abstraction and retained a strongly personalized vision.

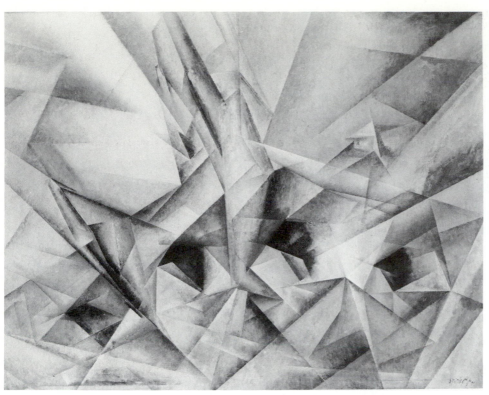

11.22 Lyonel Feininger. *Bridge V.* **1919; oil on canvas, 31½ × 39¾ in.** American artists, inheriting a tradition of native romantic realism, seemed to be reluctant to accept pure Abstract Expression. Inspired by the dramatic shapes found in human structures, but informed by the careful designs of Cubism, Feininger eventually merged these two forms of expression in a semiabstract style.
Philadelphia Museum of Art. Purchased: The Bloomfield Moore Fund.

After World War II a new generation of younger American artists renounced the last ties with nature. Some of the leaders in this movement of the mid-1940s were Irene Rice Pereira, Loren MacIver, Bradley Walker Tomlin, and Mark Rothko (fig. 11.23 and plate 101). Toward the end of the forties a new impulse, stemming from a mixture of Abstraction, Surrealism, and Expressionism, became apparent. Pure Geometric Abstraction slipped almost indistinguishably into this new movement. We must now go back in time to see how this came about.

Abstract Sculpture Picasso's collages and constructions in the Cubism of 1912–14 opened the way for a wide range of abstract sculptural forms. Perhaps the most important early Abstract sculptor was the Franco-Rumanian Constantin Brancusi. He was an artist who as early as 1913 chose to free sculpture of representation. His works, such as the *White Negress* (1928) (fig. 11.24) and the even more famous *Bird in Space* (1919), reveal an effective and sensuous charm due to their flowing, geometrical poise and the artist's emphasis on beautifully finished materials. Brancusi usually preferred to work in the near-abstract but always considered the quality of shape and the texture and handling of materials to be more significant than the representation of the subject.

Another pioneer Abstract sculptor was the Russian-born artist Alexander Archipenko. Archipenko belonged to the so-called School of Paris during the Cubist period of Picasso and Braque. His significant contribution was the use of negative space (the void) in sculpture, as in his *Woman Doing Her Hair* (1916) (*see* fig. 10.14), in which a hollow replaces the face. Archipenko also explored the use of new materials and technology, occasionally incorporating machine-made parts into a work.

The same Cubist intellectual and artistic ferment that led Archipenko to explore human-made materials and Brancusi to pioneer in use of power tools also led the Russian brothers Naum Gabo and Antoine Pevsner to their very important *Constructivist* concepts of *pure form*. This movement was founded by Vladimir Tatlin, but it is usually associated with Gabo and Pevsner because they issued the definitive manifesto in 1920 that proclaimed *pure form* to be the new realism in art. Gabo was the more exciting, being the inventor of nonobjective and nonvolumetric forms (three-dimensional forms that do not enclose space but interact with it) (fig. 11.25). Pevsner worked more in solid masses, nearer to sculpture of a traditional kind. Many artists were connected with the *Constructivist* movement: Rodchenko, Albers, and Moholy-Nagy are a few.

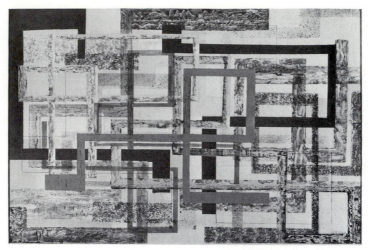

11.23 I. Rice Pereira. *Daybreak.* oil on canvas, 40 × 60 in.
This painter developed a style of abstraction that investigated
space, light, and dimensions—all of which are inherent in the
structure of the painting itself. Her work is one of the unique
variations that the general concept of abstraction has followed in
this country.
Metropolitan Museum of Art, New York. The Edward Joseph Gallagher III
Memorial Collection.

**11.24 Constantin Brancusi. *White Negress II.* 1928; marble,
19½ × 5¾ × 7½ in.** Brancusi abstracted down to essential
forms, with great concern for the properties of his medium.
Art Institute of Chicago. Grant J. Pick Collection.

**11.25 Naum Gabo. *Linear Construction #2.* plastic and nylon,
40 × 20 × 20 in.** Gabo, with his brother Pevsner, pioneered in
the use of new materials, voids, and nonobjective structure.
Art Institute of Chicago. Florence M. Schoenborn Gift.

11.26 Max Ernst. *The Horse, He's Sick.* 1920; collage: pasted paper, pencil and ink, 5¾ × 8½ in. As a part of the Dadaists' debunking of all twentieth-century art forms, a natural organism is here turned into a mechanical absurdity. At the same time, the use of pasted photoengravings is a nonsensical twist of the collage technique first invented by the Cubist Braque. Museum of Modern Art, New York. Purchase.

The common denominator discernible in the work of all Abstract sculptors during the period of 1900–1930 was an expression that emphasized materials and de-emphasized the division between the fine arts and the functional arts. This was essentially the point of view held also by the Constructivists and the Bauhaus.

Fantastic Art

The third major direction for twentieth-century art began to be recognizable about 1914, the first year of World War I. The war had evidently begun to raise questions about the individual's ability to master the machine, suggesting that individual freedoms might actually be destroyed in an age of technology. As a kind of antidote to the machine cult in abstract art, certain writers, poets, and artists began to extol artistic forms that reemphasized the emotional, subconscious side of creativity. During this period, for instance, Picasso's art moved away from the ennobled, monumental structures of early Cubism and began to take on structural perversions that eventually were to be the basis for Dadaism's destructive, cynical, and absurd parodies of the cult of materialism in society (*see* fig. 9.31).

A certain element of artistic endeavor in the past had been devoted to the creative invention of images that seemed manifestations of weird and fantastic imaginings. The centaurs of the ancient Greeks, the strange beast-symbols of human sin in medieval manuscripts and sculpture, the superstitions and alchemist's nightmares of Jerome Bosch in the early sixteenth century, and the fantasies of Goya in the late eighteenth and early nineteenth centuries are a few of the prototypes of twentieth-century fantasy.

Dadaism The years of World War I nurtured the growth of an art that emphasized the irrational side of human behavior. Neutral Switzerland had become the mecca for poets, writers, artists, liberals, and political exiles who sought refuge there from persecution or the terrors of modern warfare. Out of the intellectual ferment motivated largely by disillusionment arose Dada, a semiphilosophic creed for protestation of the moral and social degeneracy responsible, it was felt, for the war. According to the proponents of Dadaism, complete erasure of accepted institutions and conventions was needed; only on completely virgin soil could humankind rebuild a more desirable society. The Dadaists, therefore, embarked on programmatic undermining of traditional civilized mores by cynical and sardonic derision of all society's manifestations.

Duchamp, Picabia, Ernst, and others began to fashion machinelike humanized forms that suggested the robotizing of humanity. Later, with even more remarkable ingenuity, they created biomorphic images that discredited the semiorganic qualities of Kandinsky's romanticized abstract art (fig. 11.26; *see also* fig. 3.21). These inventions were meant to show disrespect for the experimental forms of the art leaders of the new century and shock a public already disturbed by a visual revolution.

11.27 Giorgio de Chirico. *The Soothsayer's Recompense.*
1913; oil on canvas, 58⅜ × 71 in. This picture combines with
poetic fullness symbols of the past (classical statue and
Renaissance architecture) with forms of the modern world
(railroad train) to create a feeling of vast timelessness and
universality. In this way de Chirico was able to emphasize the
reality of a personal symbolism.
Philadelphia Museum of Art. The Louise and Walter Arensberg Collection.

The basic premise of this bizarre movement was that
all Dadaists had complete expressive freedom in their
attack on the old order. In principle, there was no limit
to the disorder that might be projected in painting, po-
etry, and general social behavior. Dadaism left a bad
attitude toward modern art amongst the public. For
many years people tended to classify all contemporary
works of art with the outlandish forms created by the
Dadaists. Actually, the disorder of the movement even-
tually led to its demise. Dada was pure negativism, an
exhibitionism of the absurd. Being against art, its only
medium was nonsense publicly displayed to discredit
all forms of sense. Its main value today is historical since
it was the principal source of Surrealism and a new lib-
erator of expressive freedom.

Individual Fantasists The inclination toward Private
Fantasy seemed to be a general tendency in western
Europe during the period of Dada satire. This fantasy
took individual, but quite influential, direction in the
hands of certain artists who were not a part of the Dada
movement. Giorgio de Chirico, an Italian, placed in-
congruous modern machines in ancient shadowed pla-
zas (fig. 11.27; *see* fig. 6.8). De Chirico seems to imply
the decadence of the modern world using the image of

a classical world of silent squares inhabited by stat-
uelike remnants of an unknown people. The frozen, un-
progressive, and even trancelike expression suggests a
wistful desire to recover the past.

Paul Klee, a Swiss, created an art of witty, abstract
imagery based on Expressionism and Cubism. His work
seems to poke gentle but penetrating fun at the cult of
the machine and to smile shyly at human pretensions.
The implication is that there is more to extrasensorial
perception than modern humanity's addiction to prac-
ticality allows (plate 102; *see* plate 10).

Marc Chagall, Russian born but a resident of France
and the United States, originally worked in an Expres-
sionist manner. His stay in France brought him under
the discipline of Cubism. Eventually, he joined the two
styles in his own brand of romanticized poetic art that
has an Alice-in-Wonderland quality. Chagall freely
X-rays people and floats them about in a gravity-free
world. The first contact with Chagall usually brings a
chuckle to the spectator. On better acquaintance, his
underlying humanitarianism is revealed (fig. 11.28).

Surrealism Surrealism came into being about 1924
out of the work of individual fantasists and Dadaists.
With the end of World War I, there was once again a
semblance of stability, and the public tended to become

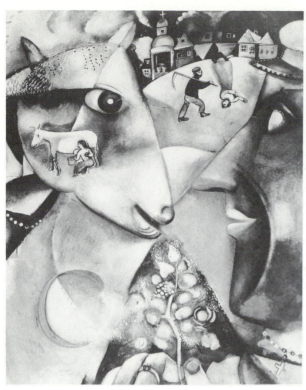

11.28 Marc Chagall. *I and the Village.* **1911; oil on canvas, 75⅝ ×59⅝ in.** The fairy-tale world of the imagination is found in this example by another artist who evades fixed classification. Recent technological concepts are reflected in the freely interpreted transparency of object forms and the disregard for gravity.
Museum of Modern Art, New York. Mrs. Simon Guggenheim Fund.

complacent about the ills of modern society. The Surrealists reacted to this by attempting to reassert "the importance of the individual's psychic life, and intended to preserve the life of the imagination against the threatening pressures and tensions of the contemporary world."[1]

Whereas the Dadaists had tried to debunk *meaning in art* as a part of the leftover traditions of a corrupt society they hoped to demolish, the Surrealists tried to build a new art tradition out of works that fused the conscious and unconscious levels of human awareness. Generally speaking, both Dadaism and Surrealism were a continuation of the counterattack (first instigated by the Romantics of the nineteenth century) against an increasingly mechanized and materialistic society. The Romantics had often created hallucinatory imagery in which the Surrealist delights. In so doing, they gave evidence of the growing belief that humanity could not solve every problem by the right application of science, and that little-known, often seemingly unsolvable,

problems existed within the human mind. Sigmund Freud's theories of dreams and their meanings lent strong credence to this belief. Operating on this thesis, Surrealistic artists created a new pantheon of subconscious imagery that was claimed to be more real than activities and behavior on the conscious level. The Surrealists believed that only in dreams, which arise from the mind below the conscious level (nightmares or daydreams), had humans retained their personal liberties. In their art the Surrealists cultivated images that arose unbidden from the mind. These images were recorded through automatic techniques of drawing and painting. Such images bring to attention the heretofore unrecognized arbitrariness of our senses concerning reality by exploring incongruous relationships of normal objects in abnormal settings. The Surrealists juxtaposed commonsense notions of space, time, and scale in unfamiliar ways.

Max Ernst's frottages (invented about 1925) involved one technique used by the Surrealists to shut off the conscious mind. *Frottages* were rubbings made on rough surfaces with crayon, pencil, or similar media. In the resulting impressions the artist would search for a variety of images while in a state of feverish mental intoxication. A process bordering on self-hypnosis was practiced to arrive at this state. Some artists, such as Salvador Dali, affected a similar creative fever, but used a meticulous, naturalistic technique to give authenticity to their improbable, weird, and shocking images (plate 103). Yves Tanguy used a method similar to Ernst's. Allowing his hand to wander in free and unconscious doodlings, he used his creative visualization to bring on nonfigurative objects that suggested life. Tanguy's pictorial shapes have the appearance of sentient, alien organisms living in a mystical twilight land (fig. 11.29).

There have been many Surrealistic artists, but Ernst, Dali, and Tanguy have been most influential, thanks to their unflagging invention of arresting images. The influence of these outstanding artists extended to the great number of other artists who did not hold to the restrictions of the orthodox Surrealist brotherhood as set forth in André Breton's manifesto of 1924. Many of these artists used some of the methods of the group while designing in a formal manner (an approach disdained by orthodox Surrealists), thus combining the methods of the Abstractionists, the Surrealists, and the Expressionists.

Surrealistic Sculpture Not many twentieth-century sculptors were pure Surrealists when we consider the character of their work. The effect of Surrealism on the work of many painters and sculptors was variable. However, the general trend was to merge the innovations of the first two decades to such an extent that

[1] Charles McCurdy, ed., *Modern Art: A Pictorial Anthology* (New York: Macmillan, 1958), pp. 40–41.

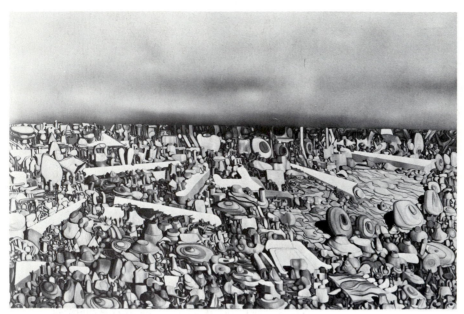

11.29 Yves Tanguy. *Multiplication of the Arcs.* **1954; oil on canvas, 40 × 60 in.** Commonly working with nonfigurative objects in a polished technique, the Surrealist Tanguy invents a new world that gives the appearance of being peopled by lifelike gems.
Museum of Modern Art, New York. Mrs. Simon Guggenheim Fund.

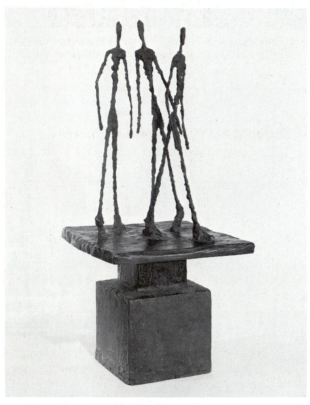

11.30 Alberto Giacometti. *Group of Three Men.* **1949; bronze.**
Giacometti emphasizes the lonely vulnerability of humanity by reducing his figures to a point of near-invisibility and by emphasizing the great spaces between the figures.
Art Institute of Chicago. Ayer Fund.

classification into specific categories is not possible. The intensity of this trend has increased since mid-century and has led to the complex, interwoven movements of the 1960s, 1970s, and 1980s.

Alberto Giacometti, a Swiss sculptor who spent much of his career in France, was perhaps one of the greatest Surrealistic sculptors of this century. Evolvement of his personal style was affected by such diverse influences as Lehmbruck's mild Expressionism, by Cubism, and by Constructivism. Like other twentieth-century sculptors, Giacometti was fascinated not only by the effects of new materials, but also by the effect of light and space on form. By 1934 he had evolved his mature style of elongated, slender figures pared away until almost nothing remained of substantial form. These figures (fig. 11.30) suggest arrested motion, poignant sadness, and isolation. Giacometti's indirect method of approaching meaning stemmed from Surrealism and was related to the *stream of consciousness* theory supported by early twentieth-century psychologists.

The first sculptor to explore direct metal sculpture (welding) was the Spanish artist Julio Gonzalez. In the late 1920s Gonzalez began to substitute outlines for masses and planes and even allowed the tendrils of metal to stop short of completion so that they were completed by implication. His sense of the dematerialization of form is similar to Giacometti's but is more often infected by a humorous quality of suggestivity that hinges

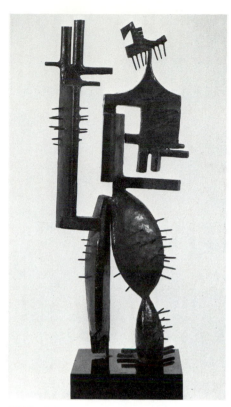

11.31 Julio Gonzalez. *Cactus Man #1.* **1934; bronze, 25½ in. (base: 5 × 8 × 8 in.)** Expressively textured surfaces appealed greatly to this Spanish sculptor who was the earliest modern sculptor to introduce welding as part of the repertoire of artists. He also used suggestive qualities in his sometimes surrealistic approach to form.
Museum of Fine Arts, Montreal, Canada. Purchased, Horsely and Anne Townsend Bequest.

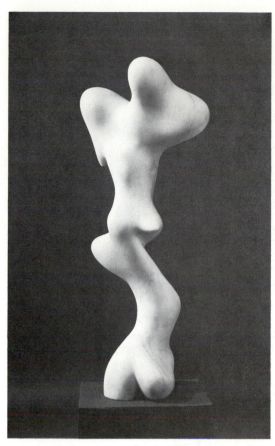

11.32 Hans Jean Arp. *Growth.* **1960; white marble, 43 in high.** The supple biomorphic "Arp shapes" contrast sharply with the rigidity of the works of Cubist-inspired sculptors such as Archipenko.
Art Institute of Chicago. Grant J. Pick Purchase Fund.

on the edge of consciousness. Gonzalez's work influenced Picasso's experiments with sculpture in the 1930s, and Gonzalez was in turn influenced by Picasso (fig. 11.31).

The French artist Hans Jean Arp was another explorer of Surrealistic preconscious suggestion and of the effect of the unexpected, or surprising, form. Before Arp's Surrealistic direction, he explored most of the avant-garde movements of the early twentieth century: Cubism, Blaue Reiter, Dada, Constructivism, and the like. Arp was a cofounder of the Zurich Dada movement in 1916. He was well known for his abstract collages and reliefs, such as *The Mountain Table,* and *Anchor and Navel* of 1925, before he turned to ovoidal sculptural forms in the 1930s. These later works reveal the influence of Brancusi and prehistoric Cycladic island sculpture (fig. 11.32). In fact, Arp's ovoidal shapes became so famous that almost all kinds of rounded, biomorphic shapes were called "Arp shapes."

ART FORMS OF THE 1940s AND 1950s

There has been a host of artists who mix certain aspects of the three major movements of early twentieth-century art. Generally speaking, these artists found pure abstraction too impersonal, machinelike, and dehumanized. On the other hand, Surrealism seemed to disregard a desire for order that had traditionally been held fundamental to art.

Abstract Surrealism

Among the artists who chose a harmony of shape relationship stemming from Abstraction and mixed with Surrealism's unbidden imagery are: Joan Miró of Spain, Rufino Tamayo of Mexico, Matta Echaurren of Chile, Mark Tobey of the United States, and some ex-Europeans, such as Willem de Kooning, Arshile Gorky, and Hans Hofmann. The latter three artists, who lived in the United States after World War II (some came to the United States in the decade previous; others, during the war), helped pioneer the first American art

movement, called Abstract Expressionism (figs. 11.33, 11.34, plates 104 and 105; *see* fig. 5.1, plates 24 and 64).

Abstract Expressionism

Abstract Expressionism was a coalescence of directions that had been forming in three of the major movements that had peaked in the 1930s: *Expressionism, Abstraction,* and *Surrealism.* The Abstract Expressionists wanted to express their emotional and spiritual states of being in relation to their world without necessarily referring to nature or representational form.

As a movement, *Abstract Expressionism* began in the 1940s and had reached major proportions by 1950. The artistic founders of the group were primarily painters concentrated in New York City toward the end of World War II, but by the 1950s there were artists working in various media in this manner all over the United States, as well as in western Europe.

As the movement developed, it divided into two basic groups: a generally romantic group (often called "Action painters") and a more classical group closely allied to the geometric branch of pre-World War II Abstraction. In the first group were such artists as Jackson Pollock, Franz Kline, and Clifford Still. These artists turned to an artistic manner that is reminiscent of the emotional content of Kandinsky's early works (before 1921). Even so unlikely a source as Monet suggested a kindred technical method. Confusion, fear, and uncertainty about humanity's place in a world threatened by thermonuclear holocaust may have led others to reject most of the forms of previous twentieth-century art and, as a kind of personal catharsis, to express their belief in the "value of doing" at the expense of disciplined design. Thus, Jackson Pollock, frequently cited as the chief exponent of the Action painting trend in Abstract Expressionism, created swirling images of a nonrepresentational kind out of linear skeins of fast-drying paint dripped directly onto large canvases, expressing the reality of self in the act of creation (plate 106).

Franz Kline, another member of the Action group, took a slightly different direction but with a similar intention of expressing self through direct contact with the forms created. His drawings, made with gestures of a brush on newsprint, were then cut up and reassembled to provide a sense of power and intensified personal rapport. Kline used these "sketches" as guides and enlarged them on big canvases without actually copying them. House painters' brushes and savage slashings in black and white or sometimes in color became monumental projections of inward experience (fig. 11.35).

A similar kind of daring and willingness to explore the unknown, which such artists displayed in revealing

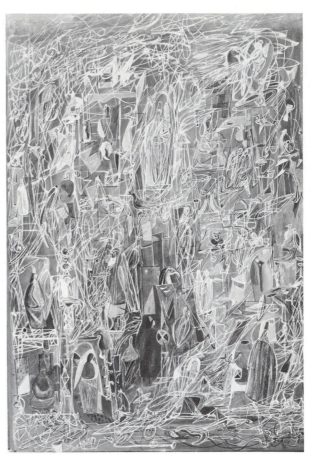

11.33 Mark Tobey. *Threading Light.* 1942; tempera on cardboard, 29⅜ × 19½ in. Tobey was not directly a member of the small group of young Americans who originally founded the Abstract Expressionist movement in the immediate post-World War II years, but seems to be formally related. He originated his own method of linear expression in painting (called "white writing"), which causes accretions of line to waver on the edge of shape recognition only to slip off into abstract controlled-tension between surface and space.
Museum of Modern Art, New York. Purchase.

their ego, is expected of the viewer to renew the experience of creativity. This conscious attempt to involve the spectator in art is, perhaps, the leitmotif of direction in the second half of this century. Involvement of the viewer goes far beyond a similar endeavor attempted in seventeenth-century European religious art. Perhaps, one of the reasons for recent efforts to involve the viewer is that artists foresaw that urban sprawl with its pressure and tension would cause humanity to seek isolation, and involvement in art had to be forced upon people, somewhat like a tonic, for their own good.

The second group of artists within Abstract Expressionism, given to a more restrained manner allied to the geometric branch of prewar Abstraction, included Mark Rothko, Carl Holty, Ad Reinhardt, and Robert Motherwell, to name a few (fig. 11.36; *see* plates 12 and 101). Many of these artists were motivated by the subtle color relationships of Joseph Albers, a former

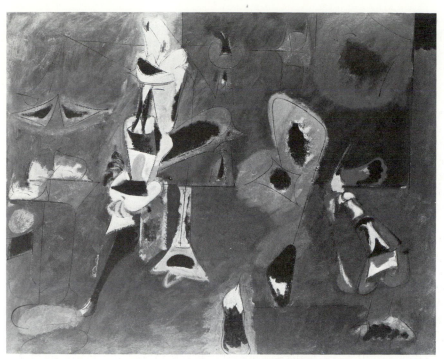

11.34 Arshile Gorky. *Agony.* 1947; oil on canvas, 40 × 50½ in. An engineering, as well as artistic, background in his student days, plus the stimulation of Surrealism's unbidden imagery led this artist into the emotionalized phase of Abstract Expressionism. A peculiar quality in his work is the precision and stability that becomes unsettled and unsettling, marking a personal life of inevitable change and tragedy. Gorky was an important influence on the younger generation of American Abstract Expressionists in the 1940s.
Museum of Modern Art, New York. A. Conger Goodyear Fund.

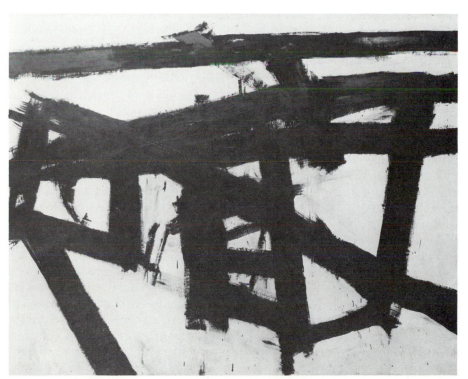

11.35 Franz Kline. *Mahoning.* 1956; oil, 80 × 100 in. The artist was more interested in the actual physical action involved in this type of expression than in the character of the resulting painting.
Courtesy the Whitney Museum, New York. Gift of the Friends of the Whitney Museum.

teacher at the Bauhaus and émigré to the United States during World War II (*see* plate 30). Hans Hofmann was another influence (*see* plate 64). All of these artists appear concerned with reducing form to the sensation of color or value alone. They tend to create broad areas of color or of shapes so closely related in value and/or color that they are not immediately detectable. Both types of painting seem to enwrap the spectator and make him or her a part of the painting as an experienced sensation. The intention seems akin in final analysis to the Action painter group discussed previously, but these paintings are not violent recollections of the emotional fervor of painting; rather they are quiet insinuations on the viewer's being.

Abstract Surrealist and Abstract Expressionist Sculpture

Many sculptors work in forms allied to Abstract Surrealism, ranging from the organically sleek figures of the Englishman Henry Moore to the open wire sculptures of Gonzalez and Picasso in the 1930s, which influenced Alexander Calder in creating the mobile. Gonzalez, as the pioneer of welded sculpture, must also be credited with instilling the attitude of a younger generation of sculptors like Theodore Roszak and David Smith, who in using Gonzalez's technique came as close as their medium of bronze, iron, and steel permitted to the Action painting of the Abstract Expressionist painters of the late 1940s and early 1950s. Dadaism and Surrealism influenced some of the "junk" sculpture of men like John Chamberlain, Richard Stankiewicz, and Robert Mallary.

Henry Moore merged the vitality and expressive potential of Gonzalez and Arp with older traditions, such as Egyptian, primitive, and pre-Columbian sculpture that he had discovered as a student. Moore's objective over the years was to create lively forms, not lifelike forms. His forms emphasized the natural qualities of the selected materials. Only secondarily do his works resemble human forms. In this respect, his frequently repeated theme of the *reclining nude* seems in stone to retain a geologically inspired character and in wood to have a feeling of organic growth and grain (fig. 11.37). Moore was primarily responsible for reestablishing British art on the international scene and laid the basis for the great vitality English sculpture and painting have shown in the twentieth century.

The Lithuanian sculptor Jacques Lipchitz, who worked in France before World War I and was at that time strongly influenced by Cubism, began to be concerned with the Surrealistic idiom in the 1930s. He developed a highly robust configuration of freely flowing, knotted, and twisted masses that suggest at times the agonies of birth and death, at others the suffering of psychic torture, and at others the creation of nameless

11.36 Robert Motherwell. *Elegy to the Spanish Republic #131.* **1974; oil on canvas, 96 × 120 in.** Motherwell's work is characterized by an intimacy and heroic scale commonly found in contemporary Abstract Expressionism.
Detroit Institute of Art, Founders Society. Purchase, W. Hawkins Ferry Fund.

new species of mythological monsters. From Surrealism Lipchitz learned to exploit the semiautomatic principle, kneading his favorite sketching medium of clay into shapeless blobs without forethought and then through the accident of suggested form devising his final form (fig. 11.38). Lipchitz came to the United States in 1941 and strongly influenced a younger generation of American Abstract Surrealistic sculptors. He also had significant influence internationally.

The most influential American pioneer of Abstract Surrealistic sculpture was the Philadelphia-born artist Alexander Calder. Calder's father was a sculptor in a conservative nineteenth-century realist style. Calder reacted at first to this academic conservatism by studying engineering. He also studied for a time at the Art Student's League in New York and then went to Paris in 1926 where he began to create the animal wire sculpture that won him almost immediate recognition. In the late 1920s he was mingling in Dada, Surrealistic, and Neo-Plasticist circles, meeting people like Miró, Mondrian, Gonzalez, and Arp. This apparently caused him to drop figurative forms for free-form abstract shapes of sheet metal and wire. By 1930 he had created the first of his mobiles, after previously employing motors and pulleys to move his kinetic assemblages. The delicate balance and perfect engineering of

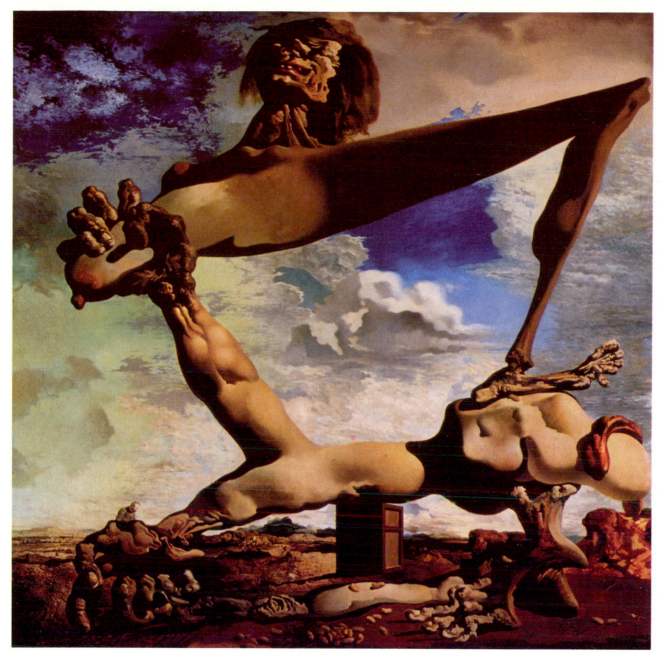

Plate 103 Salvador Dali. *Soft Construction with Boiled Beans: Premonition of Civil War.* **1936; oil.** In this painting a naturalistic technique of representation, combined with abstract tendencies, gives a nightmarish mood to political commentary. This approach to form is typical of Surrealist artists such as Dali in the early 1920s.

The Philadelphia Museum of Art. The Louise and Walter Arensberg Collection.

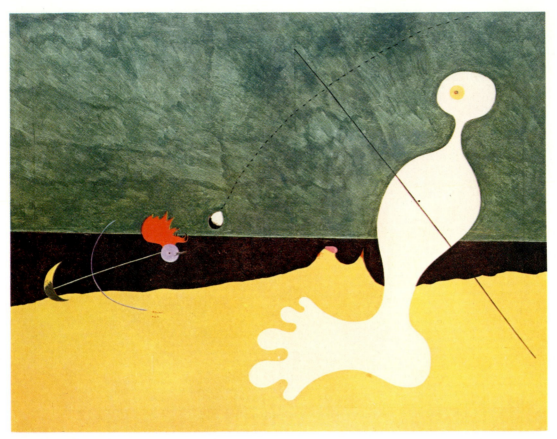

Plate 104 Joan Miró. *Person Throwing a Stone at a Bird.* 1926; oil on canvas, 29 × 36¼ in. In this painting Miró shows sophisticated color and biomorphic shapes combined with simple childlike images. In many respects, it is similar to the Klee painting (*see* plate 102). The Abstract Surrealism of Miró is, in general, semirepresentational in character.
Museum of Modern Art, New York. Purchase.

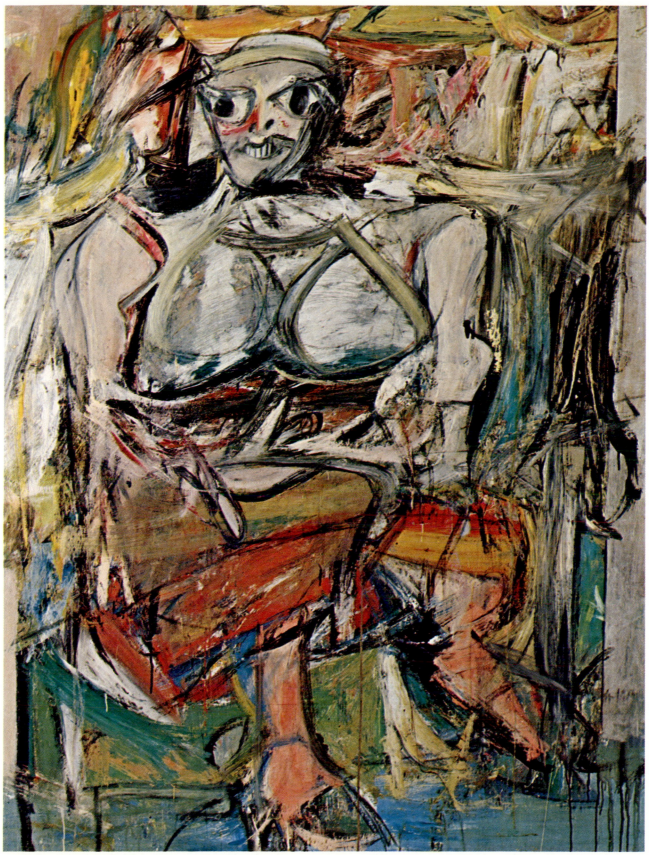

Plate 105 Willem de Kooning. *Woman, I.* 1950–1952; oil on canvas, 75⅞ × 58 in. The artist summarizes most aspects of the romantic or action group of Abstract Expressionism: revelation of the ego through the act of painting; neglect of academic or formal organization in favor of bold, direct, free gestures that are instinctively organized; and willingness to explore unknown and indescribable effects and experiences. Even though de Kooning seems to use the figure, its representational value is subordinated to the motivating activity of pure painting.
Museum of Modern Art, New York. Purchase.

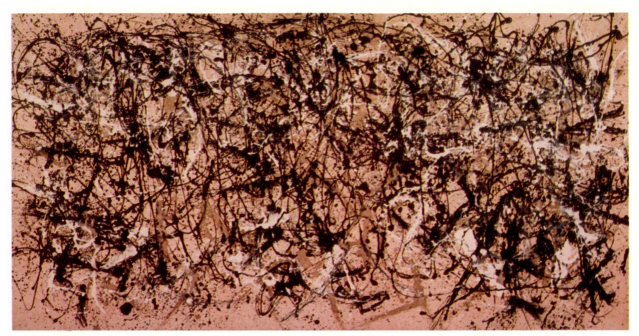

Plate 106 Jackson Pollock. *Autumn Rhythm.* 1957; oil on canvas, 105 × 207 in. This artist is considered the prime example among the youthful exponents of Abstract Expressionist Action painting in the late 1940s. He is noted primarily for the creation of swirling nonrepresentational images in linear-skeins of fast drying paint applied by dripping directly onto canvases through controlled gestures of his tools.
Metropolitan Museum of Art, New York. George A. Hearn Fund, 1957.

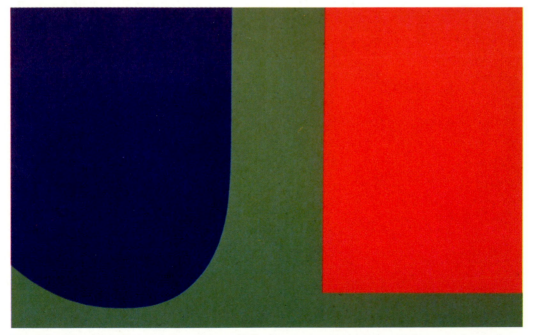

Plate 107 Ellsworth Kelly. *Red, Blue, Green.* 1963; oil on canvas, 84 × 136 in. Kelly was a pioneer of *Hard Edge painting,* descended from *Geometric Abstract* artists like Mondrian and Joseph Albers, who challenged the painterly Action Painters of the late 40s and 50s to find a new direction away from *Abstract Expressionism.*
Collection LaJolla Museum of Contemporary Art, LaJolla, California; Gift of Dr. and Mrs. Jack Ferris, LaJolla, Calif. © Ellsworth Kelly 1963.

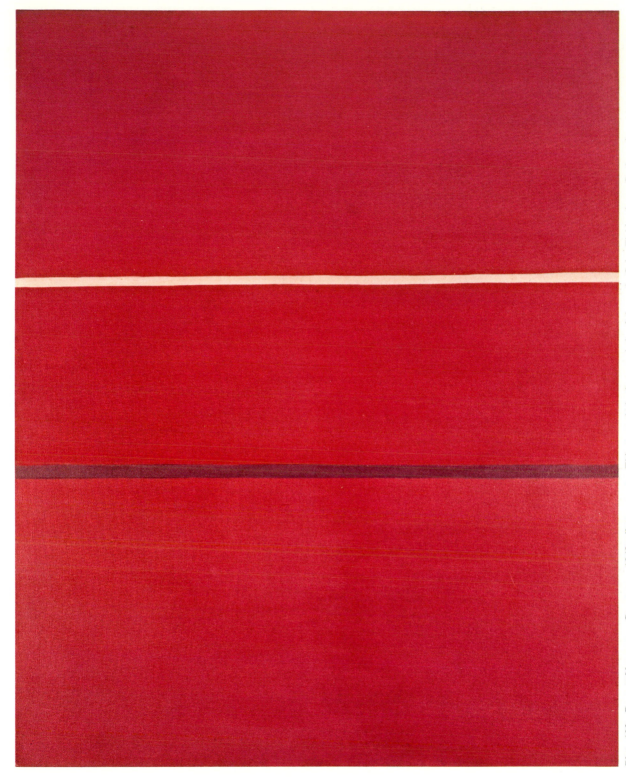

Plate 108 Barnett Newman. *Covenant.* 1949; oil on canvas. This example is characteristic of the early Color Field painter. Such works generally feature carefully placed stripes superimposed on a flat color. Hirshhorn Museum and Sculpture Garden, Smithsonian Institution.

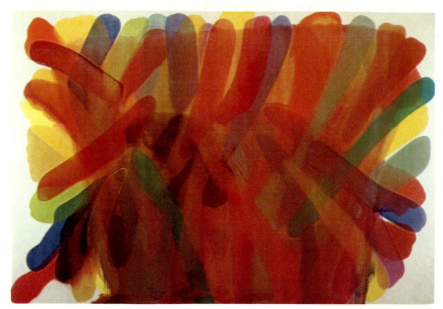

Plate 109 Morris Louis. *Number 99.* **1959; acrylic on canvas, 99 × 142 in.** Louis was of an older generation of artists related to Abstract Expressionism (such as Kline and Rothko) who became identified with the Post-Painterly Abstractionists. As a Field Painter, he was among the pioneers who flooded canvas surfaces with stains of pigment, which calmed the impetuosity of action paintings and created a new emphasis on the detached objectivity of the work of art. As opposed to hard-edge painters like Kelly, Newman, or Noland, Louis's stripes and shapes become softly focused and sometimes almost intangible, thus influencing Minimal Art. He was also among the earliest painters of the mid-twentieth century to explore the technique of spray painting.
The Cleveland Museum of Art. Contemporary Collection.

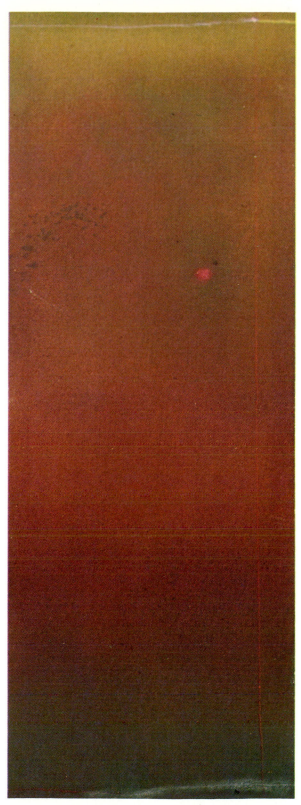

**Plate 110 Jules Olitsky. *Emma.* 1966; acrylic on canvas,
84 × 36 in.** Here, characteristics of minimalism are shown in the
relatively insignificant changes in hue and value. An intensely
concentrated effort must be made to determine that the field is
differentiated in any manner at all from the dominantly dark value
of the color.

Courtesy of Mr. and Mrs. S. Brooks Barron, Detroit, Michigan.

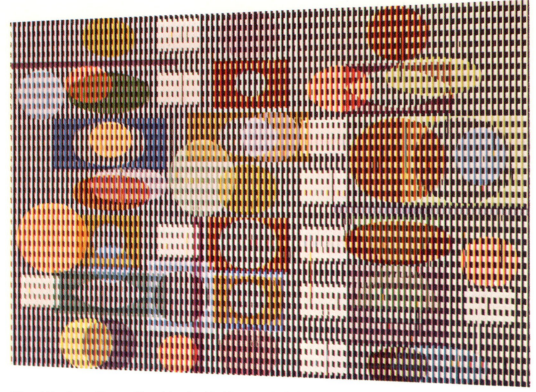

Plate 111 Agam (Yaacov Gipstein). *Double Metamorphosis II.* **1964; oil on aluminum in eleven parts, 8 ft. 10 in. × 13 ft. 2¼ in.** This Op artist explores not only the psychology of sight but the physical effect that viewing his forms of art may generate. In some ways the forms of Op art seem an extension of earlier twentieth-century geometric abstract art.

Museum of Modern Art, New York. Gift of Mr. and Mrs. George M. Jaffin.

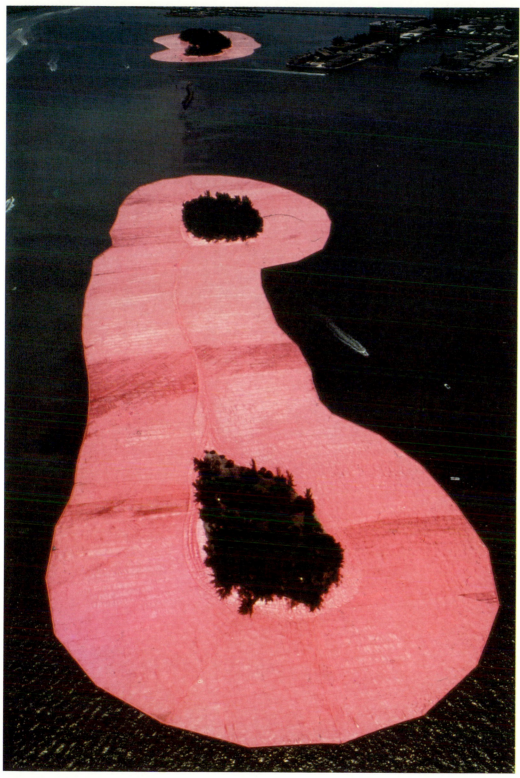

Plate 112 Christo. *Surrounded Islands.* Biscayne Bay, Greater Miami, Florida. 1983; woven plastic fiber.
Christo has continuously explored the environment and the relationship of art forms to it, as in this recent
work.
Wolfgang Volz, Photographer, copyright Christo/C.V.J. Corp.

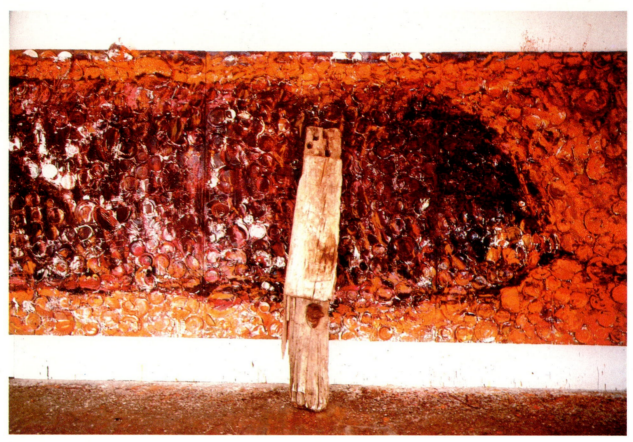

Plate 113 Julian Schnabel. *Affection for Surfing.* **1983; mixed media, 108 × 228 × 24 in.** Julian Schnabel, one of the Neo-Expressionists of the early 1980s, uses size and bulky collage to symbolize the discarded materials of a dying civilization. Pace Gallery, New York.

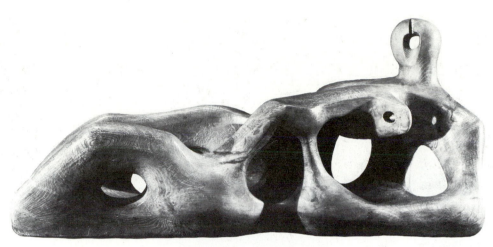

11.37 Henry Moore. *Reclining Figure*. 1939; elm wood carved, 37 × 79 × 30 in. Moore's work is a synthesis of influences from primitive sculpture with a lifelong study of the forms of nature.
Detroit Institute of Art. Gift of Dexter M. Ferry, Jr. Trustee Corporation.

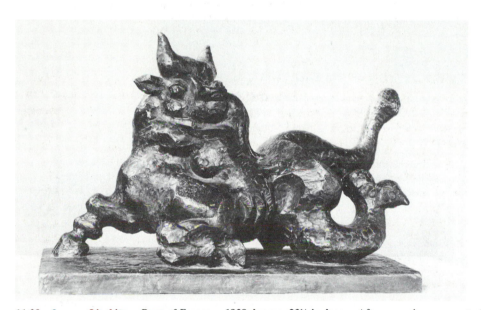

11.38 Jacques Lipchitz. *Rape of Europa*. 1938; bronze, 23⅛ in. long. After an early exposure to Cubism, Lipchitz developed his unique sculptural shapes and personal symbolism, but his Cubist background always served as a disciplinary force.
Art Institute of Chicago. Anonymous Gift.

the mobiles needed only air current to create rhythmic, varied motion that constantly produced new compositions and relationships of shapes in space (*see* fig. 10.29). Thus, Calder achieved the fourth dimension of time and movement in space for which artists, with their implied kinetics, had searched since the beginnings of Impressionism.

Calder finally evolved three basic types of assemblages:

1. The *stabile* is usually attached to a base, can rest on the ground, and does not move. However, some later works of this kind were made with moving parts.

2. The *mobile* hangs in the air, usually from a ceiling.
3. The *constellation* is a form of mobile but is usually suspended on one or more arms from a wall.

Mobiles are probably the most widely appreciated form of Modern art, and Calder is thus considered by many the most important American artist of the present century. From 1933 until his death in 1976 Calder divided his time between farms in Connecticut and France where he created, toward the end of his career, monumental stabiles and stable/mobiles of welded iron, some of which were architectural in size (fig. 11.39).

Some of the most interesting new shapes and techniques in sculpture of the late 1940s and 1950s suggested affinity with Abstract Expressionistic painting.

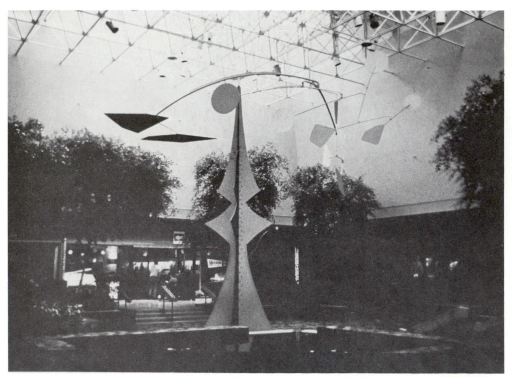

11.39 Alexander Calder. *Oscar.* 1971; polychromed steel and wire, approximately 28 ft. high. A late work by this famous inventor of movable sculpture, which in this case combines portions of moving (mobile) and static (stabile) forms.
The Franklin Park Mall, Toledo, Ohio.

Among artists whose creations imply contact with this kind of painting is the Polish-born American sculptor Theodore Roszak. Roszak began his career before World War II as a Constructivist of severely geometric shapes but later underwent a complete change. He became engrossed in portraying the conflict inherent between natural phenomena as a reflection of humanity's potential to destroy itself. Roszak employed coarse, eroded, scarred, and pitted textures, as in **Mandrake** (1951), which, with its spiked and anguished skeletal angularities, expresses with controlled violence some of the terror of the nuclear age (fig. 11.40).

The promising career of David Smith, who was born in Indiana and a student at the Art Student's League in New York during the 1930s, was cut short by a fatal automobile accident in 1965. He was the earliest American sculptor to use welding, creating powerful statements in wrought iron and steel that at first held organic and Surrealistic elements. His later works showed more Cubist-Constructivist use of volumetric shape systems strongly reminiscent of Action painters like Clifford Still and Franz Kline. Smith's ruggedness and the slashing diagonals of his metal cubes on tall poles and stands are remindful particularly of the black diagonals of Kline against their flat-white canvas surfaces. Smith's last cubic style before his death also influenced the following generation of young sculptors who got away from the open, flowing sculptural trend of the 1950s (*see* fig. 2.11).

Other artists who often used biomorphics with varying degrees of openness or closedness, suggesting involvement with Surrealistic preconscious imagery resolved by Cubist, Constructivist, or Abstract formality are: Egyptian-born Ibram Lassaw, Seymour Lipton (fig. 11.41), and Richard Lippold (*see* fig. 10.15), to name a few. Reuben Nakian appears to be a product more of the free-form manner expressed by earlier twentieth-century artists, such as Gaston Lachaise and Jacques Lipchitz. However, Nakian prefers the porous surfaces used by his peers of the 1950s rather than the smoothly refined surfaces used by his teacher, Lachaise, or those used by the Primary Structurists of the 1960s (fig. 11.42).

ART FORMS OF THE 1960s AND 1970s

Throughout history new generations of artists commonly have become dissatisfied with the direction taken by their elders and, therefore, strike out in new directions. The feeling that inherited methods and media have reached a state of perfection or have exhausted their possibilities has been especially keen among artists of the twentieth century and increasingly so since mid-century. A strong motivation for change in the present century has been the development of motion pictures and other technological advances in machinery, electronics, and space flight.

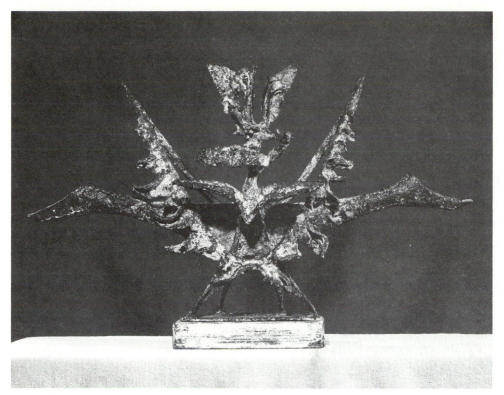

11.40 Theodore Roszak. *Mandrake.* **1951; steel brazed with copper, 25½ × 40 × 11¾ in.** In sculptural forms that paralleled the Action painting of the late 1940s and early 1950s, artists like Roszak employed welding techniques to capture through spiked angular shapes and corroded porous surfaces some of the anxieties of the nuclear age.
Cleveland Museum of Art. Gift of the Cleveland Society for Contemporary Art.

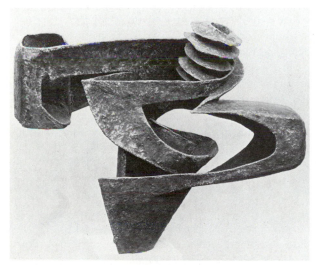

11.41. Seymour Lipton. *Earth Loom.* **20th century; metal, bronze, cast metal, copper-nickel, monel, 32 × 38 in.** In this surreal abstract sculpture are combined life-suggestive shapes and tenser rectilinear thrust—an influence, perhaps, from earlier Constructivist tendencies.
Detroit Institute of Arts. Founders Society Purchase, Friends of Modern Art Fund.

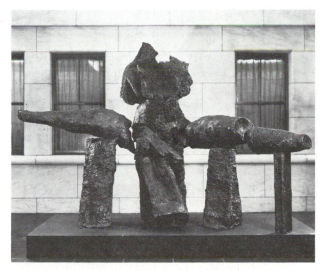

11.42 Reuben Nakian. *Goddess of the Golden Thighs.* **1964–66; metal, bronze cast, 8 ft. 8½ in. × 12 ft.** Although he studied under Gaston Lachaise, Nakian roughcast his sculptural forms to take full advantage of the emotion-evoking qualities of the resulting texture, rather than use the more smoothly finished forms employed by his teacher. His abstractions also suggest surreallike inward forces that assert a life of their own.
Detroit Institute of Arts. Founders Society Purchase, W. Hawkins Ferry Fund.

Drawn by these technological innovations, artists have met the desire for change by no longer observing the separate categories of painting and sculpture, but instead merging the two in *assemblages* that are a bit of both. This mixture of heretofore separate disciplines has its closest parallel in the Baroque art of the seventeenth century, in which a similar intermingling of traditionally separate media and disciplines took place, creating a synthesis of the two. Some artists are also exploring film, video, dance, theater, and, recently, lazer and computer-generated art.

Post-Painterly Abstraction: Hard-Edge Painters, Color Field Painters, and Minimalists

The first serious challenge to the dominance of Abstract Expressionism after World War II was among a group of painters known as the Post-Painterly Abstractionists. This category of painting breaks down into *Hard-Edge painters, Color Field painters,* and *Minimalists.* All owe source attributions to early twentieth-century geometric abstraction, particularly to Joseph Albers (*see* Abstract Expressionism). After coming to the United States, Albers, who was a product of the Bauhaus tradition, did a series of paintings during the 1930s called **Homage to the Square** (*see* plate 30). In this series he showed interest in gestalt psychology as expressed through the effects of optical illusion. He created passive, free-floating square shapes that had just enough contrast of value, hue, and intensity with surrounding colors that they seemed to emerge slightly from the background.

Albers's successors, Hard-Edge painters like Ellsworth Kelly, stress definition of edges that set off shapes in their canvas more explicitly than in the case of the Color Field painters (plate 107). The Color Field artists include Barnett Newman, Morris Louis, Kenneth Noland, Frank Stella, and Larry Poons (fig. 11.43, and plates 108, 109; *see* plate 11 and fig. 3.6). Newman, who can be considered one of the originators of Color Field painting in the early 1950s, allowed the shape of the canvas to dictate the pictorial form. He divided the canvas either horizontally or vertically with a line or lines of intense color set off by slight changes in nuance in the resulting shape of the color field.

Minimalists, of whom the nonconformist New Yorker Ad Reinhardt was a chief exponent in the late 1950s, painted pictures in such close values that only after intense concentration could the spectator determine that any shapes or lines or other elements of form were present at all. Jules Olitsky was also an exponent of such Minimalist work in the 1960s, as seen in his **Emma** (1966) (plate 110).

Another characteristic of Post-Painterly Abstraction was the tendency either to thin down the pigments to stain, to soak the canvas in color, or to lay color on

11.43 Kenneth Noland. *Purple in the Shadow of Red.* 1963; acrylic on canvas, 6 × 6 ft. Color field painters of the late 1950s and early 1960s discovered the power of pure color surfaces that were differentiated only by hard-edged lines, or shapes, of intense hues. The hues give a feeling that the art object is an extension of modern technology. The works are based on early twentieth-century nonobjective forms like those of Malevich and Rodchenko. A similar idea was carried into sculpture by the Primary Structurists.
Detroit Institute of Arts. Founders Society Purchase, Dr. and Mrs. George Kamperman.

in such thin layers as to make the work entirely without texture except for that of the canvas support (ground) on which it was painted. Morris Louis's **Number 99** (1959) is an example (*see* plate 109).

Most present-day art is concerned with ways of seeing as much as it is with what is seen. To put it another way, artists are much more concerned with the *processing* of the art object than with *form* and *meaning.* This tends to break down the former requirements for acquired skill.

Neo-Dada, Combine or Assemblage, Pop, Happenings, and Op Art

Another branch of Post-Painterly Abstraction, Neo-Dada, led directly to a significant trend of the 1950s and 1960s—Pop art. Robert Rauschenberg, combining pure, fluid brushwork in pigments with foreign materials like old mattresses, wireless sets, photographic images, animals, and the like attached to the canvas, was one of the first to indicate a drift away from pure Abstract Expressionism. From his combine-paintings also came much of the new art of Assemblage (fig. 11.44; *see* plate 44 and fig. 1.3).

Jasper Johns, another American artist more satirical in his approach than Rauschenberg, was equally

**11.44 Robert Rauschenberg. *Monogram with Ram.*
1955–1959; Construction: Free-standing combine
42 × 63¼ × 64½ in.** In this combine-painting, which merges into three-dimensional assemblage, the drift away from the pure painting of the 1950s is revealed. Such a work provided precedents for the Pop art movement shortly thereafter.
Courtesy the National Museum, Stockholm, Sweden and the Art Reference Bureau, Inc.

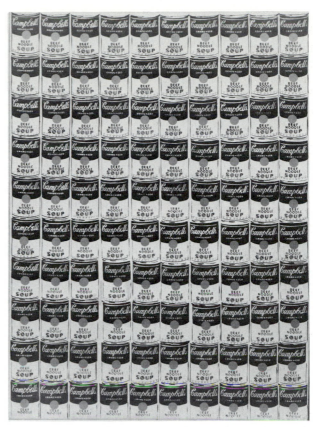

**11.45 Andrew Warhol. *100 Cans.* 1962; oil on canvas,
72 × 52 in.** Warhol's *100 Cans* beat a repetitive visual tatoo that derives from the insistence of similar commercial imagery in our daily lives. Repetitions of a more or less monotonous kind was one of the principles of form exploited first by the Pop artists and then by later artists of various styles.
Albright-Knox Gallery, Buffalo, New York.

important in pointing the new direction away from Abstract Expressionism. He chose as his chief motif single images of commonplace objects that had lost their effectiveness, such as the United States flag, targets, and the like.

The trend away from Abstract Expressionism in various forms culminated in the early 1960s in two main international movements called Pop art and Op art. The term *pop* stands for *popular* art or even for *pop bottle* art, judging by the frequency with which such objects appeared. The movement as a whole seems to have originated in England in the fifties and then became rather naturally acclimated to the United States. In it, images made popular by mass-media advertising and comic strips, and other everyday objects, such as pop bottles, beer cans, and supermarket products, are presented in bizarre combinations, distortions, or exaggerations of size, always rendered with fidelity to the original human-made object. The effect of these works, as in the case of Andrew Warhol's *Campbell Soup Cans* or Roy Lichtenstein's grotesquely magnified comic-strip heroes and villains, is to cause the viewer to react in a manner best described as a double take (figs. 11.45 and 11.46). As with Abstract Expressionism, the observer is again involved directly in the work of art, but now by the frequency with which the observer sees these commonplace items in everyday life and not only as an experienced sensation of the art form itself. The blurring between the realm of art and real life in Pop art is more pronounced in the pop-originated Happening. Happenings were a form of participatory art in which spectators, as well as artists, engaged. They have been defined as an assemblage on the move, bringing in the ideal of motion and time and space, which has been the

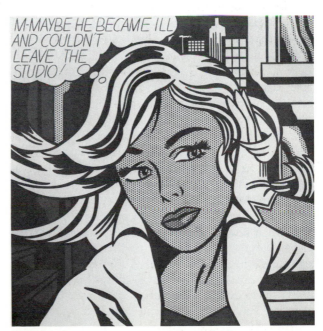

11.46 Roy Lichtenstein. *M-Maybe.* 1965; oil and magna on canvas, 60 × 60 in. Lichtenstein's use of magnified comic-strip heroes and heroines is typical of this Pop art movement.
Courtesy the Leo Castelli Gallery, New York. Collection Wallraf-Richartz Museum, Cologne.

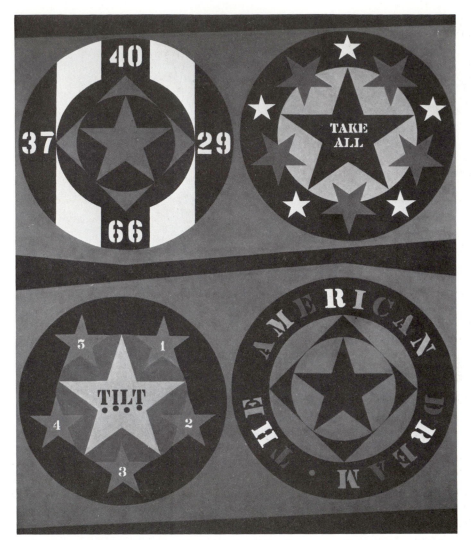

11.47 Robert Indiana. *The American Dream I.* 1961; oil on canvas, 72 × 60⅛ in. This is an example of
Pop art. Indiana utilizes the pop convention of commonly seen images of advertising. He mixes it with slogan-
conscious idioms of daily American life to create new experiences in which the conventional becomes
unconventional.
Museum of Modern Art, New York. Larry Aldrich Foundation Fund.

concern of artists for centuries, but which has reached
a new fruition in the present century.

Happenings were also based on the ancient concept
of drawing spectators into the heart of a work of art so
that they can experience the work more directly. This
concept reached its first climax in Baroque art in the
seventeenth century. At that time, as mentioned earlier
in this chapter, the disciplines overseen by the medieval
guilds had finally lost their technical control over the
artist. From the Renaissance on the religious iconog-
raphy and media used by artists were intermingled in
an artistic fabric (the church building) that was unified
within itself, but was dependent for completion on the
spectator's participation in the artistic experience.

Since similar experiences were promoted by the
Dadaists in 1916, some of the Pop artists were also
called Neo-Dadaists. But whereas Dada was nihilistic,
self-exterminating, and satirical, Pop art seems to have

had little of this purpose. Instead, it seems to have en-
couraged an awareness and acceptance of the fact that
mass media communications have a tremendous im-
pact on our daily lives. There was a kind of joyful en-
thusiasm for exploring the possibilities implied by the
daily images and objects of a metropolitan society and
culture. From billboards to bar interiors, from grocery
store cans and boxes to the bathtubs and sinks of the
average house interior came the realist subjects of Pop
art as a reaction to the inwardly directed privacy of the
Abstract Expressionists and their offshoots. Significant
artists of Pop persuasion besides Warhol and Lichten-
stein are: Jim Dine, Robert Indiana, Tom Wesselman,
Claes Oldenburg, and George Segal. Several, but es-
pecially Oldenburg and Segal, are sculptors or assem-
blers, fields in which Pop art makes inroads as much
as in painting (figs. 11.47 and 11.48).

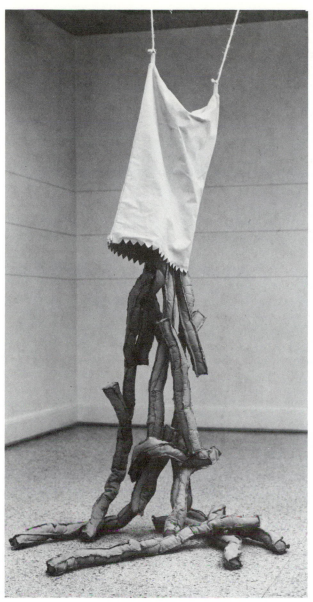

**11.48 Claes Oldenburg. *Falling Shoestring Potatoes.* 1965;
painted canvas, kapok, 108 × 46 × 42 in.** Pop artists generally
disregard all consideration of form in the belief that they create a
barrier between the observer and the everyday objects that serve as
subjects. Pop art is an art of the "now" things.
Collection Walker Art Center, Minneapolis. Gift of the T. B. Walker
Foundation.

The popularity of *assemblage* and the enhancement
of the Dada idea of the "found object" led to the junk
ethos in metal and other material form combinations.
The junk often included scrapped fragments of human-
made objects such as automobiles, farm machinery,
factory parts, airplanes, and bicycles. John Chamber-
lain's sculptures made from the parts of wrecked au-
tomobiles and those of Richard Stankiewicz created
from old boilers, sinks, and the like, welded together,
are a kind of comment on consumer culture that also

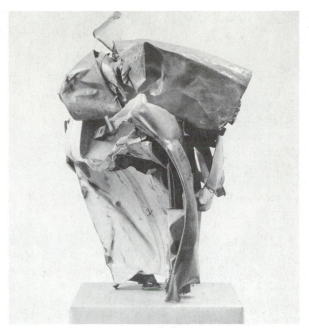

**11.49 John Chamberlain. *Untitled.* 1958–59; painted metal
and welded, 32½ × 26½ in.** The popularity of *assemblage,*
enhanced by the Dadaist idea of the "found object," led to the
junk ethos of metal and other material form combinations. During
the 1950s and 1960s, artists of this persuasion, like Chamberlain,
who works with bent and crushed metal from old automobiles,
have also been called Neo-Dadaists.
Cleveland Museum of Art. Purchase, Andrew R. and Martha Holden
Jennings Fund.

occurs in Pop art (fig. 11.49). The artists just men-
tioned are American, but Europeans like Cézar work
along similar lines. Cézar's *Compressions Derigées* are
objects made with the giant baling machines that com-
press junked automobiles and other scrap into small
size.

Edward Keinholz's works, which he calls *Tableaus,*
also fall into the category of assemblages. His combi-
nations of a variety of materials have something of the
shock value of Dada art, making pungent comment on
the sickness, tawdriness, and melancholy of modern so-
ciety (fig. 11.50).

Op art stands for the term *optical* and, again, seems
an extension and modification of earlier twentieth-
century Geometric Abstraction and Nonobjectivity.
Artists in the movement (many again influenced by Al-
bers), such as Victor Vasarely, Richard Anuszkiewicz,
George Ortman, Agam, and Bridget Riley, employ
precise shapes and sometimes wriggly lines or concen-
tric patterns that have a direct impact on the physiol-
ogy and psychology of sight (fig. 11.51, plate 111; *see*
fig. 3.12). They have explored moiré patterns and have
formed groups that seem almost dedicated more to sci-
entific investigation of vision than to its intuitive
expression in art.

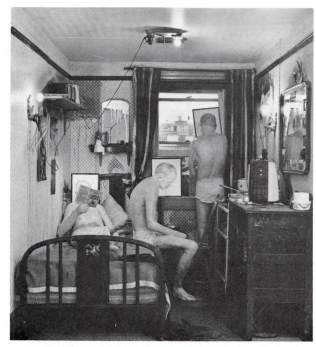

11.50 Edward and Nancy Reddin Kienholz. *Sollie 17.* **1979; mixed media, 10 × 28 × 8 ft.** This artist belongs to a branch of assemblage art sometimes known as Environments. His *Tableaus* of the old, the derelict and mentally ill were comments on the sickness, tawdriness, and melancholy of modern society.
Private collection. Courtesy of L. A. Louver Gallery, Venice, Calif. Photo by Thomas P. Vinetz.

Kinetic Sculpture

Kinetic forms of art are those that create movement. Although partly derived from Calder's motor-driven *Circus* of the 1920s and later mobiles, they also owe their origins to Op art. Kinetic art almost entirely uses a mechanical means to give motion to the art object. And even though Kinetic art owes something of its origins to Op art, Op art remains primarily a static form of art using various realistic devices to suggest movement. Kinetic art is thus another art form that came from the concern with *space and time* that began with some types of Impressionism in the late nineteenth century and continued with Futurism, Dadaism, and Calder in the early twentieth century. Dadaists, under the aegis of their credo of nonsense, with which they wished to destroy civilization and art in order to start over building a better world, created movement, or kinetics, as in Marcel Duchamp's swirling designs played on a phonograph turntable.

Present-day artists use random movement as well as movement controlled by mechanical or electronic means to produce Kinetic art. Jean Tinguely's mechanisms

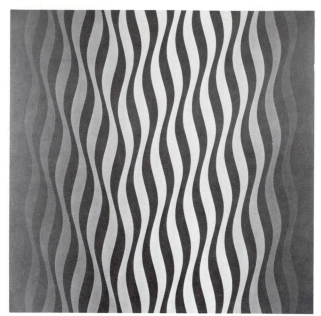

11.51 Bridget Riley. *Drift No. 2.* **1966; acrylic on canvas, 91½ × 89½ in.** Op artists generally use geometric shapes, organizing them into patterns that produce fluctuating, ambiguous, and tantalizing visual effects very similar to those observed in moiré patterns.
Albright-Knox Art Gallery, Buffalo, New York.

summarize this trend. He created large, slack, junky-appearing contrivances that outdid the imaginary cartoons of Rube Goldberg of the 1920s and 1930s. Tinguely's creations sometimes moved about, but more often merely stood and shook, as if they were going to throw away the gears and cogs that ran them. In fact, Tinguely's most famous kinetic construction of this kind did just that, destroying itself in the garden of the Museum of Modern Art in New York City in 1960 *(Homage to New York).*

Other artists, such as the Greek artist Takis and Pol Bury, exploit similar possibilities in more elegant forms that sometimes seem almost immaterial. Takis, for example, has used small metal shapes suspended on rods, whose movement can hardly be detected without close study, while Bury often uses biomorphic wood shapes that are motorized to make slight movement (fig. 11.52). Other artists explore the suggested movement in the work of Minimalist and Optical artists, and do achieve movement—but to a limited degree.

Some artists, such as Chryssa, Dan Flavin, and Nicholas Schoeffer, explore the combination of light, movement, and sound electronically produced to create kinetic fantasies. Chryssa uses the technology of the neon light in his fluorescent kinetics, as does Flavin (*see* plate 2). Schoeffer more frequently uses movement, electronic sounds, and lighting in his creations.

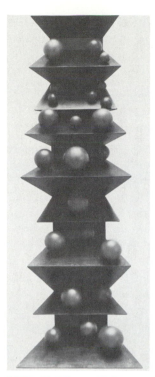

11.52 Pol Bury. *Staircase.* **1965; wood with motor, 78⅝ in. high.** Here is an example of an art form in which the ball shapes actually move. Movement had precedent in both late nineteenth-century and early twentieth-century sculpture and painting. A growing number of technologically oriented artists exploit the possibilities of such *kinetic* art today.
Collection the Solomon R. Guggenheim Museum, New York. Photo by Carmelo Guadagno.

New Realism

A general trend in the 1960s was the extension of Pop art into meticulously rendered images of reality. The movement was led by such artists as Wayne Thiebaud, Mel Ramos, Philip Pearlstein, Richard Estes, Gary Schumer, Chuck Close, Richard Lindner, and Robert Cottingham (fig. 11.53; *see* figs. 2.7, 6.6 and plate 42). Artists of this persuasion are designated New Realists. They depend on both photography and images like those in commercial advertising to gain their meticulous artistic ends. Unlike the Pop artists, they show average people at their everyday activities.

There has always been a high level of interest in realist art throughout the twentieth century, particularly in the United States. This can be witnessed not only in the unabated popularity of Andrew Wyeth, but also in resurgences of interest in artists like Grant Wood and George Bellows of the earlier part of the century (*see* figs. 7.2 and 3.31). And there has been, on occasion, a return to favor of nineteenth-century Realism, from the Pre-Raphaelites through the Impressionists.

Like Pop art, New Realism has its sculptural participants. The sculptors refined the styles of Segal and Oldenburg and made even more lifelike images in fiberglass and resins. Very popular in this area during the late 1960s and early 1970s were Frank Gallo, John De Andrea, and more recently Duane Hanson (fig.

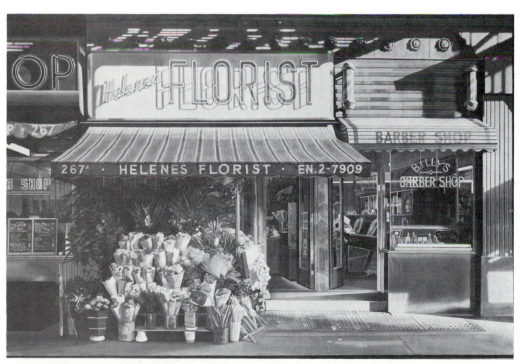

11.53 Richard Estes. *Helene's Florist.* **1971; oil on canvas, 48 × 72 in.** The meticulously rendered images attempt to reach the degree of reality found in actual photography.
Courtesy the Toledo Museum of Art, Toledo, Ohio.

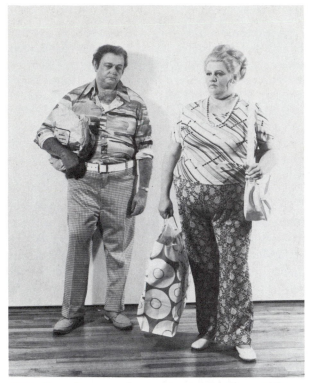

11.54 Duane Hanson. *Couple with Shopping Bags.* **1971; vinyl polychromed in oil, life size.** This work belongs in the context of photorealism painting, but it incorporates more illusions than painting can. Duane Hanson's three-dimensional, lifelike, lifesize figures are cast in colored polyester resin and fiberglass to look like real skin and are clothed in real garments. Hanson's human reproductions are detailed so meticulously that one reacts to them first as real people, only later as sculpture.
Courtesy O. K. Harris, Works of Art, New York.

11.54). Trompe l'oeil verisimilitude reaches a new level of virtuosity and tour de force in such three-dimensional illusions.

Primary Structurist, Minimalist, and Constructivist Sculpture

In sculpture the Post-Painterly Abstractionists are paralleled by a group of artists that includes Robert Morris, Donald Judd, Tony Smith, Anthony Caro, and others who carry the late mechanomorphic cubes of David Smith into blunt sculpture of simplified geometric volume that seems stripped of all psychological or symbolic meaning (figs. 11.55 and 11.56). They are called Primary Structurists. Quite often, they reject metal and welding for materials hitherto uncommon to sculpture. Cardboard, masonite, plywood, and the like are used. Some artists, such as Larry Bell and Sylvia Stone, used hard sheet plastic (Plexiglas®) or tinted glass to create transparent volumes that enclose space (fig. 11.57).

The Primary Structurists also seem to obliterate the core. The objects they create express through the power of simple volumes all that they want to say. Some are merely boxes of gigantic size. (Size is one of the characteristics of much of the sculpture in the late 1960s and 1970s.) At first, Donald Judd created loaf-shaped boxes hung on a wall (relief fashion) that were repeated a number of times. More recently, he has turned to large, open-centered concrete boxes that repeat.

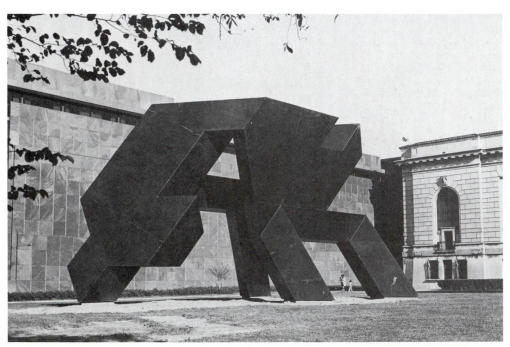

11.55 Tony Smith. *Gracehoper.* **1972; metal, steel, paint welded, 23 × 22 × 46 ft.** This primary sculptural structure utilizes size and a simplified geometric volume to create impact on the visual senses of the observer.
Detroit Institute of Arts. Purchase, Donation from
W. Hawkins Ferry and Founders' Society Fund.

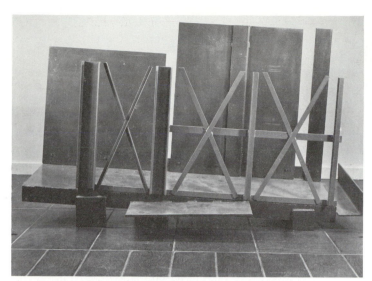

11.56 Anthony Caro. *Up Front.* 1971; sheet metal and steel beams, 69 × 47 × 110 in. This work by the Primary Structurist Caro owes some of its bluntness of expression and direct simplicity of form to the later work of David Smith. Its quality of technological precision, however, contrasts with the haphazard, ready-made castoffs of present-day technological society as suggested by the ethos of Neo-Dadaism and Junk art.
Detroit Institute of Arts. Purchase, Contributions for
W. Hawkins Ferry and Mr. and Mrs. Richard Manoogian.

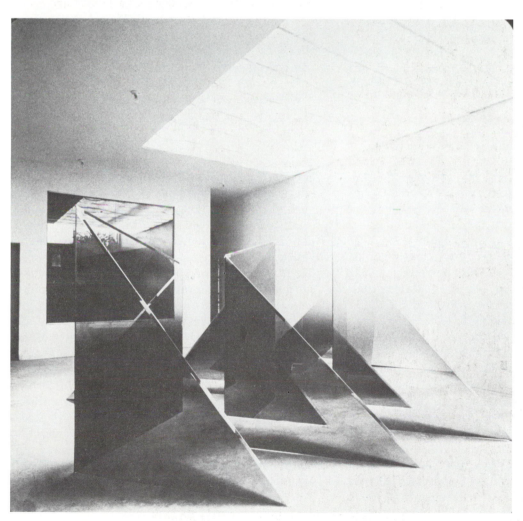

**11.57 Larry Bell. *Untitled.* 1977; Vaporized metal on plate glass, three panels: 1. 5 × 5 ft. × ⅜ in.
2. 6 × 5 ft. × ⅜ in. 3. 5 × 6 ft. × ⅜ in.** The Primary Structurists use simple monumental forms exploiting a wide variety of materials. These three panels are made of vaporized metal on plate glass.
Courtesy the Marian Goodman Gallery, New York. Private collection. Victoria, Texas.

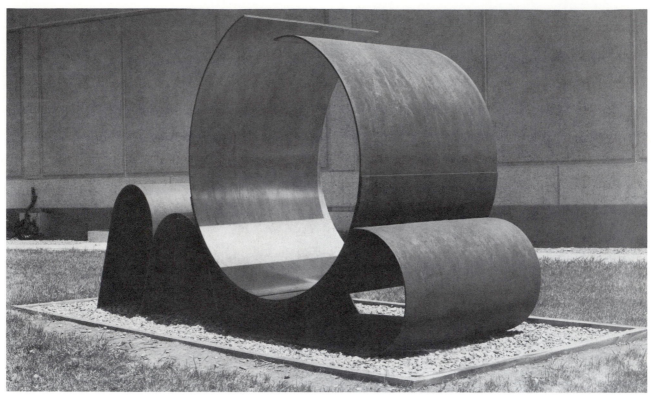

11.58 Lila Katzen. *Oracle.* 1974; steel, 11 × 17 × 5 ft. The flowing sheet metal forms set in outdoor space are typical of the works of Katzen.
The University of Iowa Museum of Art.

Repetition of similar forms seems a carry-over of similar ideas from Pop art, (for example, Warhol's **Campbell Soup Cans**). Carl Andre also repeats different materials in rows; sometimes they are laid on the floor of a gallery, at others they are placed outdoors. Sol De Witt has used this principle of interval and repetition in boxlike slatted sculptures faintly reminiscent of egg crates or bird cages piled up. Clement Meadmore adds a sudden twist in direction to his Primary Structures or Constructions so that they appear to be tied in a knot.

The Primary Structurists are often categorized as Minimalists due to the simplified economy of their forms, which have connections with the Minimalist painters (*see* Ad Reinhardt and Jules Olitsky, Post-Painterly Abstraction). In their stress on pure form, such artists seem to reject the ideal of human personality as counting for much in the work of art. This is a reminder of antecedents, purists like Mondrian and the painters of the Nonobjective movement ca. 1930–50 (*see* Pure Abstraction and Nonobjective Art). It was also a reaction to the associational suggestivity found in welded sculpture, particularly of the Abstract Expressionist kind.

There is, however, another branch of the Primary Structurist movement that seems to be more inclined toward open spatial forms in preference to the simplified enveloping boxes and planes of the first group. They have been variously called Minimalists, Environmentalists, and Neo-Constructivists. We do not have the hindsight, when we are right on top of contemporary creativity, that is necessary to distinguish major directions from one another, so no distinctive classification has been given to these artists as yet. Nonetheless, they like to concentrate on large, spatially opened, rectilinear, and curvilinear forms. Sometimes these sculptures feature beamlike arms or girderlike extensions into space, and at other times curving planes, or flat planes with curving edges, that are interrelated. These sculptures are sometimes related to the walls, floor, or ceiling of a room (as in the exhibition space of a gallery or museum) and at other times (especially in the 1970s), are only appropriate in scale to an outdoor environment. Like the more boxy, volumetric Primary Structurists, these artists' creations also seem to reject any connotations of human personality. Attention is concentrated on a machinelike impersonality that is part of our cultural heritage. Despite this apparent attitude expressed by the works, some persons may have a tendency to sense a more romantic quality due to their very free spatial play.

If there is one characteristic dominant in all these sculptures today, it is their orientation to space. The *mass* of earlier sculptors has been replaced by a preoccupation with *size* and *space* among contemporary sculptors. The factor of space might be incorporated as

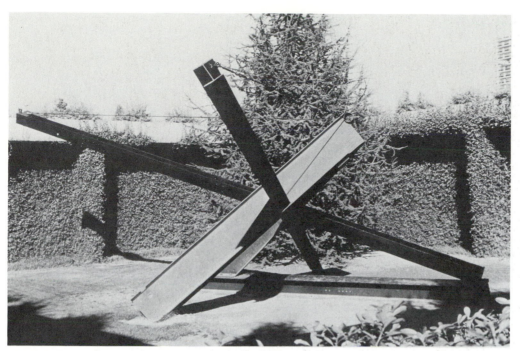

11.59 Mark di Suvero. *Homage to Charlie Parker.* **1970; steel and wood, 13¼ × 35½ × 21 ft.** This piece is typical of many contemporary sculptures in its largeness of scale, preoccupation with space, and its choice of an environmental setting.
Collection of the Oakland Art Museum, Oakland, California.

a part within the sculptural pieces, or it might be involved with a flow or thrust into the natural environment. Many of the works are located on university campuses, at outdoor settings of museums, and sometimes in front of, or related in some other manner to, city office buildings.

Examples of these trends are Lyman Kipp and his vertical, flat shafts of metal; Lila Katzen and her large, open-rolled, sheet-metal forms; Mark di Suvero and his variously angled I-beam girder structures; and Kenneth Snelson and his hanging tubes with cables (figs. 11.58 and 11.59; *see* fig. 10.3).

A few of the boxes, and occasionally some of the more rectilinear sculptures, stress brightly colored surfaces, while others are neutral or void of color. Without doubt, many have impact, but some of the boxier forms often transmit a feeling of sameness or monotony. At times, the *processing* of these objects seems more important than form and its effect on the vision of the observer. A few of these objects, especially the rectilinear constructions, sometimes involve kinetic movement. George Rickey's work is a distinguished example of this aspect of contemporary sculpture (fig. 11.60).

The strictly sculptural use of the assemblage concept had a great influence on sculptors in the 1960s and 1970s. Even those artists already mentioned probably felt the influence of the assemblage technique in their early careers.

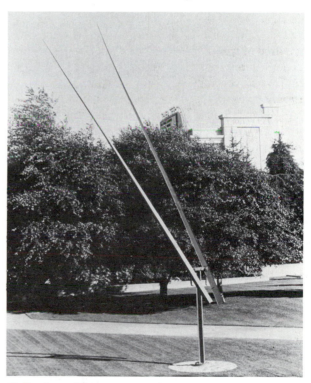

11.60 George Rickey. *Two Red Lines II.* **1966; painted steel, 32 ft. high.** Many of Rickey's works are kinetic, being constructed so as to utilize the wind to provide constantly changing aspects.
Collection of the Oakland Art Museum, Oakland, California.

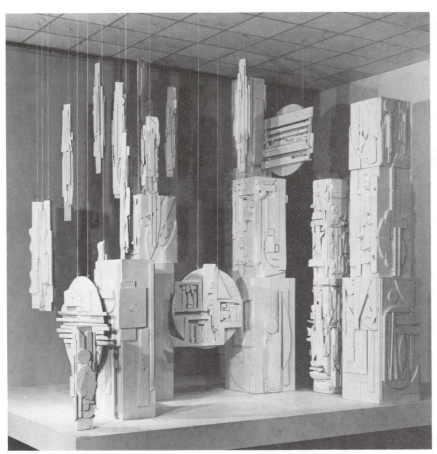

11.61 Louise Nevelson. *American-Dawn.* **1962–1967; wood, painted white.** This is an example of the assemblage concept in today's art by a well-known sculptress. She utilizes separate, columnarlike shapes that build up to a unified but dynamic verticalized accent. The shapes contrast with the more frequently used boxlike screens enclosing smaller sculptural units in other works.
Art Institute of Chicago.

If there is another characteristic of modern sculpture that needs to be emphasized, it is the apparent virility of the forms and the lively crosscurrents that seem to be carried from one category of form to another. It is difficult for this reason to even classify much of what is going on in the field of sculpture. Sculptors continually change their approaches, slipping from one style into another. Louise Nevelson, for instance, began by using smooth abstract shapes comparable to Henry Moore. Later, she moved toward assemblage, fitting together ready-made wooden shapes, such as knobs, bannisters, moldings, and posts gleaned from demolished houses and old furniture. These fragments were associated in boxlike forms compartmentalized into various-sized rectangles and squares that became large screens or freestanding walls. These complex pieces were usually painted a uniform color, which stressed the relationship of the parts as a unified total. Her relationships and complexities seem in keeping with the new trend toward processing rather than form. But her final results are often more exciting than those of the Primary Structurists (fig. 11.61).

Environmentalism: Earthworks

Environmental art takes its name from the fact that the work of art is created in such a way that it surrounds the spectator. It becomes a "slice of (artificial) life," which is completed by spectators because of the stress placed on the details of the created forms around them. Artists of this kind responded to the stimulus of the idea that not only should spectators' vision be engaged in works of art, but also their physical bodies, their sense of touch, and their sense of smell. Although Dadaists like Kurt Schwitters and Marcel Duchamp created the first twentieth-century Environments, the Pop artists must be credited with renewing this form of art in the 1960s and 1970s. Lucus Samaris's *Mirrored Room* is a good example of an environment that like the Constructivists, the Neo-Constructivists, and the Minimalists/Primary Structurists, de-emphasizes artistic personality (fig. 11.62). The desire to express purity of form more than the artist's character in a work of art has also been a continual ideal in twentieth-century art since the innovations of Cubism and Abstract art between 1906 and 1918.

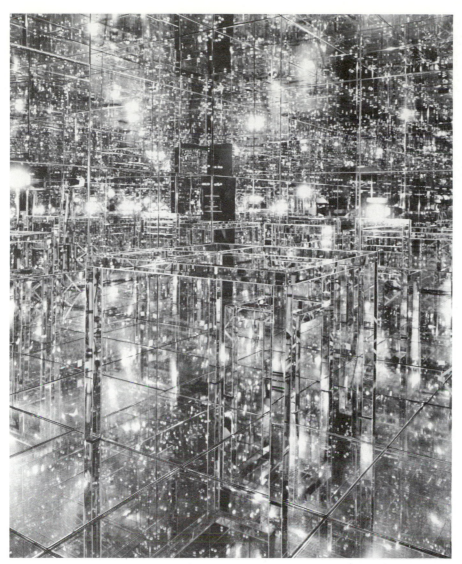

11.62 Lucas Samaris. *Mirrored Room.* 1966; mirrors on wooden frame, 8 × 8 × 10 ft. This is an example of *environmental art,* which, using size and structure, seems to enclose or actually encloses the observer within the form of the work.
Albright-Knox Art Gallery, Buffalo, New York. Gift of Seymour H. Knox, 1966.

Environments in various materials emerged from the static assemblages of the 1950s and 1960s. The Pop art concept of literal images was enlarged to encompass the spectator. These images, originally the most commonplace items in our culture, were removed from their normal settings and given the supposed legitimacy of pure art. The involvement of the spectator included the principle of space/time, or the action involved in either creating or looking at works of art.

In addition to Samaris, other artists more or less involved in producing environments, while they also create other kinds of art, are Christo, Oldenberg, Howard Woody, and Bruce Nauman. Christo's work has been continuous in its exploration of the environment in relation to his art, from the great balloons, featured at the Whitney Gallery in 1968, to his recent surrounding of islands off the coast of Florida (1983) with sheets of plastic (plate 112). One of the works in which he used metal posts and sheet plastic to enhance the contours of some hills and valleys near Petaluma, California, in 1976 is shown in figure 1.1, along with some of his drawings and/or paintings that precede the final environmental projects as models. These are also sold by Christo to raise money for the supplies and helpers required to execute the projects. The carrying out of the actual environmental form takes on the character of a Happening or Action art.

Another pioneer among the Environmentalists was the sculptor Robert Smithson, whose ***Spiral Jetty,*** created at Great Salt Lake, Utah, in 1970, had an important part to play in such large-scale environments. Some of these environments are now called Earthworks or Earth art (*see* fig. 1.2). Claes Oldenburg, the

well-known Pop artist, has also explored environments, as in his giant lipstick tube monument created for Yale University.

The Minimalist/Primary Structurist emphasis on the large scale of their "pure" forms also helped lead to that branch of Environmental art often called Earth art. The displacement of the natural and/or prepared land and space necessary for the setting or exhibiting of large-scale outdoor sculptures drew attention to the land or place where they would be situated. Some artists soon conceived that the manipulation of the setting, or natural environment itself, was significant as a work of art in its own right.

The exact incidence of Earthwork art is difficult to state, although it appears to have developed in the late 1960s. Michael Heizer, for example, dug five twelve-foot trenches that he lined with wood in the Black Rock Desert of Nevada in 1969. In Central Park, New York City in 1967 Claes Oldenburg was also digging holes, which he called "invisible sculptures."

Process and Conceptual Art

As we have pointed out, the Minimalist/Primary Structurists of the 1960s and 1970s emphasized the purity of formal meaning to be found in the simple volumes while the Action Painters in Abstract Expressionism earlier had advocated raising the creative act over formal expression in the arts. In these movements a great deal of artistic energy has been expended in the direction of exploring the creative process and the conception of works of art. These forms of art have been called *Process art* and *Conceptual art*. Both, in a strict sense, would downgrade the importance of the artist and the final form or object of art in what we call art. Process artists believe that all art is experienced primarily as an act of producing. The interpretations applied to the final form do not seem important to them. This is, perhaps, the final evolution of the attitude that once claimed that all art went far beyond what the artist was trying to express in a form (under the analysis or interpretation of various observers, from critics to connoisseurs). Process art is a continuation of (and a new name for) the Pop Happenings of the 1950s and early 1960s.

Conceptual art is an extension of this kind of thinking. Artists in this movement believe that neither the act of making or of achieving a final object is as important as the *idea*, or concept, that lies behind a work of art. Thus artists who conceived of filling the air with oxygen or steam vapor in the early 1960s (which they called *Universal art* because the vapors would expand endlessly into the universe) were the forerunners of what we now call *Conceptual* art. Today this form of art, like Process art, often involves action by the artist

11.63 Joseph Beuys. *Rescue Sled.* 1969; wood, metal, rope, blanket, flashlight, wax (attached to sled), 35½ × 13¾ in. Conceptualists such as Beuys believe ideas are more important than artistic products. Commonplace objects often symbolize complex meanings. Here, for example, the sled represents a simple form of moving transportation, the fat symbolic food, the felt blanket shelter, and the flashlight orientation.
Art Institute of Chicago.

alone, but more often involves helpers and/or an audience. In one sense, Christos's environments can be considered conceptual forms of art since they require a director, who has conceived of the work, and those who assist or participate in the recording of the idea in whatever form it may take.

The German conceptualist Joseph Beuys states, as in his *Rescue Sled,* the theory that ideas and production are more important than the medium or form of an artist. He claims that every act of society is a work of art. Objects such as the rolls of felt, pieces of animal fat, and flashlights that appear in his work, while not the ordinary media of traditional artists, are meant to express complex, deep-seated ideas or meanings that lie behind them. They are metaphorical statements about *survival* in a world on the brink of catastrophe (fig. 11.63).

ART FORMS OF THE 1980s

One detectable note of difference in the pictorial arts did not seem to be quite so manifest in the 1960s as it is in the 1980s. This is a return to the use of a variety of media and techniques in a single format. For example, where acrylic painting dominated the pictorial arts in the 1960s, we now often have the introduction of conte crayon, pastels, paper collage, powdered metallics, oils, and acrylics all in the same work of art. It is as if young artists are rediscovering the use and value of such media and are exploring them in juxtapositions. Mel Bochner's *Vertigo* (1982) and Michael Goldberg's *Le Grotte Vecchie I* (1981) are recent examples of this mixed media approach in different styles (fig. 11.64; *see* fig. 4.6).

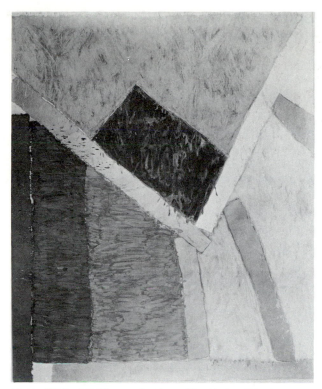

11.64 Michael Goldberg. *Le Grotte Vecchie I.* **1981; bronze powder, alkyd spray, pastel, acrylic on canvas.** The work of Goldberg and other artists seems indicative of a recent revival of interest in combining varied media and techniques in the same work of art. This revival has occurred after a pause in the 60s and 70s when acrylics were often used alone as a dominant medium. Albright-Knox, Buffalo, New York. George B. and Jenny R. Mathews Fund.

As indicated previously, it is difficult to detect what the major directions will be until we have the hindsight of several years. We have seen that just as in the 1940s, '50s, and '60s, the '70s have been filled with a diversity of manners in all media rather than any narrowing down to one or two major styles. Visual art continues to be diverse in the early 1980s, which seems to speak to its healthy condition.

Neo-Expressionism

In 1980 and 1982 there was an attempt by certain New York promoters (in a declining art market) to initiate a change from the depersonalized expression that was taking place in much recent art. It took the direction of presenting artists in a mode called *Neo-Expressionism.* This attempt to establish a new movement by commercial entrepreneurs, rather than having it grow out of artists' changing attitudes seems to be something new in the art market. Some of the so-called discoveries expressing the "new" style were young Europeans. In 1981 Italian artists, such as Enzo Cucchi and Sandro Chia, were given exhibits in New York. Much was written about them, intended to show that they were leading the way to a new manner (fig. 11.65; *see* plate 70). In 1982 some Germans were "discovered" (A. R. Penck, Rainier Fetting, George Baselitz) who appeared to reecho the pictorial emotional fervor of the Early German Expressionists (Nolde, Schmidt-Rotluff, etc.; *see* German Expressionism). At the same

11.65 Enzo Cucchi. *Paesaggio Barbaro.* **1983; oil on canvas, 117 × 156 in.** Enzo Cucchi, a recently discovered Italian Neo-Expressionist, paints heavily pigmented canvases contrasting living creatures with symbols of death, abandonment, and decay. Sperone Westwater Gallery, Soho. Collection: Slaatsgalerie Stuttgart.

time a young American artist, born in Texas but working in Europe, was also "discovered" as a native U.S. exponent of this style (Julian Schnabel). Whether this really marks a major change toward an emotionalized and humanized (figurative) style once again is not yet possible to say (plate 113).

In the summer of 1983 the Solomon R. Guggenheim Museum had an exhibition of recent European art (it also included some of the still-living artists who had become established earlier in the century). This show seems to have indicated that many of the artists abroad are, like their American counterparts, creating works similar in form to many styles of art introduced over the past thirty to forty years. In other words, there seems to be as yet no major change of direction in the arts. Change is more desirable to some people than to others, but in any case we may not be able to see whether change is occurring due to our closeness to it. All that can be said in conclusion is that there are thousands of young artists learning and at work in all fields and media. There seems to be no decrease in the vast number of artworks being produced each year. In fact, the pace of artistic activity may be increasing.

CHRONOLOGICAL OUTLINE OF WESTERN ART

200,000 B.C.	**Prehistoric art**	Paleolithic, old Stone Age.
		Flint-tool industries.
25,000		Art beginnings, cave painting.
10,000		Neolithic, new Stone Age.
		Beginning of architecture, pottery, weaving.
4000	**Ancient art**	Egyptian, Old Kingdom.
3000		Middle East, Sumerian Babylonian.
2800		*Aegean art,* Cretan (Minoan I), Cretan (Minoan II).
2200		
2100		Egyptian, Mid-Kingdom.
1800		*Aegean art,* Mycenaean Age (in Greece), Cretan (Minoan III).
1700		Middle East, Assyrian.
1580		Egyptian, New Empire.
1200		
1100		*Aegean art,* Homeric Age. *Etruscan art,* Italy.
1090		Egyptian, decadence and foreign influences.
750		*Greek art,* Archaic Age. *Etrusco-Roman,* Italy.
606		Middle East, Chaldean, Babylonian.
530		Middle East, Persian (ca. 225 B.C.).
470		*Greek art,* Classical Age.
338		*Greek art,* Hellenistic Age.
332		Egypt, Graeco-Egyptian or Ptolemaic.
280		Graeco-Roman.
146		Greece, Roman domination. Roman.
30		Egypt, Roman domination.
A.D. 300	**Medieval art**	*Early Christian art* in Italy.
330		*Early Byzantine art* in Middle East, Egypt (Coptic).
550		*Muslim* or *Islamic art,* northern Africa, southern Spain (Moorish art).
768		*Carolingian art,* France, Germany, northern Italy.
800		*Developed Byzantine art,* Middle East, Greece, Russia, parts of Italy (Ravenna, Rome) (to 1453).
		Migratory, barbarian (Vikings, Huns, Goths), and *Early Christian art* in western Europe.
1000		*Romanesque* (Roman-like, or modified Roman art in France, England, northern Spain, Italy, and Germany).
1150		*Gothic art* in Europe.
1300	**Renaissance art**	*Proto-Renaissance,* Italy: Giotto, Duccio.
1400		*Early Renaissance:* Masaccio, Donatello, Francesca, Leonardo, etc.
		Renaissance in West modified by vestiges of Medievalism, Van Eycks, Weyden, Van der Goes.
1500		*High Renaissance:* Michelangelo, Raphael, Titian, Tintoretto; western Europe influenced by Italy.
1520		*Mannerism* and *Early Baroque,* Italy: Caravaggio.
1600	**Baroque art**	*Baroque art* in Europe: Rubens, Van Dyck, Rembrandt, Hals (Netherlands); Velasquez, Ribera (Spain); Poussin, Lorrain (France); Bernini (sculpture, Italy).
		Early Colonial art, America.
1700		*Rococo art.* Primarily French: Watteau, Boucher, Fragonard, Chardin; but spreads to other European countries, Canaletto, Guardi, Tiepolo (Italy); Hogarth, Gainsborough, Reynolds (England). *Colonial art,* America.

1800	**Modern art** **Nineteenth-century art**	*Neoclassicism:* David, Ingres (France); Canova (sculpture, Italy).
1820		*Romanticism:* Gericault, Delacroix (France); Goya (Spain); Turner (England); Ryder (United States); Barye (sculpture, France).
1850		*Realism* and *Naturalism:* Daumier, Courbet, Manet (France); Homer, Eakins (United States); Constable (England).
1870		*Impressionism:* Monet, Pissarro, Renoir, Degas (France); Sisley (England); Hassam, Twachtman (United States); Medardo-Rosso (sculpture, Italy); Rodin (sculpture, France).
1880		*Post-Impressionism:* Cezanne, Seurat, Gauguin, van Gogh, Toulouse-Lautrec (France).
1900	**Twentieth-century art**	Sculptors working in a *Post-Impressionist* manner: Maillol (France); Lachaise (United States); Lehmbruck, Marcks, Kolbe (Germany).
1901		*Expressionism:* Picasso* (Blue, Rose, and Negro Periods). *Les Fauves:* Matisse, Rouault, Vlaminck, Modigliani, Dufy, Utrillo (France). Recent French *Expressionists:* (1930) Soutine, Buffet, Balthus. *German Expressionists:* Nolde, Kirchner, Kokoschka, Schmidt-Koftluff; Marc, Jawlensky, Macke, Beckmann, Grosz, Dix, Munch (Norway). *Sculpture:* Marini (Italy); Epstein (England); Zorach (United States).
1901–1930		*American Expressionists:* Weber, Shahn, Levine, Avery, Baskin, Orozco (Mexico).
1906	**Abstract art (early)**	*Cubism:* Picasso,* Braque, Légér, Gris. *Sculpture:* Laurens (French). *Futurism:* Balla, Boccioni, Severini, Carra (Italy); Boccioni (sculpture, Italy).
ca. 1910–1950		*Abstraction* and *Nonobjective art:* Kandinsky, Albers (Germany); Moholy-Nagy (Hungary); Larionov, Malevich, Tatlin (Russia); Delaunay (France); Nicholson (England); Mondrian, VanDoesburg, Van Tongerloo (Holland); Dove, Marin, Feininger, Frank Stella, O'Keefe, MacDonald-Wright, Stuart Davis, Demuth, Hartley, Knaths, Diller, Pereira, MacIver, Tomlin, Rothko (United States). *Abstract sculpture:* Brancusi, Archipenko, Arp (France); Epstein, Passmore (England); Di Rivera, Nevelson, Hajdu, Noguchi (United States); Gabo, Pevsner (Russia and United States).
ca. 1910	**Fantasy in art**	DeChirico (Italy); Chagall (France); Klee (Switzerland); Rousseau (French primitive).
1916		*Dada:* Tzara, Duchamp, Picabia, Arp (France); Ernst, Schwitters (Germany).
1924		*Surrealism:* Ernst (Germany); Tanguy (France, United States); Dali (Spain, United States); Magritte (Belgium); Masson (France); Bacon (England). *Sculpture:* Giacometti (Switzerland); Gonzalez (Spain); Arp (France).
1925		*Surrealistic Abstraction:* Picasso* (France); Miró (Spain); Tamayo (Mexico); Matta (Chile, United States); Baziotes, Tobey, Gorky, Rothko, Hofmann, DeKooning (United States). *Sculpture:* Moore, Hepworth (England); Lipchitz (Lithuania, United States, France); Calder (United States).
1930–1940		*Traditional Realism:* Regionalists: John Sloan, Grant Wood, Thomas Hart Benton, Andrew Wyeth (United States).
1945	**Post-World War II trends**	*Abstract Expressionism* and *Action Painting:* Pollock, Motherwell, Kline, Still, Reinhardt, Frankenthaler, Tworkov, Rothko (United States); Mathieu, Soulages, Manessier (France); Vieira da Silva (Portugal); De Stael, Appel (Holland); Okada (Japan); Tapies (Spain). *Abstract Expressionist* Sculpture: Roszak, David Smith, Lipton, Lassaw, Lippold, Nakian (United States); Richier (France).
1950	**Post-Painterly Abstraction**	*Colorfield* and *Hard-Edge* Painters (all United States): Newman, Morris Louis, Kelly, Noland, Stella, Poons, Ron Davis. *Minimalists:* Yves Klein (France); Olitsky, Reinhardt (United States). *Primary Structurist* Sculpture: Judd, Bontecou, Tony Smith, Di Suvero, Nevelson, Rosenthal, Bell, Stone, Davis, André (United States); Paolozzi, Caro, King (England); Bill (Switzerland).

*Artists frequently change their styles, hence the names appearing
more than once under different categories of form-style. Most no-
table in this respect was Pablo Ruiz Picasso.

ca. 1955	*Neo-Dada* and *Funk art:* Collage-assemblage: Johns, Rauschenberg (United States); Dubuffet (France).
	Sculpture: Kienholz, Stankiewicz, Mallary, Chamberlain (United States); César (France).
	Pop art and *Happenings:* Warhol, Lichtenstein, Dine, Indiana, Kaprow, Oldenburg, Segal, Grooms, Marisol, Wesselman, Rosenquist (United States); Hamilton, Kitaj, Smith (England).
	Op art: Vasarely (France); Anuskiewicz, Ortmann, Stanczak (United States); Agam (Israel); Riley, Denny (England).
1965–1980	*New Realism:* Pearlstein, Ramos, Katz, Thiebaud, Lindner, Close, Cottingham, Estes (United States).
	Sculpture: Gallo, De Andrea, Hanson (United States).
	Technological art (*Kinetics*): Wolfert (color organ, 1930–1963), Tinguely (Swiss); Chryssa (Greece); Samaras, Sonnier, Riegack, Flavin (United States); Haese (Germany); Schoeffer (Hungary); Soto (Venezuela); Castro-Cid (Chile); Le Parc (Argentina); Takis (Greece).
	Environments, Land art, or *Earthworks, Conceptualists:* Lansman, Andre, Chrysto, Smithson, Serra, Lewitt, Heizer, Oldenburg, Kipp, De Suvero; Katzen, Snelson, Rickey, Woody, Nauman (United States); Beuys (Germany).
1980–1984	*Neo-Expressionism:* Scnabel (United States); Cucchi, Chia (Italy); Penck, Fetting, Baselitz (Germany).

GLOSSARY

abstract, abstraction A term given to forms created by the artist but usually derived from objects actually observed or experienced. Abstraction usually involves a simplification and/or rearrangement of natural objects to meet needs of artistic organization or expression. Sometimes there is so little resemblance to the original object that the shapes seem to have no relationship to anything ever experienced in the natural environment.

academic A term applied to any kind of art that stresses the use of accepted rules for technique and form organization. It represents the exact opposite of the creative approach, which results in a vital, individual style of expression.

accent Any stress or emphasis given to elements of a composition that makes them attract more attention than other features that surround or are close to them. Accent can be created by brighter color, darker tone, greater size, or any other means by which it expresses difference.

achromatic Relating to differences of lightness and darkness; the absence of color.

actual texture A surface that is experienced through the sense of touch (as opposed to surfaces often imitated by the artist).

addition A sculptural term meaning to build up, to assemble, or to put on.

aesthetics The theory of the artistic or the "beautiful"; traditionally a branch of philosophy, but now a compound of the philosophy, psychology, and sociology of art. As a compound of the above, aesthetics is no longer solely confined to determining what is beautiful in art, but now attempts to discover the origins of sensitivity to art forms and the relationship of art to other phases of culture (such as science, industry, morality, philosophy, and religion).

Frequently used in this book to mean concern with artistic qualities of form as opposed to descriptive form or mere recording of facts in visual form (*see* "Objective").

amorphous Without clarity of definition; formless; indistinct and of uncertain dimension.

analogous colors Closely related colors, especially those in which we can see one common hue; colors that are neighbors on the color wheel.

approximate symmetry The use of similar forms on either side of a vertical axis. The forms may give a feeling of the exactness of equal relationship but are sufficiently varied to prevent visual monotony.

artificial texture Any actual texture created by humans.

asymmetrical balance A form of balance attained when visual units are placed in positions within the pictorial field so as to create a sense of equilibrium of the total form concept.

atectonic The opposite of tectonic; a quality of three-dimensional complexity involving fairly frequent and often considerable extension into space, producing a feeling of openness.

atmospheric (aerial) perspective The illusion of deep space produced in graphic works by lightening values, softening contours, reducing value contrasts, and neutralizing colors in objects as they recede.

balance A feeling of equality in weight, attention, or attraction of the various visual elements within an artwork as a means of accomplishing organic unity.

Bauhaus Originally a German school of architecture that flourished between World War I and World War II. The Bauhaus attracted many of the leading experimental artists of both the two- and three-dimensional fields.

biomorphic shape An irregular shape that resembles the freely developed curves found in live organisms.

calligraphy The use of flowing, rhythmical lines that intrigue the eye as they enrich surfaces. Calligraphy is highly personal in nature, similar to the individual qualities found in handwriting.

casting A sculptural technique in which liquid materials are shaped by pouring into a mold.

cast shadow The dark area created on a surface when an object is positioned so as to prevent light from falling on that surface.

chiaroscuro A technique of representation that concentrates on the effects of blending the light and shade on objects to create the illusion of space or atmosphere.

chromatic Relating to color.

classical Art forms that are characterized by a rational, controlled, clear, and intellectual approach. The term derives from the ancient art of Greece in the fourth and fifth centuries B.C. The term *classic* has an even more general connotation, meaning an example or model of first rank or highest class for any kind of form, literary, artistic, natural, or otherwise. *Classicism* is the application or adherence to the principles of Greek culture by later cultural systems such as Roman classicism, Renaissance classicism, or the art of the Neoclassic movements of the early nineteenth century (*see* chapter 11, "Forms of Expression").

collage An art form in which the artist creates the image, or a portion of it, by adhering real materials that possess actual textures to the picture plane surface.

color The character of a surface that is the result of the response of vision to the wavelength of light reflected from that surface.

color tonality An orderly planning in terms of selection and arrangement of color schemes or color combinations; involves not only hue, but also value and intensity relationships.

color triad A group of three colors spaced an equal distance apart on the color wheel. The twelve-color wheel has a primary triad, a secondary triad, and two intermediate triads.

complementary colors Two colors that are directly opposite each other on the color wheel. A primary color is complementary to a secondary color that is a mixture of the two remaining primaries.

composition The act of organizing all of the elements of a work of art into a harmoniously unified whole. Each element used may have intrinsic characteristics that create interest, but must function in such a way that the whole is more important than its parts.

concept A comprehensive idea or generalization that brings diverse elements into some basic relationship.

content The essential meaning, significance, or aesthetic value of an art form. Content refers to the sensory, psychological, or emotional properties that we tend to feel in a work of art as opposed to the perception of mere descriptive aspects.

contour A line that creates a boundary separating an area of space from its surrounding background.

craftsmanship Aptitude, skill, or manual dexterity in the use of tools and materials.

cross-contour(s) The line or lines that define a surface form between the outermost edges of shapes of objects.

Cubism A term given to the artistic style that generally uses two-dimensional geometric shapes.

curvilinear Stressing the use of curved lines as opposed to *rectilinear,* which stresses straight lines.

Dada (meaning "hobbyhorse") A nihilistic, antiart, anti-everything movement resulting from the social, political, and psychological dislocations of World War I. The movement is important historically as a generating force for Surrealism.

decorative The quality that emphasizes the two-dimensional nature of any of the visual elements. Decoration enriches a surface without denying the essential flatness of its nature.

decorative shape A two-dimensional shape that seems to lie flat on the surface of the picture plane.

decorative space A concept in which the visual elements have interval relationships in terms of a two-dimensional plane.

decorative value A term given to a two-dimensional dark and light pattern. Decorative value usually refers to areas of dark or light definitely confined within boundaries, rather than the gradual blending of tones.

descriptive art A manner or attitude based upon adherence to visual appearances.

design A framework or scheme of pictorial construction on which artists base the formal organization of their total work. In a broader sense, design might be considered synonymous with the term *form*.

distortion Any change made by an artist in the size, position, or general character of forms based on visual perception, when those forms are organized into a pictorial image. Any personal or subjective interpretation of natural forms necessarily involves a degree of distortion.

dominance The principle of visual organization that suggests that certain elements should assume more importance than others in the same composition. Dominance contributes to organic unity because one main feature is emphasized and other elements are subordinate to it. The principle applies in both representational and nonrepresentational work.

elements of art The basic visual signs as they are combined into optical units used by the artist to communicate or express creative ideas. The combination of the basic elements of line, shape, value, texture, and color represent the visual language of the artist.

expression A general term meaning the special characteristics of form that mark the work of an artist or group of artists. The manner in which artists attempt to say something about their time in terms of the artistic forms then considered to be of aesthetic merit.

When a work of art remains largely realistic in form but strongly emotional or intellectual in content, we call the work *expressive*. In a more general usage of the term, all art can be so characterized when the final goal is an intrinsic or self-sufficient aesthetic meaning. Opposed to this would be art with extrinsic, practical ends; commercial art, with its easily read message, is intended to promote the product rather than the work of art itself.

Expressionistic art is art in which there is a desire to express what is felt rather than perceived or reasoned. Expressionistic form is defined by an obvious exaggeration of natural objects for the purpose of emphasizing an emotion, mood, or concept. It can be better understood as a more vehement kind of *romanticism*. The term *expressionism* is best applied to a movement in art of the early twentieth century, although it can be used to describe all art of this character.

fantasy (in art) Departure from accepted appearances or relationships for the sake of psychological expression; may exist within any art style, but usually thought of in connection with realism; unencumbered flights of pictorial fancy, freely interpreted or invented.

Fauvism A name (meaning "wild beasts") for an art movement that began in Paris about 1905. It is expressionist art in a general sense but more decorative and with more of the French sense of orderliness and charm than in German expressionism (*see* chapter 11, "Forms of Expression").

form The arbitrary organization or inventive arrangement of all of the visual elements according to principles that will develop an organic unity in the total work of art.

formal An orderly system of organization as opposed to a less disciplined system.

form-meaning Another term for *content*, the third component of a work of art as used in this book. Since artists create artistic forms that cause spectator reactions, form-meaning implies that such reaction is the associations and/or sensory experience the observer finds in those forms.

four-dimensional space A highly imaginative treatment of forms that gives a sense of intervals of time or motion.

fractional representation A device used by various cultures (notably the Egyptians) in which several spatial aspects of the same subject are combined in the same image.

Futurism A submovement within the framework of abstract directions taken by many twentieth-century artists. The expression of Futurist artists was based on an interest in time and rhythm, which they felt were manifested in the machinery and human activities of modern times.

genre Subject matter that concerns everyday life, domestic scenes, sentimental family relationships, etc.

geometric perspective (*see* "perspective").

geometric shapes Shapes created by the exact mathematical laws of geometry. They are usually simple, such as the triangle, the rectangle, and the circle.

glyptic 1. A term referring to the quality of an art material like stone, wood, or metal, that can be carved or engraved. 2. An art form that retains the tactile, color, and tensile quality of the material from which it was created. 3. The quality of hardness, solidity, or resistance found in carved or engraved materials.

graphic art 1. Any of the visual arts that involves the application of lines or strokes to a two-dimensional surface. 2. The two-dimensional use of the elements. 3. Two-dimensional art forms, such as drawings, paintings, and prints. 4. Also may refer to the techniques of printing as used in newspapers, books, and magazines.

harmony The unity of all of the visual elements of a composition. Harmony is achieved by repetition of characteristics that are the same or similar.

highlight The area of a represented shape that receives the greatest amount of direct light.

hue Used to designate the common name of a color and to indicate its position in the spectrum or on the color wheel. Hue is determined by the specific wavelength of the color in a ray of light.

illusionism The imitation of visual reality created on the flat surface of the picture plane by the use of perspective, shading, and other techniques.

illustration(al) An art practice, usually commercial in character, that stresses anecdotes or story situations, and stresses subject in preference to serious considerations of aesthetic quality; noneloquent, nonformal, easily understood, and temporal rather than sustained or universal.

image An arresting aspect; a mentally envisioned thing or plan given concrete appearance through the use of an art medium; the general appearance of a work (en toto).

Impression and Impressionism A strong immediate effect produced in the mind by an outward or inward agency. Artists might have worked in this general sense (as Impressionists) at any time in history. The specific movement known as *Impressionism* was a late nineteenth-century movement, primarily connected with such painters as Claude Monet and Camille Pissarro (*see* chapter 11, "Forms of Expression").

infinite space A pictorial concept in which the illusion of space has the quality of endlessness found in the natural environment. The picture frame has the quality of a window through which one can see the endless recession of forms into space.

intensity The saturation or strength of a color determined by the *quality* of light reflected from it. A vivid color is of high intensity; a dull color, of low intensity.

interpenetration The movement of planes, objects, or shapes through each other, locking them together within a specific area of space.

intuitive Knowing or recognizing by an instinctive sense rather than by the application of exact rules; sensing or feeling something without a specific reason.

intuitive space A pictorial spatial illusion that is not the product of any mechanical system but that relies, instead, on the physical properties of the elements and the instincts or feel of the artist. The illusion of space resulting from the exercise of the artist's instincts in manipulating certain space-producing devices, including overlapping, transparency, interpenetration, inclined planes, disproportionate scale, fractional representation, and the inherent spatial properties of the art elements.

invented texture Patterns created by the repetition of lines or shapes on a small scale over the surface of an area. The repeated motif can be an abstraction or an adaptation of natural patterns used in a more regular or planned fashion.

light pattern The typical relationship of light and dark shapes appearing on a form as a result of its physical character and the kind and direction of light falling upon it.

line The path of a moving point; that is, a mark made by a tool or instrument as it is drawn across a surface. It is usually made visible by the fact that it contrasts in value with the surface on which it is drawn.

linear perspective (*see* "perspective").

local (objective) color The naturalistic color of an object as seen by the eye (green grass, blue sky, red fire).

local value The characteristic tone quality of an area or surface that is determined by its particular pigmentation. For example, a shape painted with gray pigment will reflect only a *certain amount of light* even when that light strikes it directly.

lyrical A term borrowed from poetry that attempts to define a quality of a special aesthetic or sensory experience in the visual arts (as opposed to a dramatic experience, for example). A songlike outpouring of the artist's experience usually accomplished in form by graceful rhythms, light color tonalities, and spontaneous drawing or brushwork. The term *poetic* is sometimes used in place of *lyrical,* for the same kind of meaning.

manipulation To shape by skilled use of the hands; sometimes used to mean modeling (*see* "modeling").

mass The physical bulk of a solid body of material.

media, mediums The materials and tools used by the artist to create the visual elements perceived by the viewer of the work of art.

mobile A three-dimensional, moving sculpture.

modeling A sculptural term meaning to shape a pliable material.

moments of force Direction(s) and degree(s) of energy implied by art elements in specific pictorial situations; amounts of visual thrust produced by such matters as dimension, placement, and accent.

motif A visual element or a combination of elements that is repeated often enough in a composition to make it the dominating feature of the artist's expression. Motif is similar to theme or melody in a musical composition.

narrative art A form of art that depends on subject matter to tell a story. At its best, such art is more concerned with aesthetic qualities than with the story; at its worst, it is a documentary description of the facts of the story without regard for aesthetic form.

naturalism The approach to art in which all forms used by the artist are essentially descriptive representation of things visually experienced. True naturalism contains no interpretation introduced by the artist for expressive purposes. The complete recording of visual effects of nature is a physical impossibility, and naturalistic style thus becomes a matter of degree.

natural texture Textures that are created as the result of natural processes.

negative areas The unoccupied or empty space left after the positive shapes have been laid down by the artist. However, because these areas have boundaries, they also function as shapes in the total pictorial structure.

neutralized color A color that has been grayed or reduced in intensity by mixture with any of the neutrals or with a complementary color.

neutrals Surface hues that do not reflect any single wavelength of light but rather all of them at once. No single color is noticed—only a sense of light or dark, such as white, gray, or black.

nonobjective An approach to art in which the visual signs are entirely imaginative and not derived from anything ever seen by the artist. The shapes, their organization, and their treatment by the artist are entirely personalized and consequently not associated by the observer with any previously experienced natural form.

objective An impersonal statement of observed facts. In art, the exact rendering by the artist of surface characteristics without alteration or interpretation of the visual image.

objective color (*see* "local color").

optical perception A way of seeing in which the mind seems to have no other function than the natural one of providing the physical sensation of recognition of form. *Conceptual perception,* on the other hand, refers to the artist's imagination and creative vision.

organizational control Specific or planned relationships of the art elements in pictorial space.

orthographic drawing A two-dimensional graphic representation of an object showing a plan, a vertical elevation, and/or a section.

paint quality The use of paint to enrich a surface through textural interest. Interest is created by the ingenuity in handling paint for its intrinsic character.

papier collé A technique of visual expression in which scraps of paper having various textures are pasted to the picture surface to enrich or embellish areas.

patina A film, usually greenish in color, that results from oxidation of bronze or other metallic material; colored pigments, usually earthy, applied to a sculptural surface.

pattern The obvious emphasis on certain visual form relationships and certain directional movements within the visual field. Pattern also refers to the repetition of elements or the combinations of elements in a readily recognized systematic organization.

perception The act of taking notice; recognition of an object, quality, or idea through the use of the physical and/or mental faculties.

perspective A mechanical system of creating the illusion of a three-dimensional space on a two-dimensional surface.
 Aerial or atmospheric perspective Uses value and color modification to suggest or enhance the effect of space.
 Linear perspective Primarily linear in treatment.

pictorial area The area within which the design exists; generally of measurable dimensions and bounded by mat, frame, or lines.

picture frame The boundary of the picture plane.

picture plane The actual flat surface on which the artist executes a pictorial image. In some cases the picture plane acts merely as a transparent plane of reference to establish the illusion of forms existing in a three-dimensional space.

pigments Color substances, usually powdery in nature, that are used with liquid vehicles to produce paint.

plane A shape that is essentially two-dimensional but whose relationships with other shapes may give an illusion of a third dimension.

plastic A quality that emphasizes the three-dimensional nature of shape or mass. On a two-dimensional surface, plasticity is always an illusion created by the use of the visual elements in special ways.

plastic art 1. The three-dimensional use of the elements. 2. On a two-dimensional surface, plasticity is always an illusion created by the use of the visual elements in special ways. 3. Three-dimensional art forms such as architecture, sculpture, and ceramics.

plastic shape A shape that is indicated by the artist as being in the round and surrounded by space; a shape displaying the third dimension of depth.

plastic space A concept in which the visual elements on the surface of the picture plane are made to give the illusion of having relationships in depth as well as in length and breadth.

positive shapes The enclosed areas that represent the initial selection of shapes planned by the artist. Positive shapes might suggest recognizable objects or merely be planned nonrepresentational shapes.

primary colors The three colors in the spectrum that cannot be produced by a mixture of pigments; red, yellow, and blue.

primitive art The art of people with a tribal social order or a Neolithic stage of culture. This kind of art is characterized by heightened emphasis on form and a mysterious but vehement expression and content. A secondary meaning is found in the work of such artists as Henri Rousseau and Grandma Moses. This kind of art shows a naivete of expression and form closely related to the untrained but often sensitive forms of folk art.

proportion The comparison of elements one to another in terms of their properties of size, quantity, and degree of emphasis. Proportion can be expressed in terms of a definite ratio, such as "twice as big," or be more loosely indicated in such expressions as "darker than," "more neutralized," or "more important than."

radial balance Two or more identical forces distributed around a center point to create a repetitive equilibrium; rotating forces that create a visual circular movement.

Realism A form of expression that retains the basic impression of visual reality but, in addition, attempts to relate and interpret the universal meanings that lie underneath the surface appearance of natural form.

reality (*see* "visual reality").

rectilinear shape A shape whose boundaries usually consist entirely of straight lines.

relief (sculptural) Partial projection from a main mass, the degree of projection determining the type of relief; limited three-dimensional masses bound to a parent surface.

repetition The use of the same visual element a number of times in the same composition. Repetition can accomplish a dominance of one visual idea, a feeling of harmonious relationship, an obviously planned pattern, or a rhythmic movement.

representation A manner of expression by the artist in which the subject matter is presented so that visual elements seen by the observer are reminiscent of actual forms previously perceived.

rhythm A continuance, a flow, or a feeling of movement achieved by repetition of regulated visual units; the use of measured accents.

Romanticism A philosophical attitude toward life that can occur during any period. In art, the *romantic* form is characterized by an experimental point of view and extols spontaneity of expression, intuitive imagination, and a picturesque rather than a carefully organized, rational approach. The *Romantic* movement of nineteenth-century artists, such as Delacroix, Gericault, Turner, and others, is characterized by such an approach to form.

saturation (*see* "intensity").

sculpture The art of shaping expressive three-dimensional forms. "Man's expression to man through three-dimensional form" (Jules Struppeck).

shadow, shade, shading The darker value on the surface of a form that gives the illusion that that portion of the form is turned away from the imagined source of light.

shallow space Sometimes called "limited depth" because the artist controls the use of the visual elements so that no point or form is so remote that it does not take its place in the pattern of the picture surface.

shape An area that stands out from the space next to or around it because of a defined boundary or because of difference of value, color, or texture.
 Three-dimensional A solid, or the illusion of a solid.
 Two-dimensional An area confined to length and width and set apart by contrasts of value or color.

silhouette The area existing between or bounded by the contours, or edges, of an object; the total shape.

simulated texture The copying or imitation of object surfaces.

simultaneity In art, use of separate views, representing different points in time and space, brought together to create one integrated image.

simultaneous contrast Intensified contrast that results whenever two different colors come into direct contact.

space Might be characterized as boundless or unlimited extension in all directions; void of matter. Artists use the term to describe the interval or measurable distance between preestablished points.

Decorative Space limited to length and breadth.

Four-dimensional Possessing time as well as thickness or depth, length, and breadth.

Infinite A pictorial concept in which the illusion of space has the quality of endlessness found in the natural environment. The picture frame has the quality of a window through which one can see the endless recession of forms into space.

Plastic Involving length, breadth, and thickness or depth.

Shallow Sometimes called "limited depth" because the artist controls the use of the visual elements so that no point or form is so remote that it does not take place in the pattern of the picture surface.

Three-dimensional Possessing thickness or depth as well as length and breadth.

Two-dimensional Possessing only length and breadth.

spectrum The band of individual colors that results when a beam of light is broken into its component wavelengths of hues.

split-complement A color and the two colors on either side of its complement.

style The specific artistic character and dominant form trends noted in art movements or during specific periods of history. Style might also mean artists' expressive use of media to give their works individual character.

subject This term in a descriptive style of art refers to the persons or things represented, as well as the artists' experience, that serve as inspiration. In abstract or nonobjective forms of art, subject refers merely to the basic character of all the visual signs employed by the artist. In this case the subject has little to do with anything experienced in the natural environment.

subjective The personal as opposed to the impersonal; an individual attitude or bias through which the artist feels free to change or modify natural visual characteristics. In this approach, the artist is able to emphasize personal emotions aroused by the characteristics of the natural form.

subjective colors Colors chosen by the artist without regard to the natural appearance of the object portrayed. Subjective colors have nothing to do with objective reality but represent the expression of the individual artist.

substitution A sculptural term meaning the replacement of one material or medium by another; casting (*see* "casting").

subtraction A sculptural term meaning to carve or cut away materials.

Surrealism A style of artistic expression that emphasizes fantasy and whose subjects are usually the experiences revealed by the subconscious mind.

symbol Representation of a quality or situation through the use of an intermediate agent; the word is not the thing itself but a sign of the thing (for example, the owl represents wisdom); indirect understanding as opposed to direct understanding through form-meaning.

symmetrical balance A form of balance achieved by the use of identical compositional units on either side of a vertical axis within the confining pictorial space.

tactile A quality that refers to the sense of touch.

technique The manner and skill with which artists employ their tools and materials to achieve a predetermined expressive effect. The ways of using media can have an effect on the aesthetic quality of an artist's total concept.

tectonic Pertaining to the quality of simple massiveness; lacking any significant extension.

tenebrism A style of painting that exaggerates or emphasizes the effects of chiaroscuro. Larger amounts of dark value are placed close to smaller areas of highly contrasting lights in order to concentrate attention on certain important features.

tension (pictorial) Dynamic interrelationships of force as manifested by the moments of force inherent in art elements; semiarchitectural stresses affecting balance.

texture The surface feel of an object or the representation of surface character. Texture is the actual and "visual feel" of surface areas as they are arranged and altered by natural forces or through an artist's manipulation of the art elements.

Actual A surface that stimulates a tactile response when actually touched.

Invented Patterns sometimes derived from actual textures, frequently varied to fit form needs, and often freely created without reference to any item.

Simulated A representation of an actual texture created by a careful copying of the light-and-dark pattern characteristic of its surface.

three-dimensional (*see* "shape" and "space").

tonality An orderly selection and arrangement of color schemes or color combinations. It is concerned not only with hue, but also with value and intensity relationship.

tone The character of color or value of a surface determined by the amount or quality of light reflected from it. The kind of light reflected can be determined by the character of the medium that has been applied to the surface.

transparency A situation in which a distant plane or shape can be seen through a nearer one.

trompe l'oeil A technique involving the copying of nature with such exactitude that the subject depicted may be mistaken for the natural forms.

two-dimensional (*see* "shape" and "space").

unity The total effect of a work of art that results from the combination of all of the work's component parts, including the assigned ratio between harmony and variety.

value The relative degree of lightness or darkness given to an area by the *amount of light* reflected from it; (color) the characteristic of a color in terms of lightness and darkness and determined by the amount or quantity of light reflected by a color.

value pattern The total effect of the relationships of light and dark given to areas within the pictorial field.

Three-dimensional Value relationships that are planned to create an illusion of objects existing in depth back of the picture plane.

Two-dimensional Value relationships in which the changes of light and dark seem to occur only on the surface of the picture plane.

variety The use of opposing, contrasting, changing, elaborating, or diversifying elements in a composition to add individualism and interest. The counterweight of *harmony* in a work of art.

visual reality The objective (insofar as that is possible) optical image; obvious appearances; naturalism in the sense of the physically observed.

void The penetration of an object to its other side, thus allowing for the passage of space through it; an enclosed negative shape.

volume A three-dimensional shape that occupies a quantity of space. On a flat surface the artist can only create the *illusion* of a volume.

BIBLIOGRAPHY

Anderson, Donald M. *Elements of Design.* New York: Holt, Rinehart & Winston, 1961.

Armstrong, Tom. *200 Years of American Art,* Catalogue for Whitney Museum of American Art. Boston, Mass.: The Godine Press, 1976.

Arnason, H. H. *History of Modern Art.* Englewood Cliffs, N.J.: Prentice-Hall, 1968.

Arnheim, Rudolph. *Art and Visual Perception.* Berkeley, Calif.: University of California Press, 1954.

Babcock, Gregory. *The New Art.* New York: E. P. Dutton & Co., 1966.

Bates, Kenneth F. *Basic Design: Principle and Practice.* New York: Funk & Wagnalls, 1975.

Beam, P. C. *Language of Art.* New York: John Wiley & Sons, 1958.

Bethers, Ray. *Composition in Pictures.* New York: Pitman Publishing Corporation, 1956.

Betti, Claudia, and Sale, Teel. *A Contemporary Approach: Drawing.* New York: Holt, Rinehart & Winston, 1980.

Bevlin, Marjorie E. *Design through Discovery.* New York: Holt, Rinehart & Winston, 1980.

Birren, Faber. *Creative Color.* New York: Van Nostrand Reinhold Company, 1961.

Bloomer, Carolyn M. *Principles of Visual Perception.* New York: Van Nostrand Reinhold Company, 1976.

Bro, L. V. *Drawing, A Studio Guide.* New York: W. W. Norton & Co., 1978.

Burnham, Jack. *Beyond Modern Sculpture.* New York: George Braziller, 1968.

Canaday, John. *Mainstreams of Modern Art.* New York: Henry Holt and Company, 1959.

————. *What Is Art?* New York: Alfred A. Knopf, 1980.

Capers, Roberta M. and Maddox. *Images and Imagination.* New York: John Wiley & Sons, 1965.

Carpenter, James M. *Visual Art: An Introduction.* New York: Harcourt, Brace Jovanovich, 1982.

Chaet, Bernhard. *The Art of Drawing.* New York: Holt, Rinehart & Winston, 1970.

Cleaver, Dale G. *Art: An Introduction.* New York: Harcourt Brace Jovanovich, 1972.

Coleman, Ronald. *Sculpture: A Basic Handbook for Students.* Dubuque, Iowa: Wm. C. Brown Publishers, 1980.

Collier, Graham. *Form, Space, and Vision.* Englewood Cliffs, N.J.: Prentice-Hall, 1972.

Compton, Michael. *Pop Art.* London: Hamlyn Publishing, Ltd., 1970.

Davis, Phil. *Photography.* Dubuque, Iowa: Wm. C. Brown Publishers, 1979.

Edwards, Betty. *Drawing on the Right Side of the Brain.* Los Angeles: J. P. Tarcher, 1979.

Elsen, Albert E. *Origins of Modern Sculpture.* New York: George Braziller, 1974.

Emerson, Sybil. *Design: A Creative Approach.* Scranton, Pa.: International Textbook Company, 1951.

Faulkner, Ray, et al. *Art Today: An Introduction to the Visual Arts.* New York: Holt, Rinehart & Winston, 1974.

Goldstein, Nathan. *The Art of Responsive Drawing.* Englewood Cliffs, N.J.: Prentice-Hall, 1973.

Hanks, Kurt, et al. *Design Yourself.* Los Altos, Calif.: William Kaufmann, Inc., 1977.

Harlan, Calvin. *Vision and Invention: A Course in Art Fundamentals.* Englewood Cliffs, N.J.: Prentice-Hall, 1970.

Heller, Jules. *Printmaking Today.* New York: Holt, Rinehart & Winston, 1972.

Hunter, Samuel. *American Art of the 20th Century.* New York: Harry N. Abrams, 1972.

Itten, Johannes. *The Art of Color.* New York: Van Nostrand Reinhold Company, 1970.

————. *Design and Form.* New York: Van Nostrand Reinhold Company, 1975.

Janis, Harriet, and Blesh, Rudi. *Collage: Personalities, Concepts, Techniques.* Philadelphia, Pa.: Chilton Book Company, 1962.

Kepes, Gyorgy. *Language of Vision.* Chicago: Paul Theobald and Company, 1951.

Knobler, Nathan. *The Visual Dialogue.* New York: Holt, Rinehart & Winston, 1980.

Kuh, Katherine. *Art Has Many Faces.* New York: Harper & Row Publishers, 1957.

Lauer, David. *Design Basics.* New York: Holt, Rinehart & Winston, 1979.

Lerner, Abram; Nochlin, Linda; et al. *The Hirshhorn Museum and Sculpture Garden.* New York: Harry N. Abrams, 1974.

Longman, Lester. *History and Appreciation of Art.* Dubuque, Iowa: Wm. C. Brown Publishers, 1949.

Lowry, Bates. *Visual Experience: An Introduction to Art.* New York: Harry N. Abrams, 1961.

Lucie-Smith, Edward. *Late Modern: The Visual Arts Since 1945.* New York: Praeger Publishers, 1969.

McCurdy, Charles, ed. *Modern Art: A Pictorial Anthology.* New York: Macmillan, 1958.

Mendelowitz, Daniel M. *A Guide to Drawing.* New York: Holt, Rinehart & Winston, 1976.

Moholy-Nagy, L. *Vision in Motion,* 5th ed. Chicago: Paul Theobald and Company, 1956.

Nelson, Roy P. *Design of Advertising.* Dubuque, Iowa: Wm. C. Brown Publishers, 1967.

Preble, Duane. *We Create, Art Creates Us.* New York: Harper & Row Publishers, 1976.

————. *Art Forms.* New York: Harper & Row Publishers, 1978.

Rasmussen, Henry N. *Art Structure.* New York: McGraw-Hill Book Company, 1951.

Read, Herbert. *A Concise History of Modern Painting.* New York: Praeger Publishers, 1959.

————. *A Concise History of Modern Sculpture.* New York: Praeger Publishers, 1964.

Renner, Paul. *Color, Order, and Harmony.* New York: Van Nostrand Reinhold Company, 1965.

Saff, Donald, and Sacilotto, Deli. *Printmaking.* New York: Holt, Rinehart & Winston, 1978.

Scott, Robert G. *Design Fundamentals.* New York: McGraw-Hill Book Company, 1951.

Seiberling, Frank. *Looking into Art.* New York: Holt, Rinehart & Winston, 1959.

Seuphor, Michel. *The Sculpture of This Century.* New York: George Braziller, 1961.

Simmons, Seymour, III, and Winer, Marc S. A. *Drawing: The Creative Process.* Englewood Cliffs, N.J.: Prentice-Hall, 1977.

Struppeck, Jules. *The Creation of Sculpture.* New York: Henry Holt and Company, 1952.

Wickiser, Ralph L. *An Introduction to Art Activities.* New York: Henry Holt and Company, 1947.

Wong, Wucius. *Principles of Three Dimensional Design.* New York: Van Nostrand Reinhold Company, 1977.

Index of Media

Architecture, 10, 176
Ceramics, 174 (pl. 84)
Collage, 29, 32, 41, 102 (pl. 44), 215, 222 (pl. 113)
Computer art, 31, 37, 38, 69, 99, 158 (pl. 79)
Constructions and assemblages, 29, 30, 174 (pl. 88), 185, 214, 224, 227, 229, 230, 231, 236, 238
 Environments, 2, 3, 222 (pl. 112), 230, 237
 Mobiles, 185, 186, 224
Drawings, 2, 5, 7, 19, 28, 32, 52, 54, 55, 57, 59, 84, 163, 204
Fiber arts, 174 (pl. 85)
Glass and metalwork, 14 (pl. 2), 30 (pl. 16), 86 (pl. 39), 174 (pl. 83)
 Jewelry, 174 (pl. 82)

Mixed media, 75, 86 (pl. 40), 101, 222 (pl. 113), 210, 230, 239
Paintings, 4, 11, 12, 15, 16, 17, 22, 26, 27, 28, 30, 35, 41, 42, 43, 44, 45, 54, 56, 58, 62 (pl. 22), 64, 66, 68, 69, 72, 74, 75, 76, 86, 87, 88, 89, 95, 96, 100, 101, 102, 124, 125, 126, 128, 129, 130, 131, 132, 133, 134, 135, 136, 137, 138, 139, 146, 148, 149, 150, 152, 154, 156, 157, 158, 160, 161, 162, 164, 165, 166, 196, 198, 199, 205, 209, 211, 212, 213, 214, 216, 217, 218, 220, 221, 222, 225, 226, 227, 229, 230, 231, 232, 239; pls. after pp. 14, 30, 62, 78, 86, 102, 158, 206, 222

Papier collé, 100, 159
Photography, 2, 18, 21, 59, 85, 89, 99, 109, 158 (pl. 79)
Prints, 5, 7, 30 (pl. 14), 38, 43, 53, 57, 59, 84, 90, 146, 157, 158 (pl. 79), 197, 203
Product design, 174 (pl. 86), 176
Sculpture, 6, 20, 30, 96, 174, 174 (pl. 87), 175, 180, 181, 182, 184, 185, 187, 200, 201, 202, 206, 207, 208, 209, 214, 218, 219, 223, 229, 232, 233, 234, 235

Index of Artists' Works

Index

261